CANINES OF NEW YORK

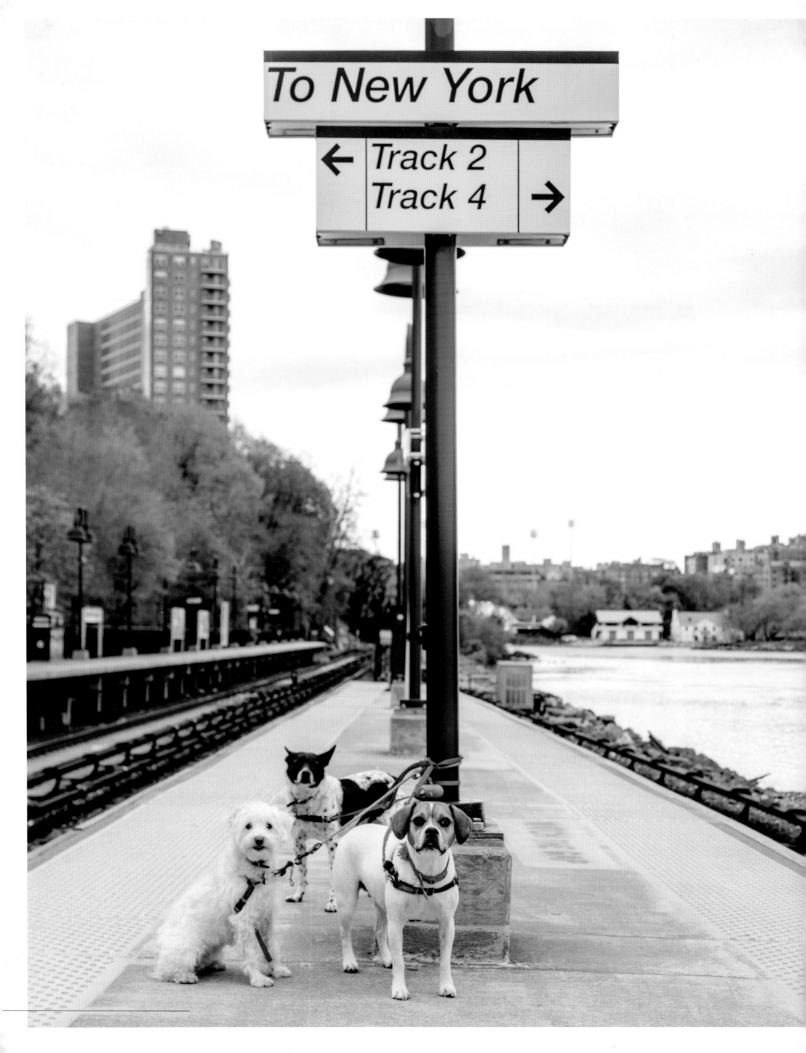

CANINES OF NEW YORK

HEATHER WESTON

Bluestreak
BOOKS

⹀Bluestreak

An imprint of Weldon Owen
1150 Brickyard Cove Road, Richmond, CA 94801
www.weldonowen.com

Copyright © 2017 Weldon Owen
Photographs © 2017 Heather Weston

Library of Congress Cataloging in Publication data is available.

ISBN: 978-1-68188-305-2

10 9 8 7 6 5 4
2024 2023 2022

Printed in China

Produced by Blue Sky Books
Designed by Krzysztof Poluchowicz / Paper Plane Design
Endpapers copyright 2017 Jeff Peters.

For Joe and Trish,
my number one dog people

In memory of Desdemona

Introduction:
Dogs in the City

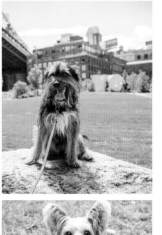

I spent my childhood with dogs—my parents are crazy dog people. Ilke was a German Shepherd who had been with my dad since he joined the Marine Corps. She was very protective when I was a little girl, and she wouldn't let anyone get near me: my own private nanny watchdog. Then there was Daisy, an Old English Sheepdog. We called her "crazy Daisy." She loved riding in cars, and once she even jumped into our neighbors' car as they were getting ready to go somewhere. Later there was Tri, a German Shorthaired Pointer. Tri went to a summer training camp to hone his natural hunting skills. He was good at pointing . . . but not so good at retrieving. He was a real family dog. My sister and I had a great time dressing him up in our pajamas. To our dad's dismay, we even let Tri sleep in our beds—maybe we snuggled the retrieving instinct right out of him.

I don't have a dog anymore because I live in a tiny Brooklyn apartment. Still, I love dogs so much that when the opportunity to photograph New York dogs came up, I said, "Yes! Let me at them!" Dachshunds and Pit bulls and Pugs and mutts: I wanted to meet them and pet them and feed them treats. Oh yes, and make them mine by taking pictures of them.

I didn't know how much I needed to learn about photographing dogs, though.

As a photographer, I have spent much of my life getting to know people through my camera. That's what I do. Now I would apply all that knowledge to photographing dogs.

But you know what? Unlike dogs, people sit when you tell them to sit. They smile when you tell them to smile. They don't bark at the camera, don't try to eat lens caps, and (most of the time) don't lick the photographer.

Dogs are a completely different story.

My first subject was Lottie, a rescue from Tennessee. I met Lottie and her person, Heidi, one morning at Brooklyn Bridge Park. Goodness, it was early. Lesson one: Dogs go out early. Like, 6 a.m. early. Most dog people in the city don't have yards, so they need to take their dogs out somewhere to get a little exercise before they go to work.

For my first shot, I wanted a photo with Manhattan in the background. Heidi told me that Lottie, a Whippet–hound mix, is "surely part seal," meaning that she's exceptionally talented at jumping and catching balls. So we let her off the leash and tossed balls until we got our shot. What a beautiful way to spend an early New York morning!

Turns out dogs are not actually allowed off leash in Brooklyn Bridge Park. We managed to go undetected and we got some fun action shots. My second lesson: Break the rules a little, especially if it means you get your shot.

Later I learned that dogs are allowed off leash in almost every city park from the time the park opens until 9 a.m., and again from 9 p.m. to park closing. Hooray!

Prospect Park was first on the list. For those of you who aren't Brooklynites, it's our largest city park and was designed by Frederick Law Olmsted and Calvert Vaux after they finished Central Park. I went with my human friends Kate (owner of Maisie, a rescue mutt with a huge smile and a habit of running past the ball she is trying to catch), Hazel (owner of not a single dog because her mother likes cats), and Emily (cat person who is willing to hold my bag while I'm shooting). Third lesson: You need an Emily. To get good dog pictures, you gotta have two people. One to capture the image, and the other to hold your stuff, dole out treats, and chat up the humans.

What an amazing morning! During off-leash hours, dogs are everywhere. I started with Maisie and then shot about twenty dogs in the next few hours. I was rolling around on the ground with dogs coming at me from all directions. I had a squeaky toy. I had tennis balls. I had dog treats. What I didn't have were knee pads or elbow pads—and here is when I learned my fourth lesson: To capture a dog's life, you will need to lie on the ground. A lot. And it will hurt. Especially concrete. Also, it turns out that when you lie on the ground, dogs think you want to play with them. And they give you slobbery kisses. Fifth lesson: Bring wipes.

I discovered that New York is a city of working dogs. Marti is an actor who has performed on Broadway and appeared in movies. She has numerous handlers and gets paid more than a lot of the human actors in the shows she's in. Marti posed for me on the Great White Way—ironically, right in front of the theater where *Cats* was playing. Her owner, animal behaviorist and dog trainer extraordinaire William Berloni, gave me some great advice on getting canine subjects to focus so you can capture a dog's expressiveness. Among his best tips—my sixth lesson for photographing dogs—was to make unusual noises: The sound of a bag of chips opening or a crinkling candy wrapper can often prompt dogs to make eye contact.

Labrador Retriever Deke is a service dog who belongs to the owner of Books of Wonder, a delightful children's bookshop in Chelsea. Before becoming a service dog, Deke was a blue-ribbon champion in Rally, an obedience-based sport, as well as a top-notch hunting dog. Max is a Border Collie who works on Governors Island. Every morning he chases the geese off the grounds. He is the only dog

allowed on the island. Tori, a black Labrador, and Blue, a German Shepherd, are New York state–certified police K9s. They work for the New York City Police Department on Staten Island. Despite being expertly trained at explosive detection and criminal apprehension, they are totally comfortable around people and happy to receive lots of affection. I also photographed Pretzel, a rescue from a high-kill shelter in Los Angeles who now works as a model, most recently posing with the Fearless Girl statue in Manhattan's financial district.

Seventh lesson: Professional dogs will sit still for you. Amateur dogs . . . not so much. Eighth lesson: You can buy the inserts to squeaky toys separately. It's easier to hide them in your hand and manage your camera at the same time. Cultivate the skill of making crazy-sounding noises. I got better and better at this one—ask me sometime and I'll show you. Ninth lesson: Be ready to shoot on the first noise you make, because by the second noise, the dog may lose interest or discover that he or she is afraid of the camera.

Tenth lesson: Bribery almost always works. Eleven: Even dogs who generally don't like treats can be tempted by the peanut butter–flavored ones.

And, finally, the twelfth lesson: Despite the city's reputation, most New Yorkers are super friendly, especially New York dog owners. Devoted, giving, and kind, most of them are happy to take time out of their busy days to hang out and help you get a great shot of their dog.

I didn't start out as a dog photographer. I've spent the last twenty years focusing my lens on pretty people and pretty things, from food and textiles to home decor. This project made me a dog photographer—and the wonderful dogs and people I met have made me a better photographer, period. This, my year of dogs, has been one of the best of my life. And though the work for this book may be done, I have just gotten started.

Thank you, dog lovers and canines of New York.

—Heather Weston, May 2017

MANHATTAN

"Vehement silhouettes of Manhattan—
that vertical city with unimaginable diamonds."

—Le Corbusier (1961)

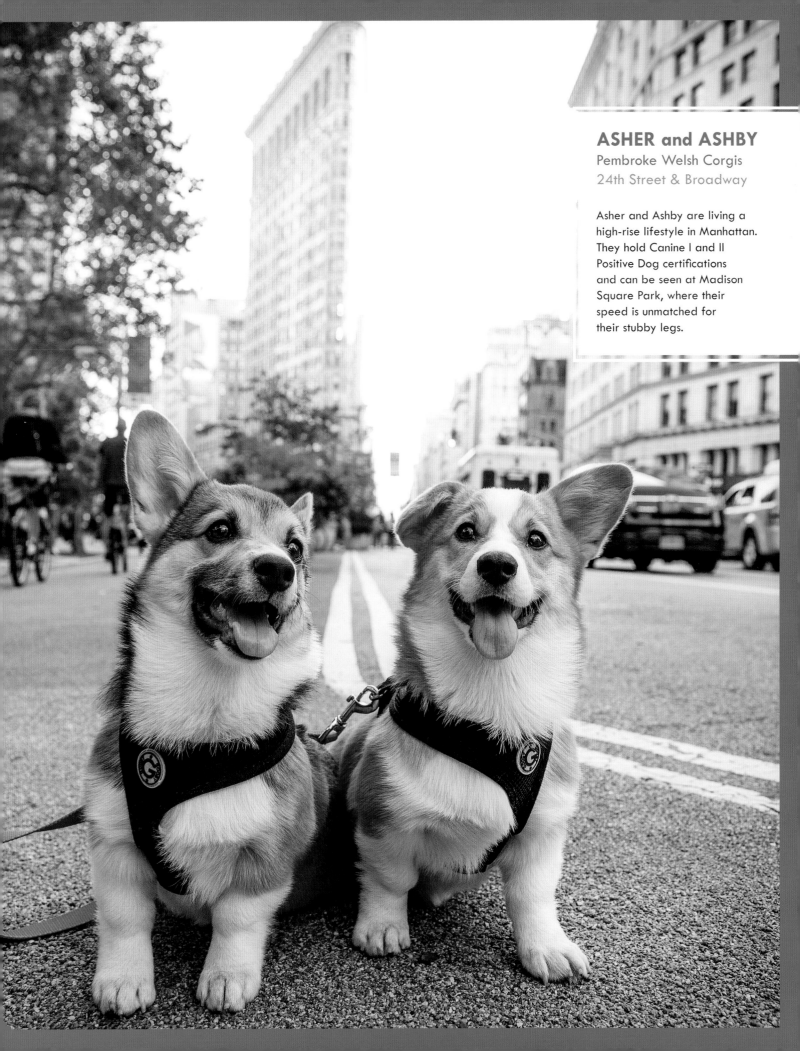

ASHER and ASHBY
Pembroke Welsh Corgis
24th Street & Broadway

Asher and Ashby are living a
high-rise lifestyle in Manhattan.
They hold Canine I and II
Positive Dog certifications
and can be seen at Madison
Square Park, where their
speed is unmatched for
their stubby legs.

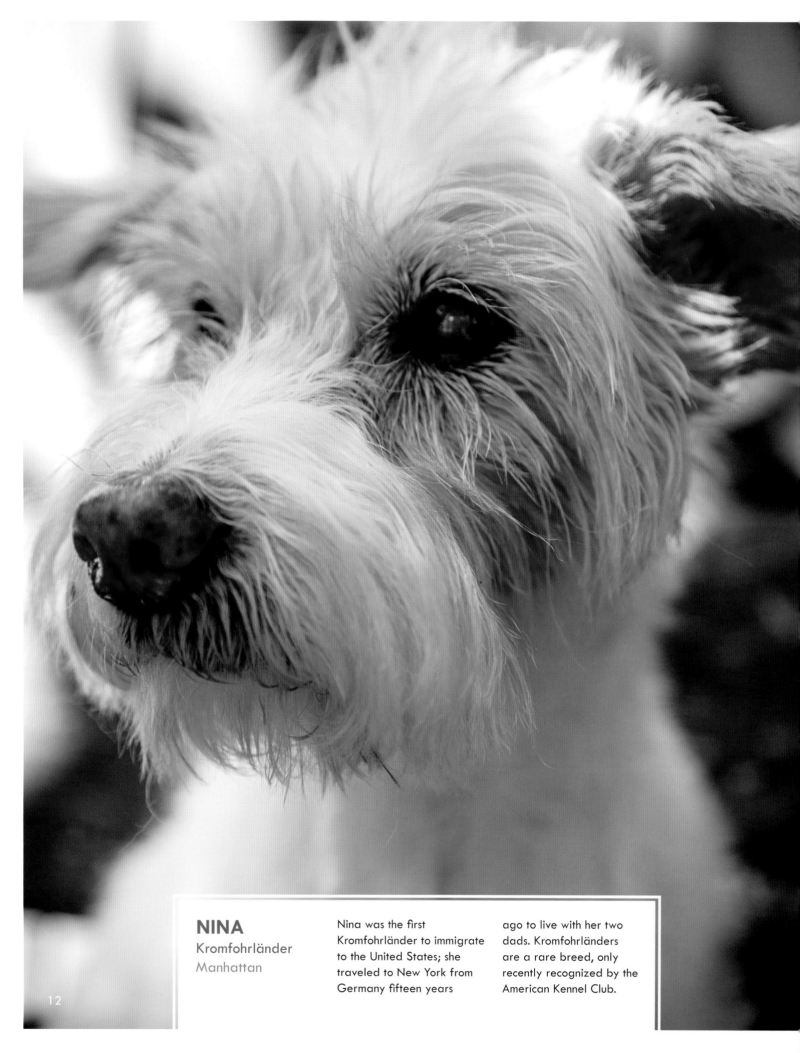

NINA
Kromfohrländer
Manhattan

Nina was the first Kromfohrländer to immigrate to the United States; she traveled to New York from Germany fifteen years ago to live with her two dads. Kromfohrländers are a rare breed, only recently recognized by the American Kennel Club.

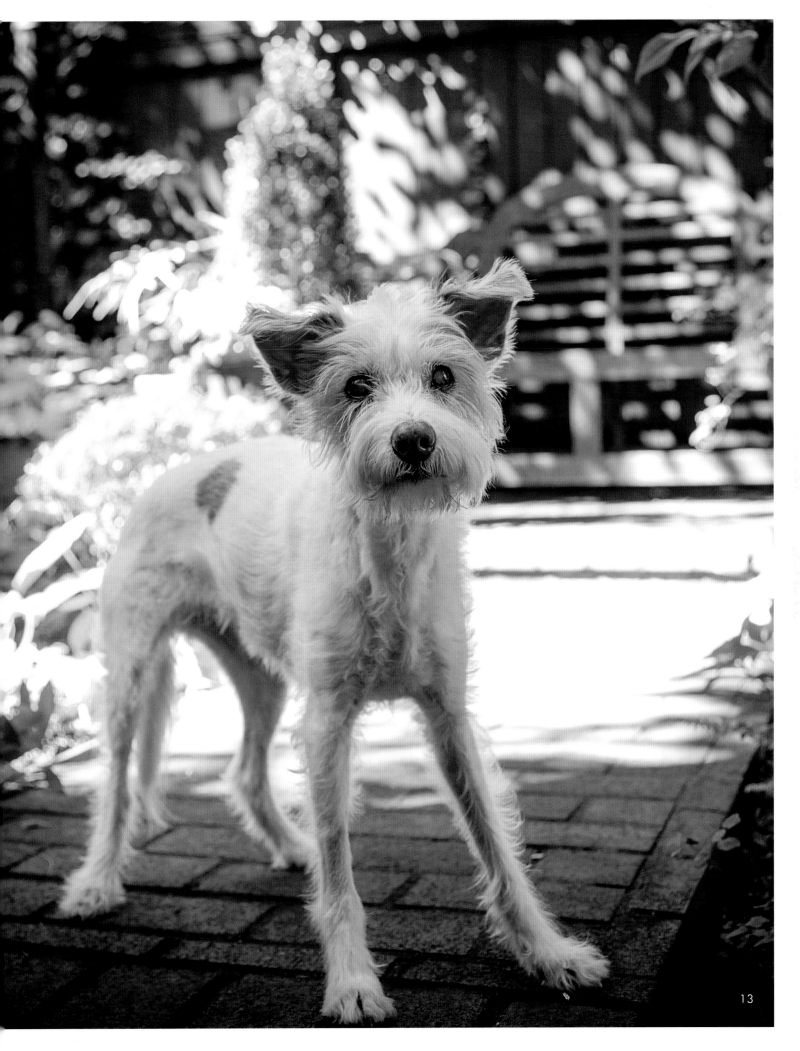

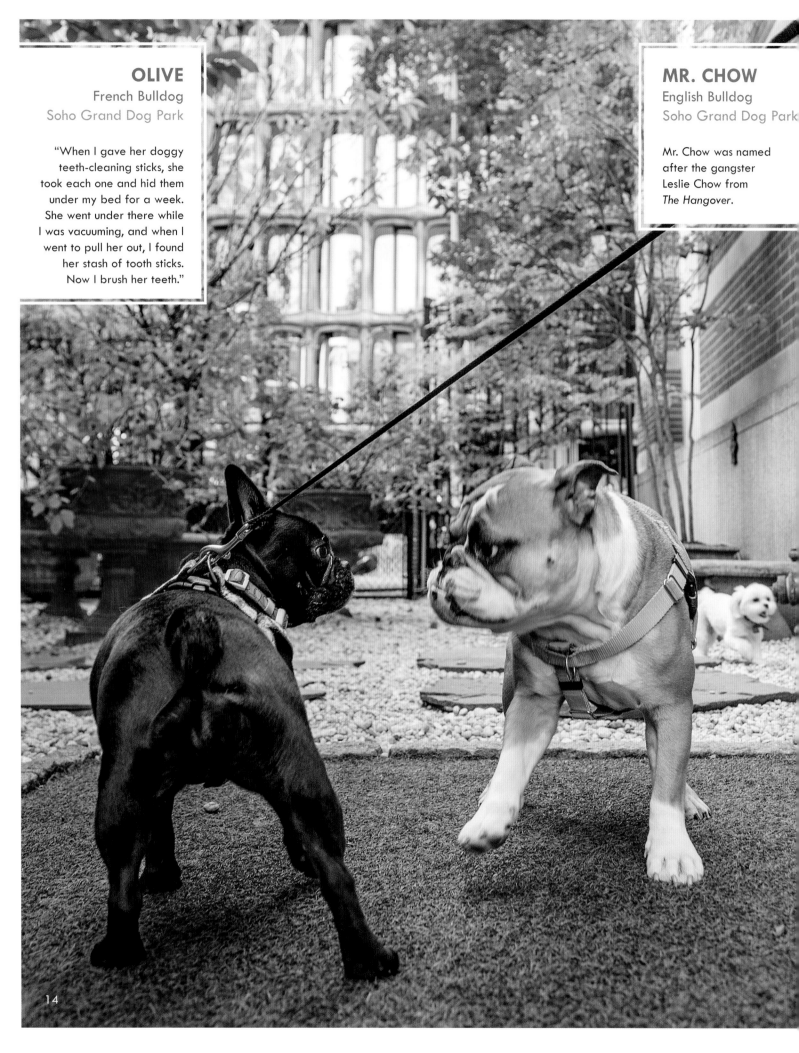

OLIVE
French Bulldog
Soho Grand Dog Park

"When I gave her doggy teeth-cleaning sticks, she took each one and hid them under my bed for a week. She went under there while I was vacuuming, and when I went to pull her out, I found her stash of tooth sticks. Now I brush her teeth."

MR. CHOW
English Bulldog
Soho Grand Dog Park

Mr. Chow was named after the gangster Leslie Chow from *The Hangover*.

14

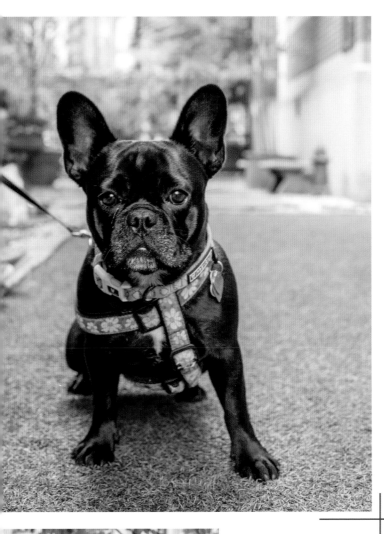

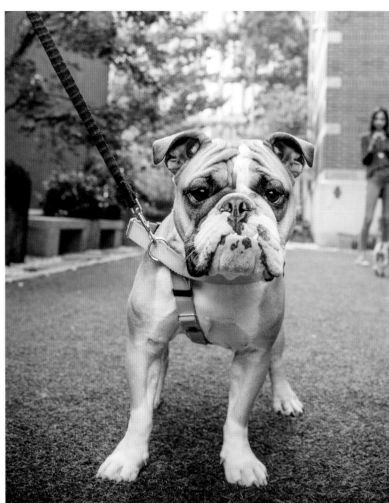

MADELINE
Maltese
Soho Grand Dog Park

ELOISE
Yorkie
Soho Grand Dog Park

Eloise and Madeline are both named after the characters in children's books. Their human is a second-grade teacher at an all-girls school. See more of them @eloise_takes_nyc and @madelines_adventures.

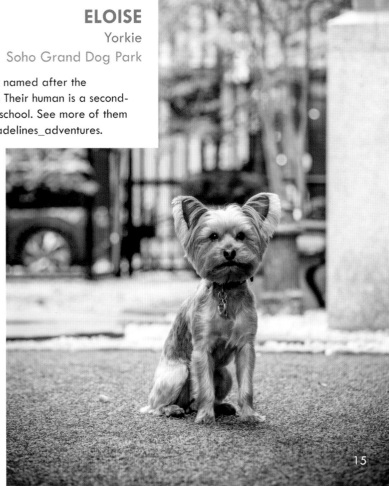

15

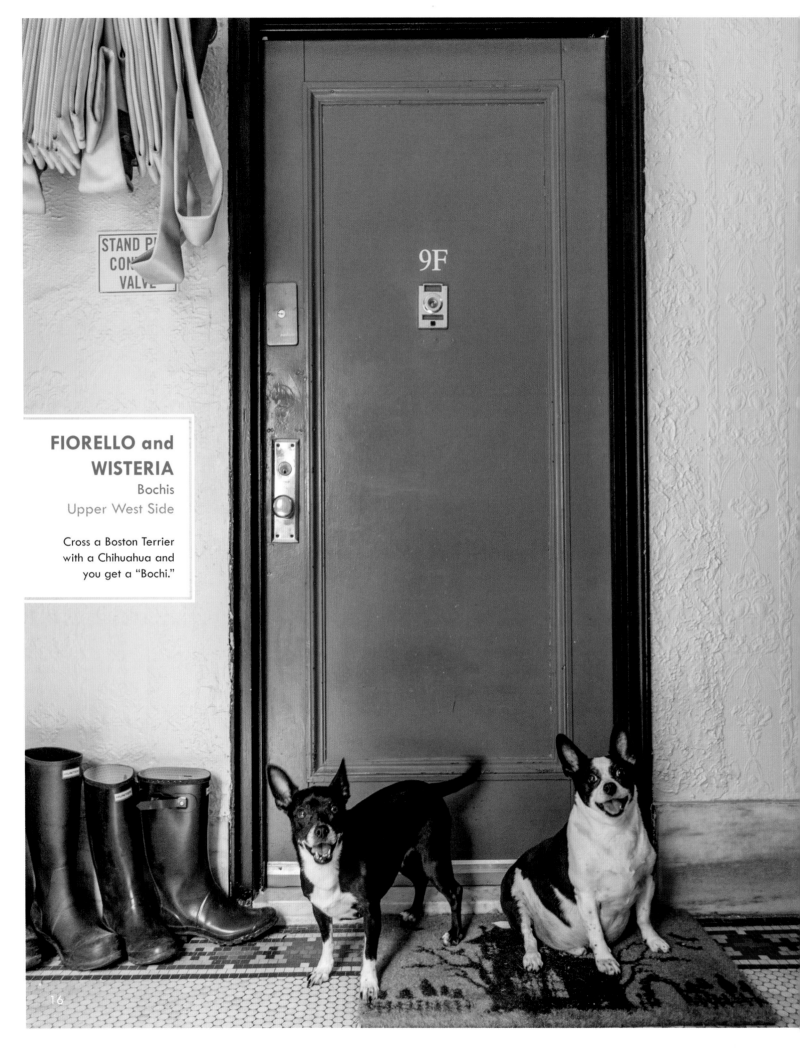

FIORELLO and WISTERIA
Bochis
Upper West Side

Cross a Boston Terrier
with a Chihuahua and
you get a "Bochi."

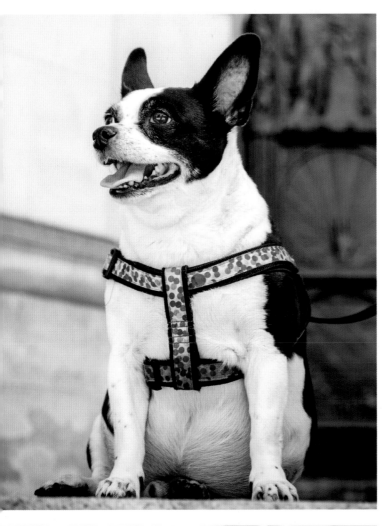

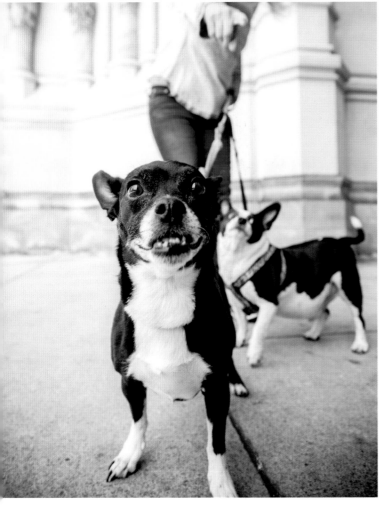

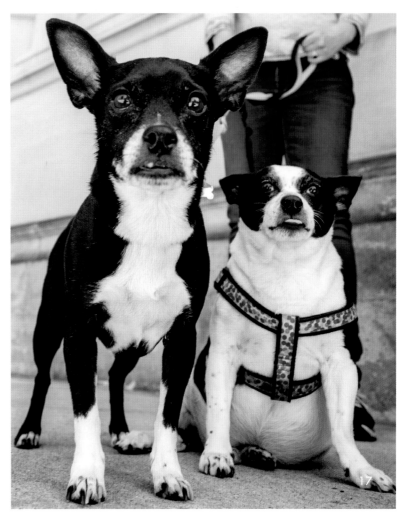

17

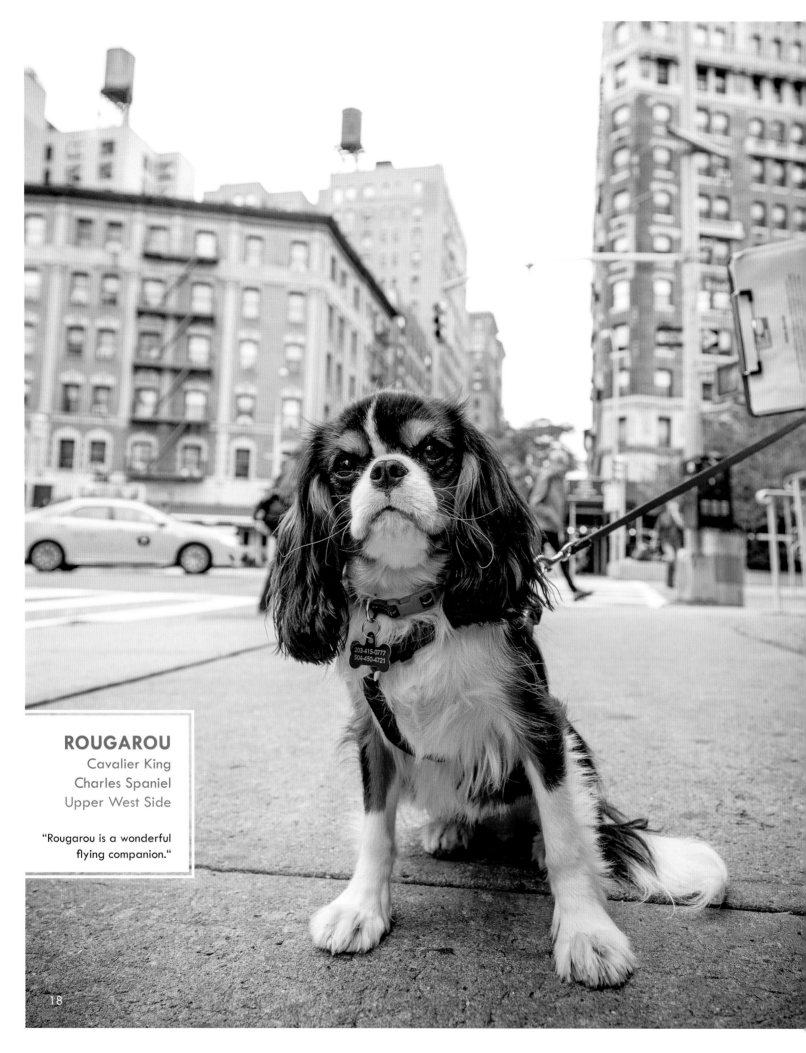

ROUGAROU
Cavalier King
Charles Spaniel
Upper West Side

"Rougarou is a wonderful
flying companion."

18

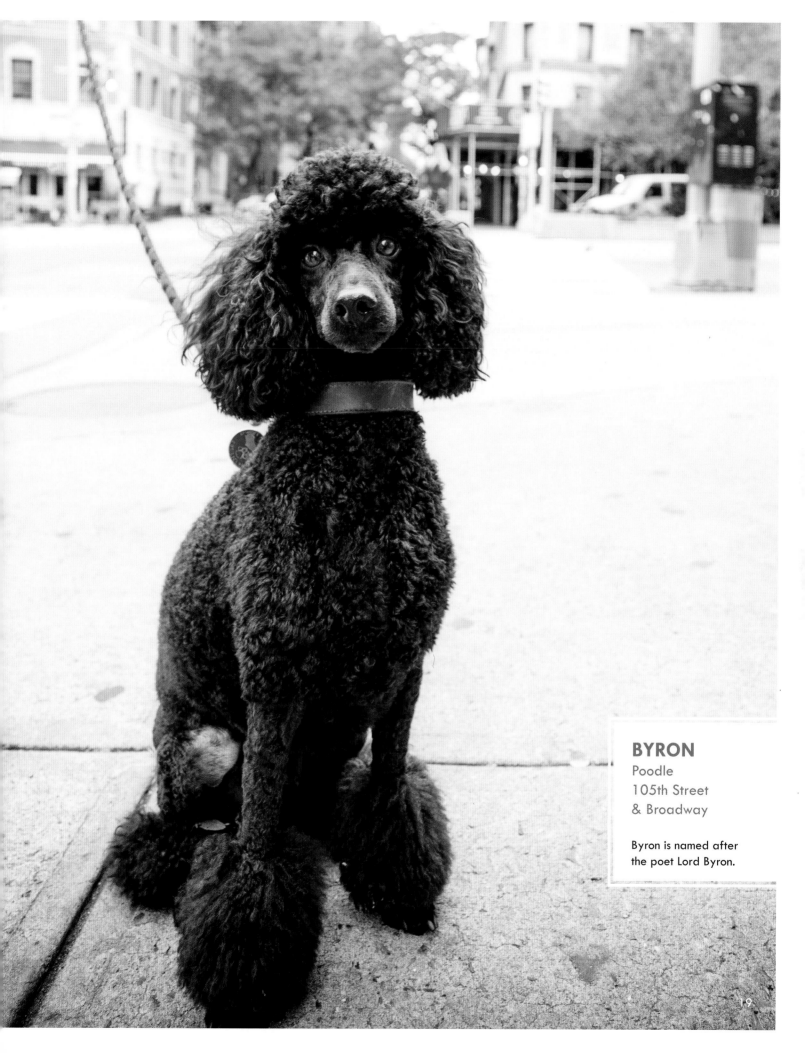

BYRON
Poodle
105th Street
& Broadway

Byron is named after
the poet Lord Byron.

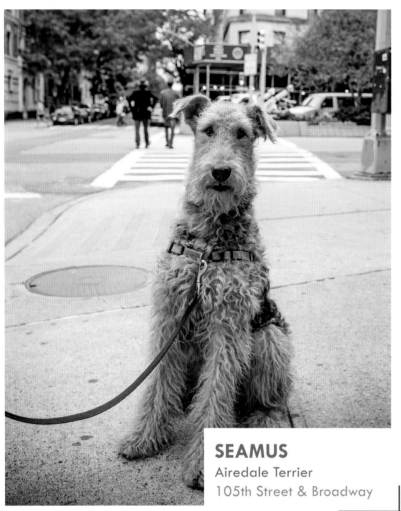

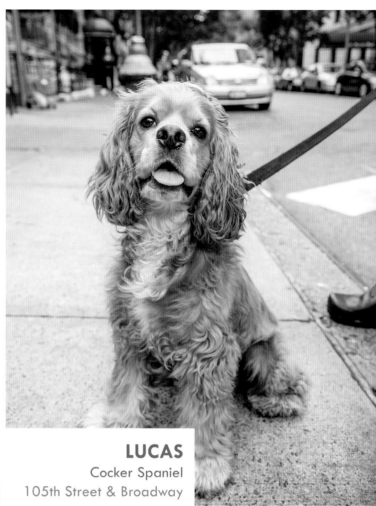

SEAMUS
Airedale Terrier
105th Street & Broadway

LUCAS
Cocker Spaniel
105th Street & Broadway

COOPER
Golden Retriever
105th Street & Broadway

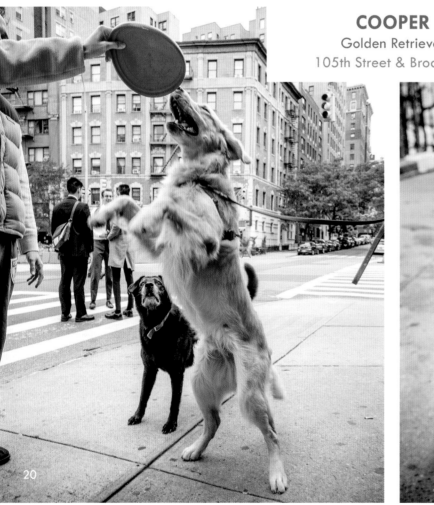

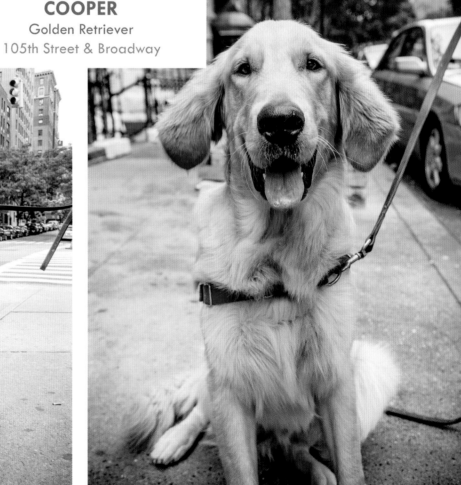

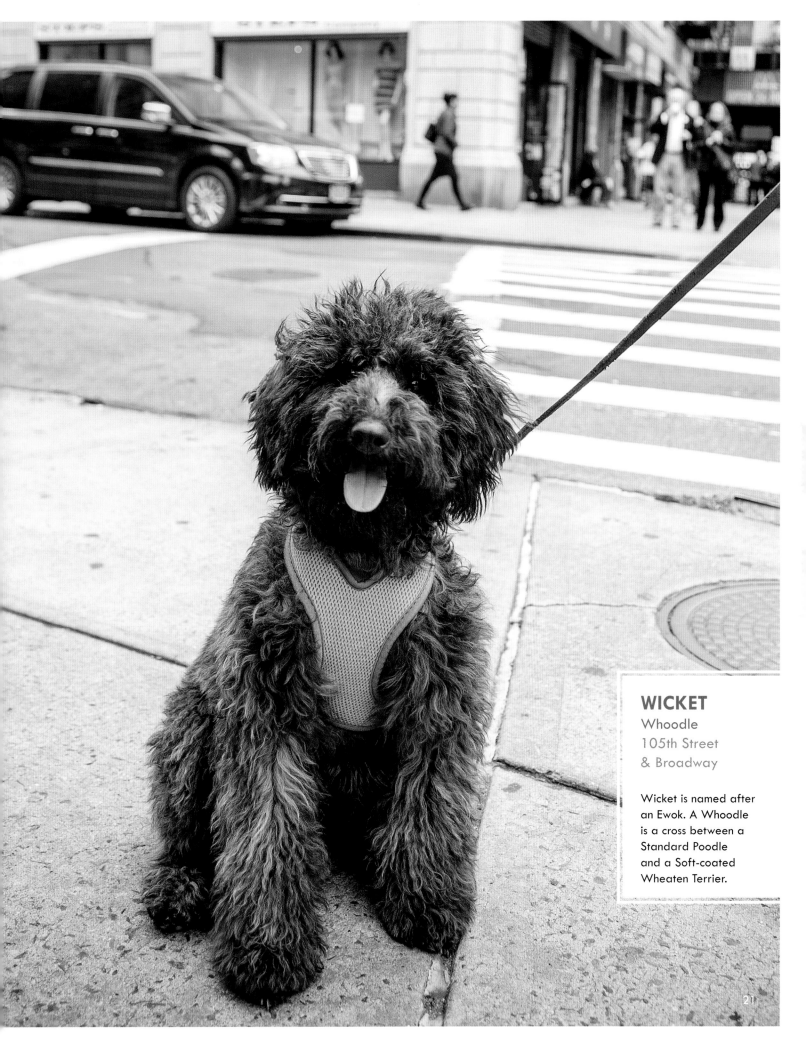

WICKET
Whoodle
105th Street
& Broadway

Wicket is named after
an Ewok. A Whoodle
is a cross between a
Standard Poodle
and a Soft-coated
Wheaten Terrier.

21

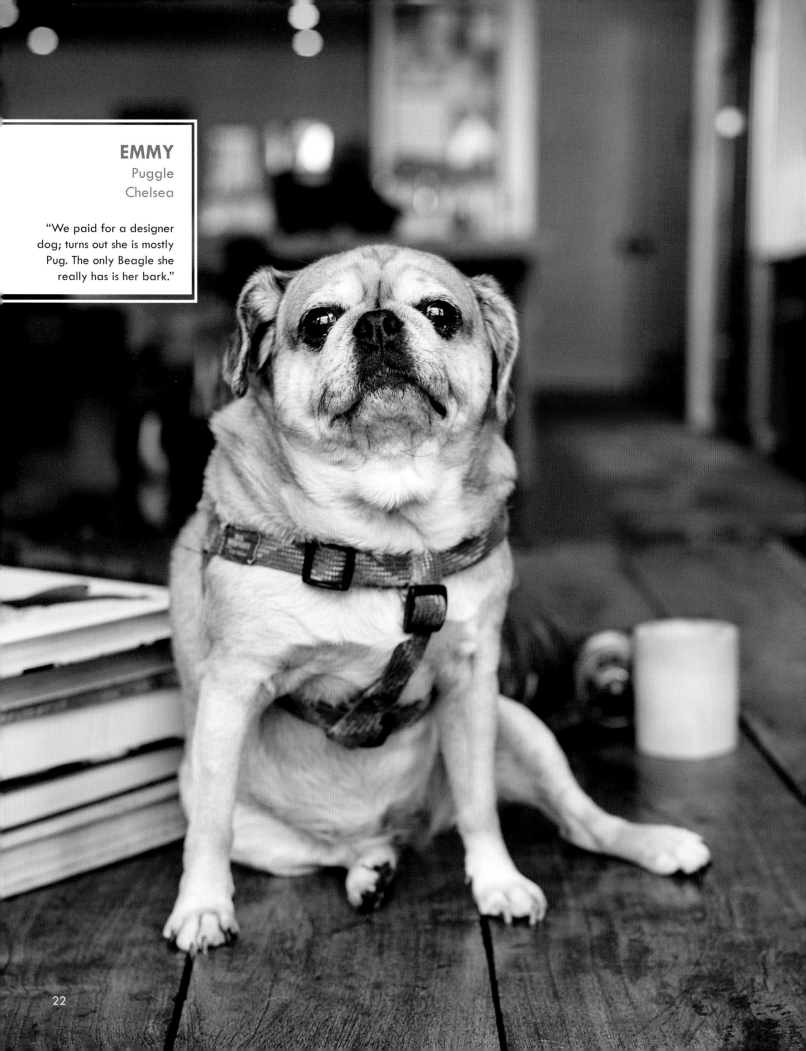

EMMY
Puggle
Chelsea

"We paid for a designer dog; turns out she is mostly Pug. The only Beagle she really has is her bark."

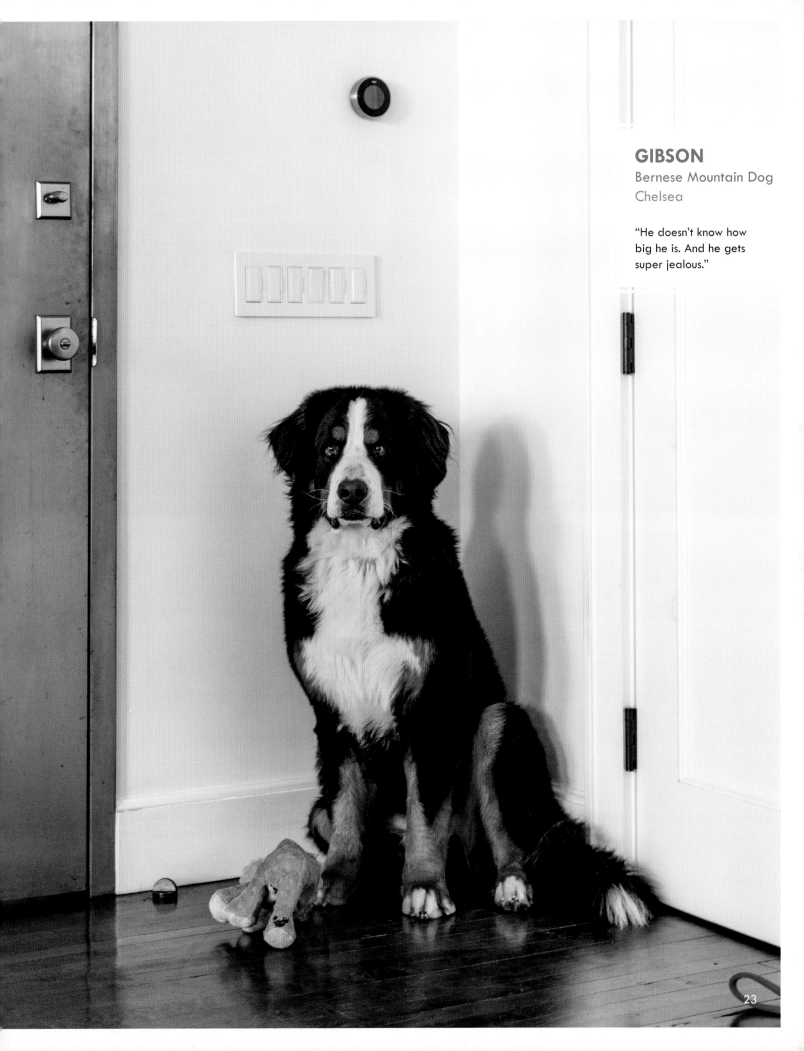

GIBSON
Bernese Mountain Dog
Chelsea

"He doesn't know how big he is. And he gets super jealous."

23

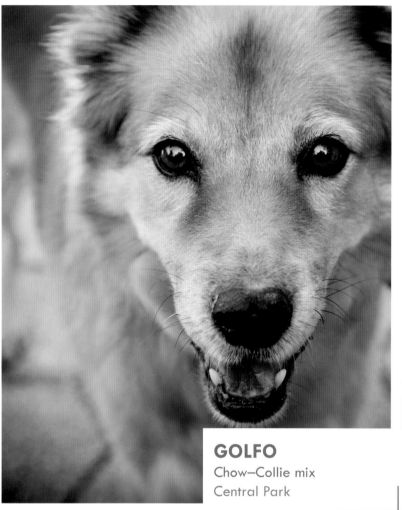

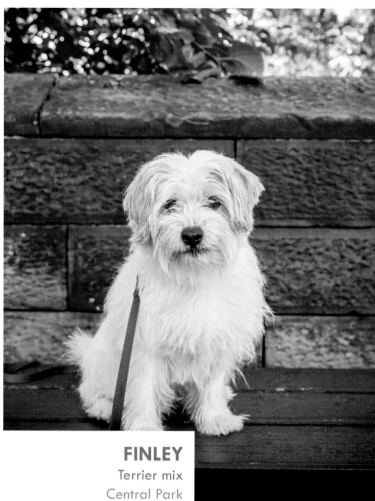

GOLFO
Chow–Collie mix
Central Park

FINLEY
Terrier mix
Central Park

HUNTLEY
Australian Shepherd
Madison Square Park

PIXIE
Labrador–Terrier mix
Riverside Park

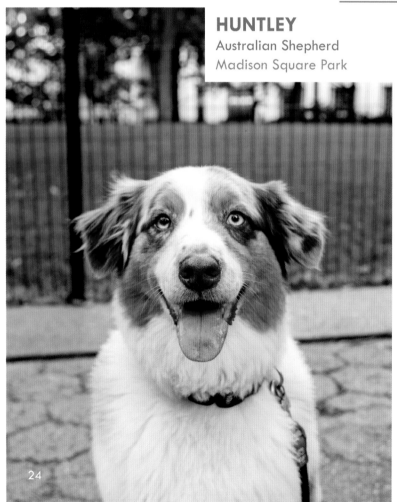

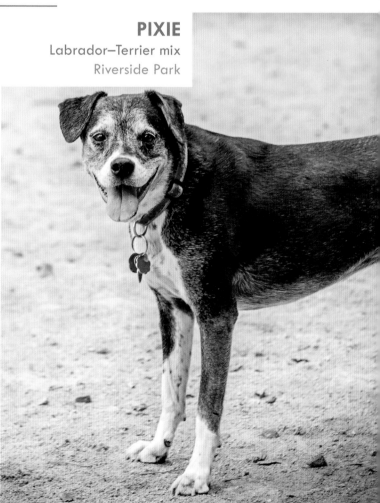

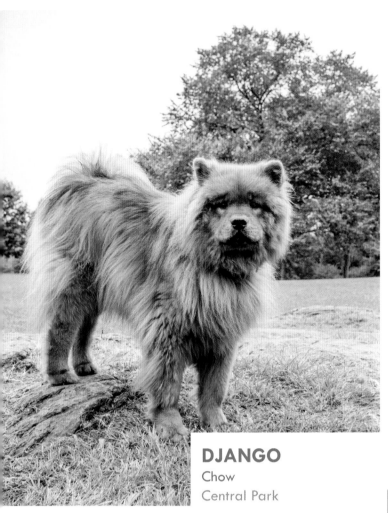

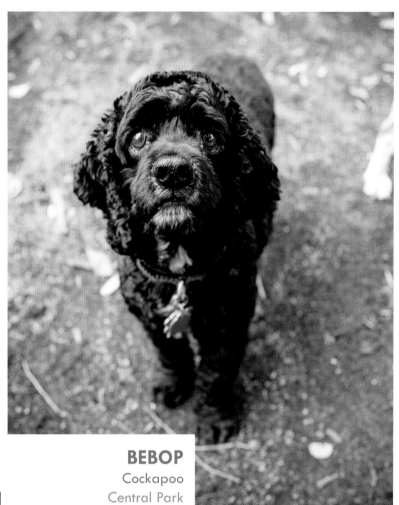

DJANGO
Chow
Central Park

BEBOP
Cockapoo
Central Park

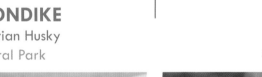

KLONDIKE
Siberian Husky
Central Park

ARCHIE
Beagle mix
Central Park

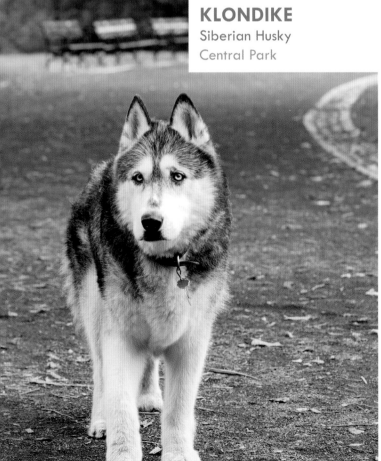

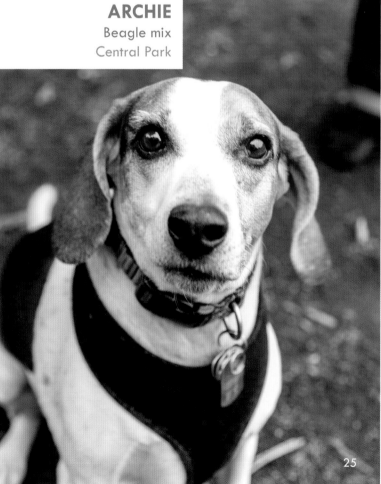

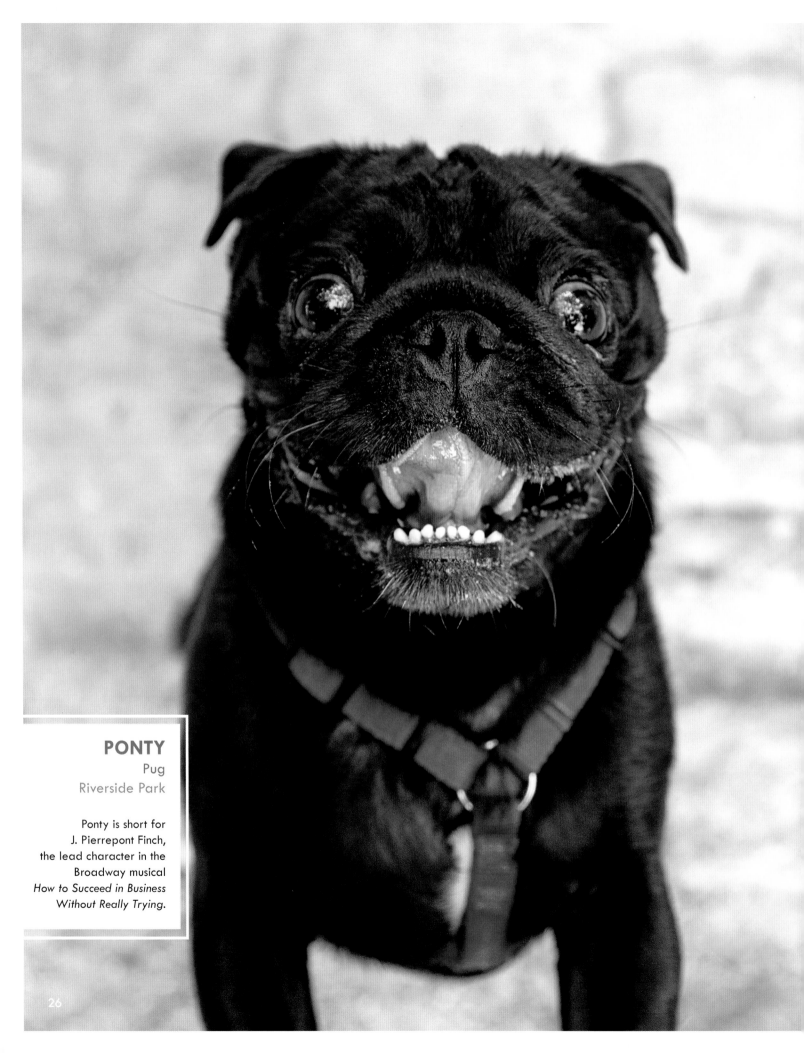

PONTY
Pug
Riverside Park

Ponty is short for
J. Pierrepont Finch,
the lead character in the
Broadway musical
*How to Succeed in Business
Without Really Trying.*

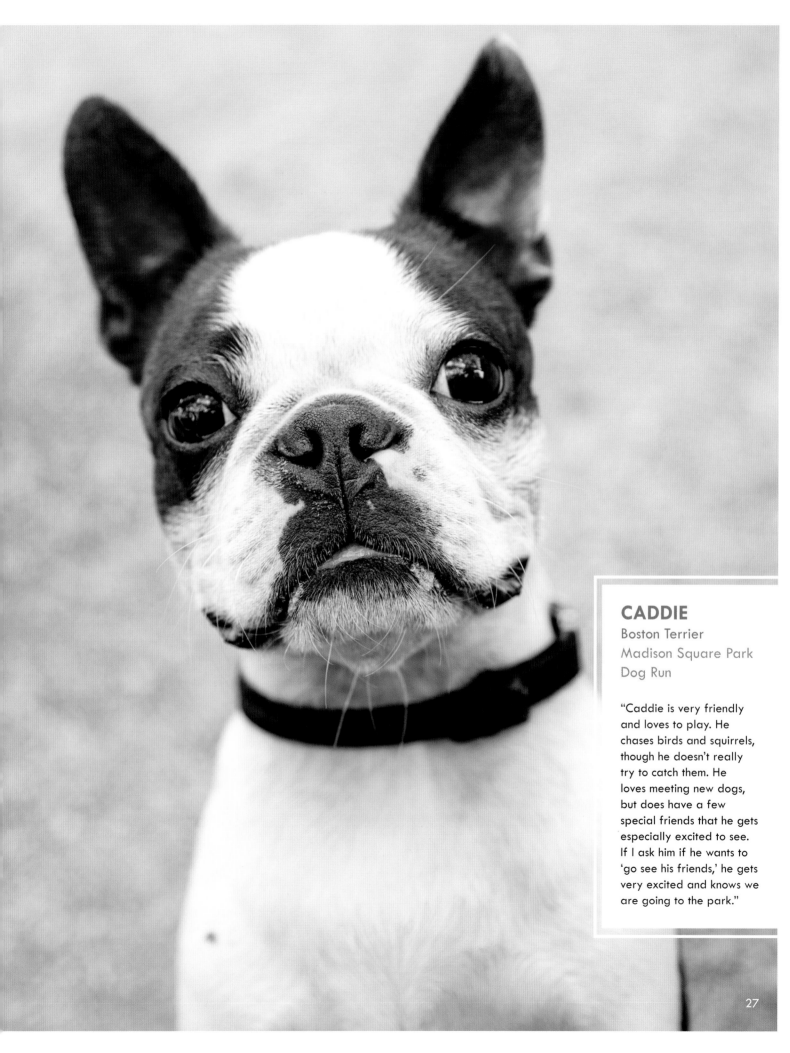

CADDIE
Boston Terrier
Madison Square Park
Dog Run

"Caddie is very friendly and loves to play. He chases birds and squirrels, though he doesn't really try to catch them. He loves meeting new dogs, but does have a few special friends that he gets especially excited to see. If I ask him if he wants to 'go see his friends,' he gets very excited and knows we are going to the park."

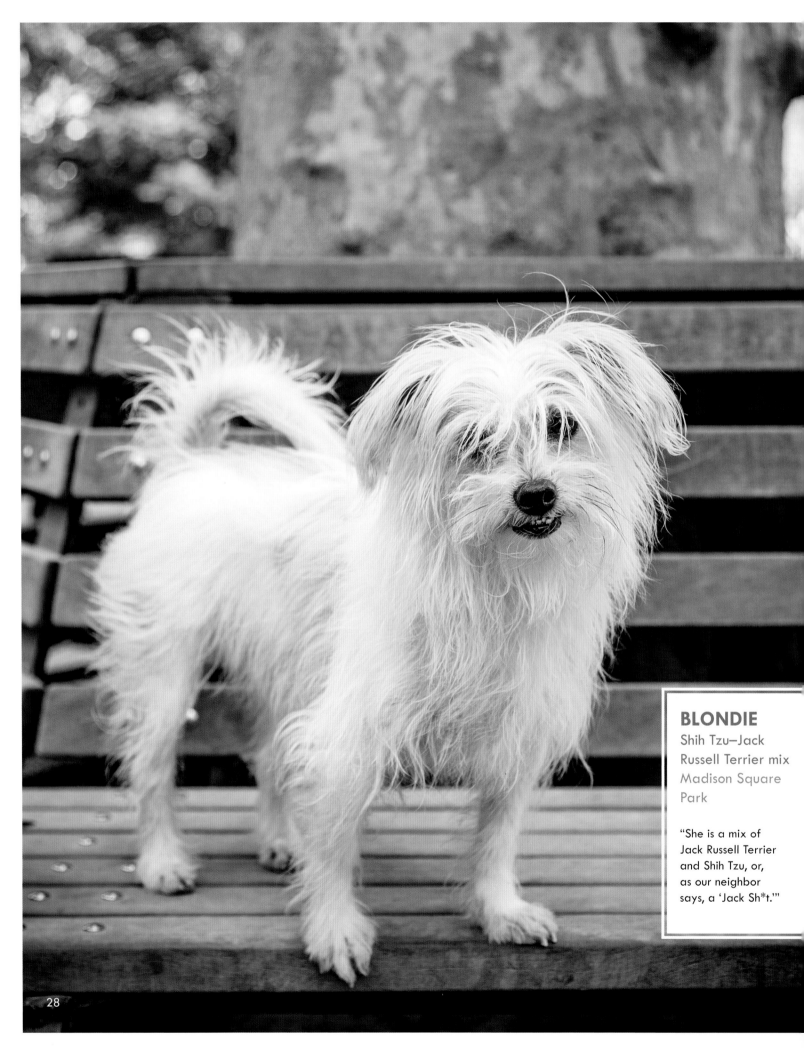

BLONDIE
Shih Tzu–Jack
Russell Terrier mix
Madison Square
Park

"She is a mix of
Jack Russell Terrier
and Shih Tzu, or,
as our neighbor
says, a 'Jack Sh*t.'"

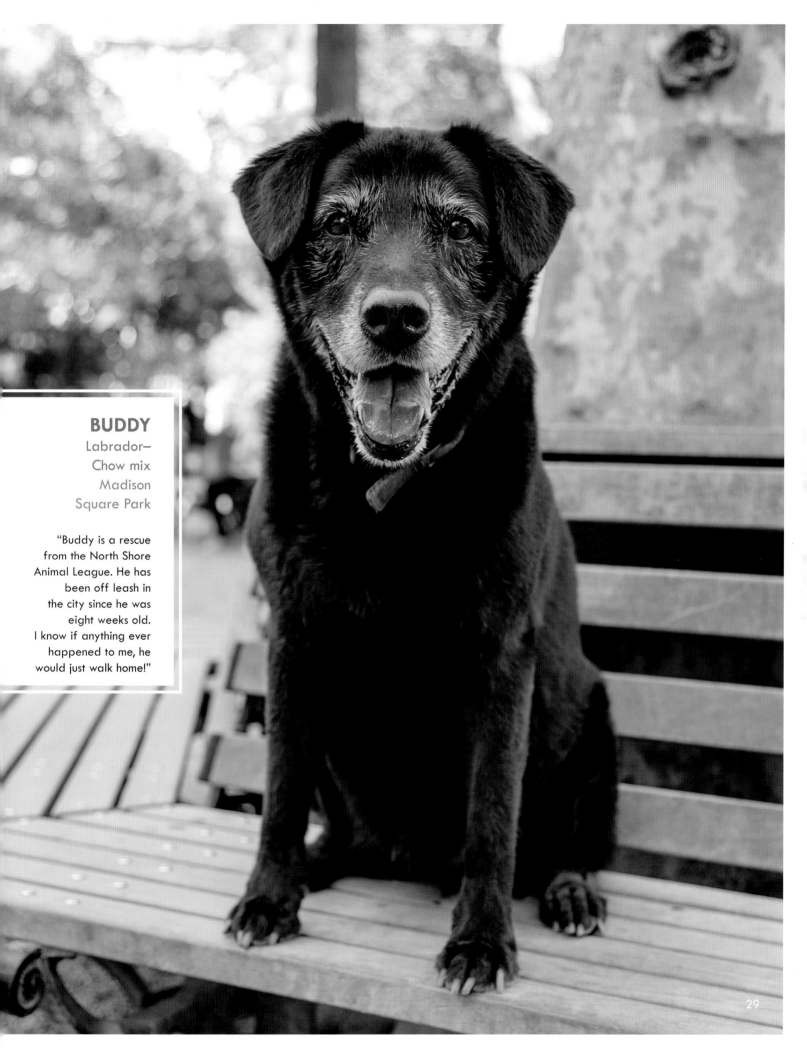

BUDDY
Labrador–
Chow mix
Madison
Square Park

"Buddy is a rescue
from the North Shore
Animal League. He has
been off leash in
the city since he was
eight weeks old.
I know if anything ever
happened to me, he
would just walk home!"

29

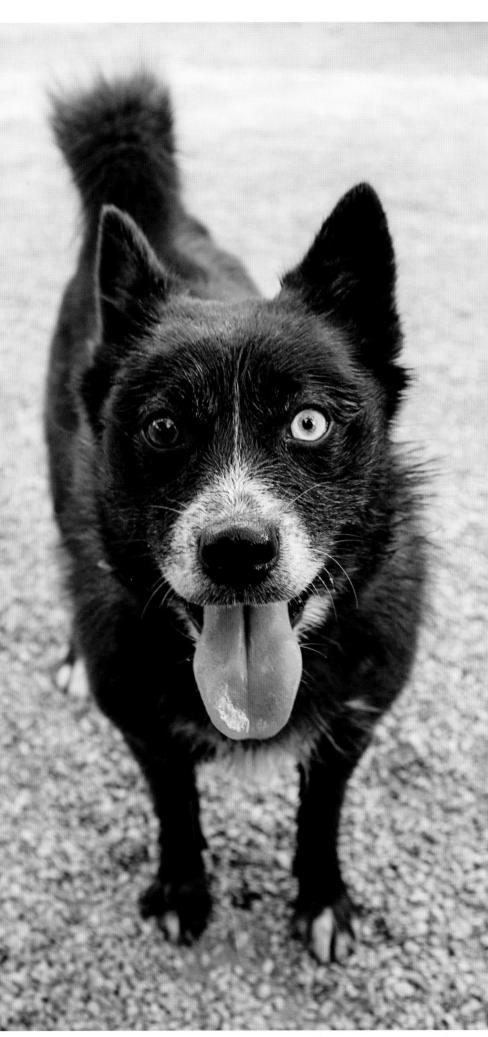

FIONA
Pomsky
Madison
Square Park

A Pomsky is a
cross between
a Siberian
Husky and a
Pomeranian.

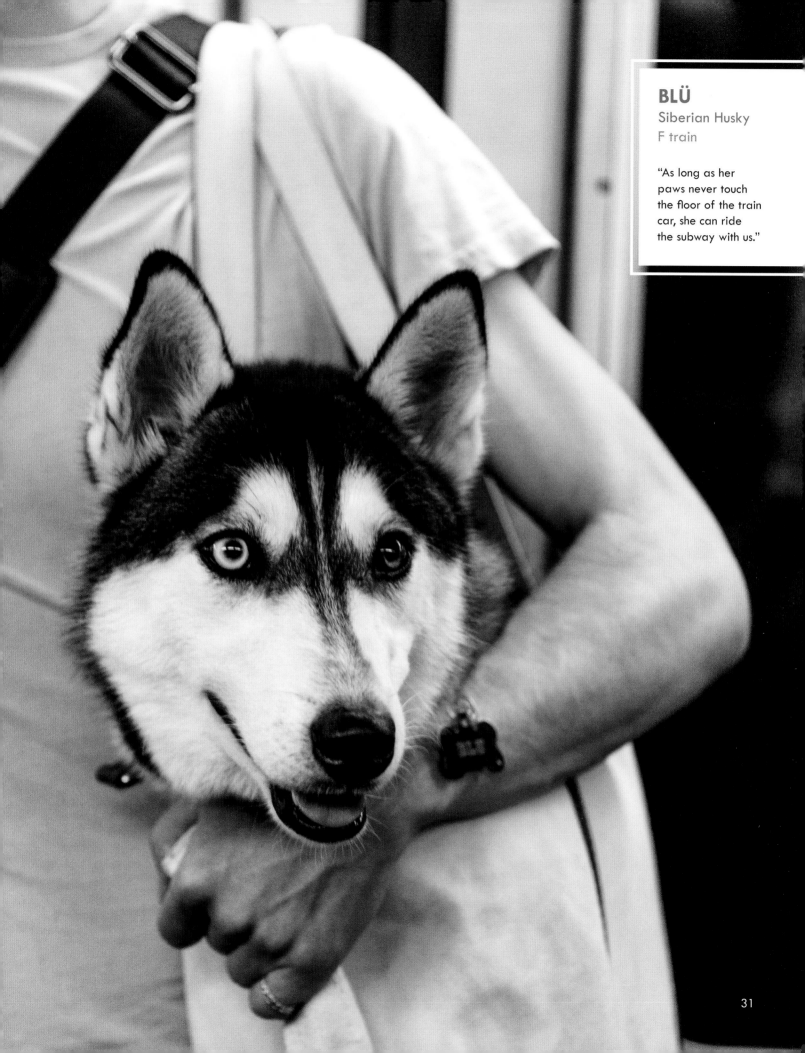

BLÜ
Siberian Husky
F train

"As long as her paws never touch the floor of the train car, she can ride the subway with us."

31

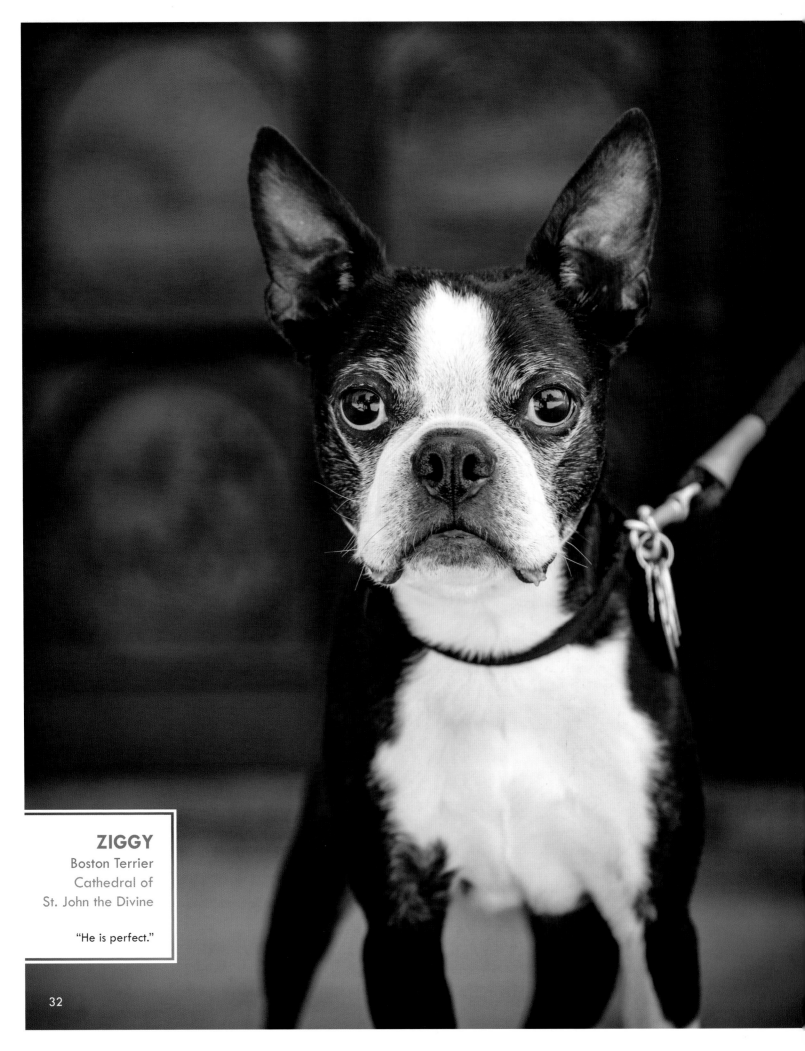

ZIGGY
Boston Terrier
Cathedral of
St. John the Divine

"He is perfect."

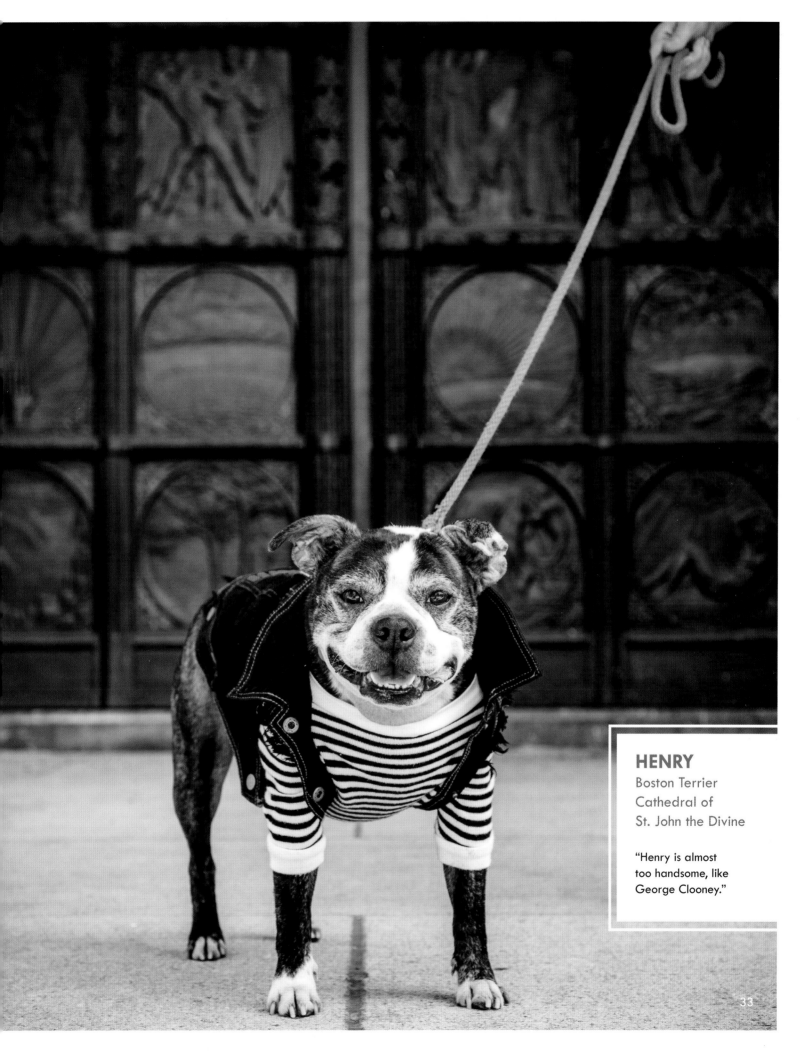

HENRY
Boston Terrier
Cathedral of
St. John the Divine

"Henry is almost
too handsome, like
George Clooney."

33

LAYLA and BELLA
Cane Corsos
Washington Square Park

"They have been in *Vogue Japan*. Follow them at @laylabella_nyc."

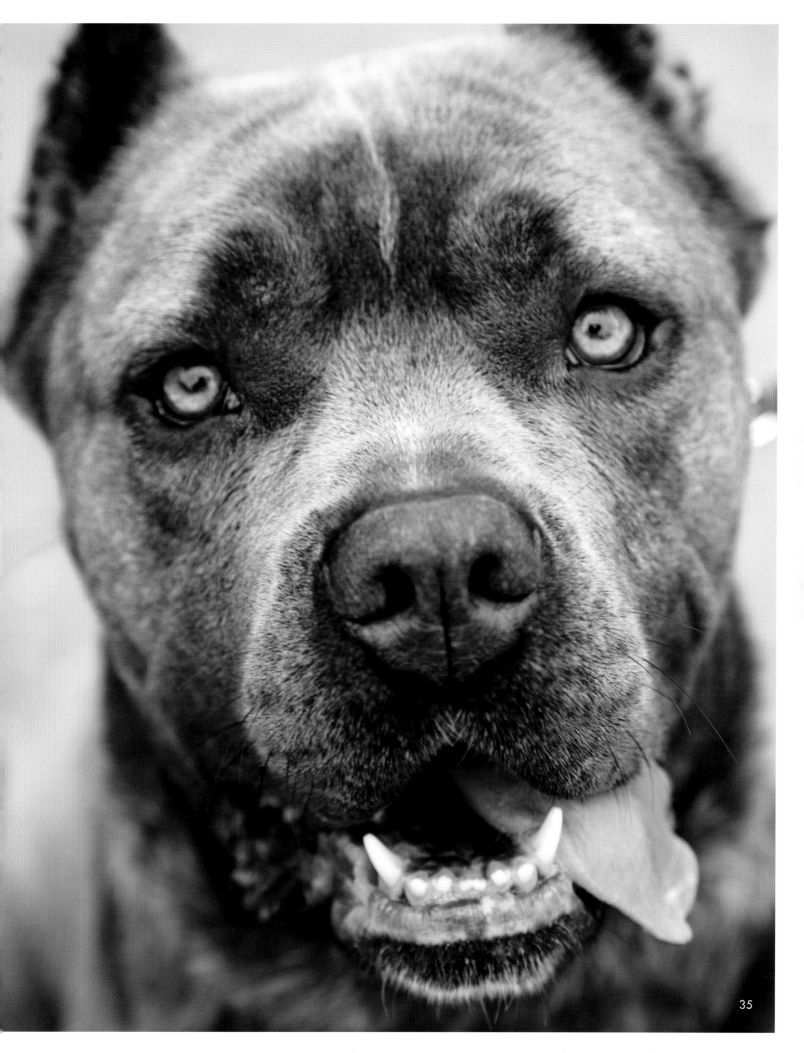

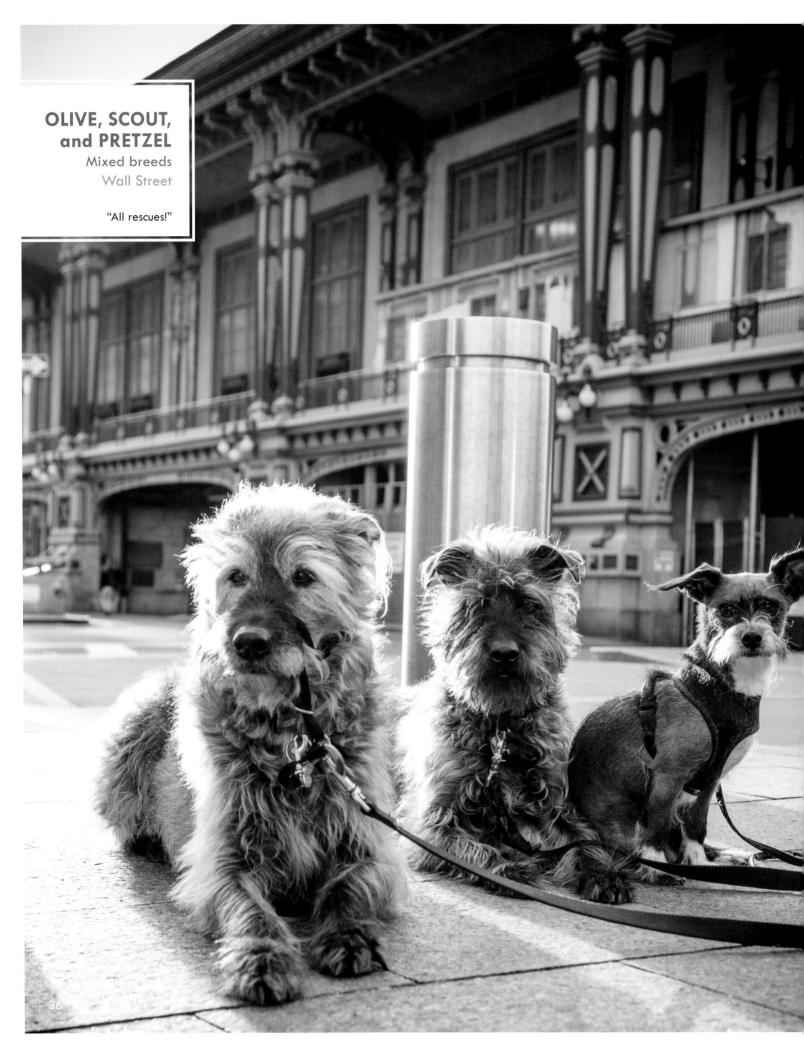

OLIVE, SCOUT, and PRETZEL
Mixed breeds
Wall Street

"All rescues!"

36

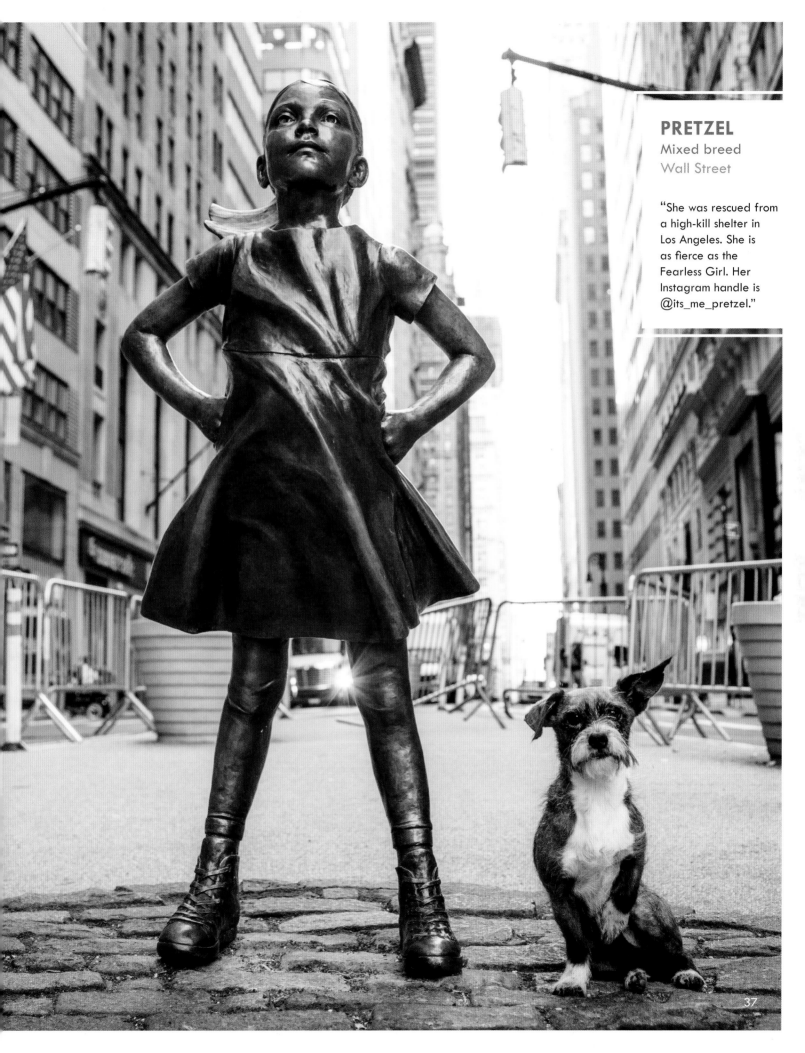

PRETZEL
Mixed breed
Wall Street

"She was rescued from a high-kill shelter in Los Angeles. She is as fierce as the Fearless Girl. Her Instagram handle is @its_me_pretzel."

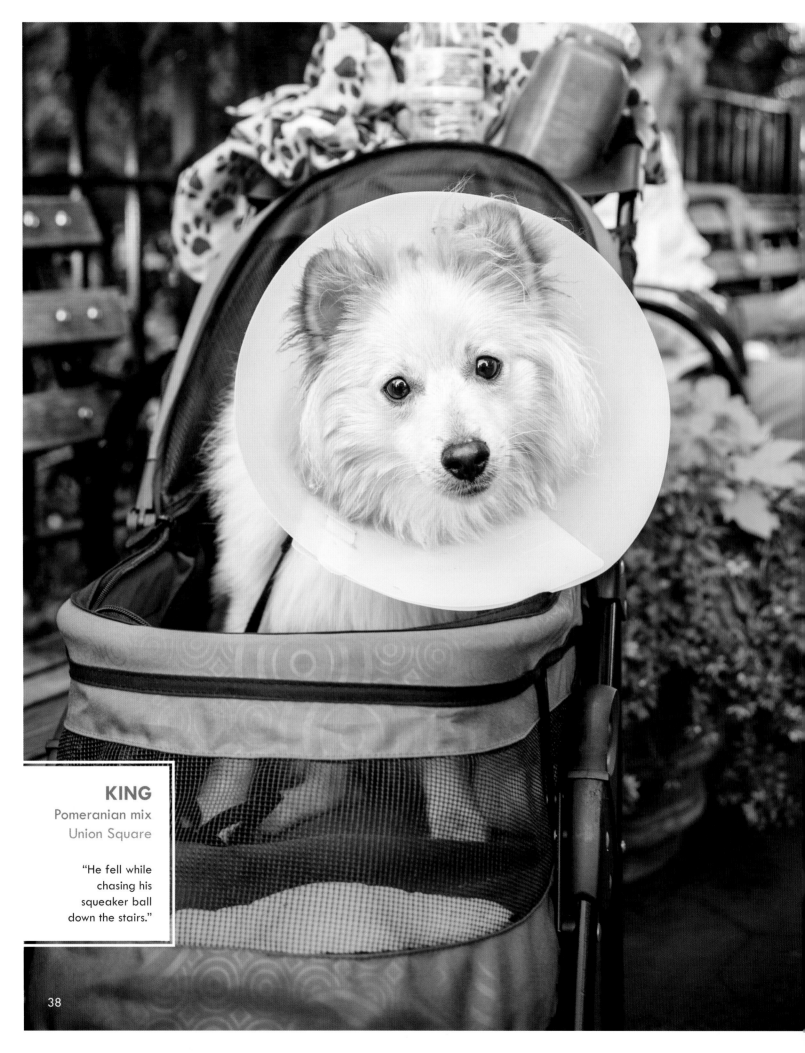

KING
Pomeranian mix
Union Square

"He fell while
chasing his
squeaker ball
down the stairs."

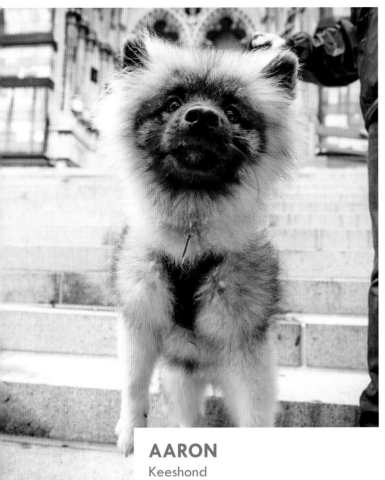

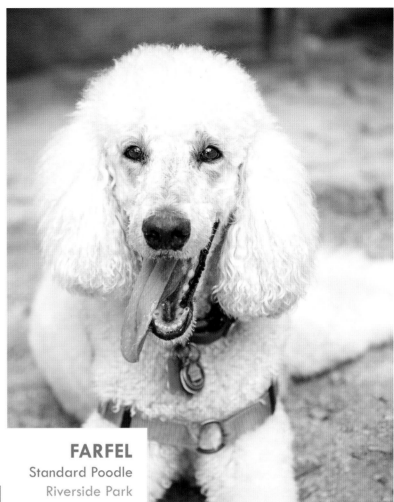

AARON
Keeshond
Cathedral of St. John the Divine

FARFEL
Standard Poodle
Riverside Park

STELLA, BELLA, and BELLA
Yorkie–Maltese mixes
Riverside Park

PRINCESS
Dixie Dingo
Upper West Side

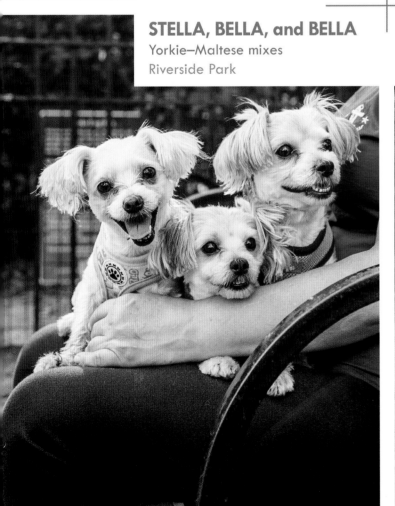

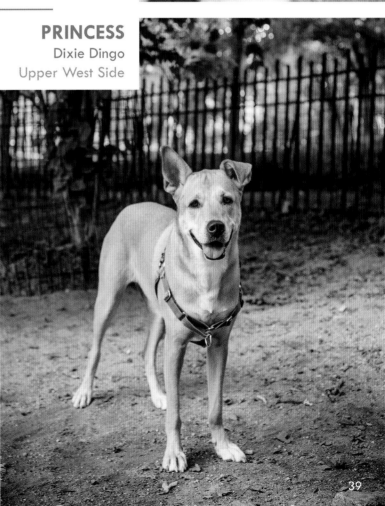

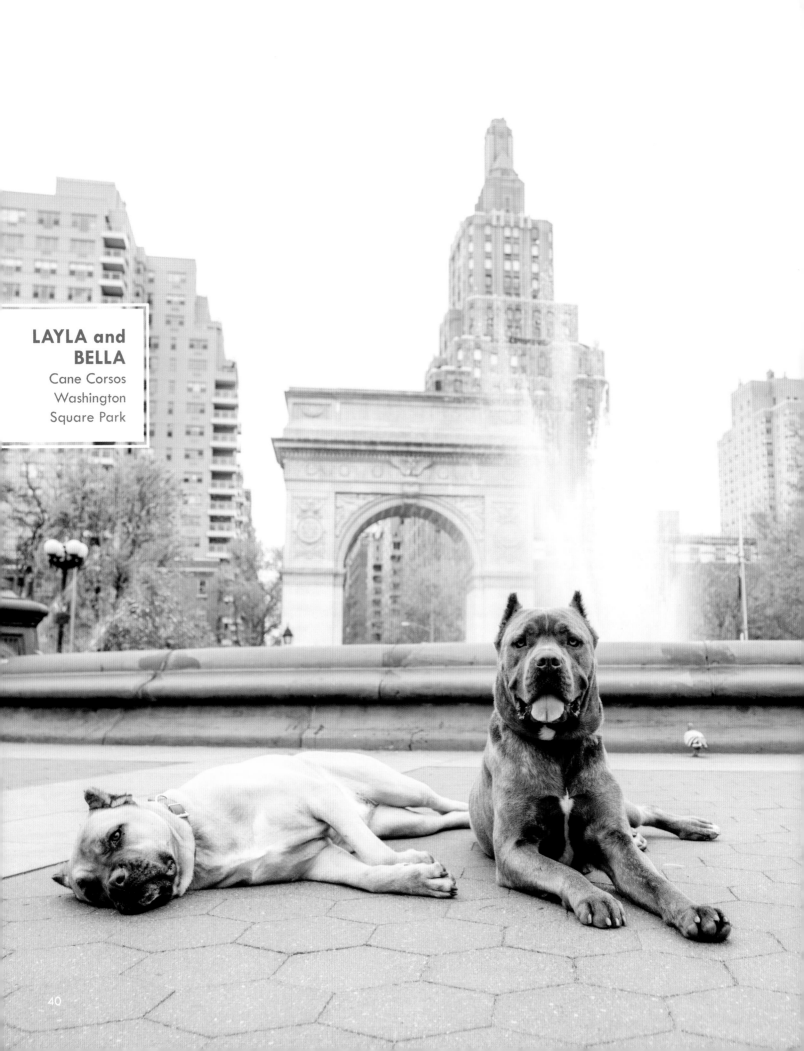

LAYLA and BELLA
Cane Corsos
Washington
Square Park

40

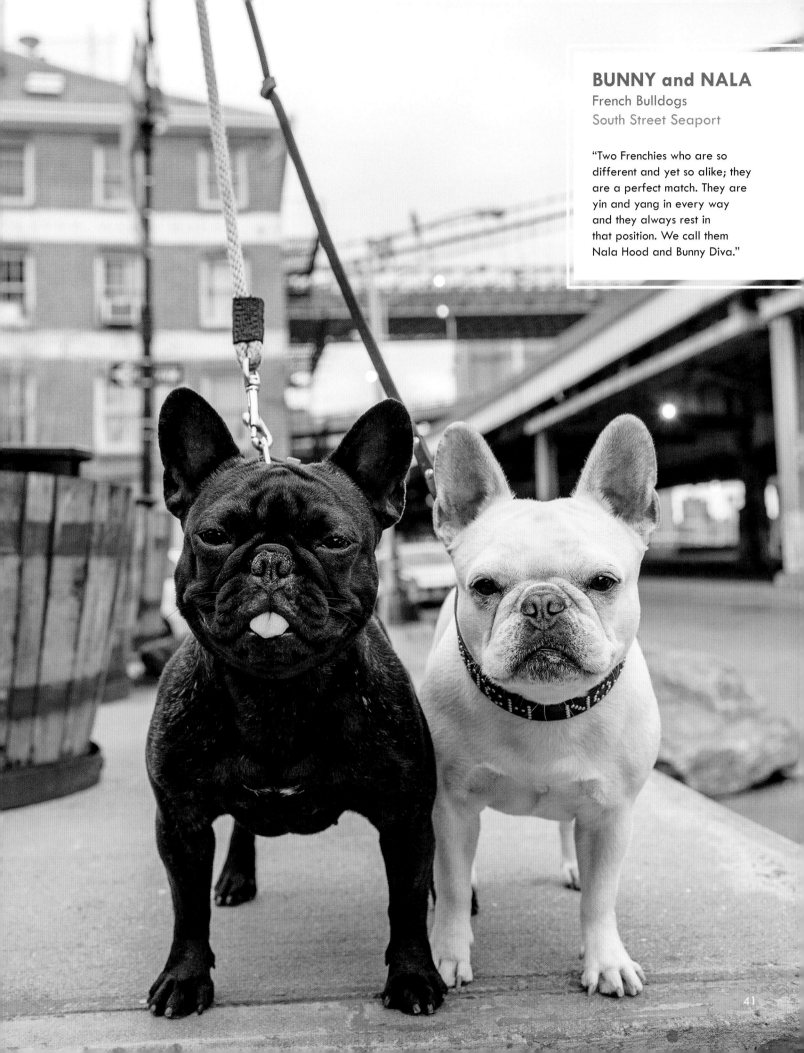

BUNNY and NALA
French Bulldogs
South Street Seaport

"Two Frenchies who are so different and yet so alike; they are a perfect match. They are yin and yang in every way and they always rest in that position. We call them Nala Hood and Bunny Diva."

GRACE

Hungarian
Vizsla
Washington
Square Park

"Grace is poised and regal. She hails from a pedigreed line of champions. For Grace, however, the show circuit was a bore. She much prefers spending her days making friends in and around Washington Square Park, which is her front yard and beloved stomping ground. Grace is a regular neighborhood celebrity in Greenwich Village and thrives among creatives. Grace is socially savvy and is a true Renaissance woman who loves weekends away from the city in East Hampton, where she demands ritual morning meet-ups with her New York City pals. While it's nice to escape the Big Smoke for some rest and relaxation, her heart is never far from downtown Manhattan. See more of her @gracethevizsla on Instagram."

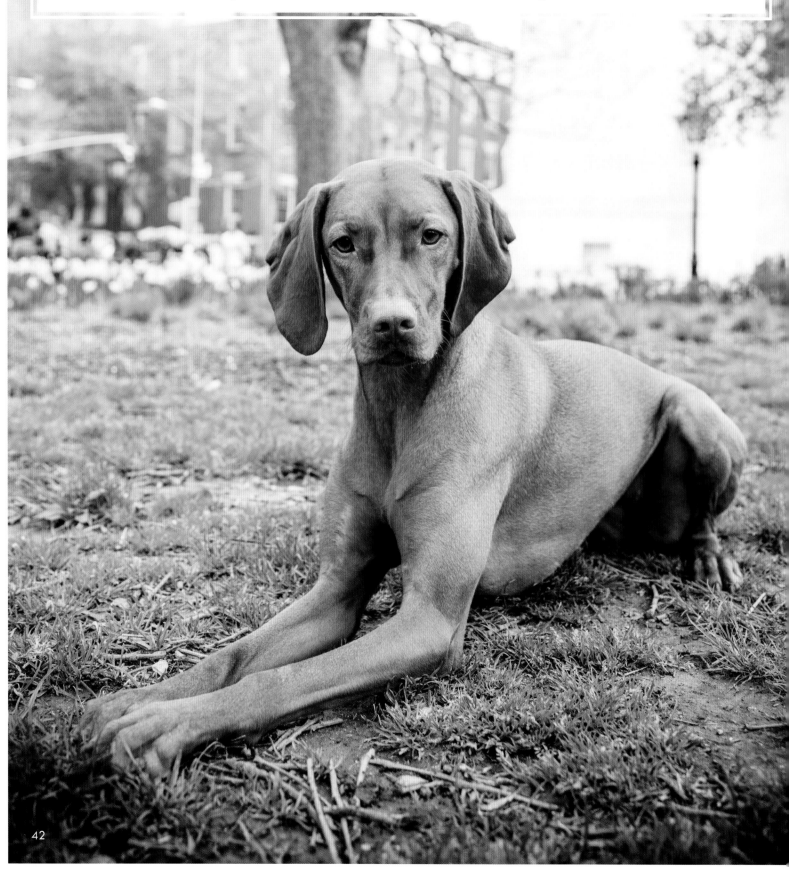

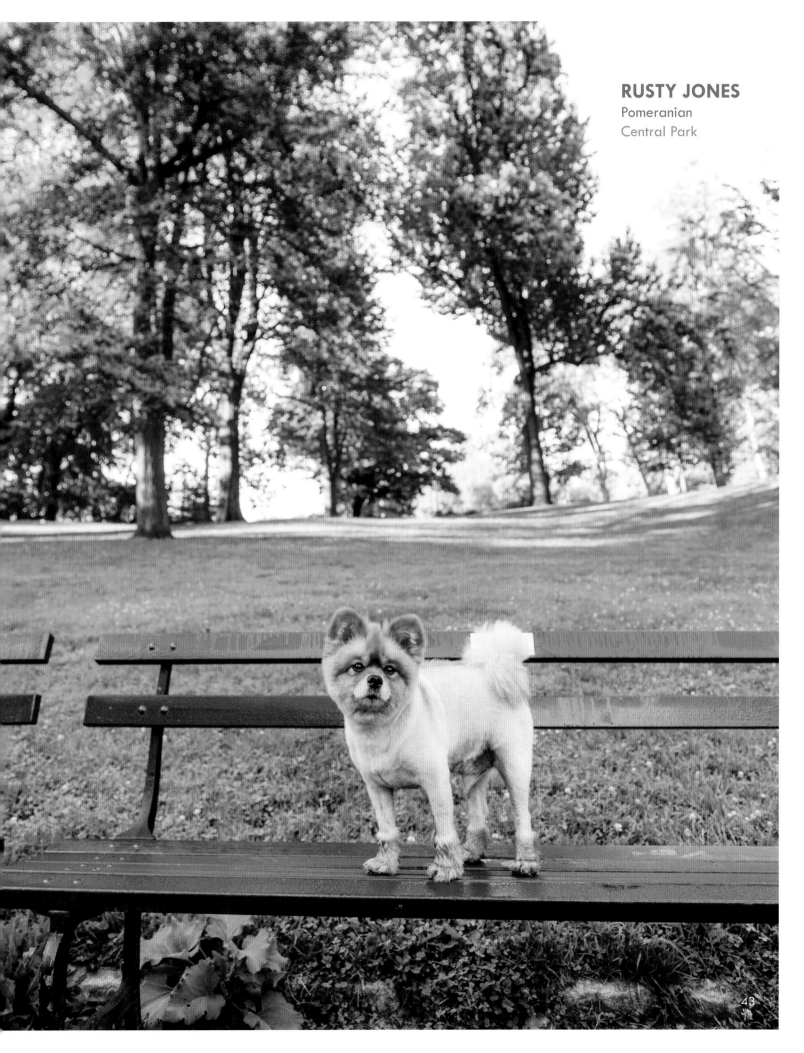

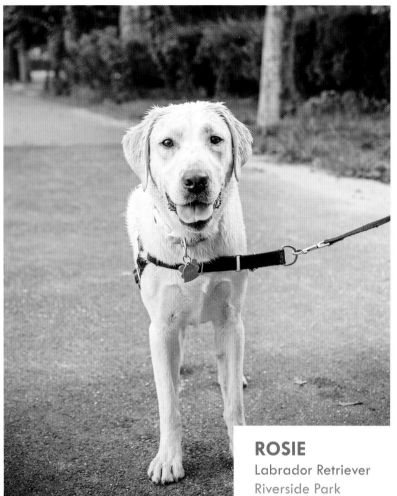

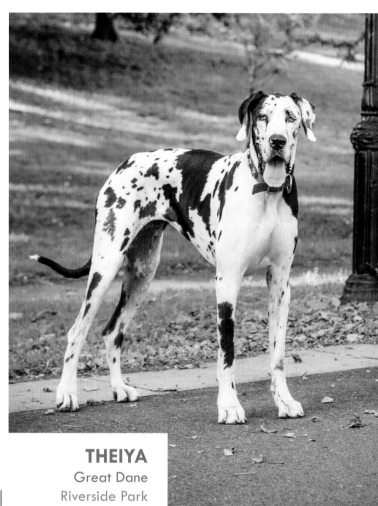

ROSIE
Labrador Retriever
Riverside Park

THEIYA
Great Dane
Riverside Park

MAYA EBNER
Pug–Beagle mix
Riverside Park

ARTIE
Great Dane
Riverside Park

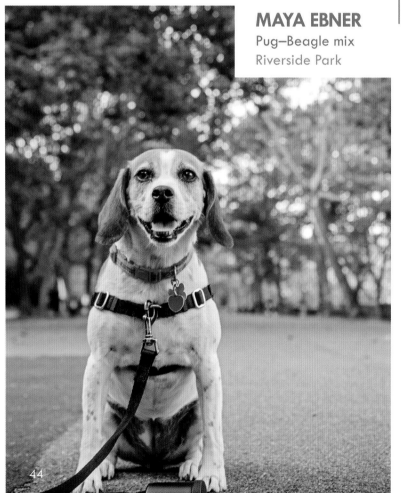

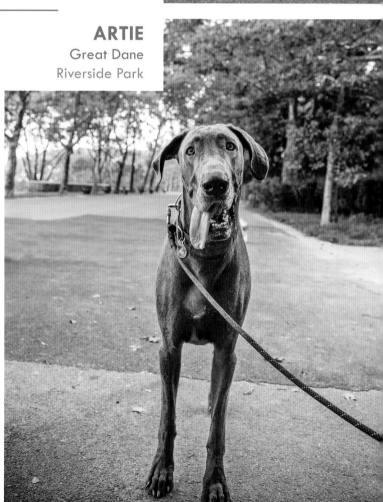

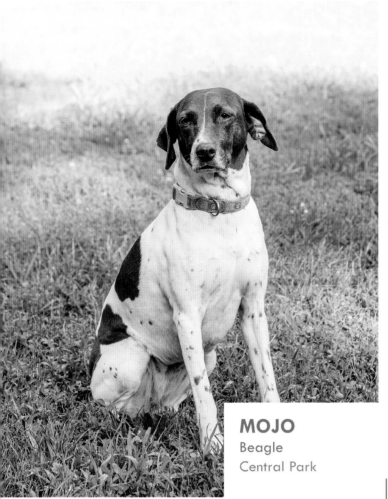

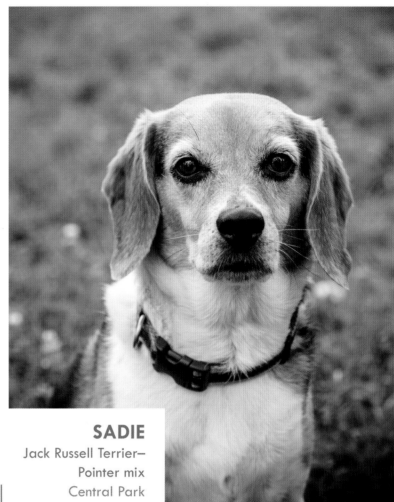

MOJO
Beagle
Central Park

SADIE
Jack Russell Terrier–
Pointer mix
Central Park

ANDIE
Cattle Dog mix
Central Park

DUCHESS
Standard Poodle
Central Park

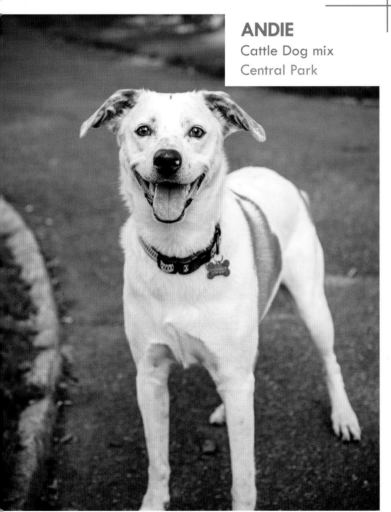

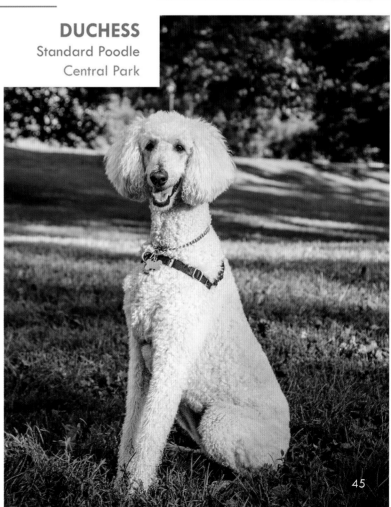

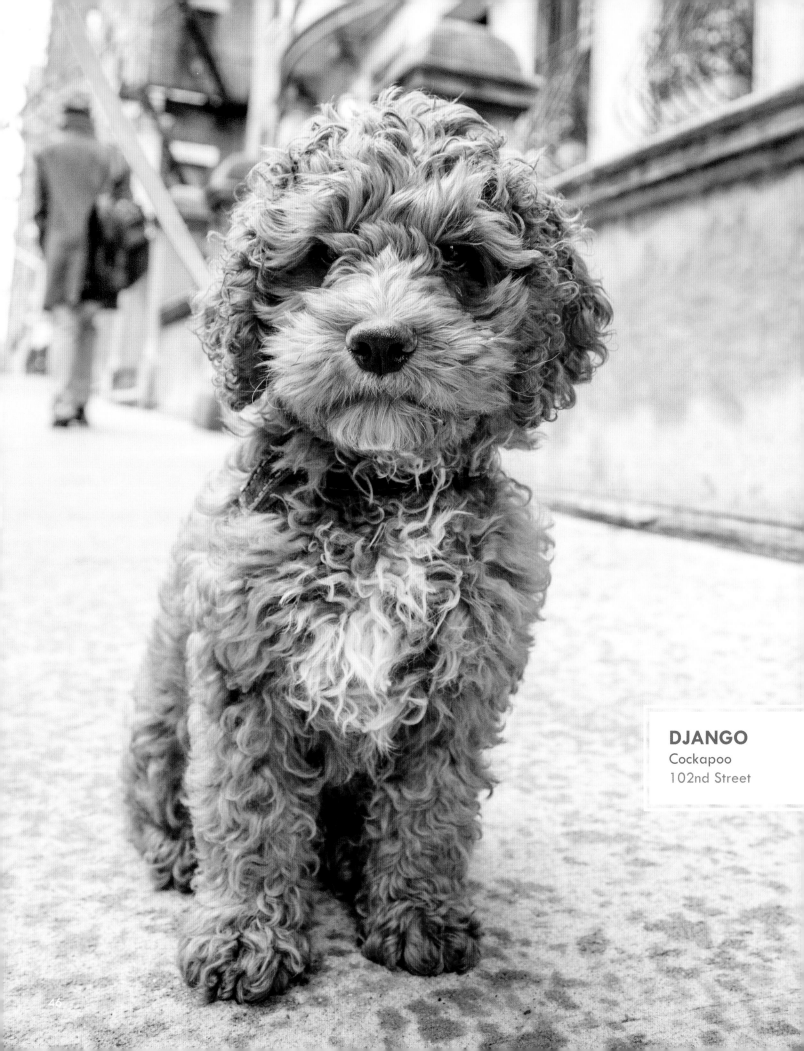

DJANGO
Cockapoo
102nd Street

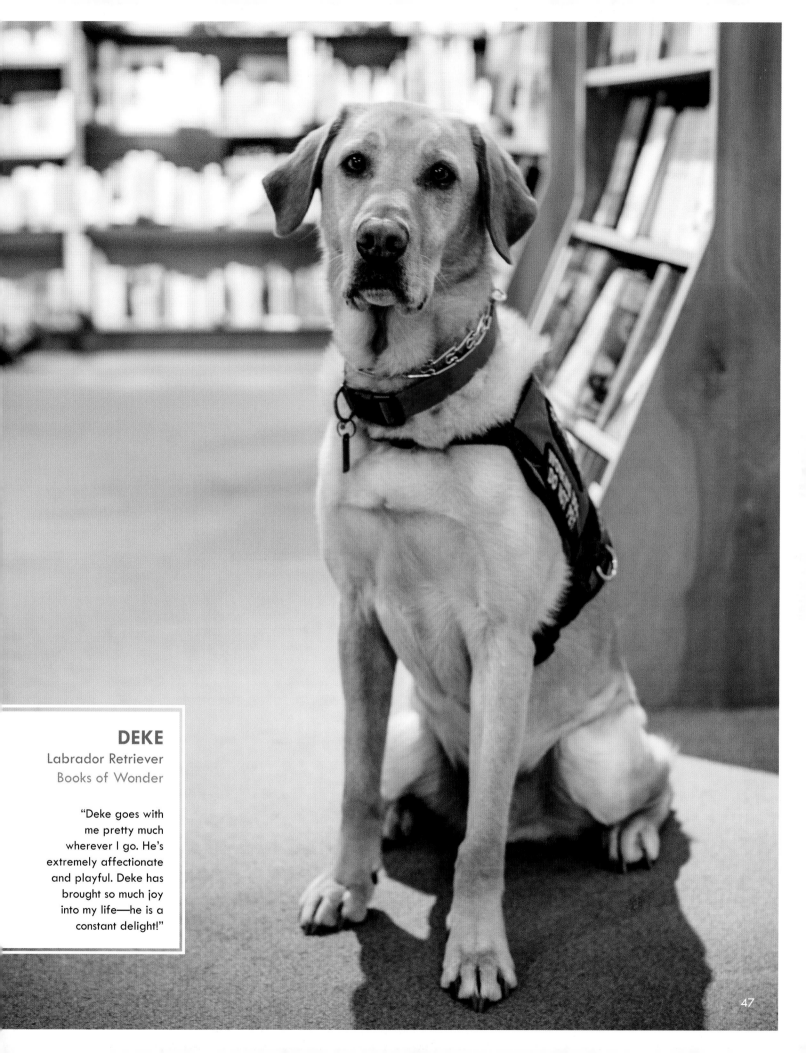

DEKE
Labrador Retriever
Books of Wonder

"Deke goes with me pretty much wherever I go. He's extremely affectionate and playful. Deke has brought so much joy into my life—he is a constant delight!"

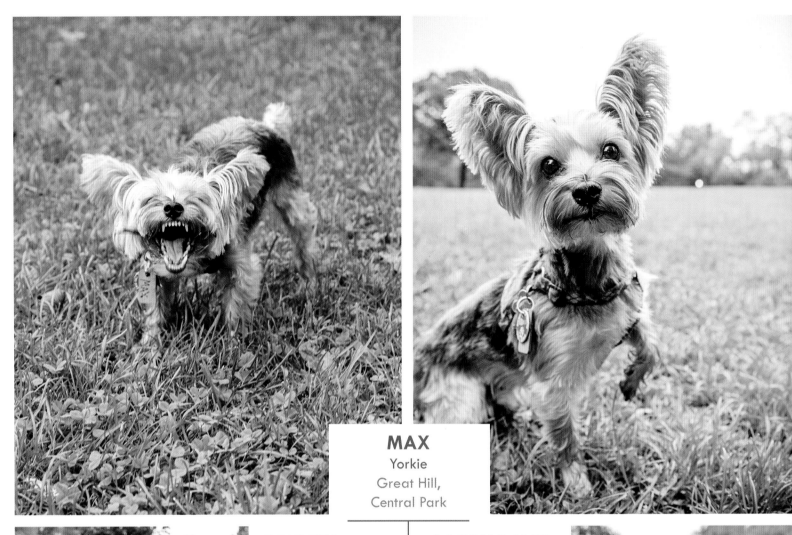

MAX
Yorkie
Great Hill,
Central Park

DRUNKY
German
Shepherd mix
Great Hill,
Central Park

LARRY DAVID
Silver Labrador
Retriever
Great Hill,
Central Park

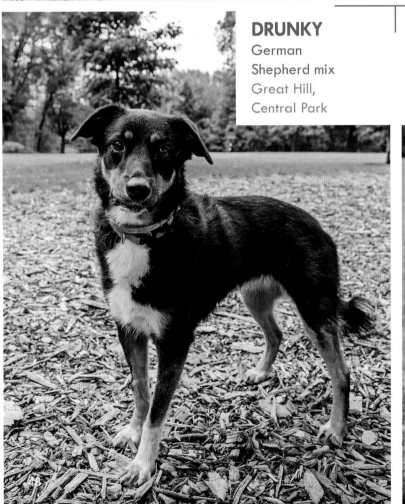

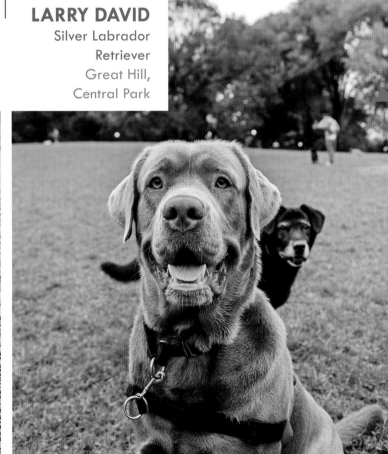

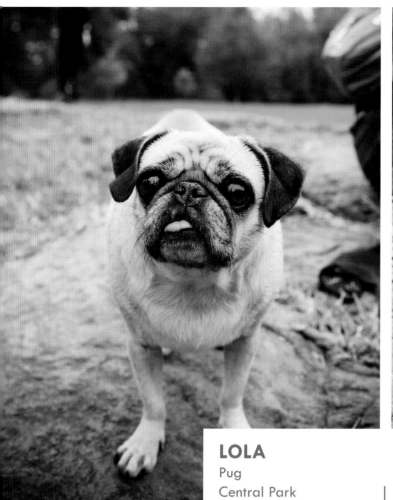

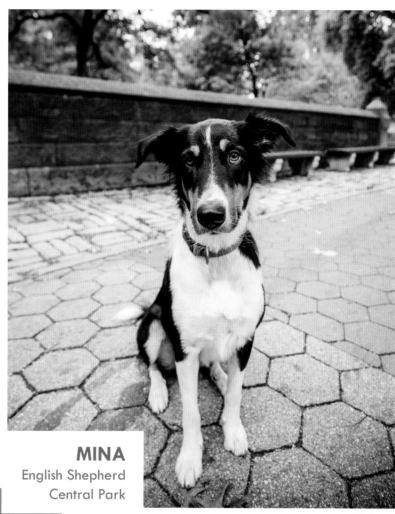

LOLA
Pug
Central Park

MINA
English Shepherd
Central Park

GEORGE
Peagle
Washington Square Park

NEYMAR
Terrier mix
Central Park

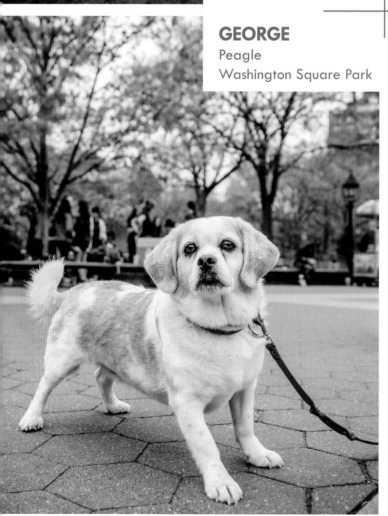

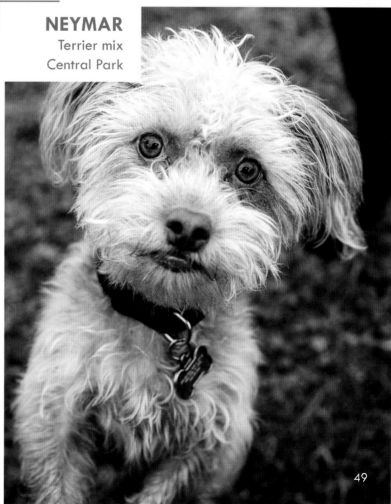

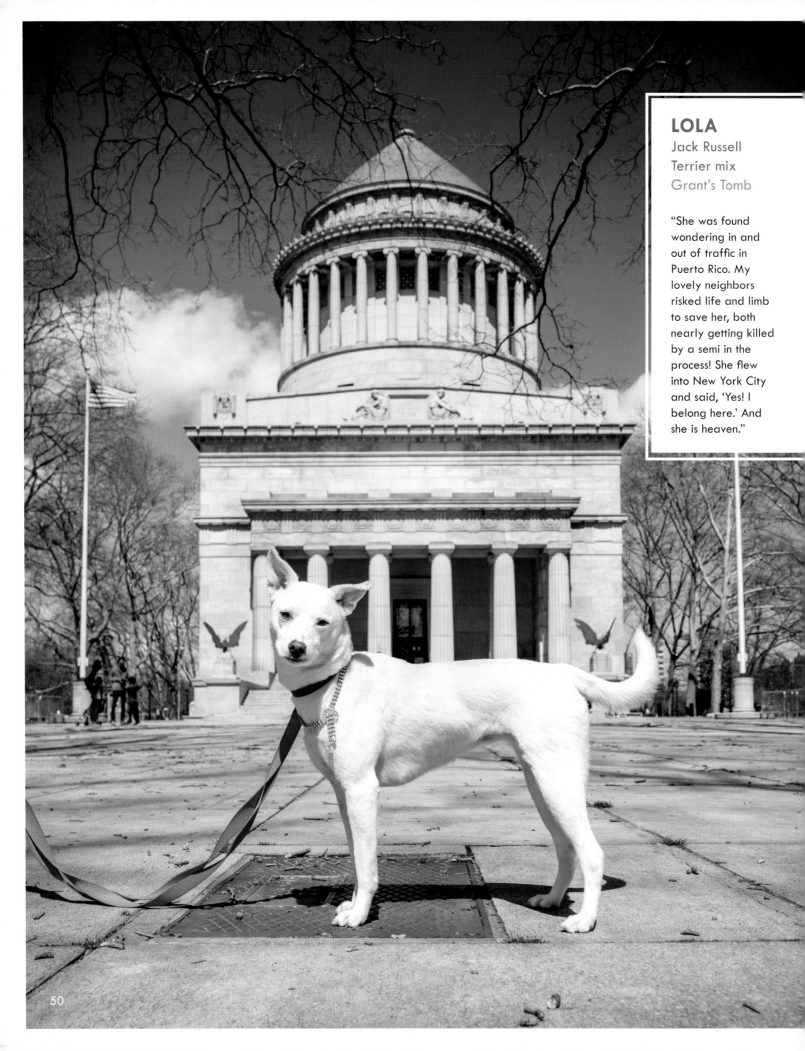

LOLA
Jack Russell
Terrier mix
Grant's Tomb

"She was found
wondering in and
out of traffic in
Puerto Rico. My
lovely neighbors
risked life and limb
to save her, both
nearly getting killed
by a semi in the
process! She flew
into New York City
and said, 'Yes! I
belong here.' And
she is heaven."

50

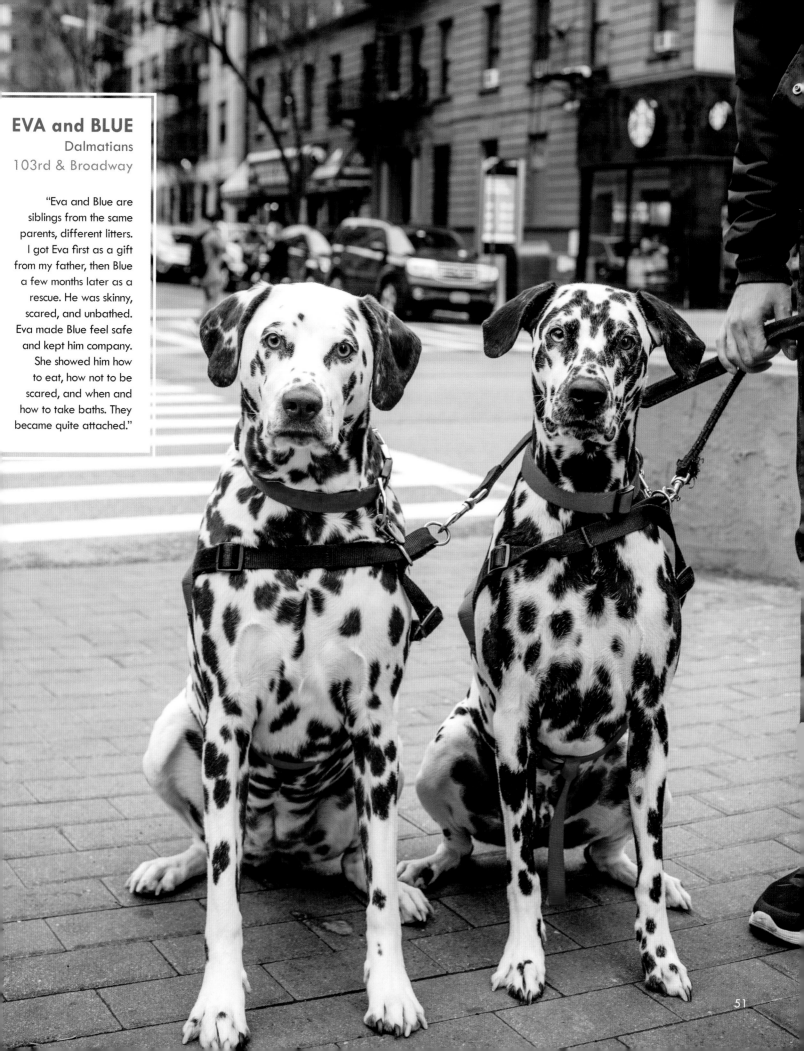

EVA and BLUE
Dalmatians
103rd & Broadway

"Eva and Blue are siblings from the same parents, different litters. I got Eva first as a gift from my father, then Blue a few months later as a rescue. He was skinny, scared, and unbathed. Eva made Blue feel safe and kept him company. She showed him how to eat, how not to be scared, and when and how to take baths. They became quite attached."

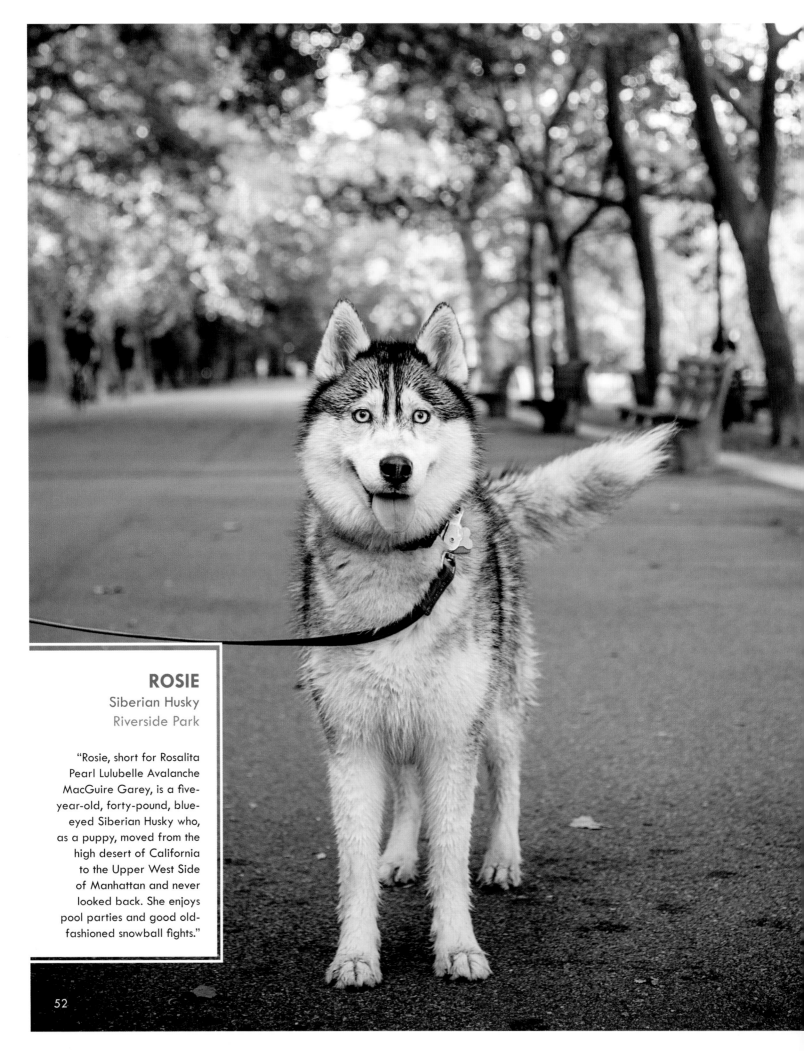

ROSIE
Siberian Husky
Riverside Park

"Rosie, short for Rosalita Pearl Lulubelle Avalanche MacGuire Garey, is a five-year-old, forty-pound, blue-eyed Siberian Husky who, as a puppy, moved from the high desert of California to the Upper West Side of Manhattan and never looked back. She enjoys pool parties and good old-fashioned snowball fights."

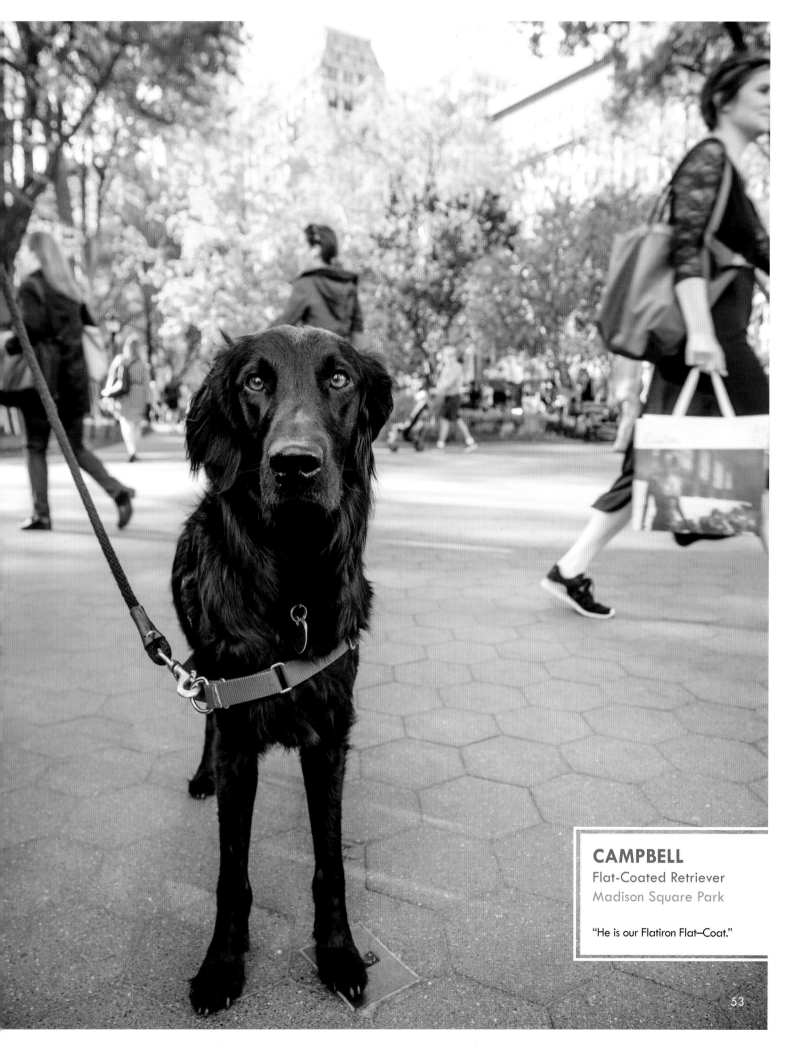

CAMPBELL
Flat-Coated Retriever
Madison Square Park

"He is our Flatiron Flat–Coat."

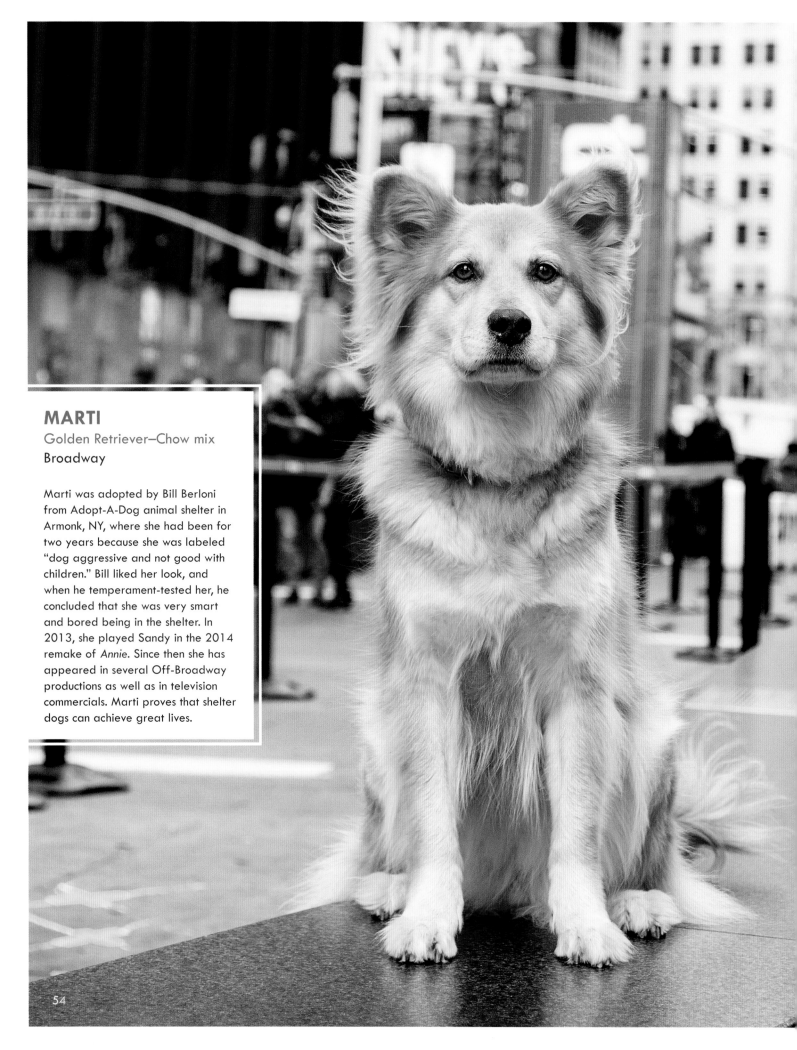

MARTI
Golden Retriever–Chow mix
Broadway

Marti was adopted by Bill Berloni from Adopt-A-Dog animal shelter in Armonk, NY, where she had been for two years because she was labeled "dog aggressive and not good with children." Bill liked her look, and when he temperament-tested her, he concluded that she was very smart and bored being in the shelter. In 2013, she played Sandy in the 2014 remake of *Annie*. Since then she has appeared in several Off-Broadway productions as well as in television commercials. Marti proves that shelter dogs can achieve great lives.

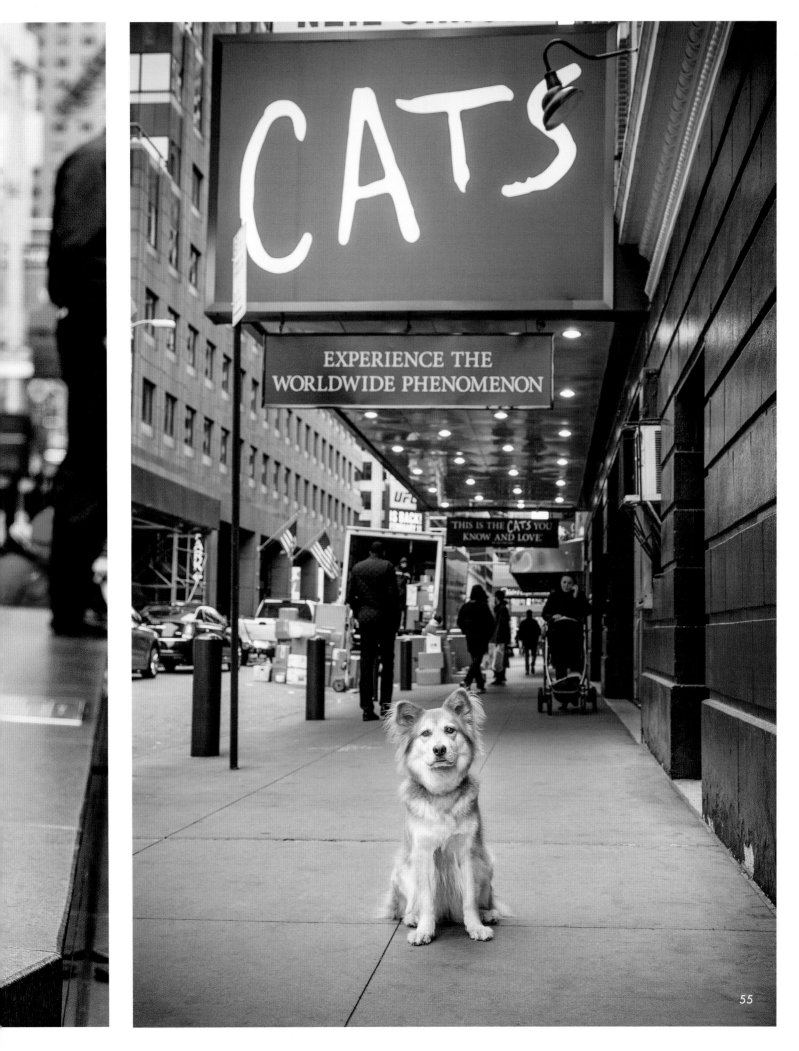

BROOKLYN

"Apparently Brooklyn needn't always push itself to be something else, something conscious and anxious, something pointed toward Manhattan . . . Brooklyn might sometimes also be pleased, as here on Flatbush, to be its grubby, enduring self."

—Jonathan Lethem, *The Fortress of Solitude* (2003)

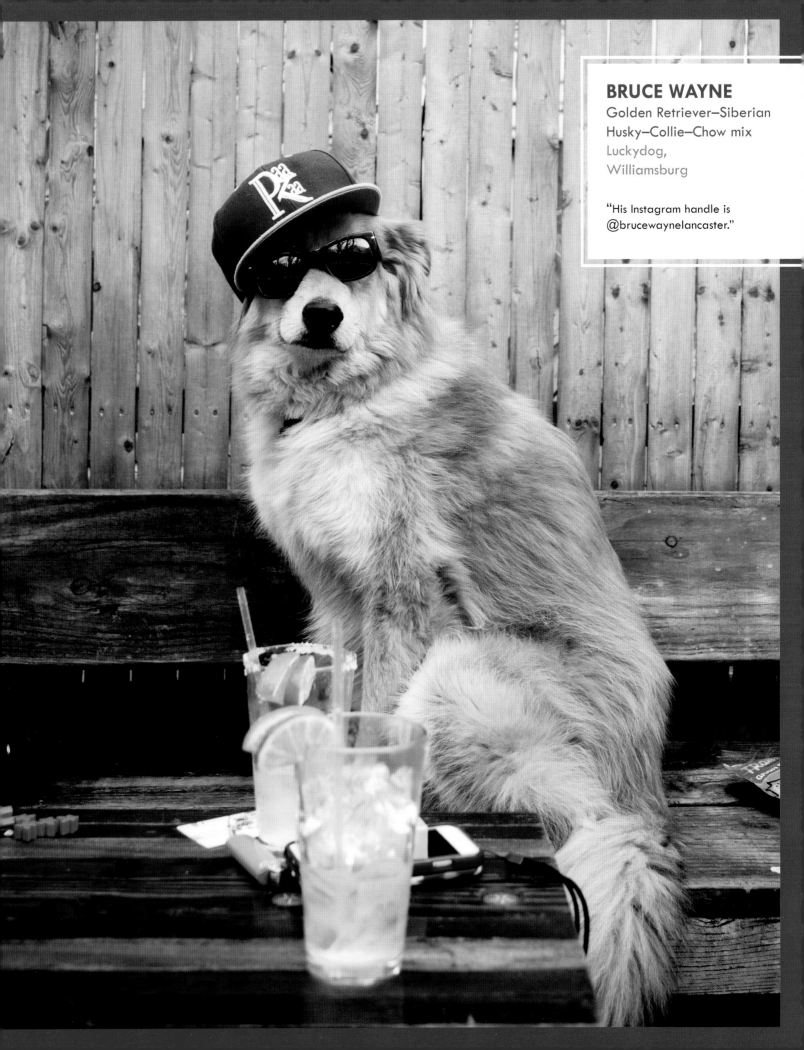

BRUCE WAYNE
Golden Retriever–Siberian
Husky–Collie–Chow mix
Luckydog,
Williamsburg

"His Instagram handle is
@brucewaynelancaster."

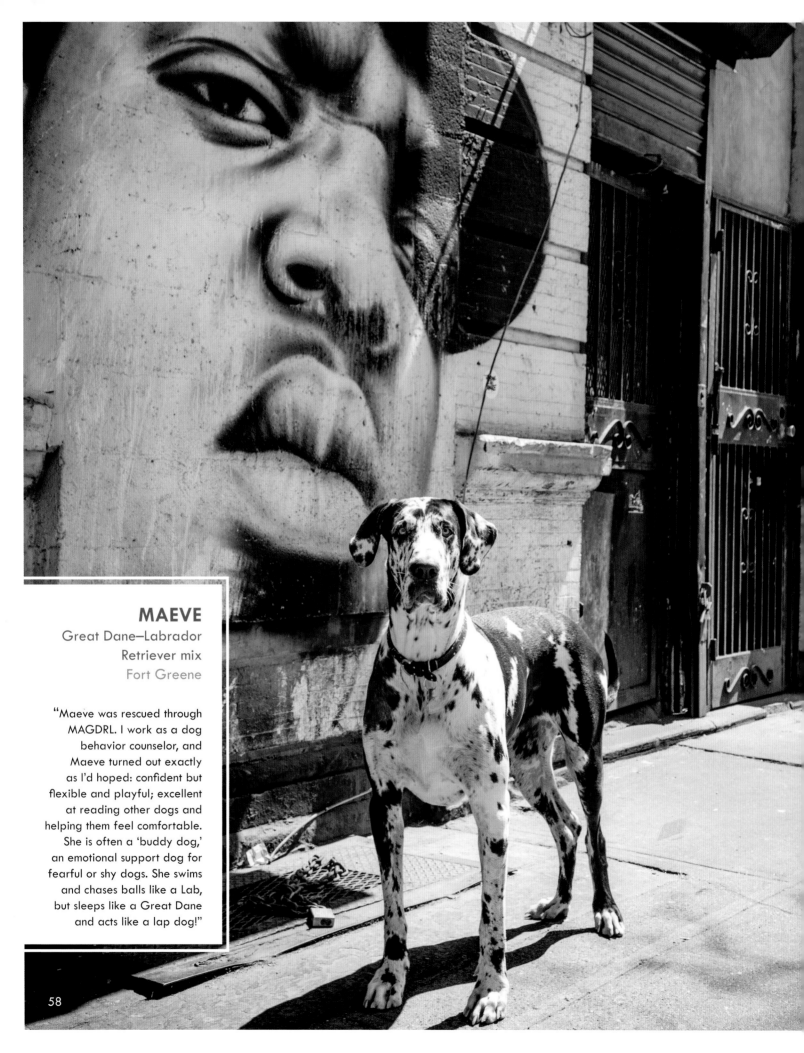

MAEVE
Great Dane–Labrador
Retriever mix
Fort Greene

"Maeve was rescued through MAGDRL. I work as a dog behavior counselor, and Maeve turned out exactly as I'd hoped: confident but flexible and playful; excellent at reading other dogs and helping them feel comfortable. She is often a 'buddy dog,' an emotional support dog for fearful or shy dogs. She swims and chases balls like a Lab, but sleeps like a Great Dane and acts like a lap dog!"

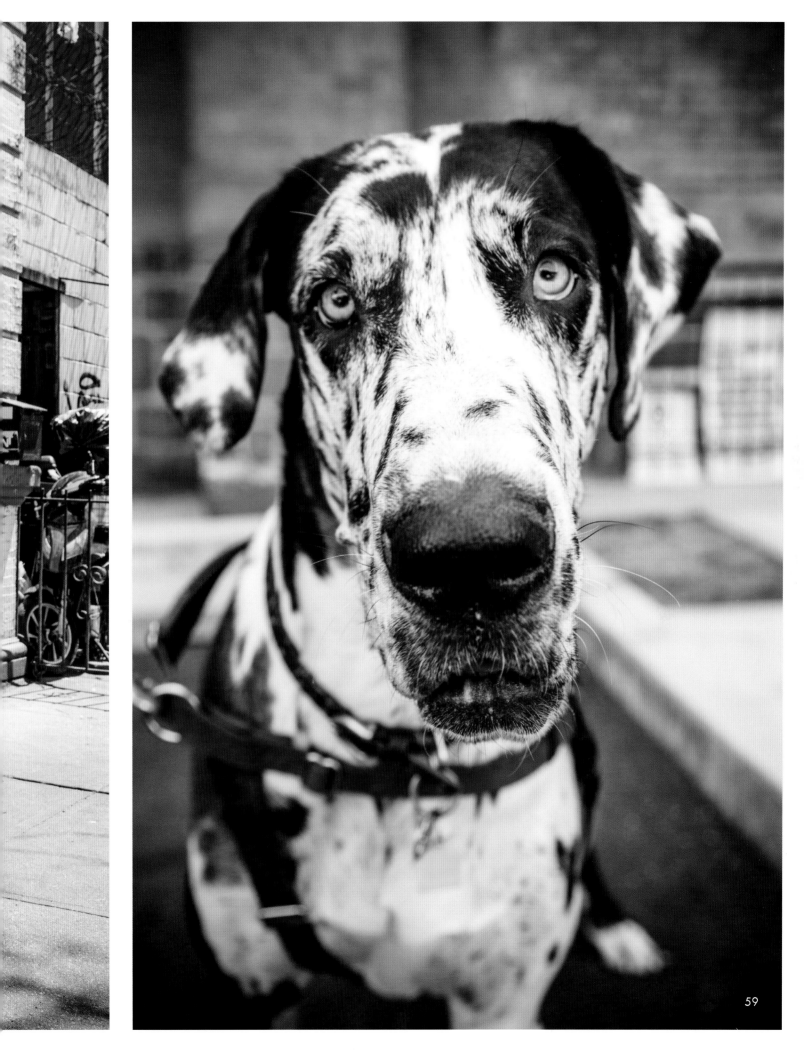

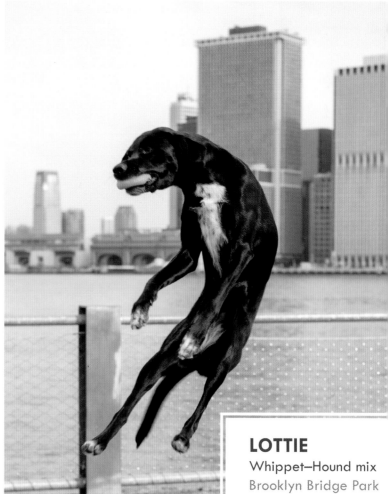

LOTTIE
Whippet–Hound mix
Brooklyn Bridge Park

"Lottie was rescued along with her littermates from a Walmart parking lot somewhere in Tennessee. She's a mixture of Whippet and some other kind of hound— maybe with a little bit of kangaroo and some seal thrown in for good measure."

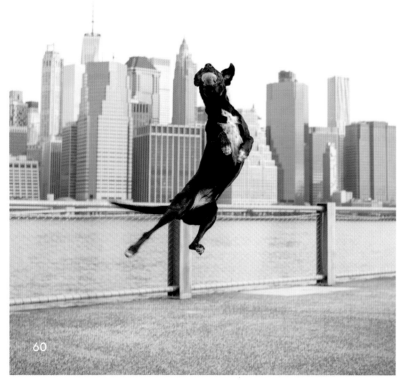

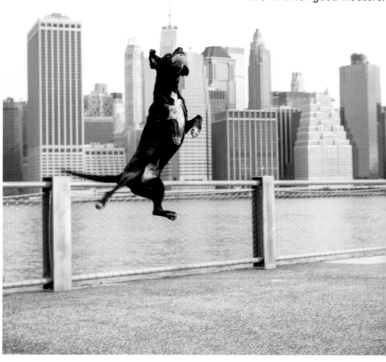

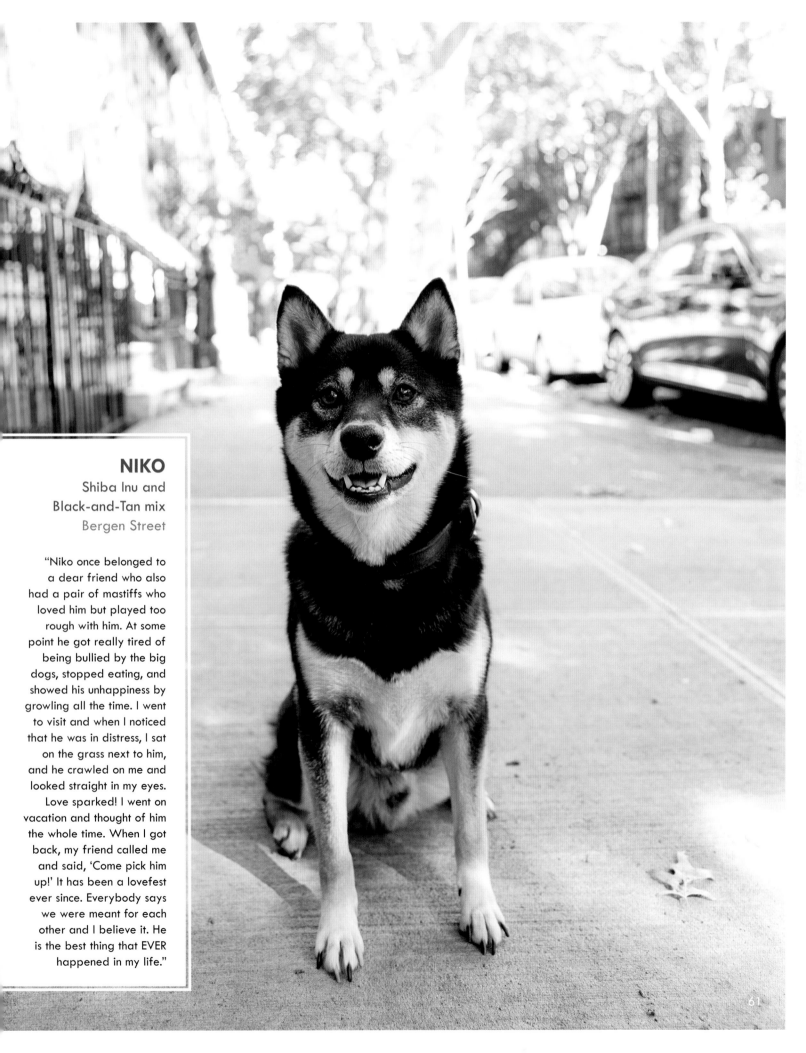

NIKO

Shiba Inu and
Black-and-Tan mix
Bergen Street

"Niko once belonged to
a dear friend who also
had a pair of mastiffs who
loved him but played too
rough with him. At some
point he got really tired of
being bullied by the big
dogs, stopped eating, and
showed his unhappiness by
growling all the time. I went
to visit and when I noticed
that he was in distress, I sat
on the grass next to him,
and he crawled on me and
looked straight in my eyes.
Love sparked! I went on
vacation and thought of him
the whole time. When I got
back, my friend called me
and said, 'Come pick him
up!' It has been a lovefest
ever since. Everybody says
we were meant for each
other and I believe it. He
is the best thing that EVER
happened in my life."

61

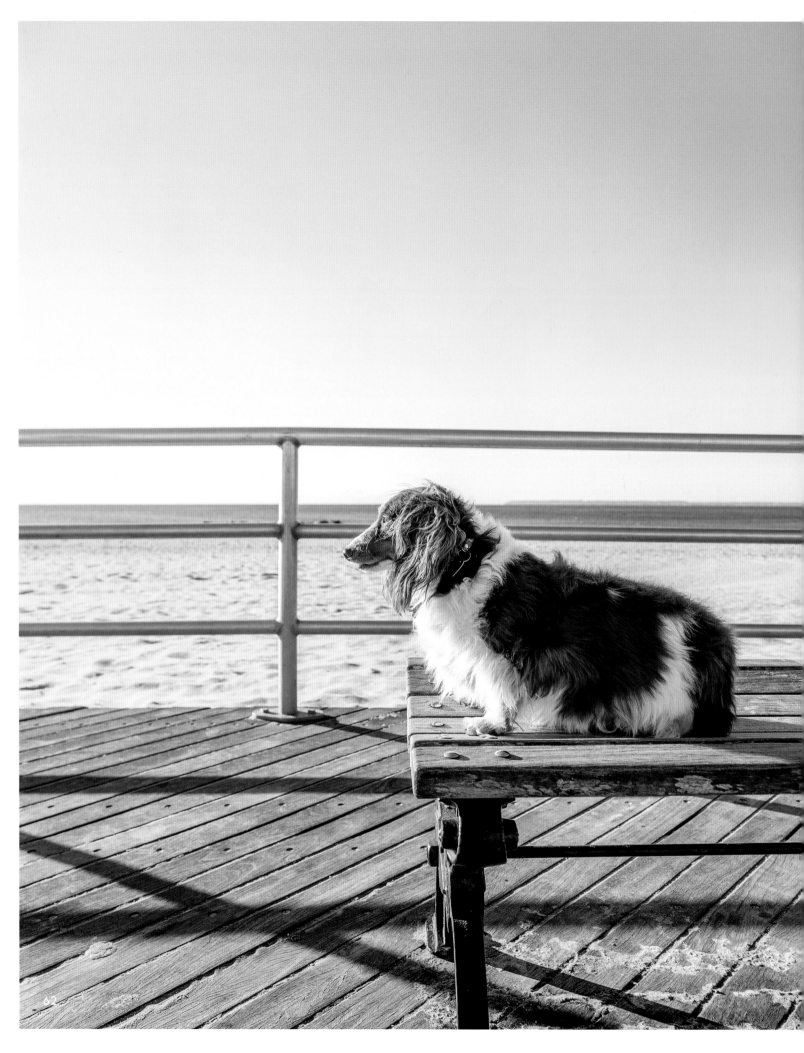

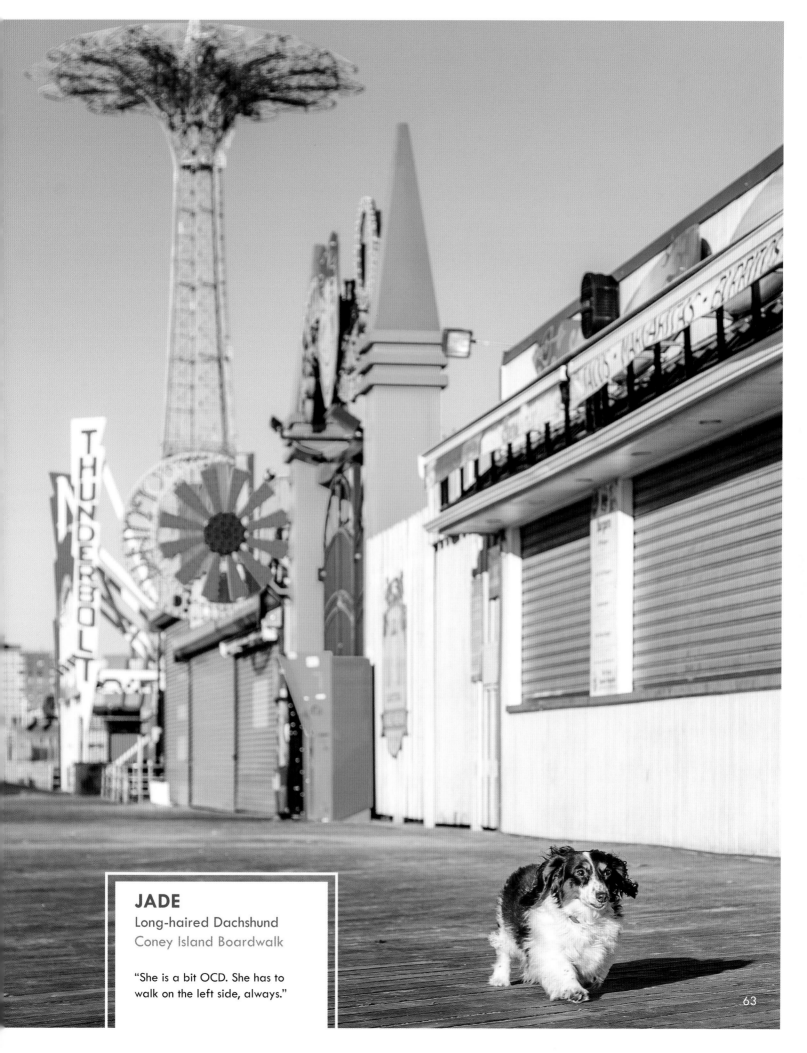

JADE
Long-haired Dachshund
Coney Island Boardwalk

"She is a bit OCD. She has to walk on the left side, always."

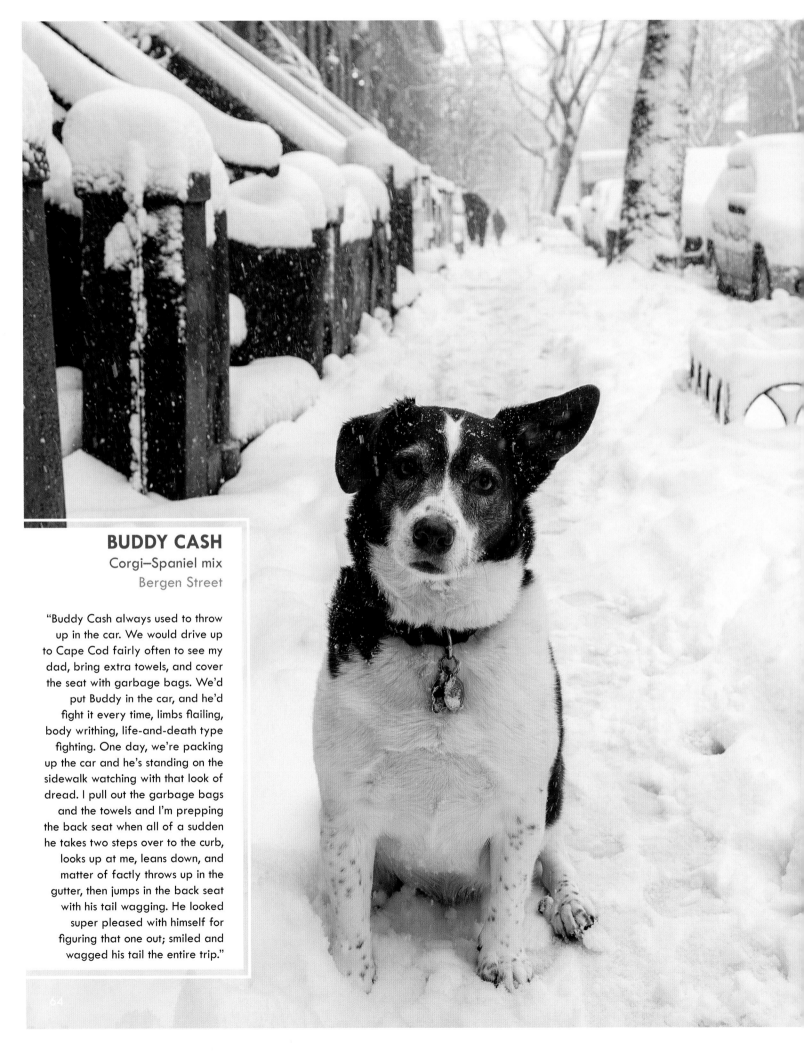

BUDDY CASH
Corgi–Spaniel mix
Bergen Street

"Buddy Cash always used to throw up in the car. We would drive up to Cape Cod fairly often to see my dad, bring extra towels, and cover the seat with garbage bags. We'd put Buddy in the car, and he'd fight it every time, limbs flailing, body writhing, life-and-death type fighting. One day, we're packing up the car and he's standing on the sidewalk watching with that look of dread. I pull out the garbage bags and the towels and I'm prepping the back seat when all of a sudden he takes two steps over to the curb, looks up at me, leans down, and matter of factly throws up in the gutter, then jumps in the back seat with his tail wagging. He looked super pleased with himself for figuring that one out; smiled and wagged his tail the entire trip."

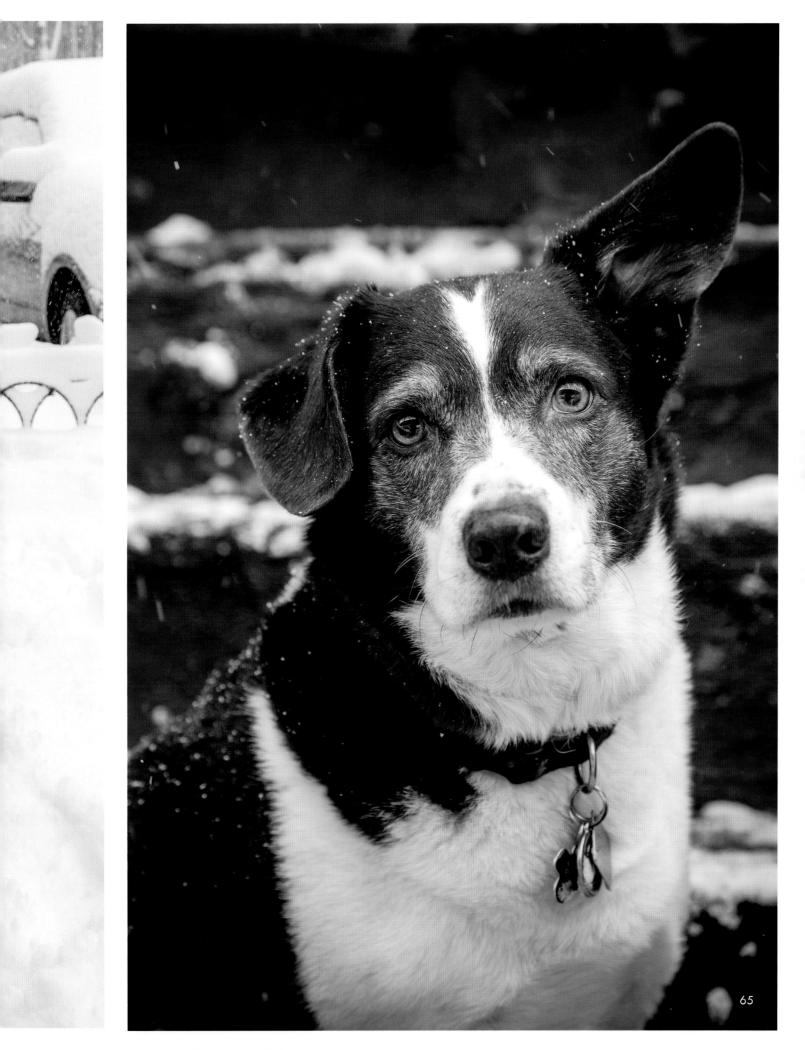

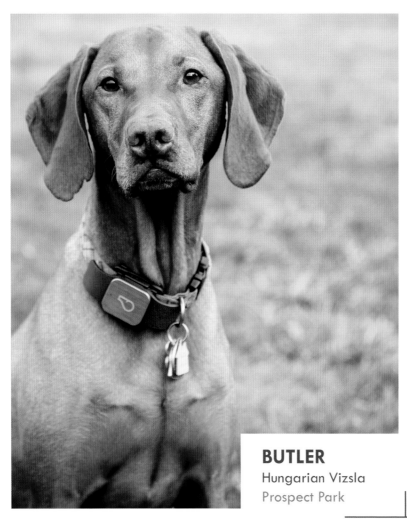

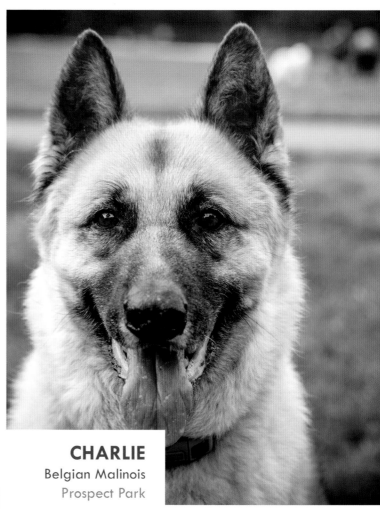

BUTLER
Hungarian Vizsla
Prospect Park

CHARLIE
Belgian Malinois
Prospect Park

LUCY
Mixed breed
Hillside Dog Park

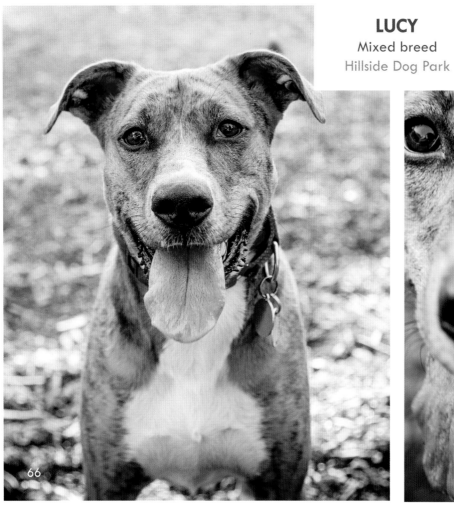

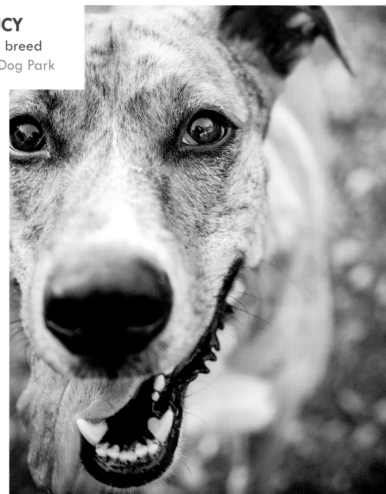

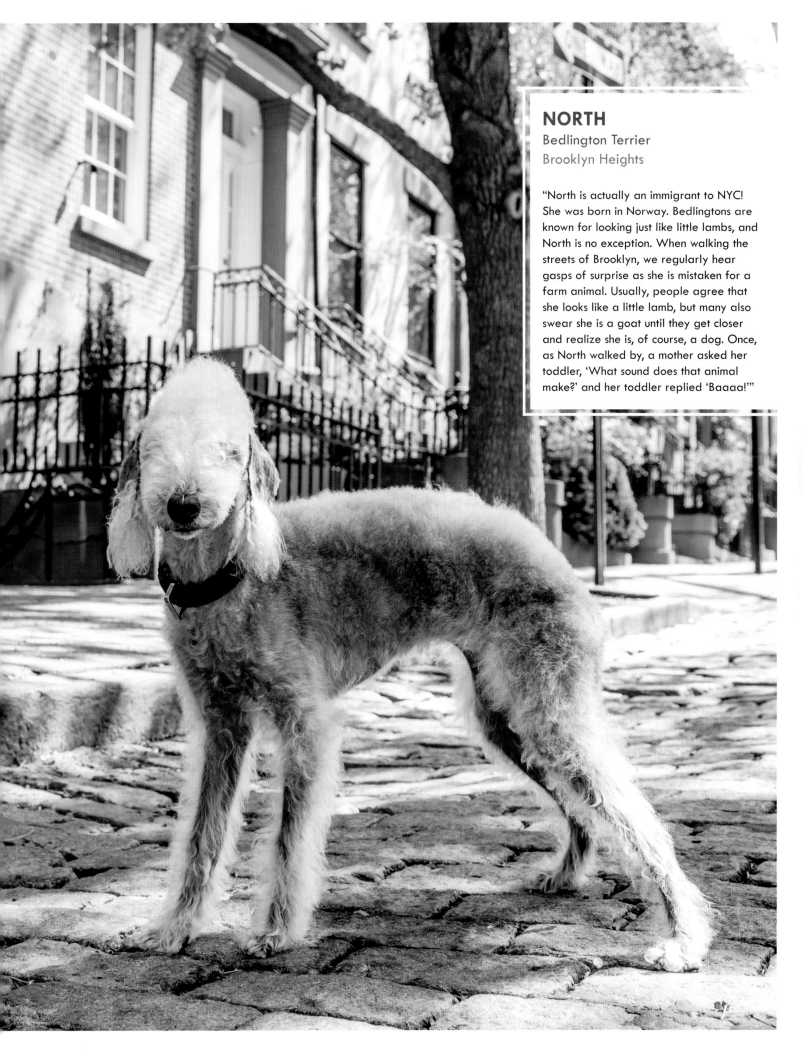

NORTH
Bedlington Terrier
Brooklyn Heights

"North is actually an immigrant to NYC! She was born in Norway. Bedlingtons are known for looking just like little lambs, and North is no exception. When walking the streets of Brooklyn, we regularly hear gasps of surprise as she is mistaken for a farm animal. Usually, people agree that she looks like a little lamb, but many also swear she is a goat until they get closer and realize she is, of course, a dog. Once, as North walked by, a mother asked her toddler, 'What sound does that animal make?' and her toddler replied 'Baaaa!'"

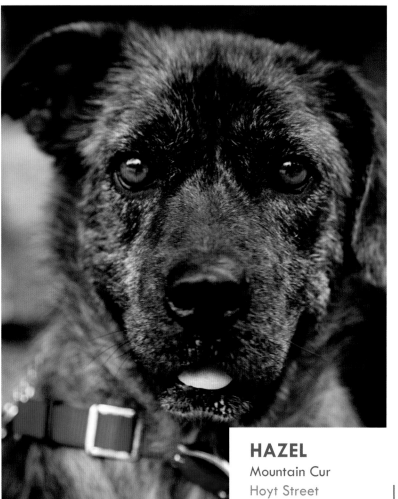

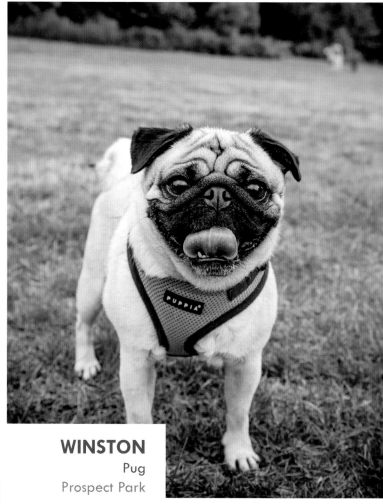

HAZEL
Mountain Cur
Hoyt Street

WINSTON
Pug
Prospect Park

WINSTON
English Bulldog
Prospect Park

MAXIE
Mastiff mix
Prospect Park

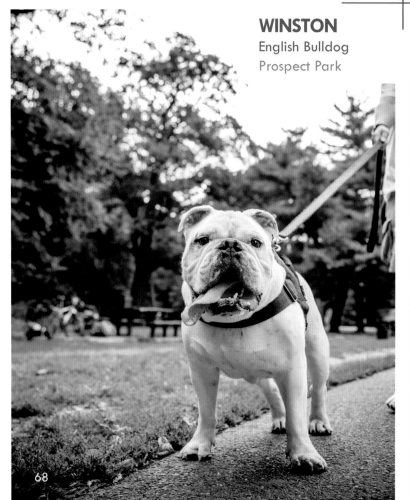

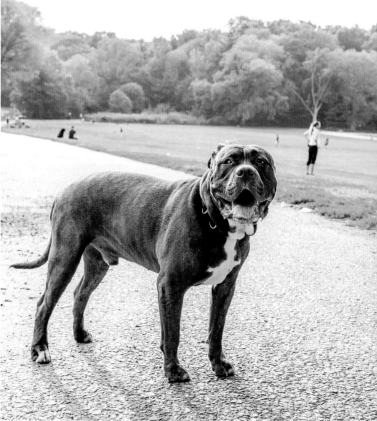

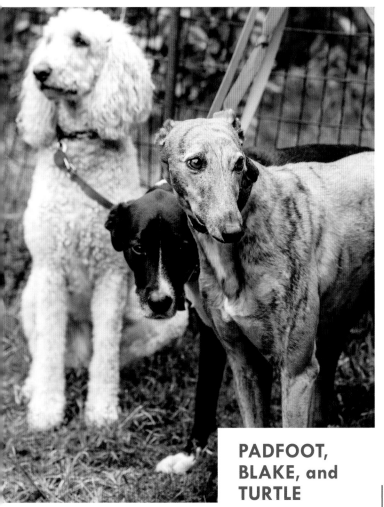

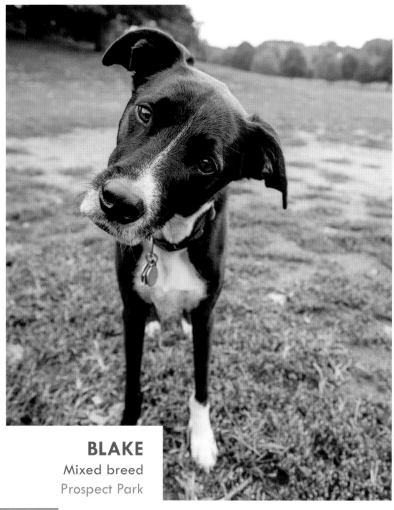

PADFOOT, BLAKE, and TURTLE

BLAKE
Mixed breed
Prospect Park

BERTIE
Beagle–Hound mix
Prospect Park

FINNEGAN
Spinone Italiano
Prospect Park

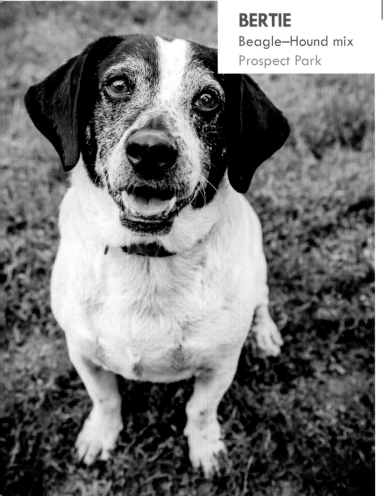

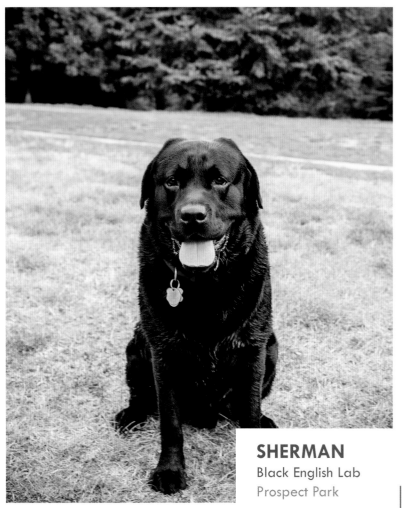

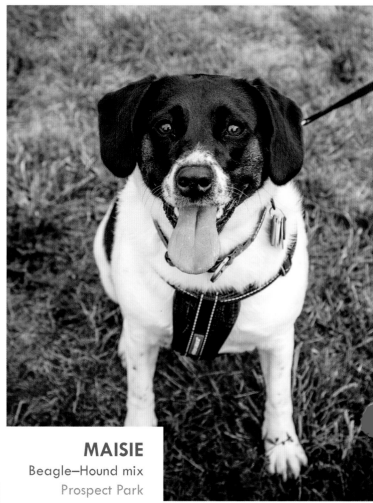

SHERMAN
Black English Lab
Prospect Park

MAISIE
Beagle–Hound mix
Prospect Park

BUSTER
Mutt
Prospect Park

HARVEY
Old English Sheepdog
Prospect Park

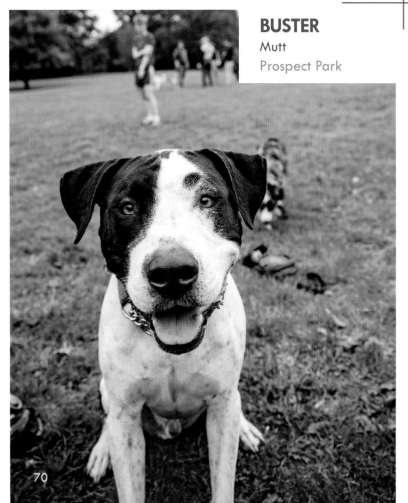

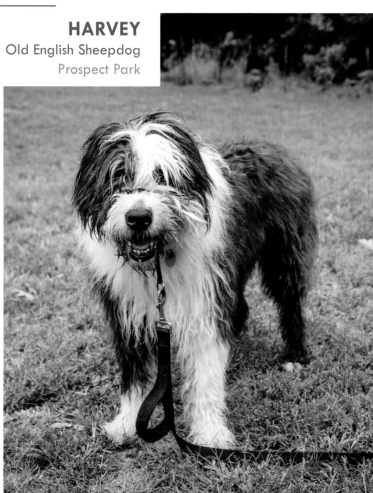

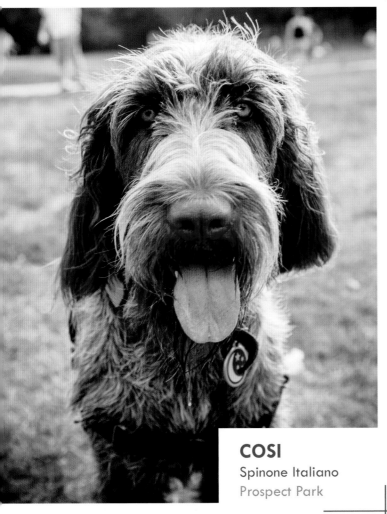

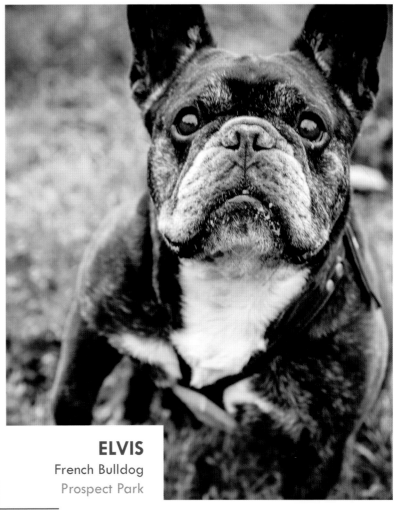

COSI
Spinone Italiano
Prospect Park

ELVIS
French Bulldog
Prospect Park

KLYDE
Dachshund–Terrier mix
Prospect Park

SAYA
Husky mix
Prospect Park

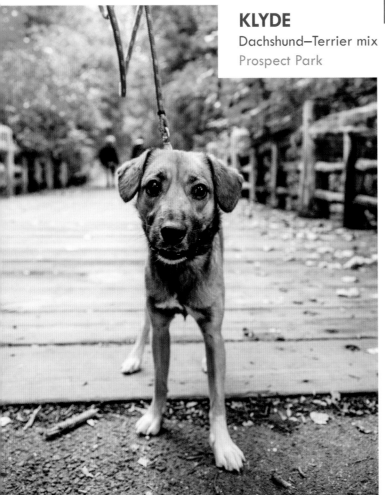

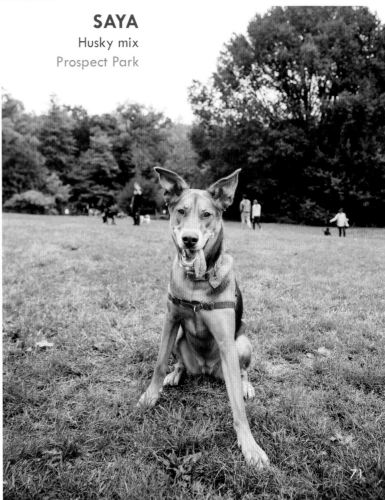

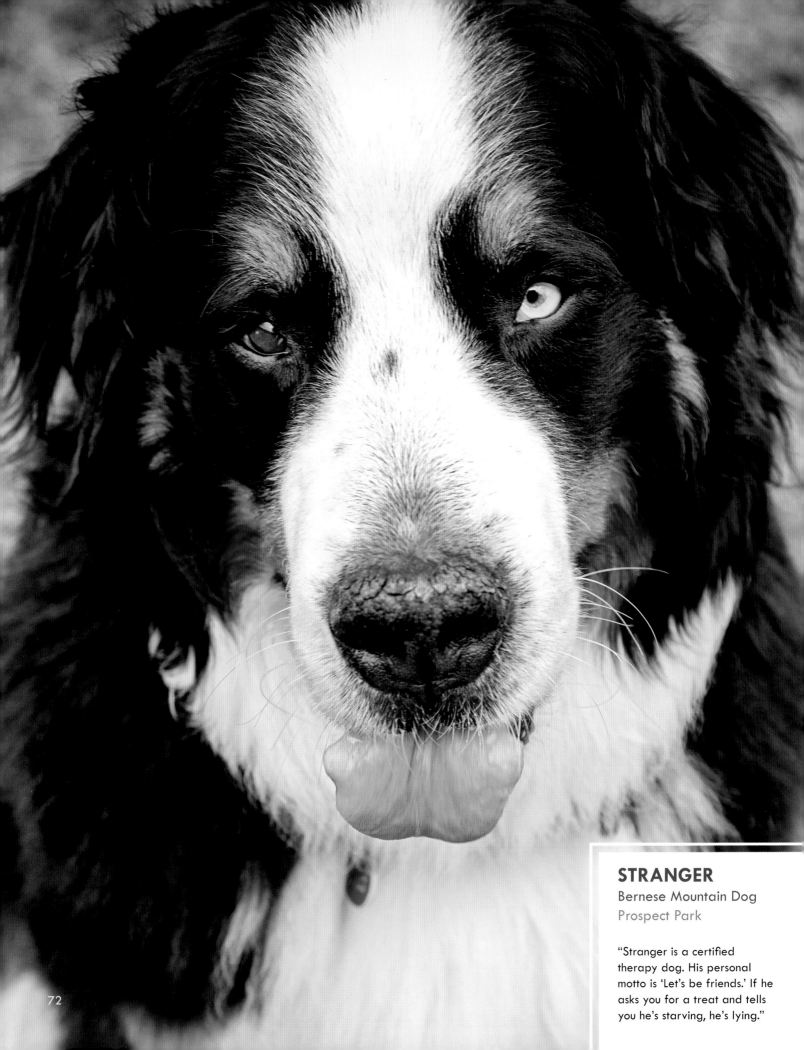

72

STRANGER
Bernese Mountain Dog
Prospect Park

"Stranger is a certified therapy dog. His personal motto is 'Let's be friends.' If he asks you for a treat and tells you he's starving, he's lying."

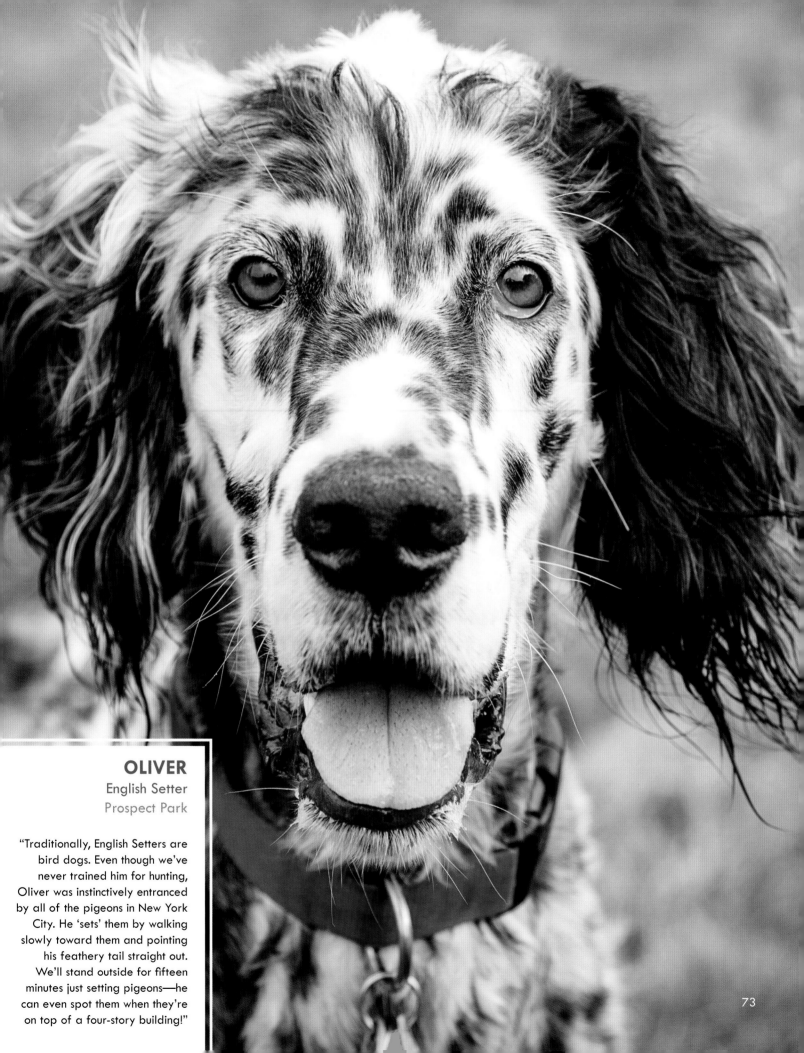

OLIVER
English Setter
Prospect Park

"Traditionally, English Setters are bird dogs. Even though we've never trained him for hunting, Oliver was instinctively entranced by all of the pigeons in New York City. He 'sets' them by walking slowly toward them and pointing his feathery tail straight out. We'll stand outside for fifteen minutes just setting pigeons—he can even spot them when they're on top of a four-story building!"

73

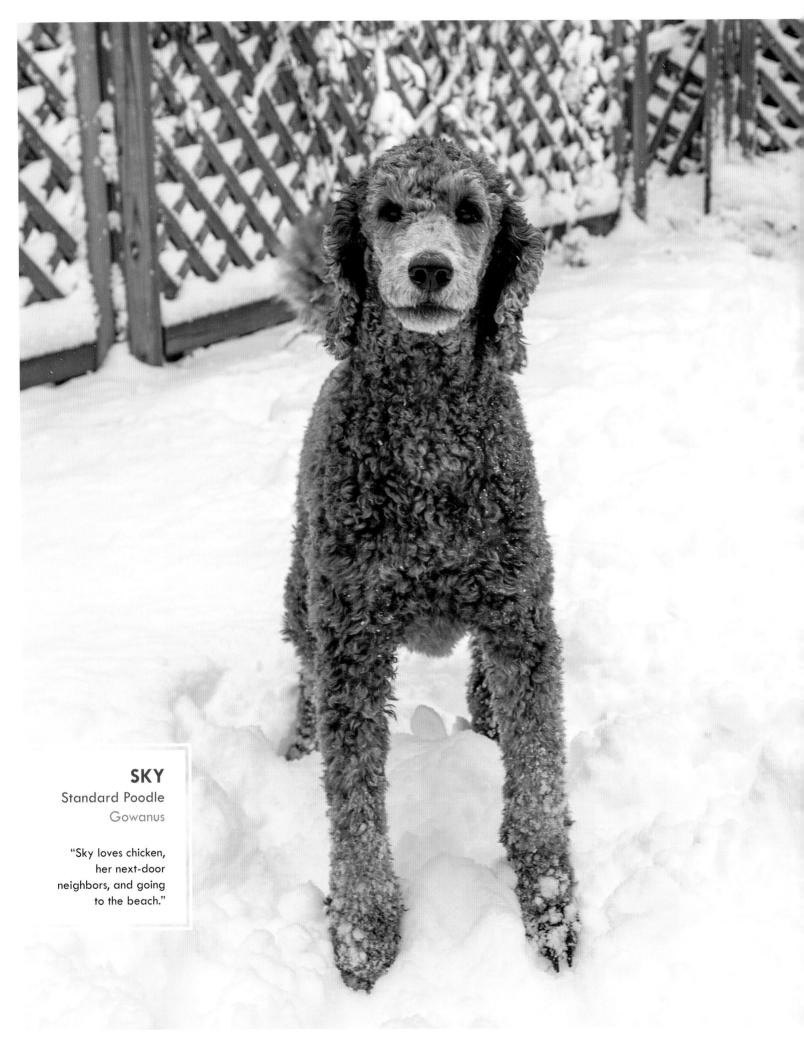

SKY
Standard Poodle
Gowanus

"Sky loves chicken, her next-door neighbors, and going to the beach."

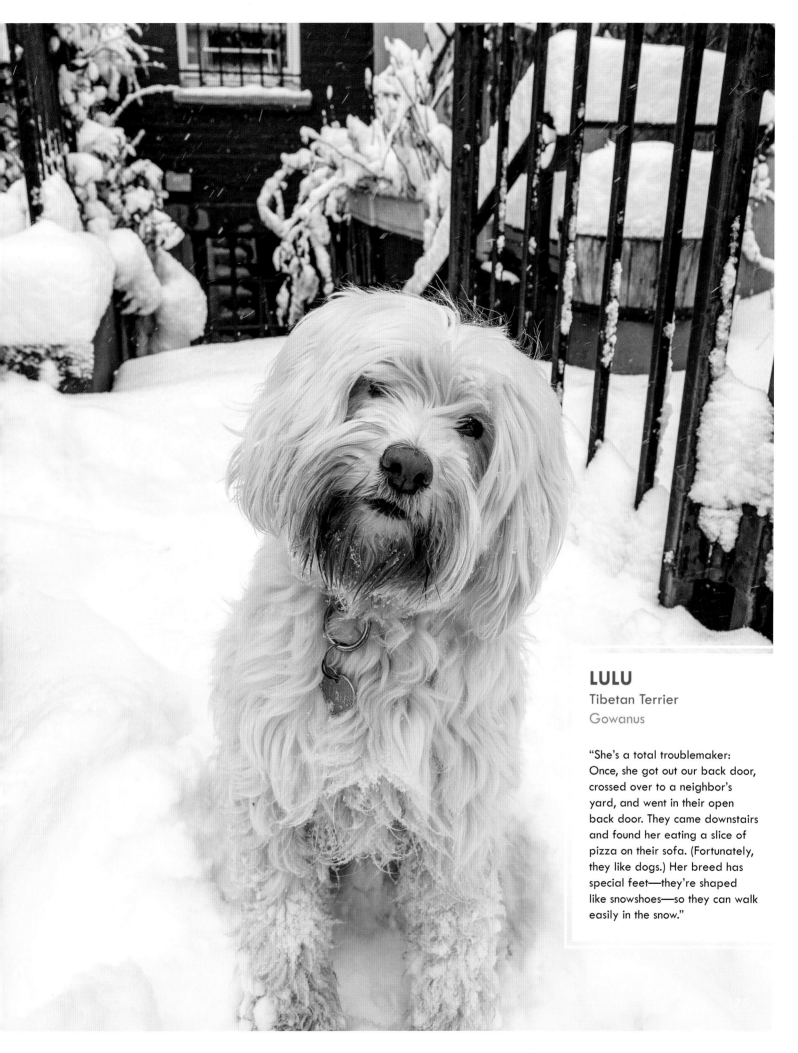

LULU
Tibetan Terrier
Gowanus

"She's a total troublemaker: Once, she got out our back door, crossed over to a neighbor's yard, and went in their open back door. They came downstairs and found her eating a slice of pizza on their sofa. (Fortunately, they like dogs.) Her breed has special feet—they're shaped like snowshoes—so they can walk easily in the snow."

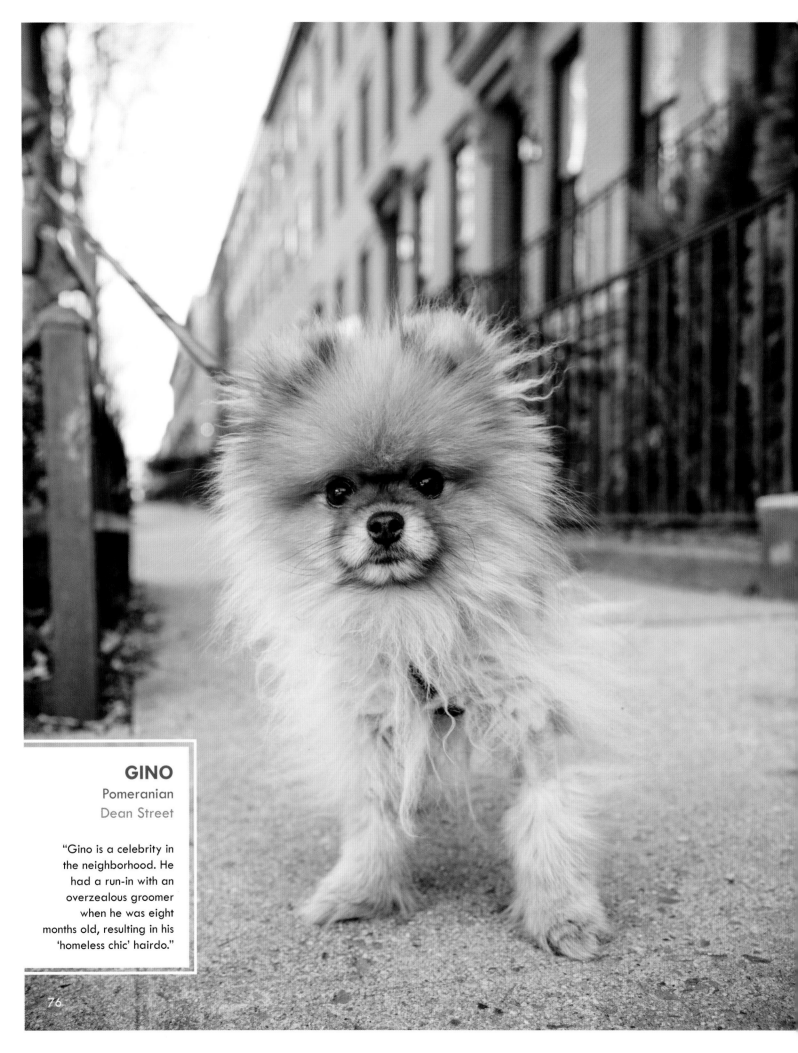

GINO
Pomeranian
Dean Street

"Gino is a celebrity in the neighborhood. He had a run-in with an overzealous groomer when he was eight months old, resulting in his 'homeless chic' hairdo."

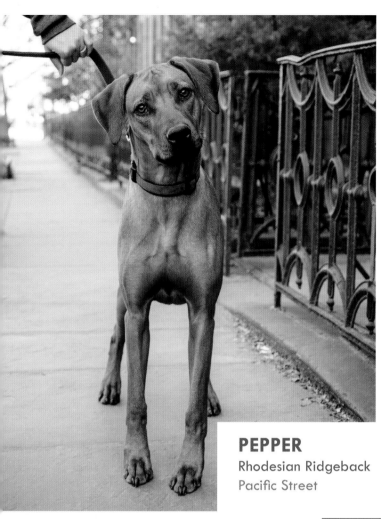

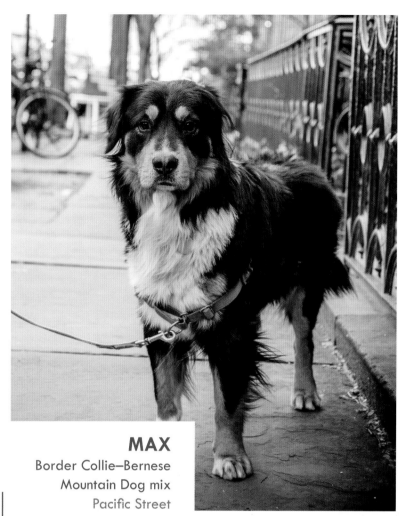

PEPPER
Rhodesian Ridgeback
Pacific Street

MAX
Border Collie–Bernese
Mountain Dog mix
Pacific Street

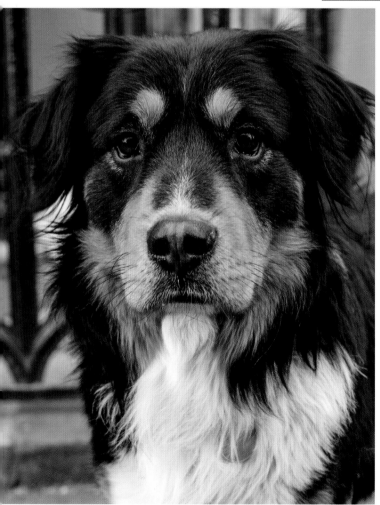

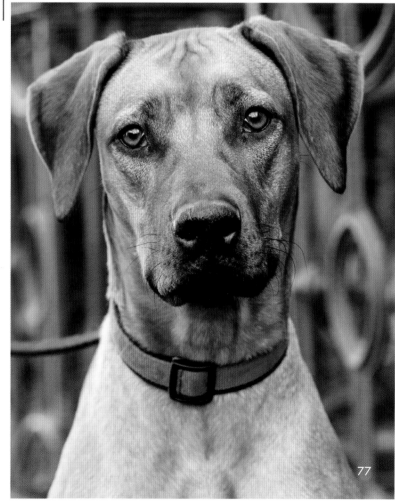

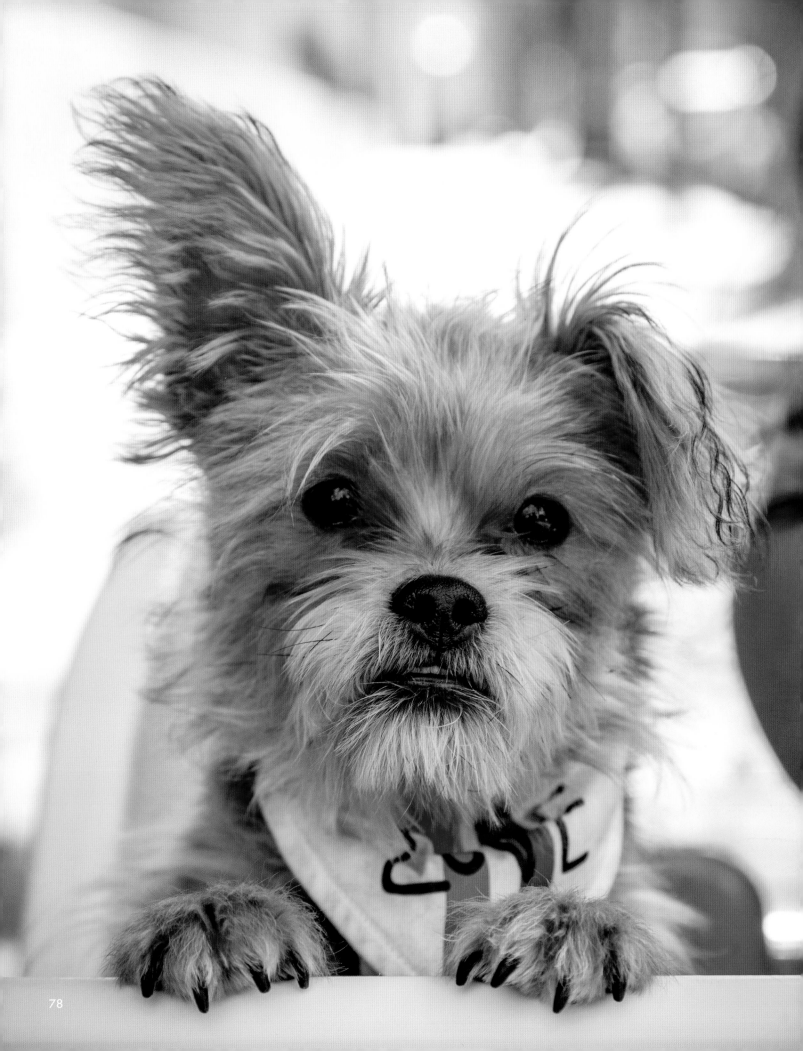

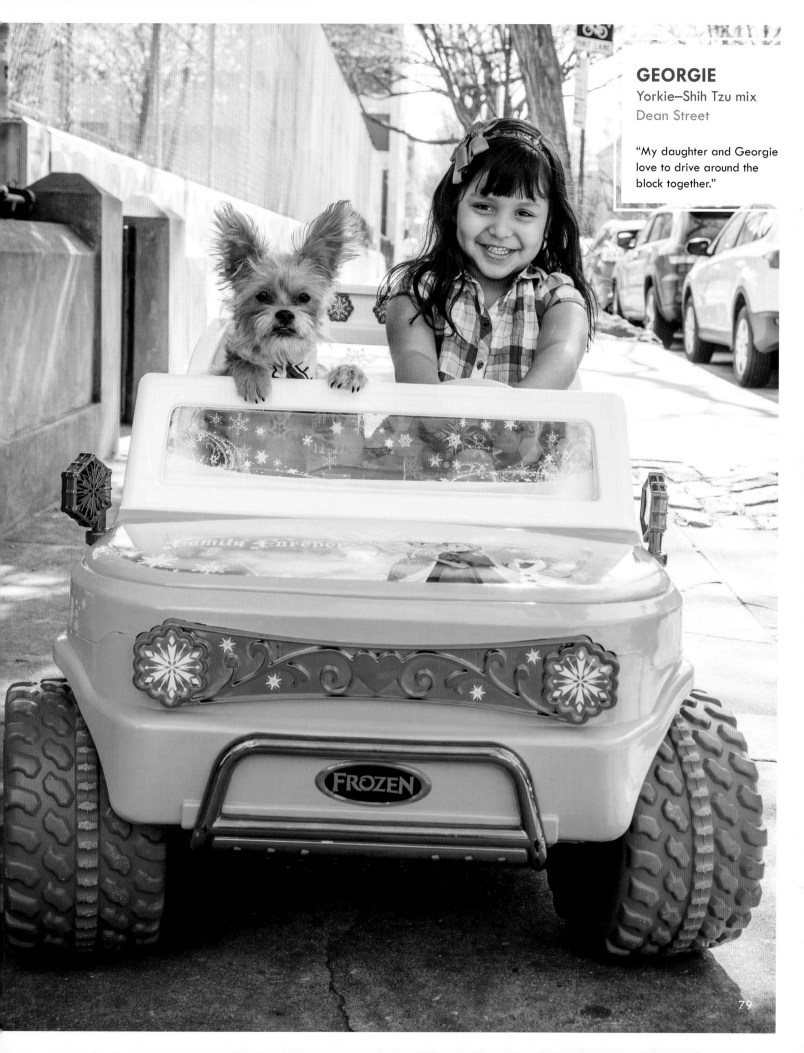

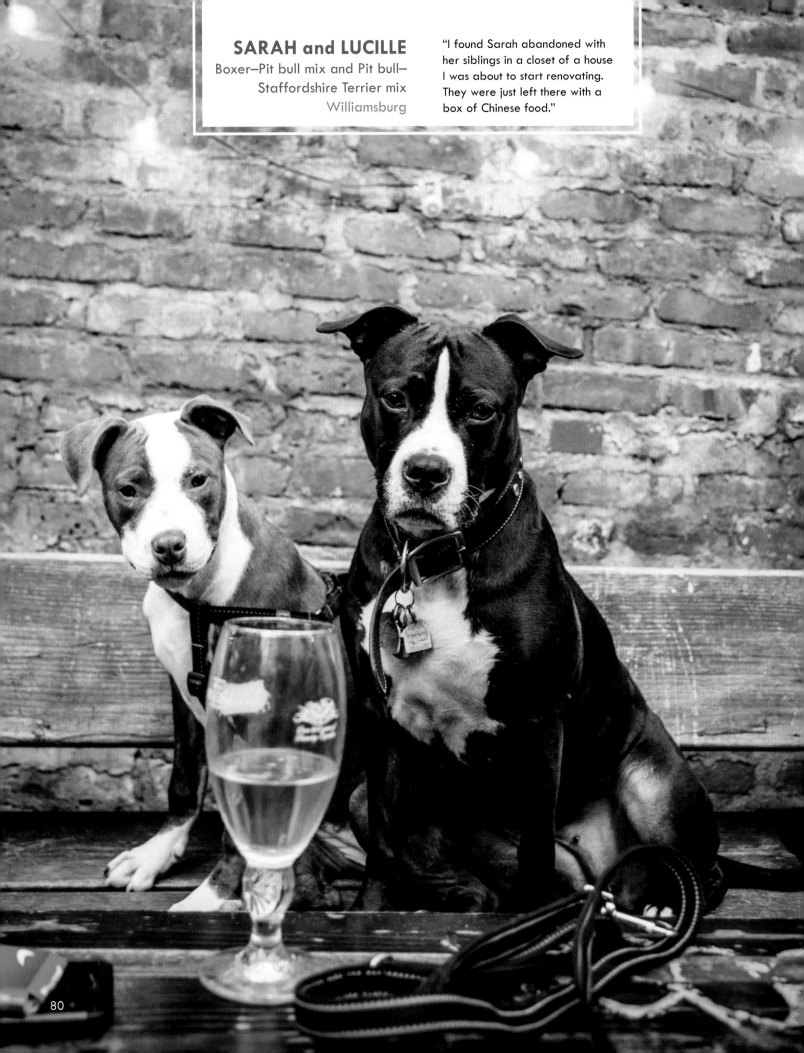

SARAH and LUCILLE
Boxer–Pit bull mix and Pit bull–
Staffordshire Terrier mix
Williamsburg

"I found Sarah abandoned with her siblings in a closet of a house I was about to start renovating. They were just left there with a box of Chinese food."

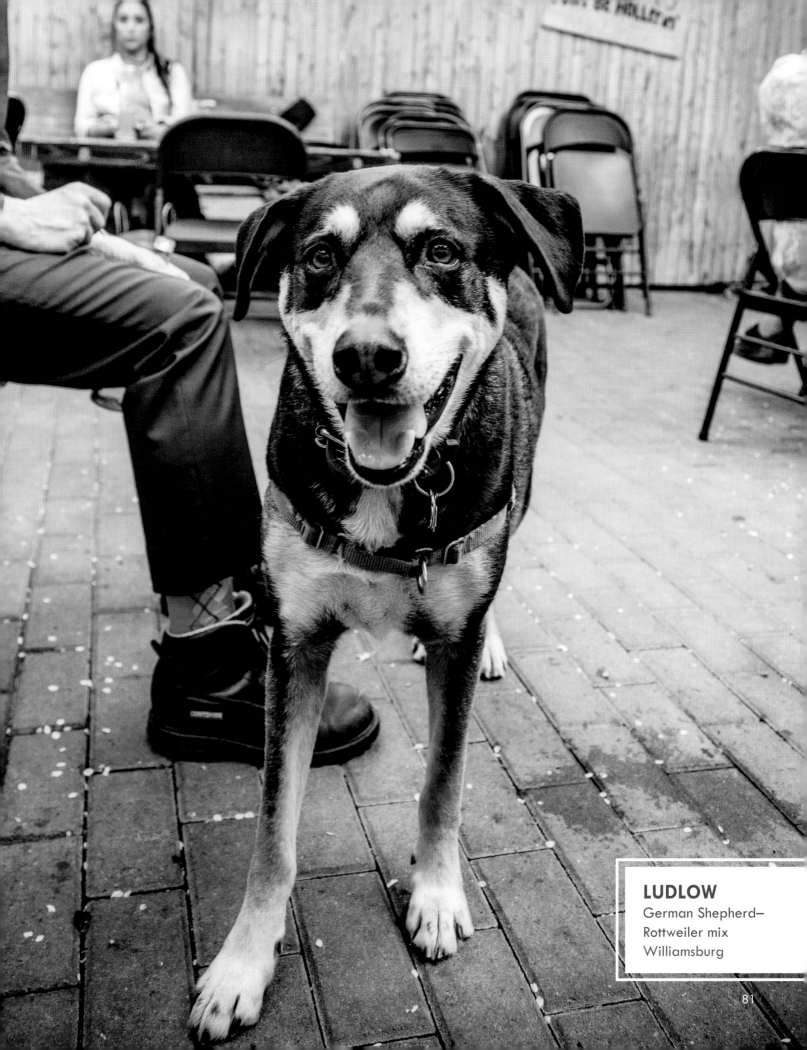

LUDLOW
German Shepherd–
Rottweiler mix
Williamsburg

RINGO

Cocker Spaniel
Boerum Hill

"Ringo was a stud at a puppy mill in Georgia. When authorities raided the place, the dogs were in terrible shape. My daughter had complained of being a lonely only child; she suggested we should adopt an older brother. We compromised on a dog. When we met Ringo—furry, matted, with shaved patches missing from his coat—we both cried. We paid $25, filled out some forms, and carried him home on the A train. Within a day he was part of the family. Now we just have to find a college with dog-friendly dorms."

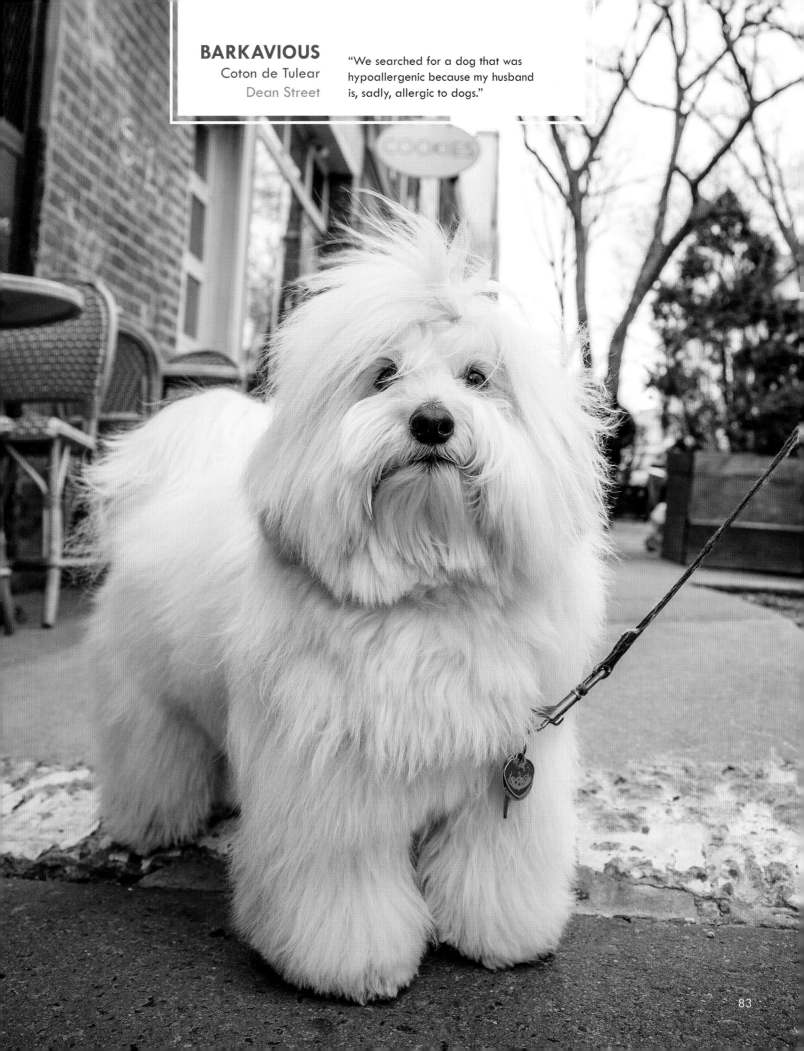

BARKAVIOUS
Coton de Tulear
Dean Street

"We searched for a dog that was hypoallergenic because my husband is, sadly, allergic to dogs."

83

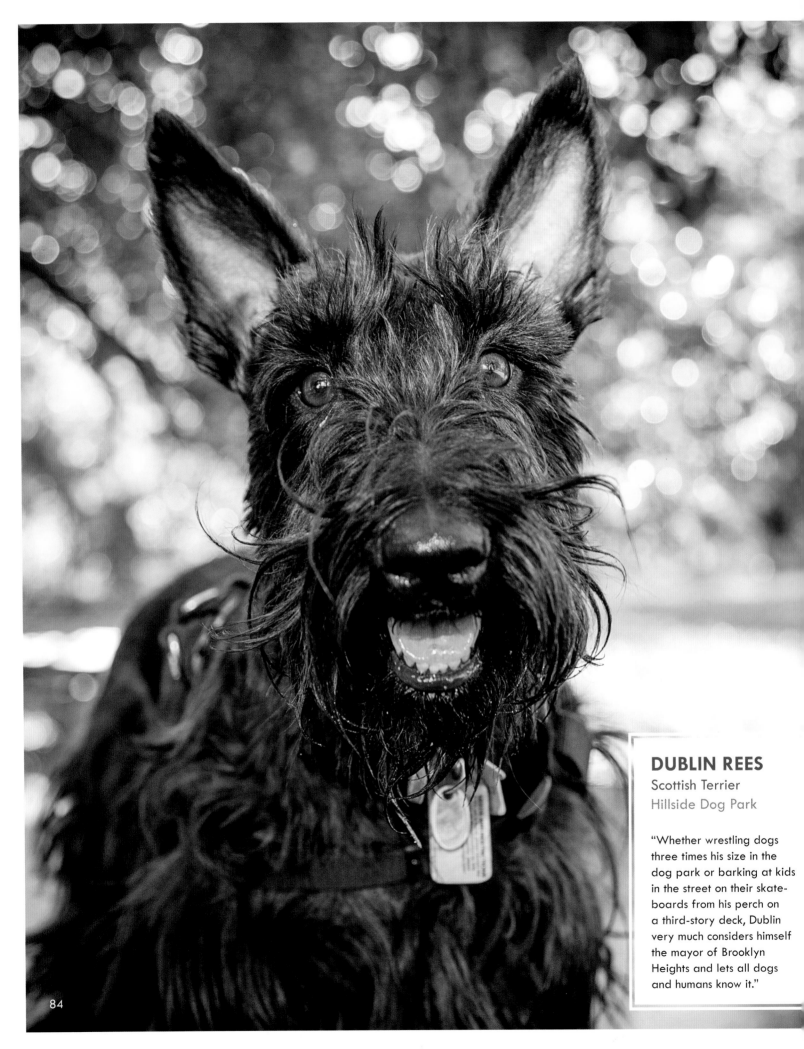

DUBLIN REES
Scottish Terrier
Hillside Dog Park

"Whether wrestling dogs three times his size in the dog park or barking at kids in the street on their skateboards from his perch on a third-story deck, Dublin very much considers himself the mayor of Brooklyn Heights and lets all dogs and humans know it."

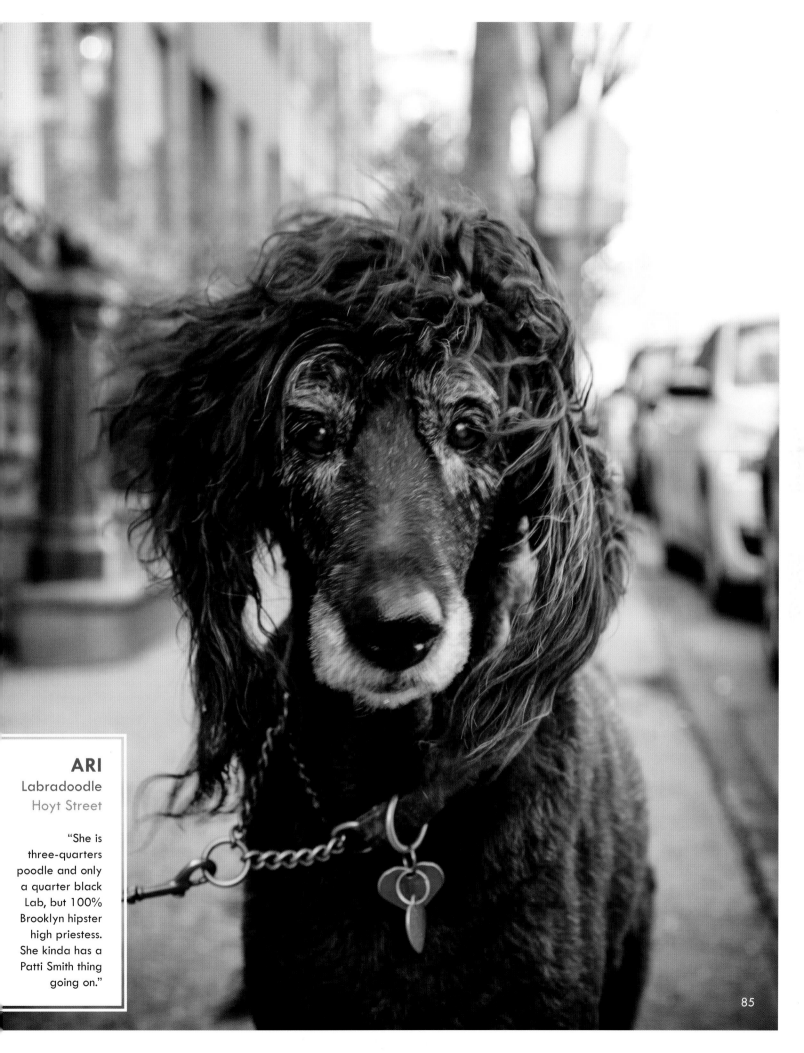

ARI
Labradoodle
Hoyt Street

"She is three-quarters poodle and only a quarter black Lab, but 100% Brooklyn hipster high priestess. She kinda has a Patti Smith thing going on."

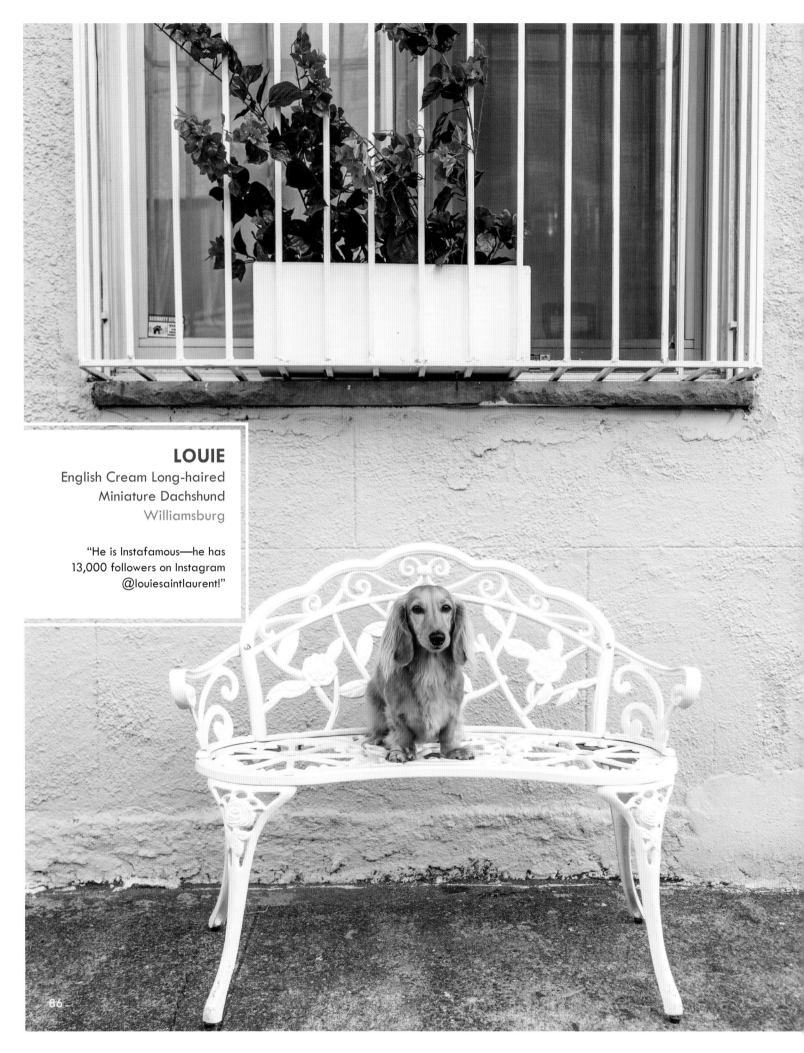

LOUIE
English Cream Long-haired
Miniature Dachshund
Williamsburg

"He is Instafamous—he has
13,000 followers on Instagram
@louiesaintlaurent!"

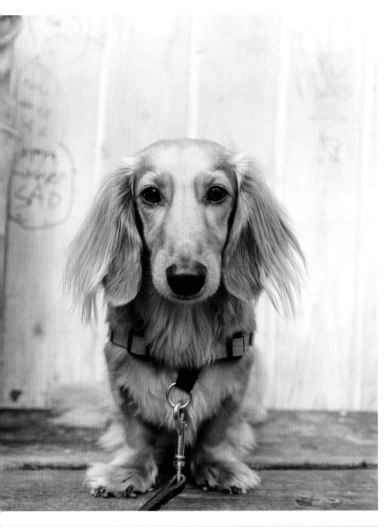

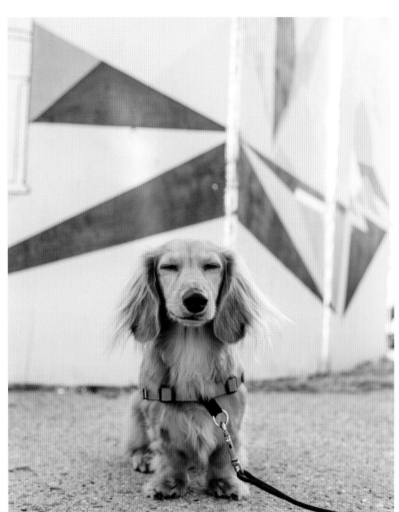

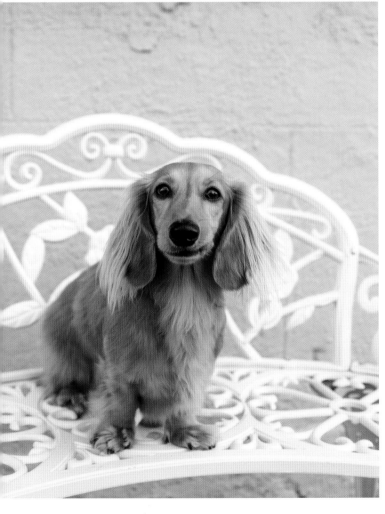

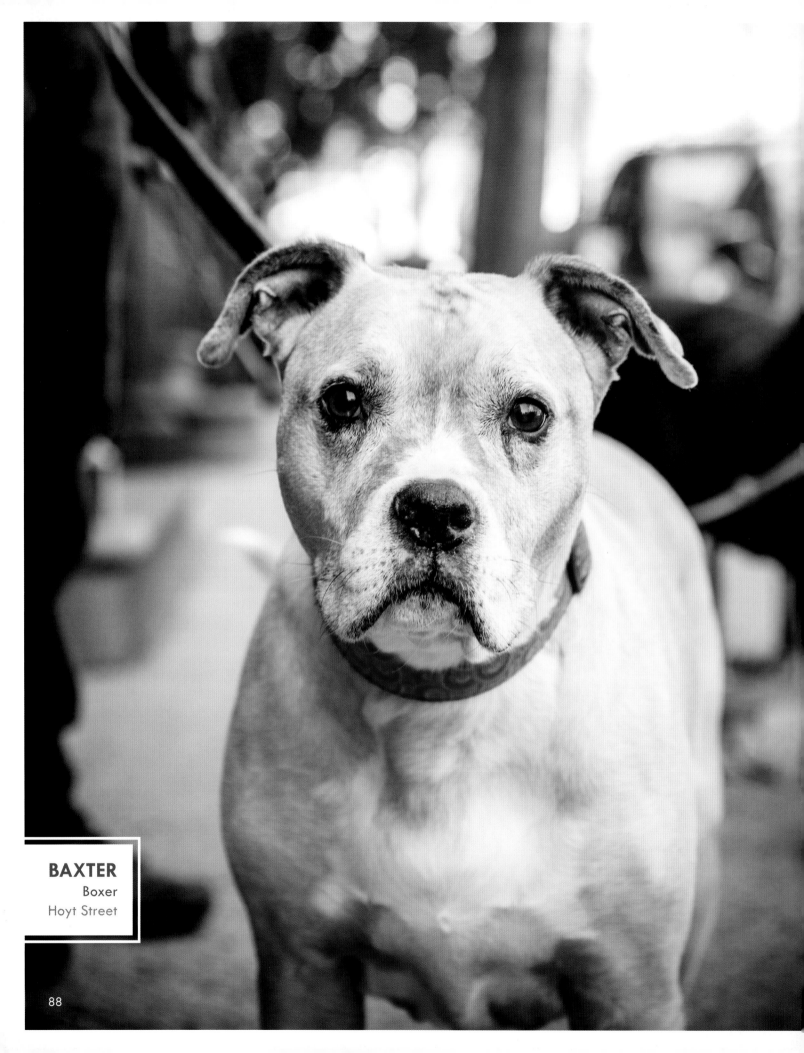

BAXTER
Boxer
Hoyt Street

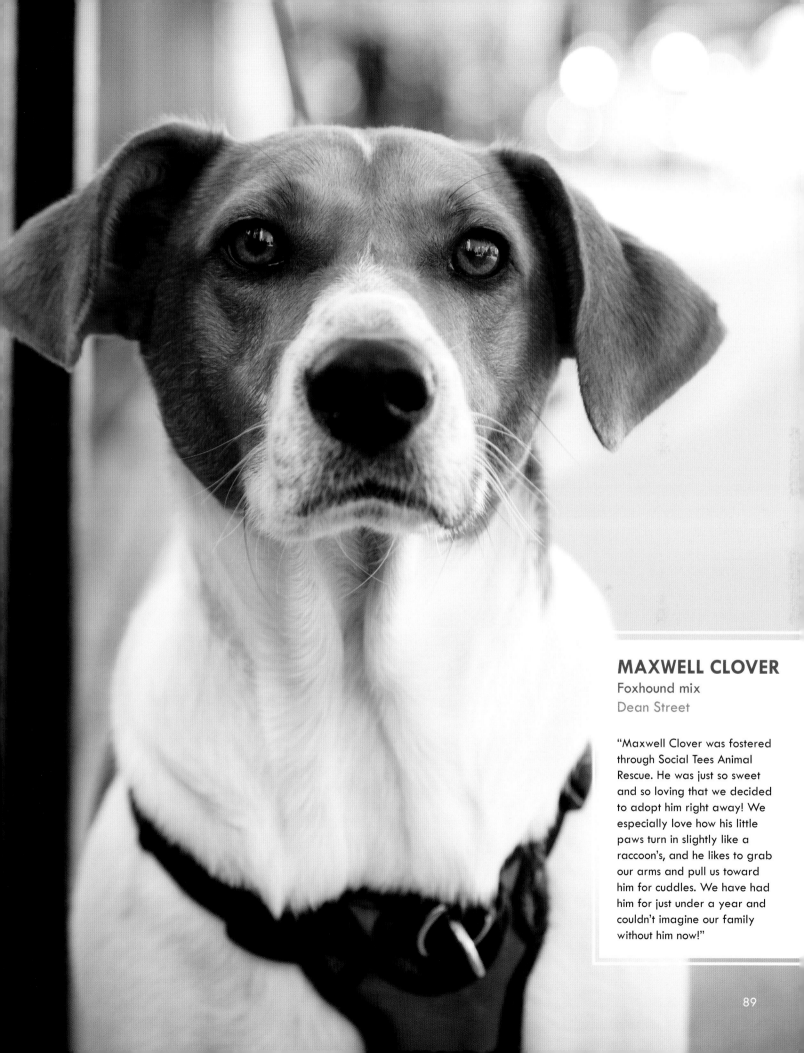

MAXWELL CLOVER
Foxhound mix
Dean Street

"Maxwell Clover was fostered through Social Tees Animal Rescue. He was just so sweet and so loving that we decided to adopt him right away! We especially love how his little paws turn in slightly like a raccoon's, and he likes to grab our arms and pull us toward him for cuddles. We have had him for just under a year and couldn't imagine our family without him now!"

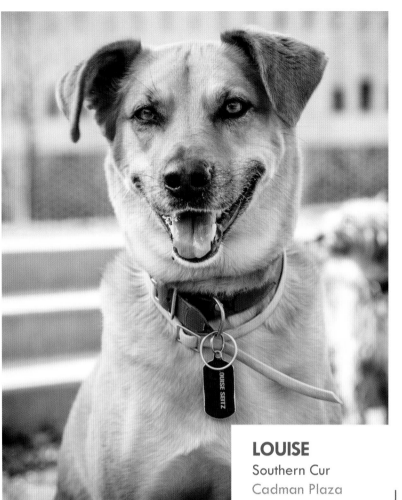

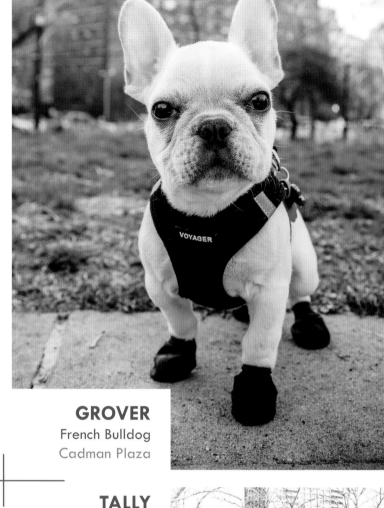

LOUISE
Southern Cur
Cadman Plaza

GROVER
French Bulldog
Cadman Plaza

HERMES
Mixed breed
Cadman Plaza

TALLY
Goldendoodle
Cadman Plaza

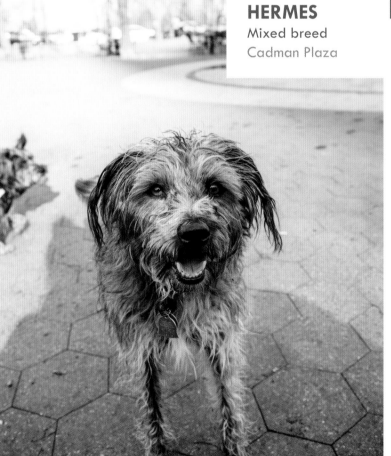

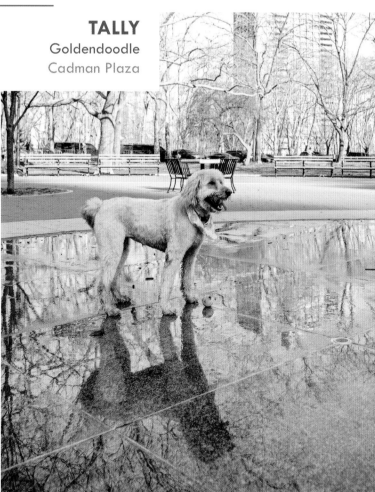

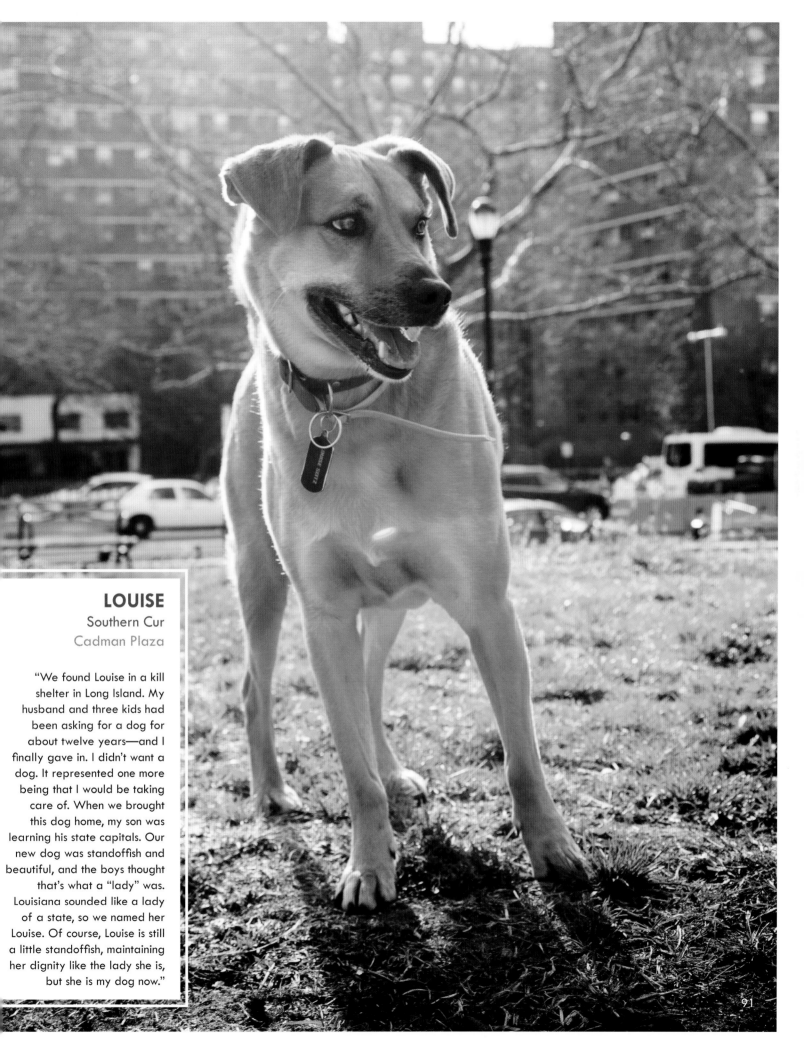

LOUISE
Southern Cur
Cadman Plaza

"We found Louise in a kill shelter in Long Island. My husband and three kids had been asking for a dog for about twelve years—and I finally gave in. I didn't want a dog. It represented one more being that I would be taking care of. When we brought this dog home, my son was learning his state capitals. Our new dog was standoffish and beautiful, and the boys thought that's what a "lady" was. Louisiana sounded like a lady of a state, so we named her Louise. Of course, Louise is still a little standoffish, maintaining her dignity like the lady she is, but she is my dog now."

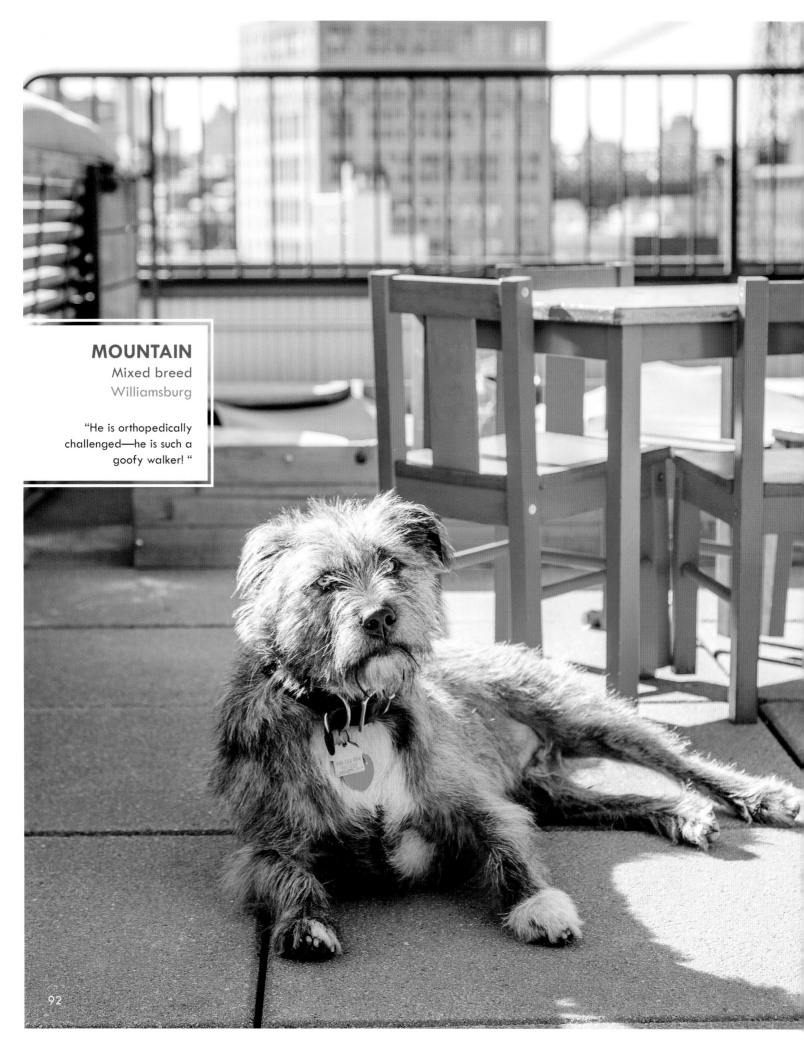

MOUNTAIN
Mixed breed
Williamsburg

"He is orthopedically challenged—he is such a goofy walker! "

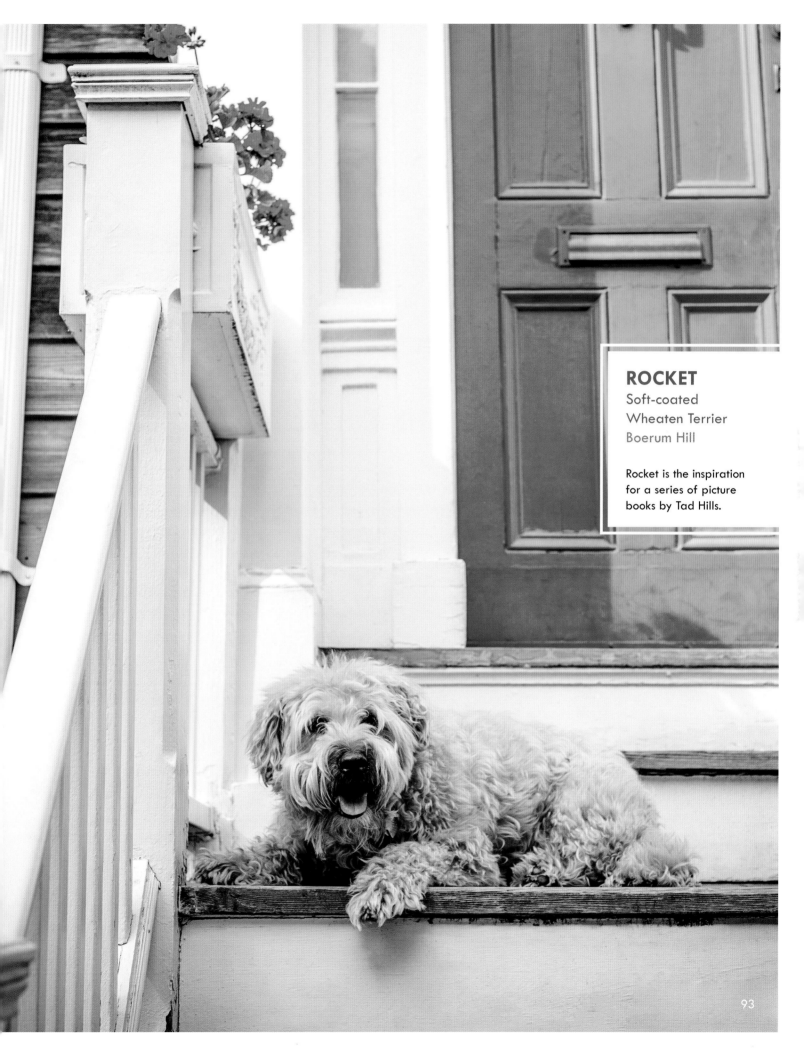

ROCKET
Soft-coated
Wheaten Terrier
Boerum Hill

Rocket is the inspiration
for a series of picture
books by Tad Hills.

93

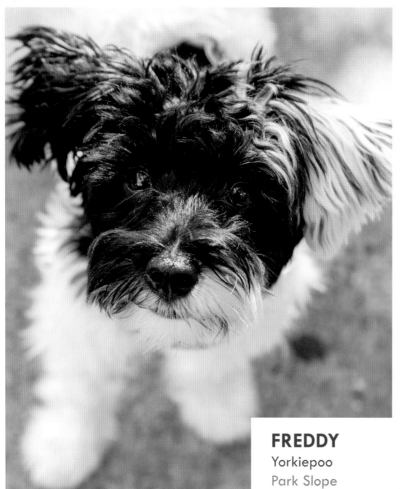

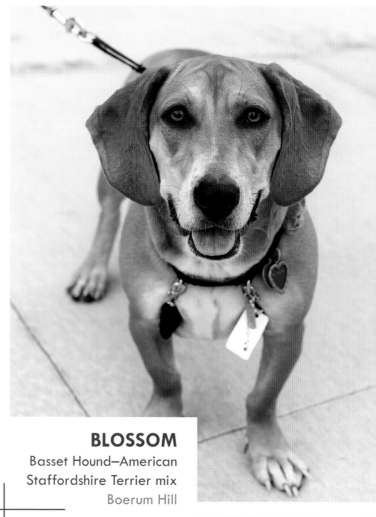

FREDDY
Yorkiepoo
Park Slope

BLOSSOM
Basset Hound–American
Staffordshire Terrier mix
Boerum Hill

ODEN
Cavalier King
Charles Spaniel
Boerum Hill

WILBUR
Pug
Boerum Hill

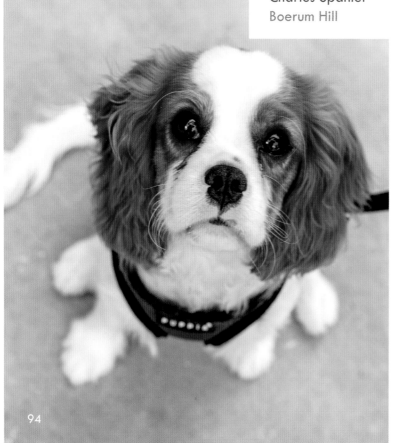

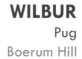

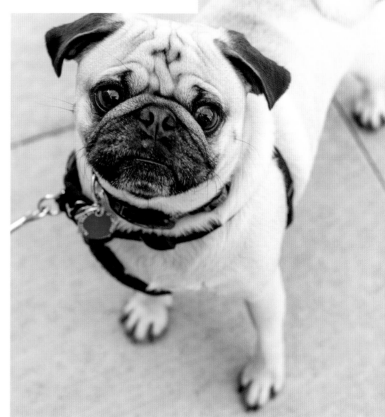

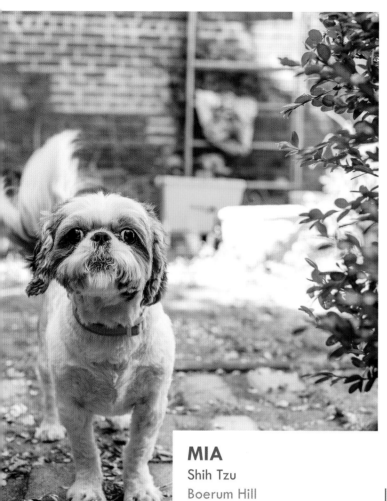

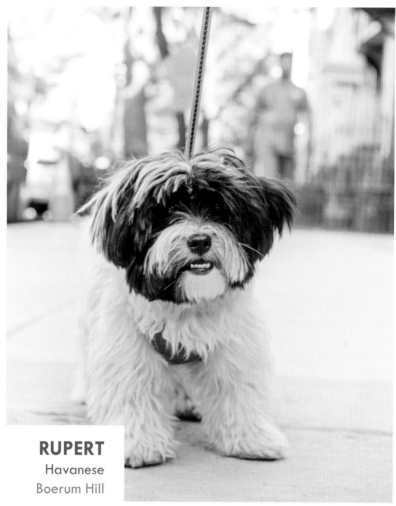

MIA
Shih Tzu
Boerum Hill

RUPERT
Havanese
Boerum Hill

JAMES
Cavalier King Charles Spaniel
Boerum Hill

TEDDY
Labradoodle
Boerum Hill

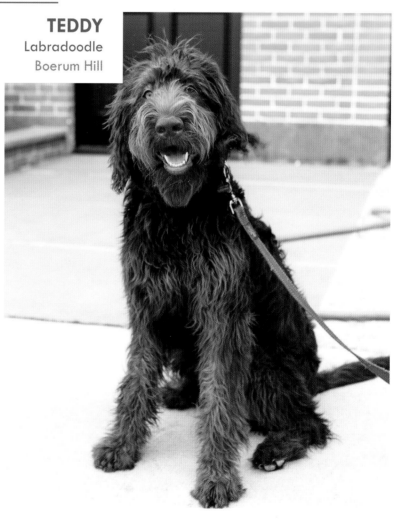

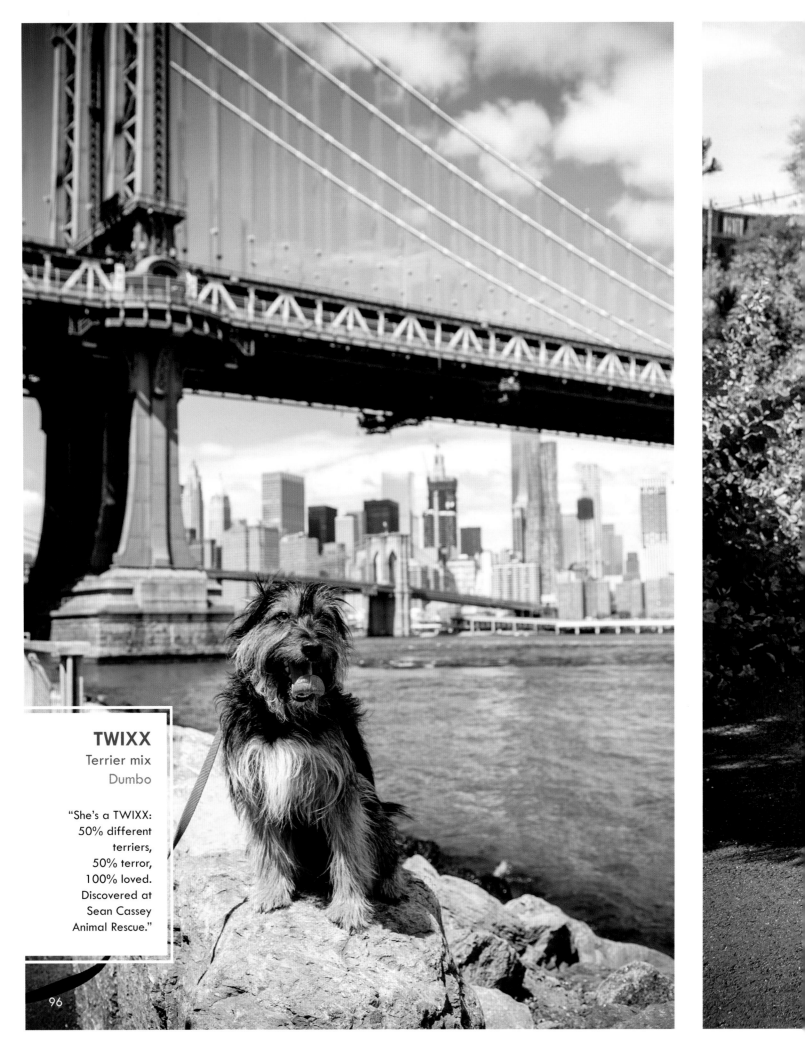

TWIXX
Terrier mix
Dumbo

"She's a TWIXX: 50% different terriers, 50% terror, 100% loved. Discovered at Sean Cassey Animal Rescue."

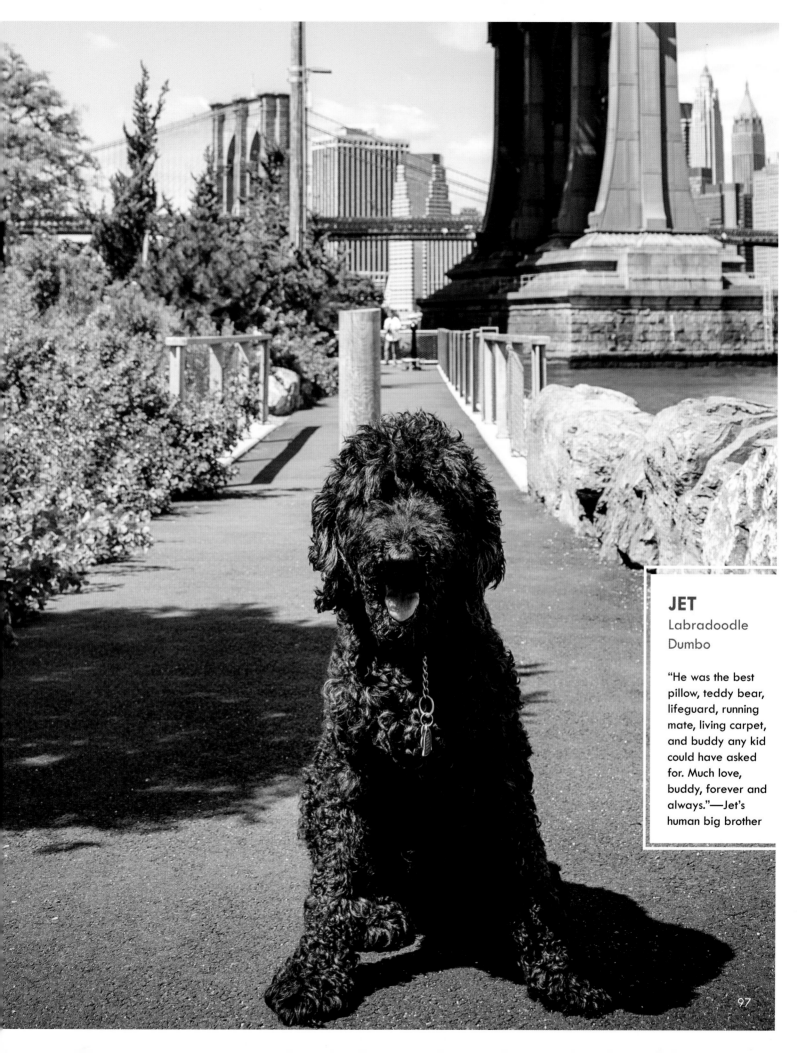

JET
Labradoodle
Dumbo

"He was the best pillow, teddy bear, lifeguard, running mate, living carpet, and buddy any kid could have asked for. Much love, buddy, forever and always."—Jet's human big brother

97

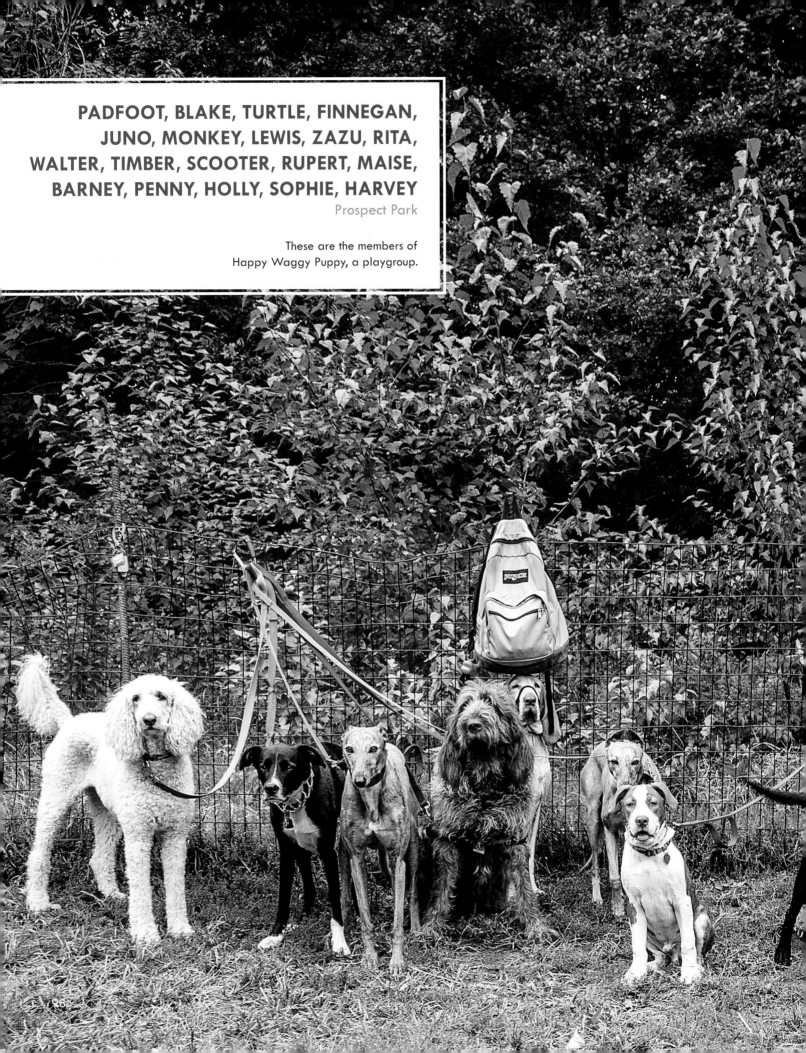

PADFOOT, BLAKE, TURTLE, FINNEGAN,
JUNO, MONKEY, LEWIS, ZAZU, RITA,
WALTER, TIMBER, SCOOTER, RUPERT, MAISE,
BARNEY, PENNY, HOLLY, SOPHIE, HARVEY

Prospect Park

These are the members of
Happy Waggy Puppy, a playgroup.

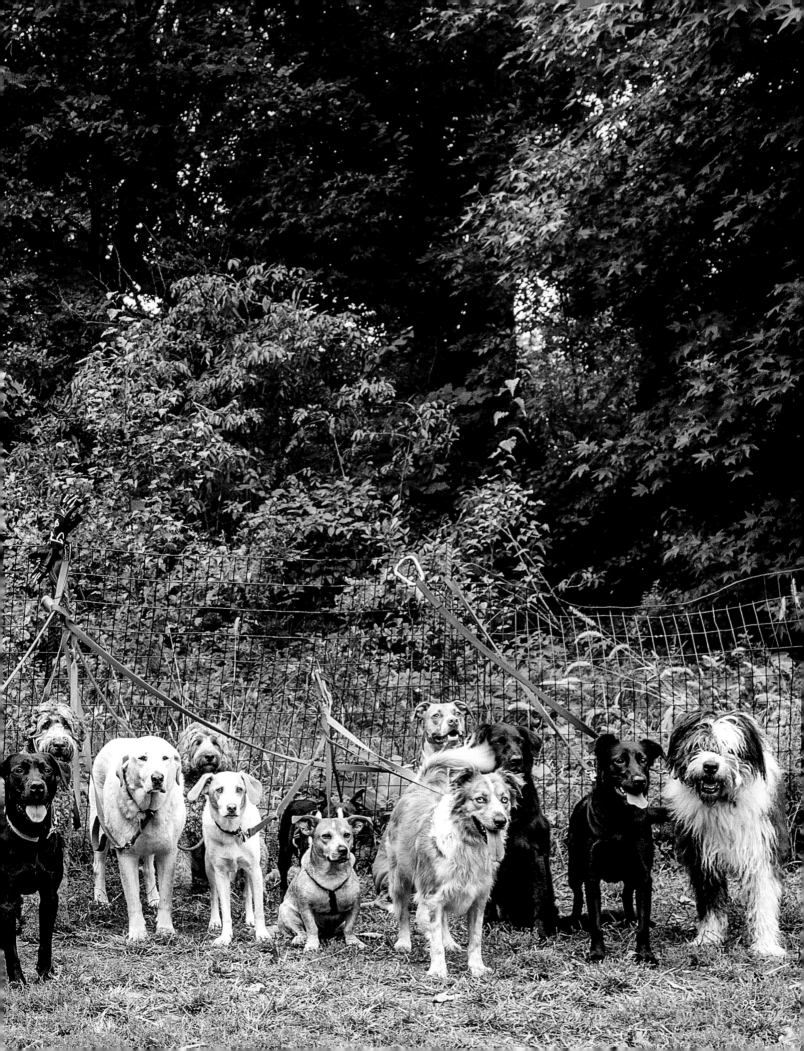

MORO
Labrador–Pit bull mix
Boerum Hill

"A New York story: Moro goes once or twice a week to a dog daycare. One day at pickup, they told us he had been in 'time-out' for playing rough. We had a good laugh thinking that none of our kids have been given a time-out at school, ever."

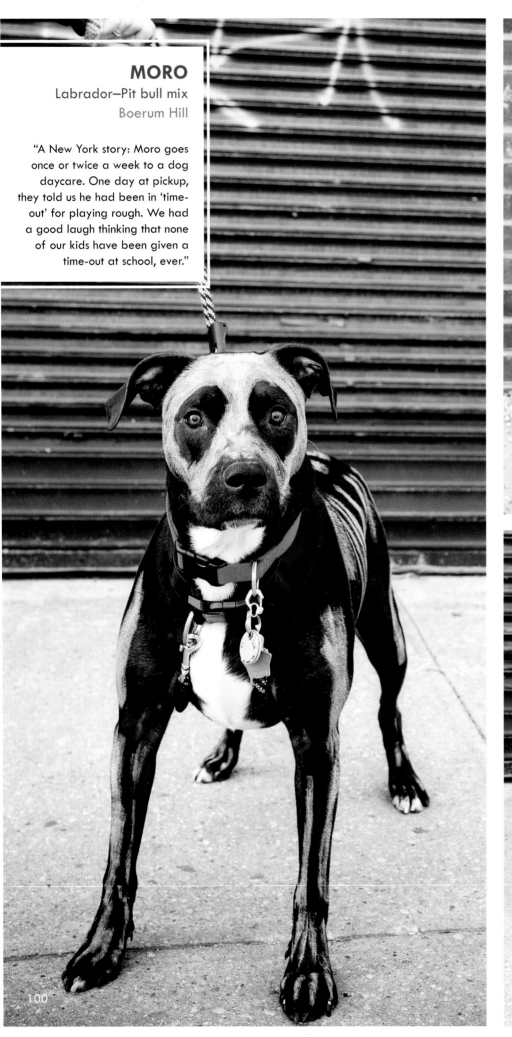

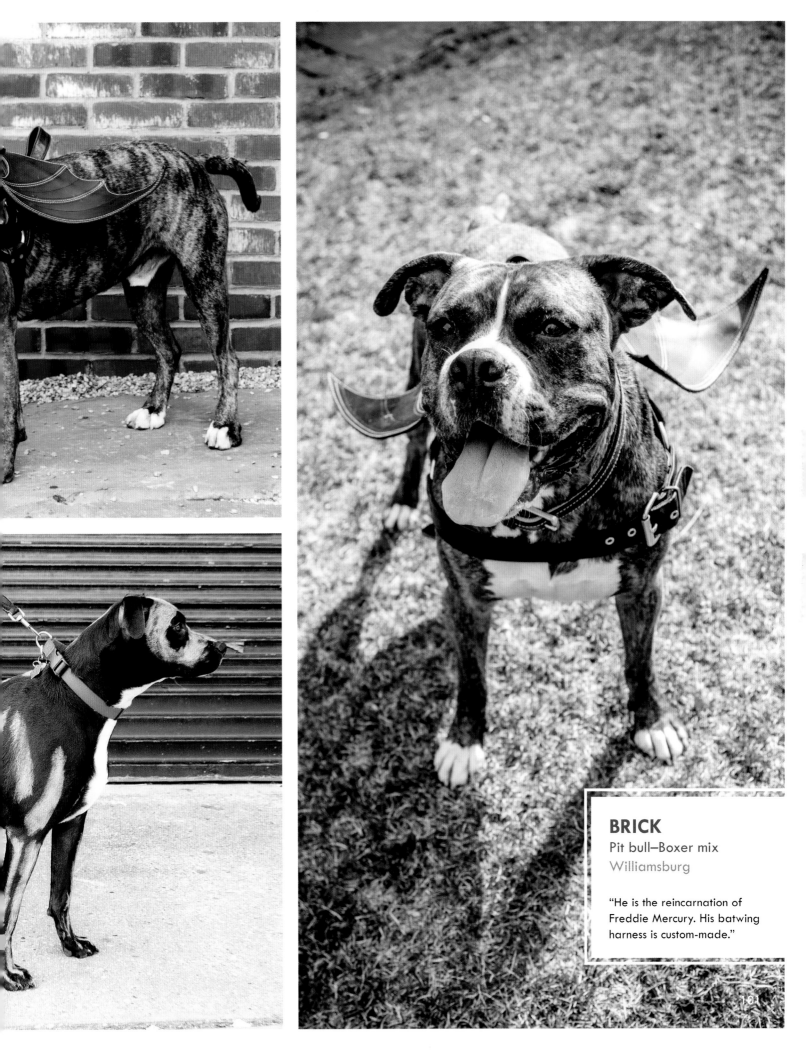

BRICK
Pit bull–Boxer mix
Williamsburg

"He is the reincarnation of
Freddie Mercury. His batwing
harness is custom-made."

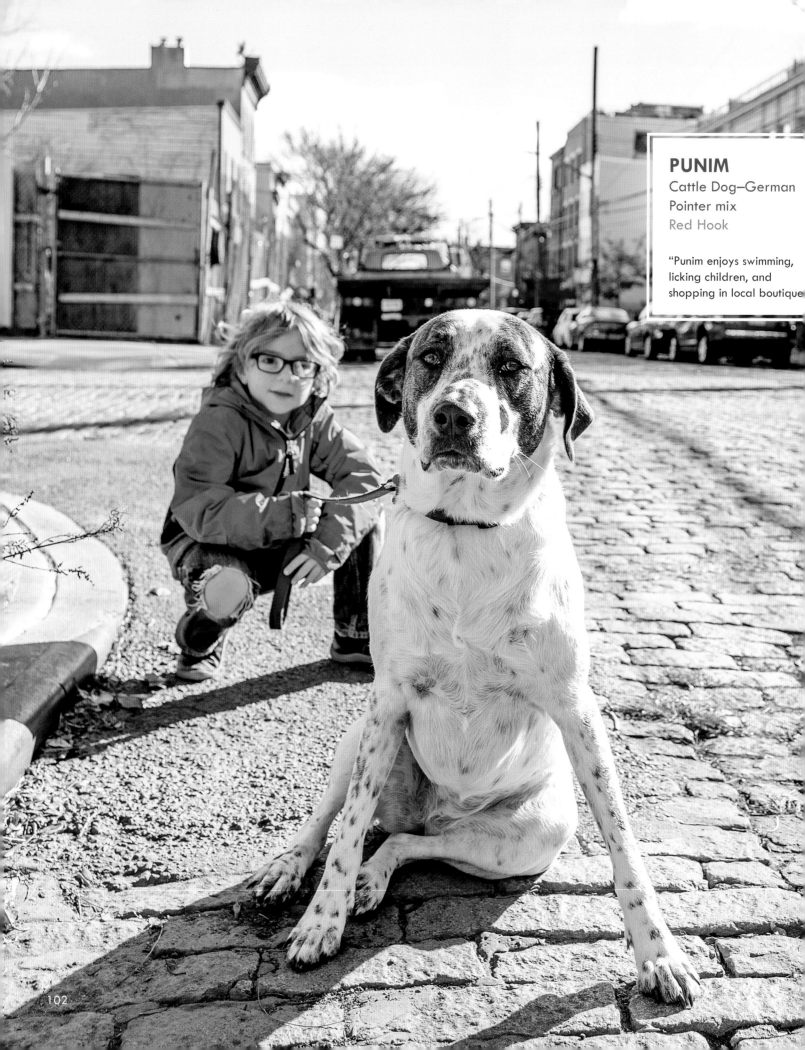

PUNIM
Cattle Dog–German
Pointer mix
Red Hook

"Punim enjoys swimming,
licking children, and
shopping in local boutique

102

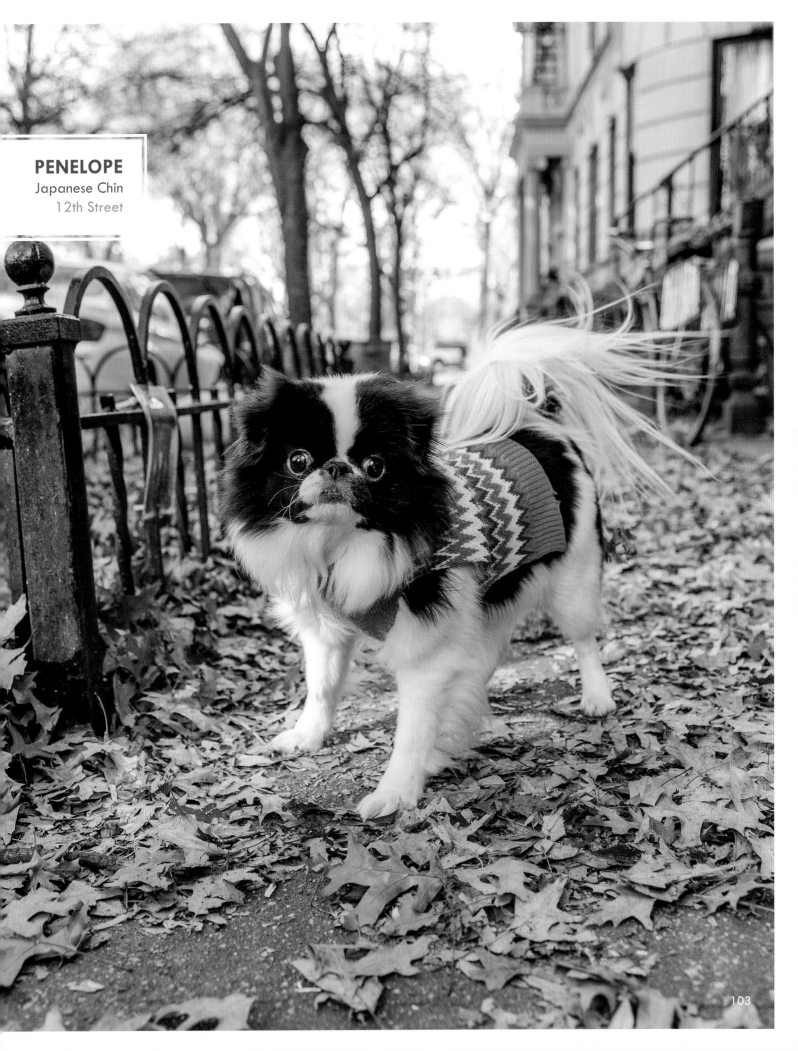

PENELOPE
Japanese Chin
12th Street

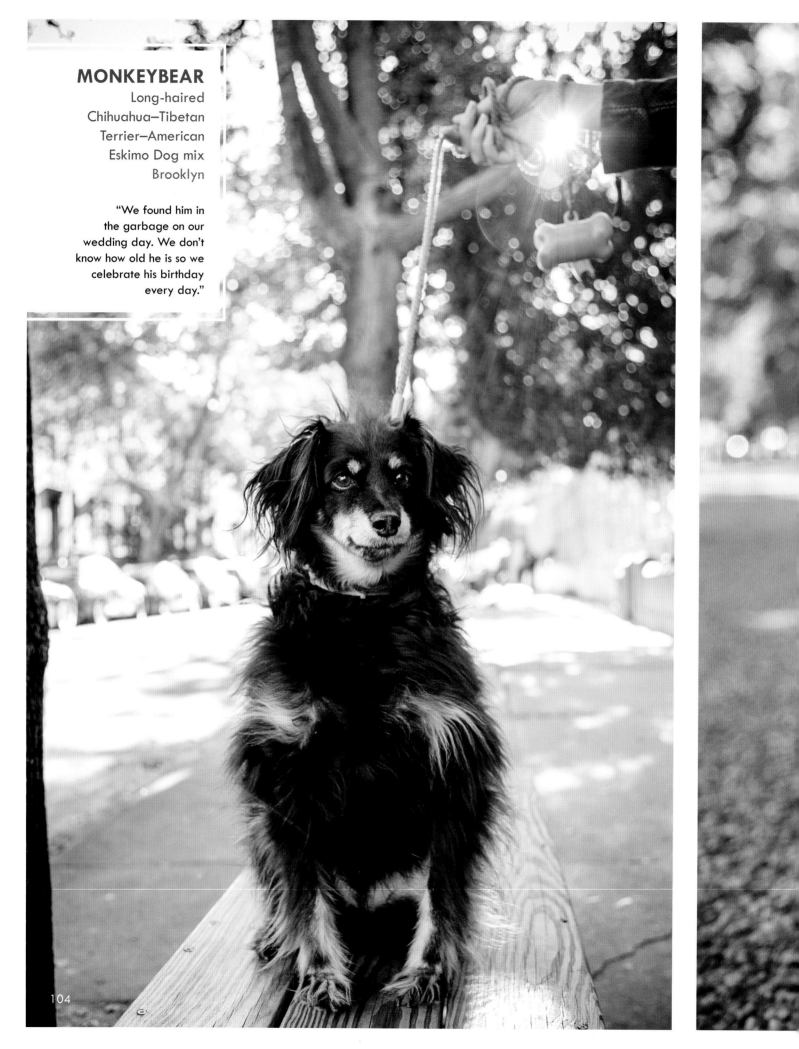

MONKEYBEAR
Long-haired
Chihuahua–Tibetan
Terrier–American
Eskimo Dog mix
Brooklyn

"We found him in
the garbage on our
wedding day. We don't
know how old he is so we
celebrate his birthday
every day."

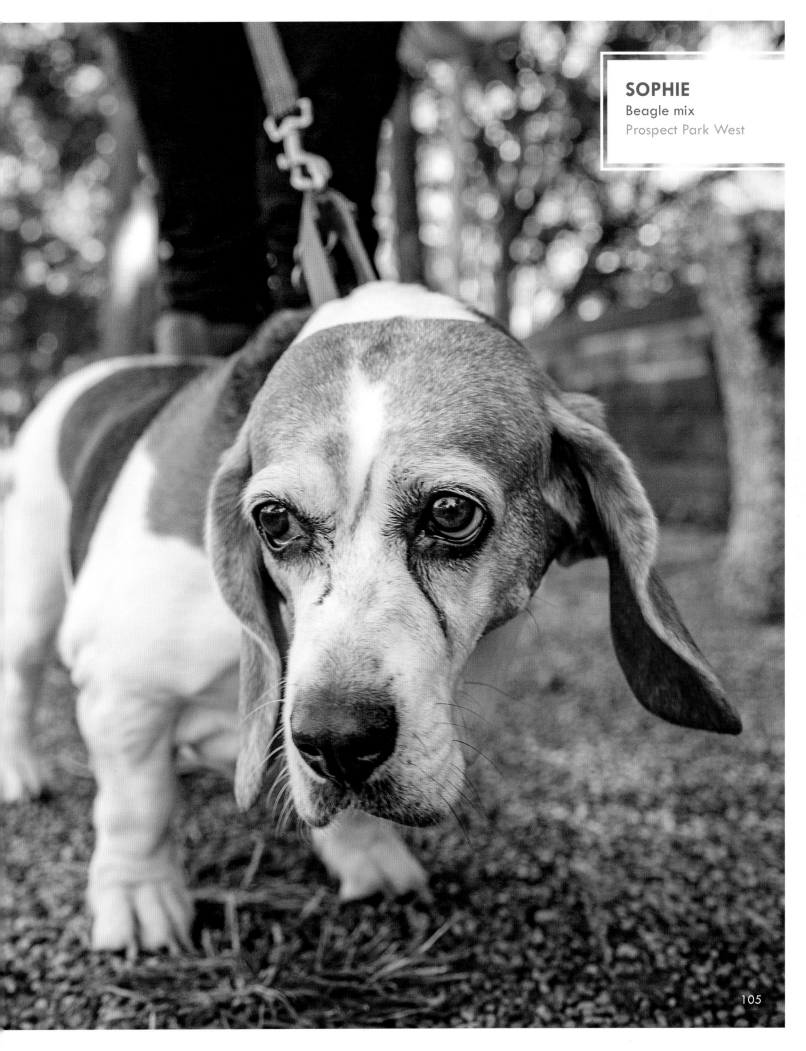

SOPHIE
Beagle mix
Prospect Park West

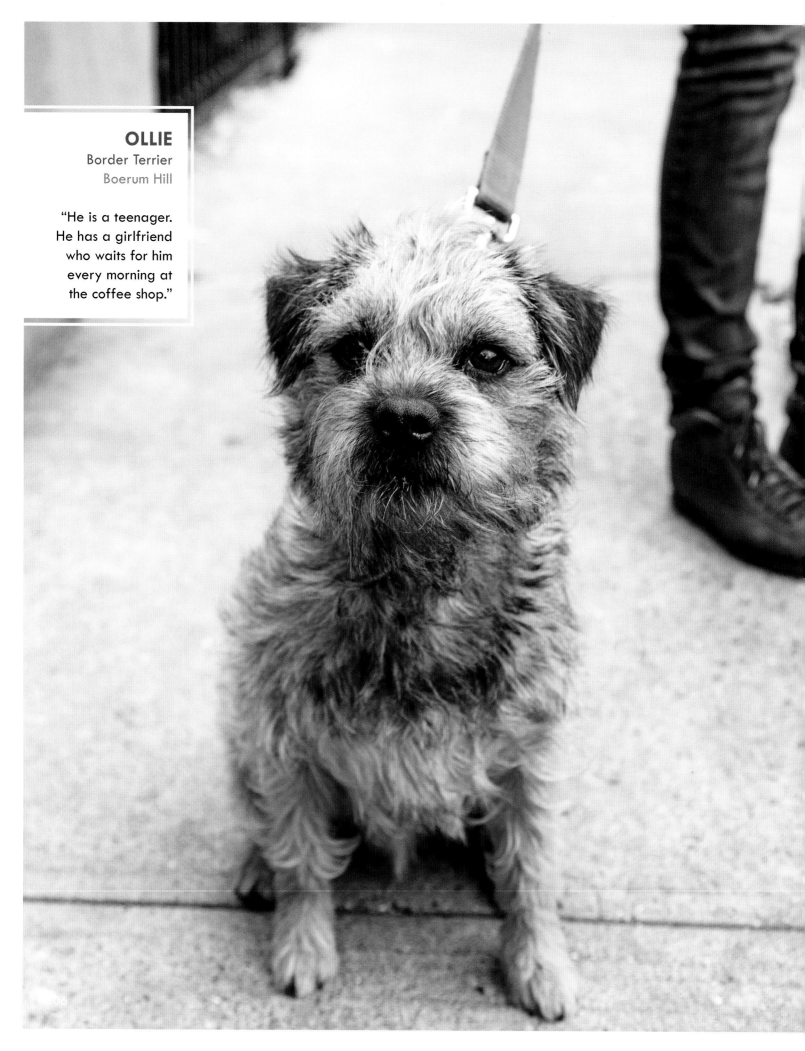

OLLIE
Border Terrier
Boerum Hill

"He is a teenager. He has a girlfriend who waits for him every morning at the coffee shop."

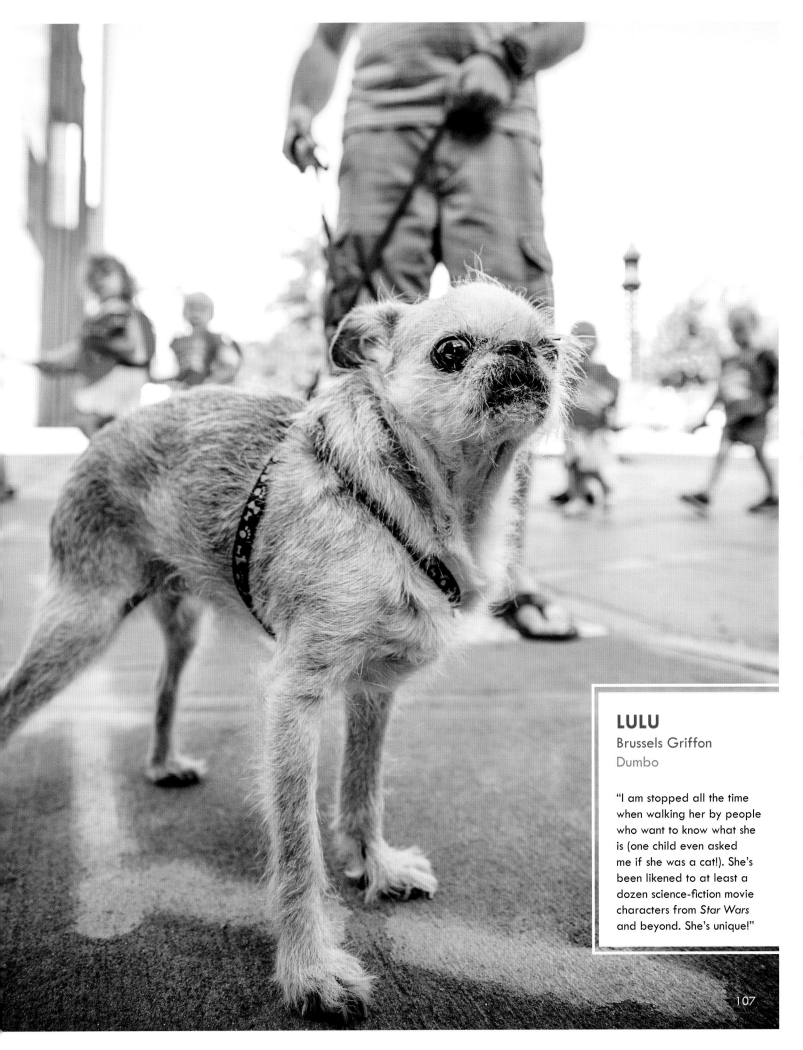

LULU
Brussels Griffon
Dumbo

"I am stopped all the time when walking her by people who want to know what she is (one child even asked me if she was a cat!). She's been likened to at least a dozen science-fiction movie characters from *Star Wars* and beyond. She's unique!"

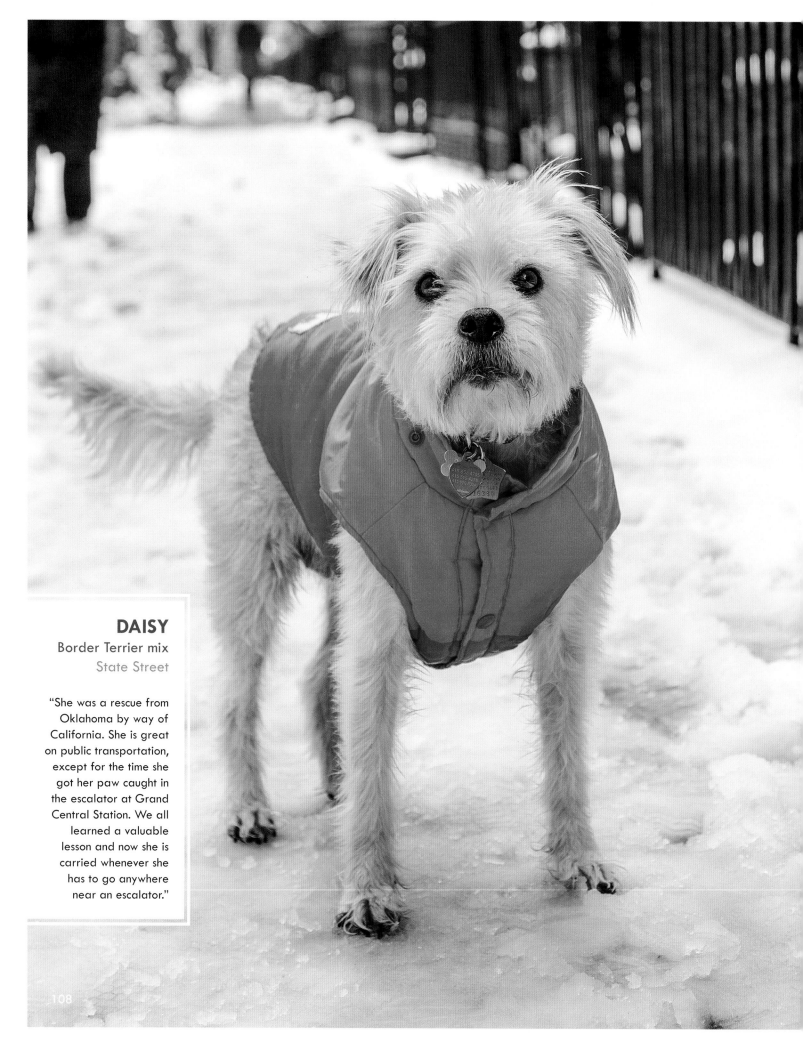

DAISY
Border Terrier mix
State Street

"She was a rescue from Oklahoma by way of California. She is great on public transportation, except for the time she got her paw caught in the escalator at Grand Central Station. We all learned a valuable lesson and now she is carried whenever she has to go anywhere near an escalator."

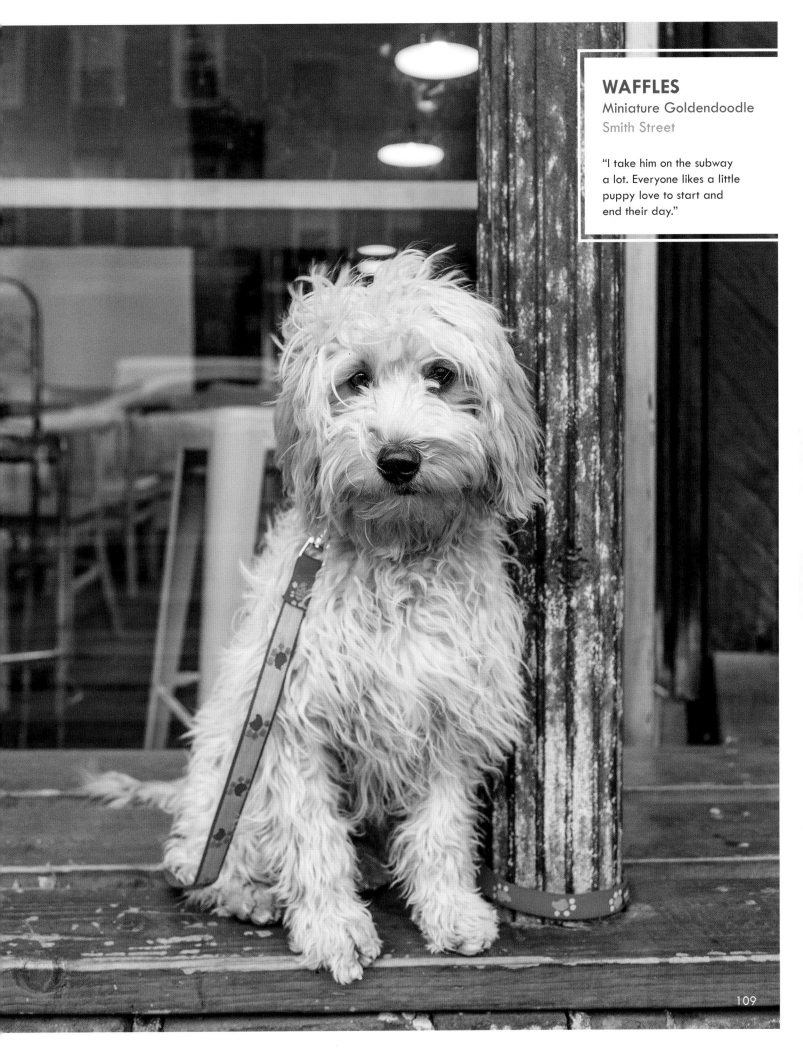

WAFFLES
Miniature Goldendoodle
Smith Street

"I take him on the subway a lot. Everyone likes a little puppy love to start and end their day."

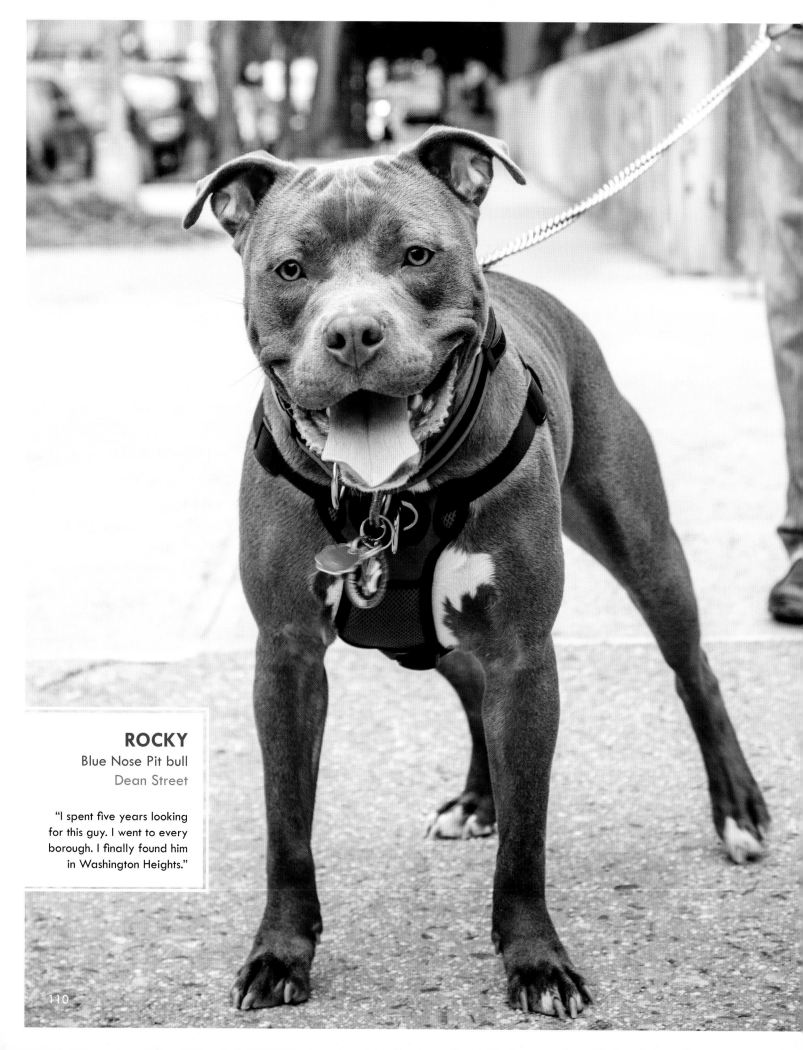

ROCKY
Blue Nose Pit bull
Dean Street

"I spent five years looking
for this guy. I went to every
borough. I finally found him
in Washington Heights."

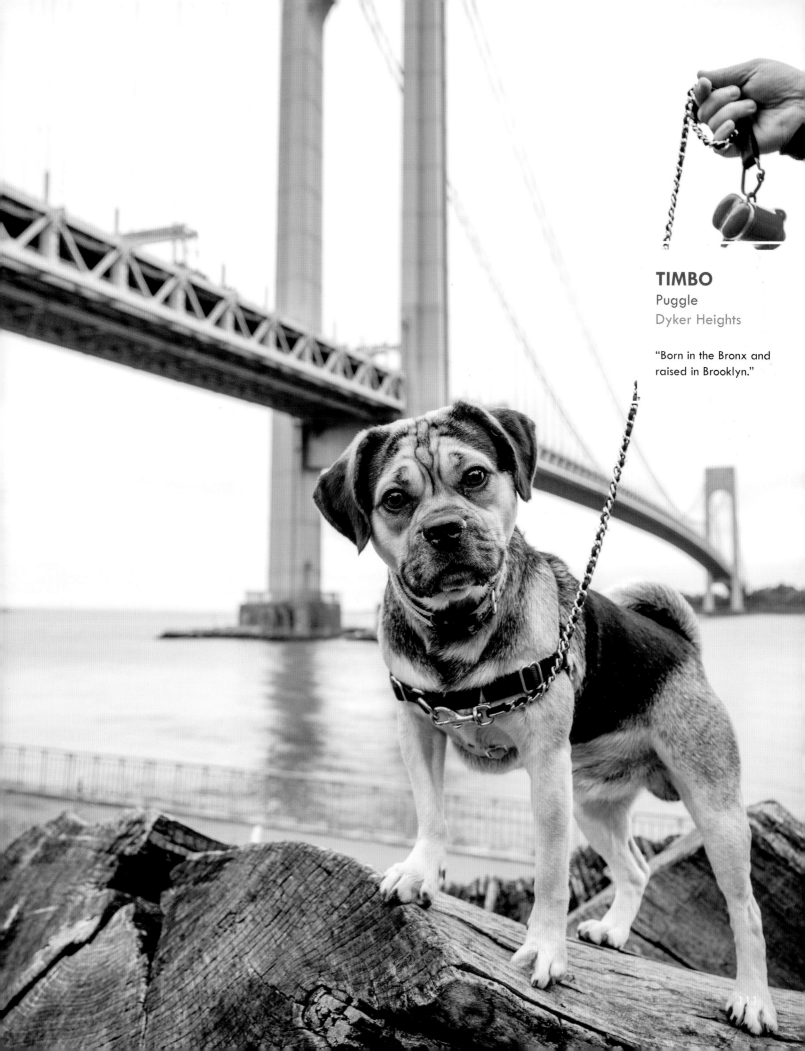

TIMBO
Puggle
Dyker Heights

"Born in the Bronx and raised in Brooklyn."

111

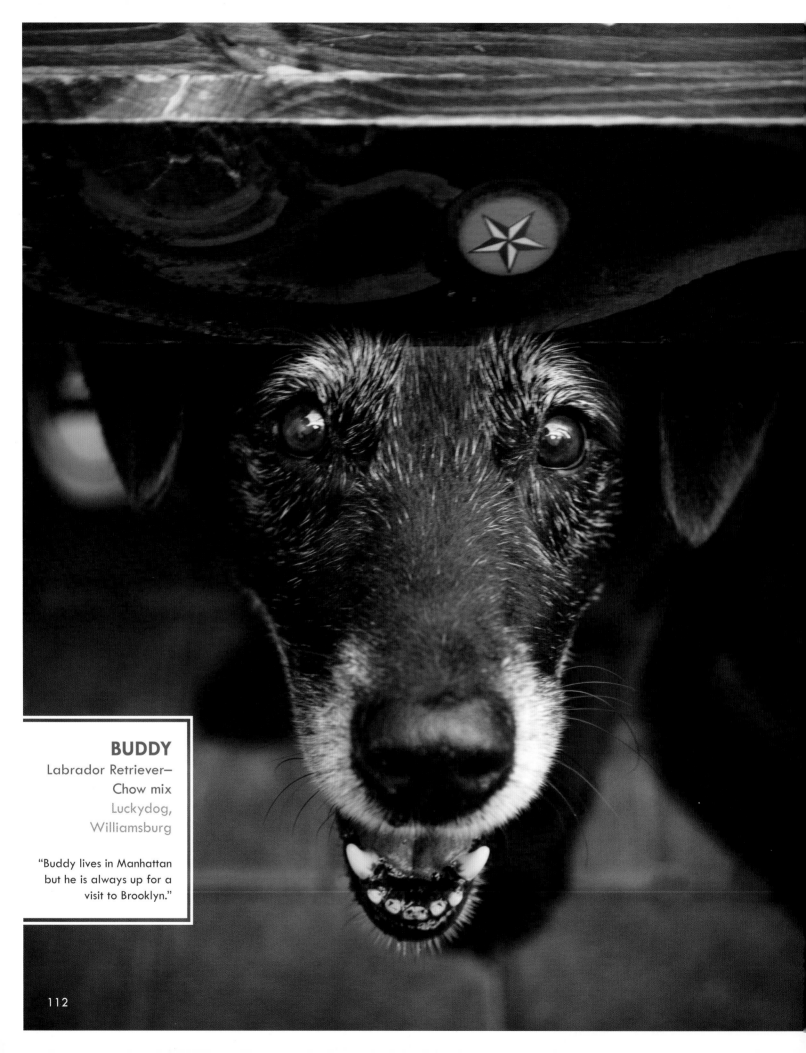

BUDDY
Labrador Retriever–
Chow mix
Luckydog,
Williamsburg

"Buddy lives in Manhattan but he is always up for a visit to Brooklyn."

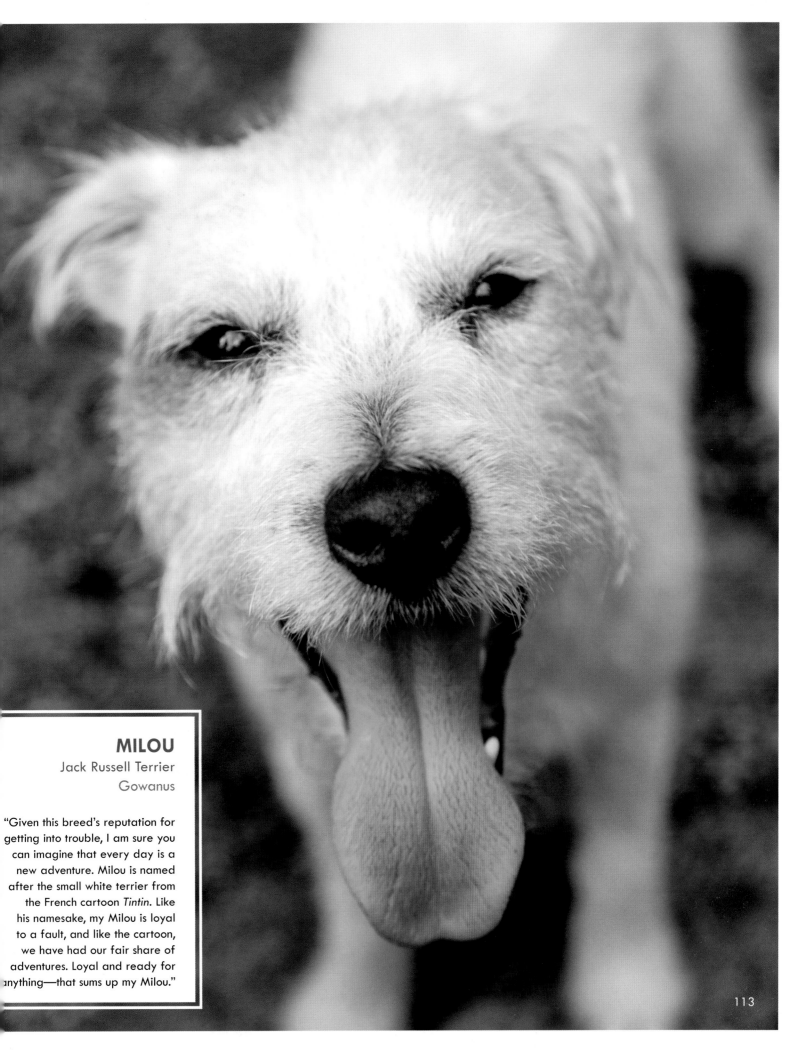

MILOU
Jack Russell Terrier
Gowanus

"Given this breed's reputation for getting into trouble, I am sure you can imagine that every day is a new adventure. Milou is named after the small white terrier from the French cartoon *Tintin*. Like his namesake, my Milou is loyal to a fault, and like the cartoon, we have had our fair share of adventures. Loyal and ready for anything—that sums up my Milou."

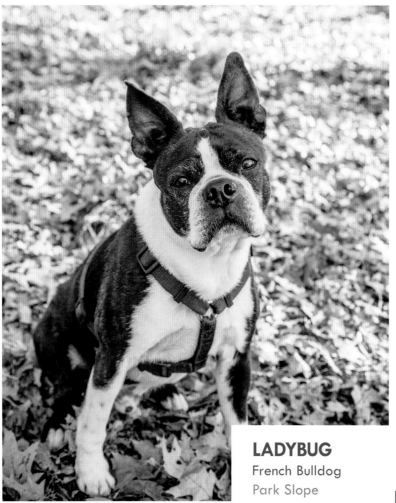

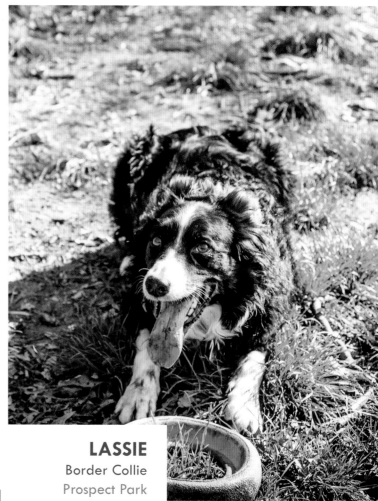

LADYBUG
French Bulldog
Park Slope

LASSIE
Border Collie
Prospect Park

HERSCHEL
German Shepherd
Cadman Plaza

BLEEKER
German Shepherd mix
Cadman Plaza

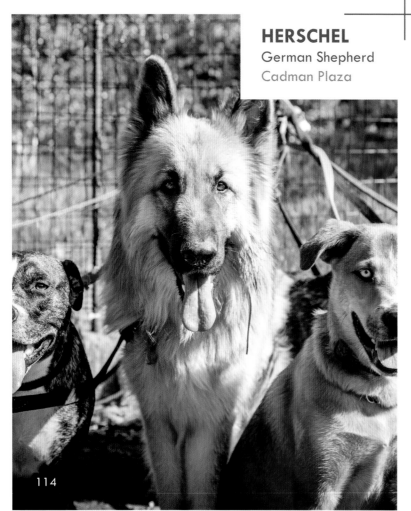

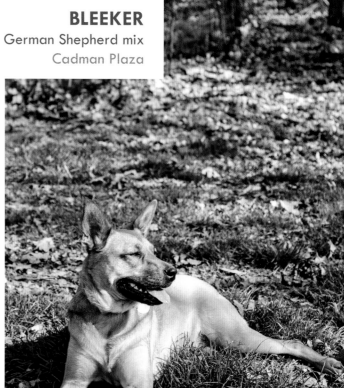

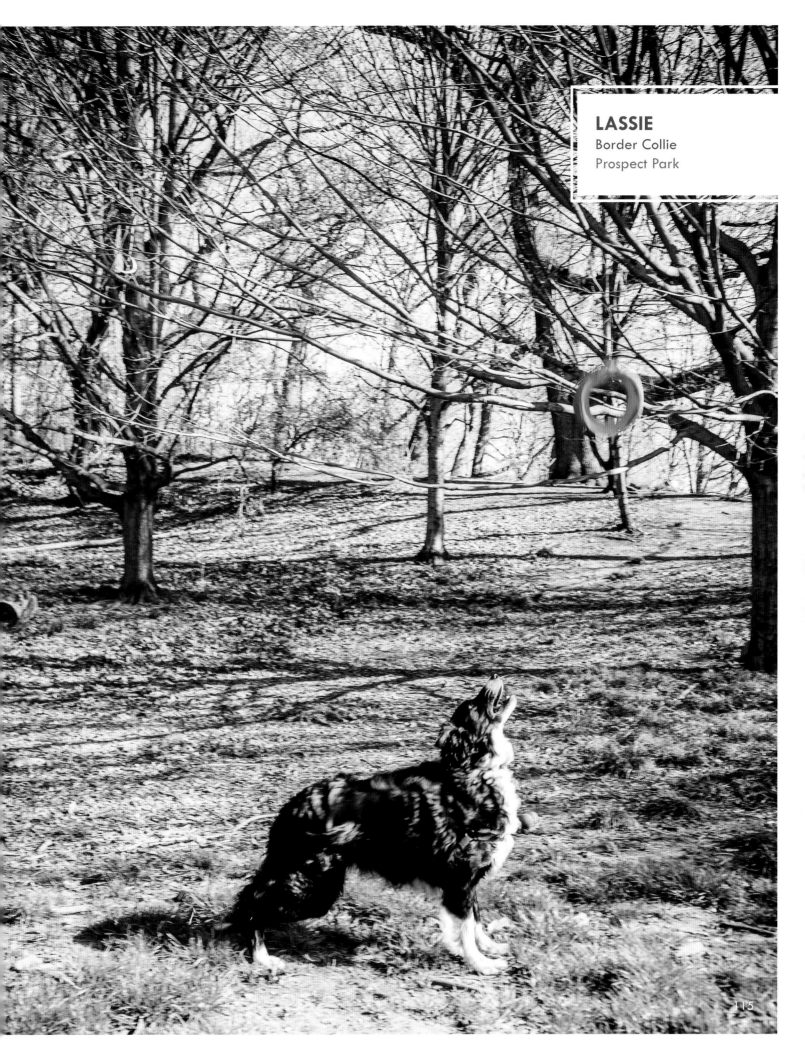

LASSIE
Border Collie
Prospect Park

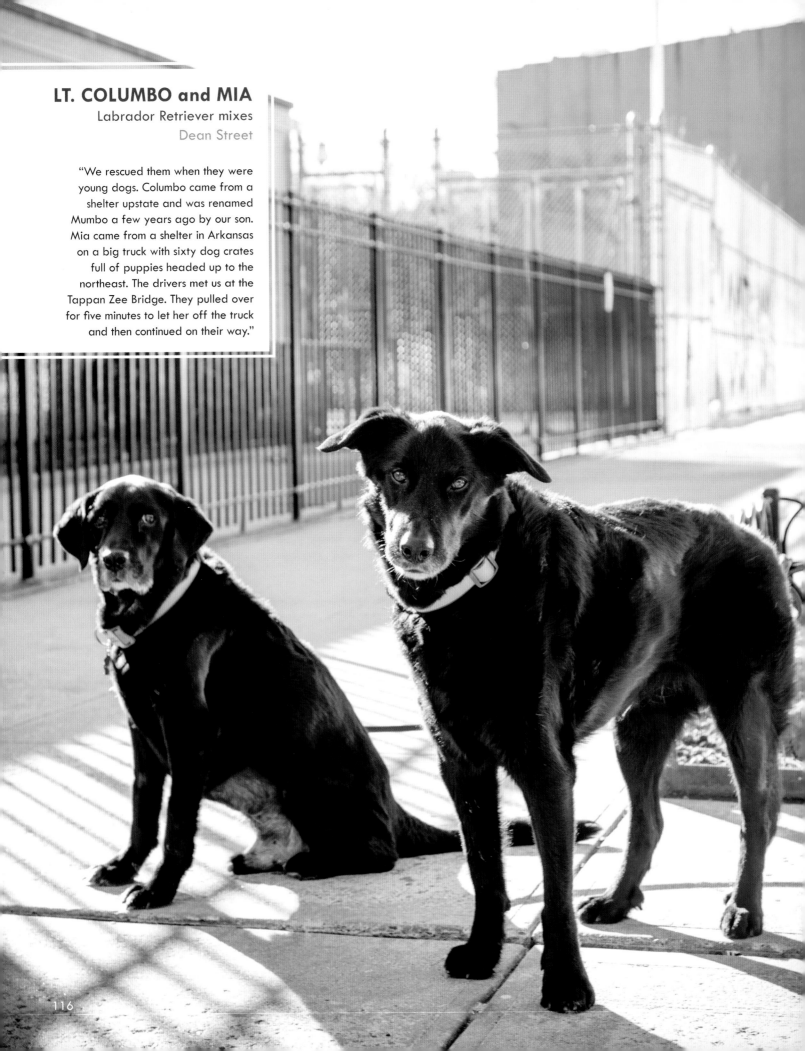

LT. COLUMBO and MIA
Labrador Retriever mixes
Dean Street

"We rescued them when they were young dogs. Columbo came from a shelter upstate and was renamed Mumbo a few years ago by our son. Mia came from a shelter in Arkansas on a big truck with sixty dog crates full of puppies headed up to the northeast. The drivers met us at the Tappan Zee Bridge. They pulled over for five minutes to let her off the truck and then continued on their way."

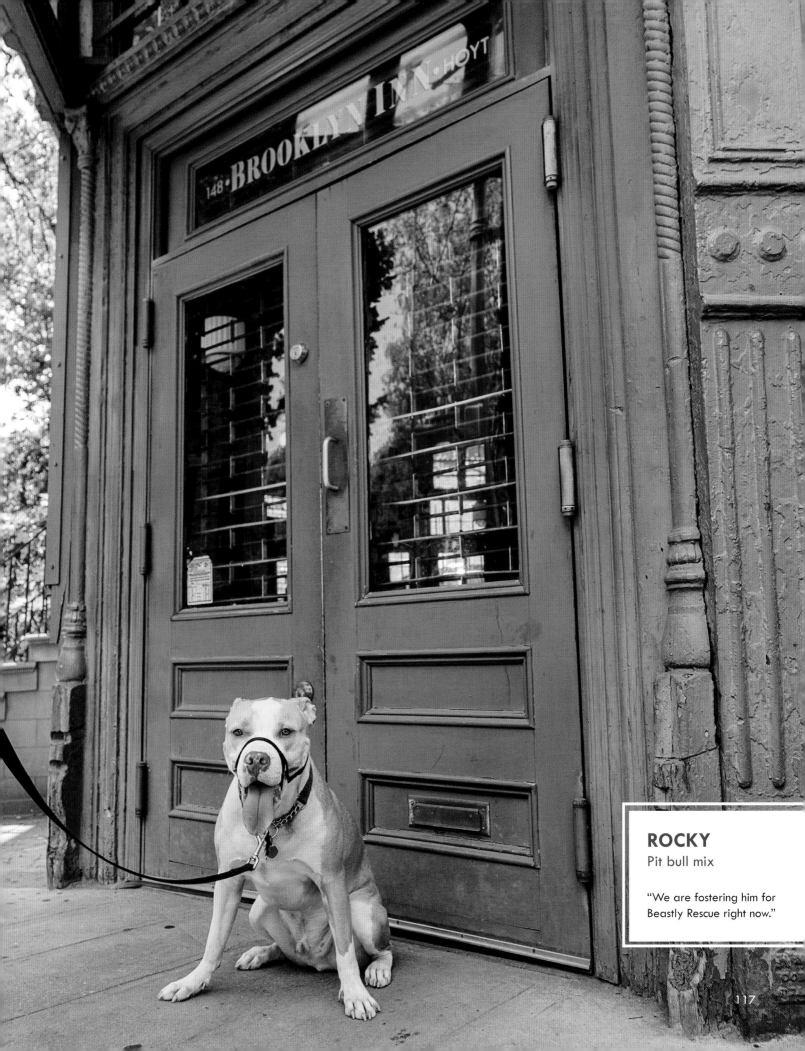

ROCKY
Pit bull mix

"We are fostering him for Beastly Rescue right now."

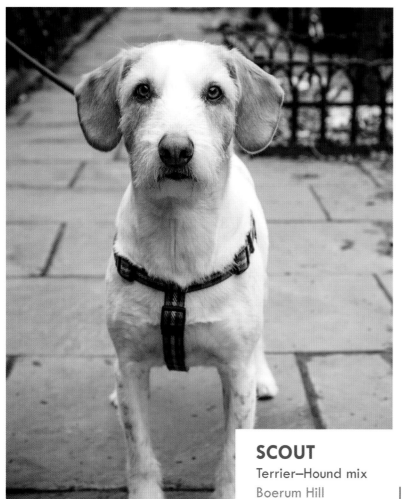

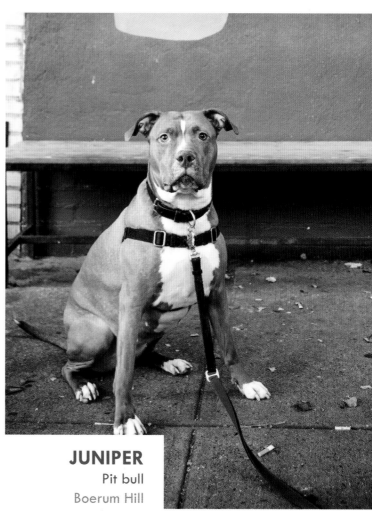

SCOUT
Terrier–Hound mix
Boerum Hill

JUNIPER
Pit bull
Boerum Hill

SKETCH
Mixed breed brindle
Downtown Brooklyn

MOLLY
Flat-Coated Retriever
Boerum Hill

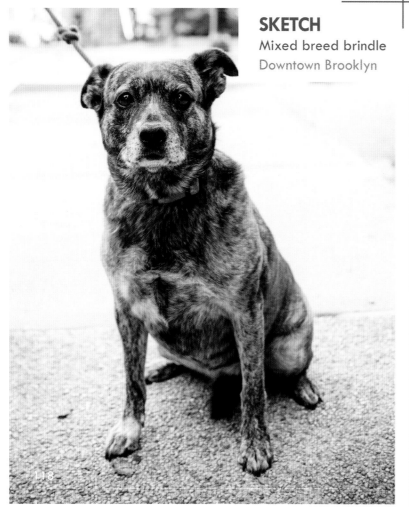

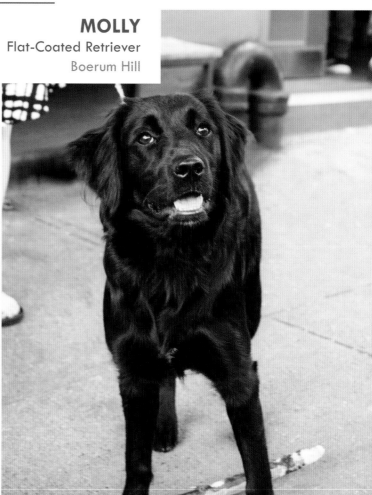

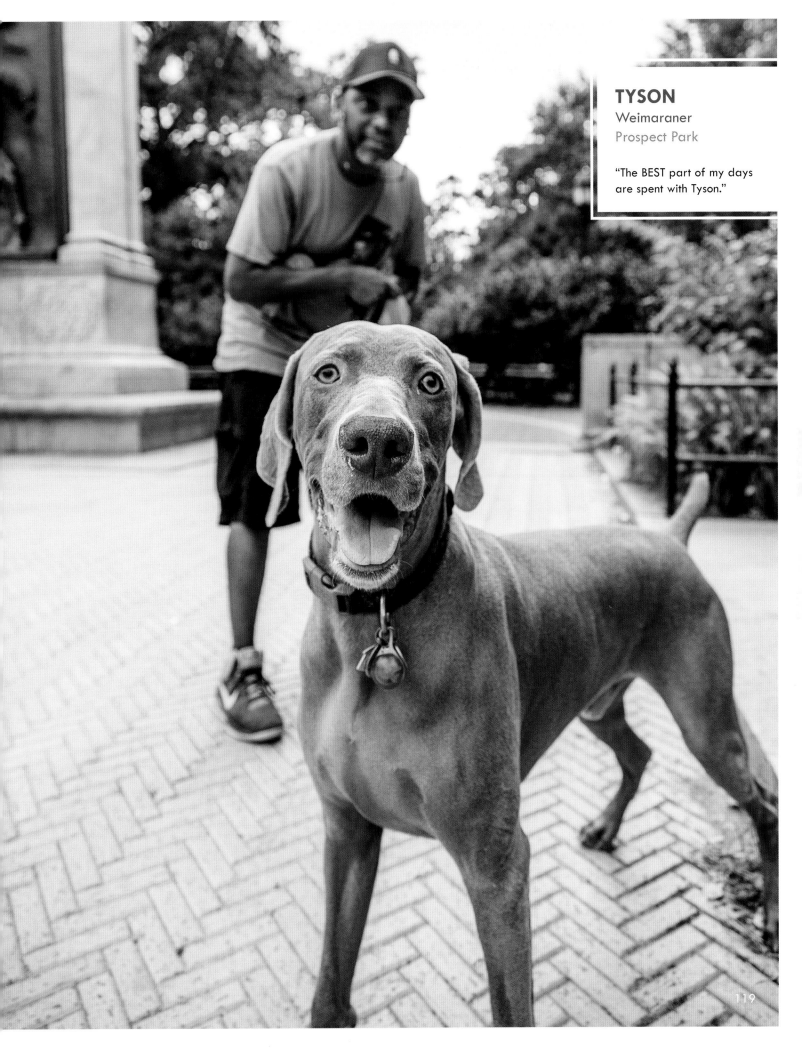

TYSON
Weimaraner
Prospect Park

"The BEST part of my days
are spent with Tyson."

119

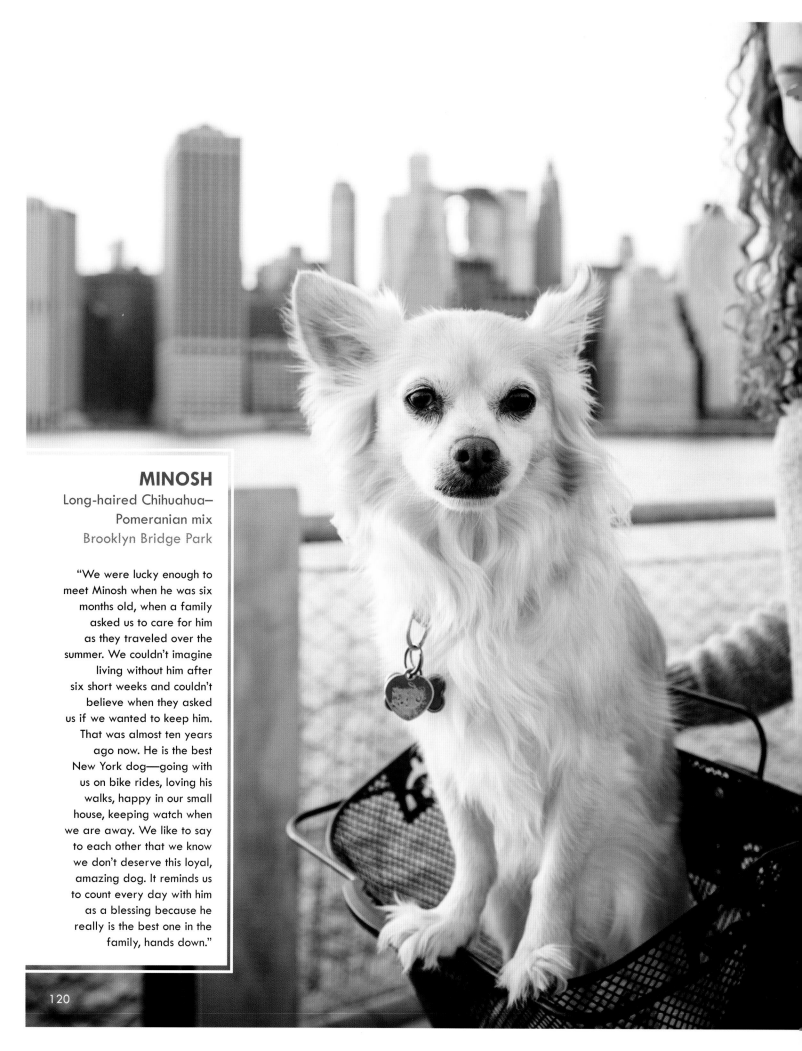

MINOSH

Long-haired Chihuahua–
Pomeranian mix
Brooklyn Bridge Park

"We were lucky enough to meet Minosh when he was six months old, when a family asked us to care for him as they traveled over the summer. We couldn't imagine living without him after six short weeks and couldn't believe when they asked us if we wanted to keep him. That was almost ten years ago now. He is the best New York dog—going with us on bike rides, loving his walks, happy in our small house, keeping watch when we are away. We like to say to each other that we know we don't deserve this loyal, amazing dog. It reminds us to count every day with him as a blessing because he really is the best one in the family, hands down."

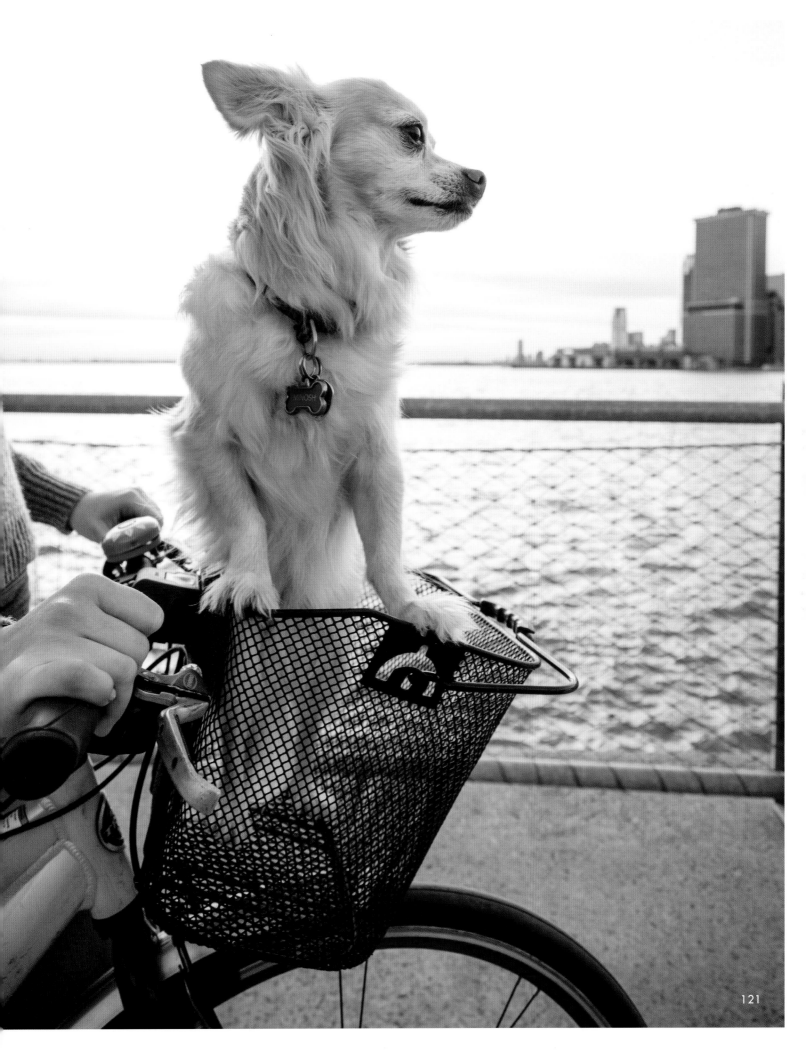

PETEY PARKER
Shih Tzu mix
MS 88

"Petey is our classroom comfort dog at MS 88 in Brooklyn. We got him from the Mutt-i-grees movement program at North Shore Animal League program. The kids love him."

SID
Shih Tzu–Maltese–Borzoi mix
Ditmas Park

"Sidney was my grandfather's name and I just really like it. He is a rescue from a kill shelter in Tennessee. He is a Shih Tzu–Maltese–Borzoi mix, which is a tough one to wrap your head around considering the dogs' size differences, but that's what the DNA test said."

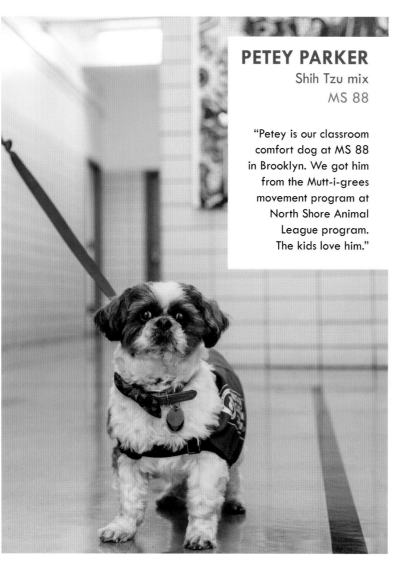

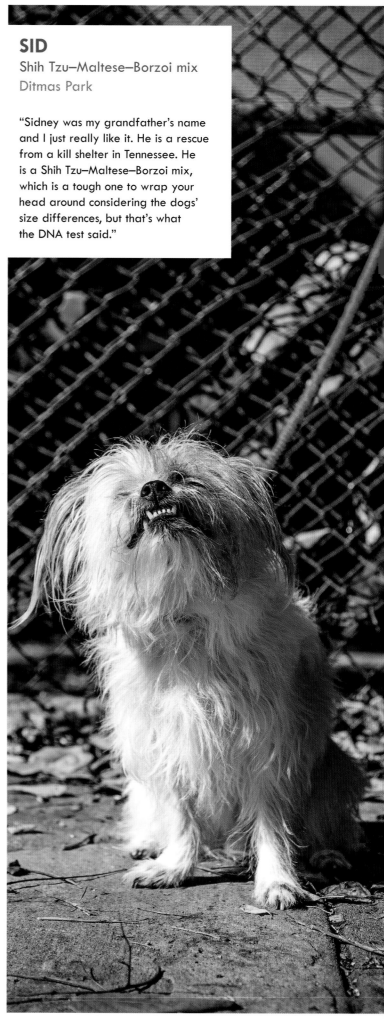

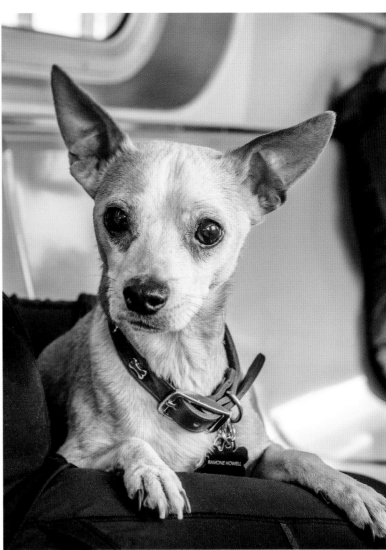

RAMONE
Rat Terrier–Chihuahua mix
On the subway

"Ramone is like me, he doesn't like the subway so much! He is a bit of a neurotic dog and doesn't do very well in big groups of people, so it's interesting to watch him watch people. After a while he tucks his head down and takes a nap until we get off."

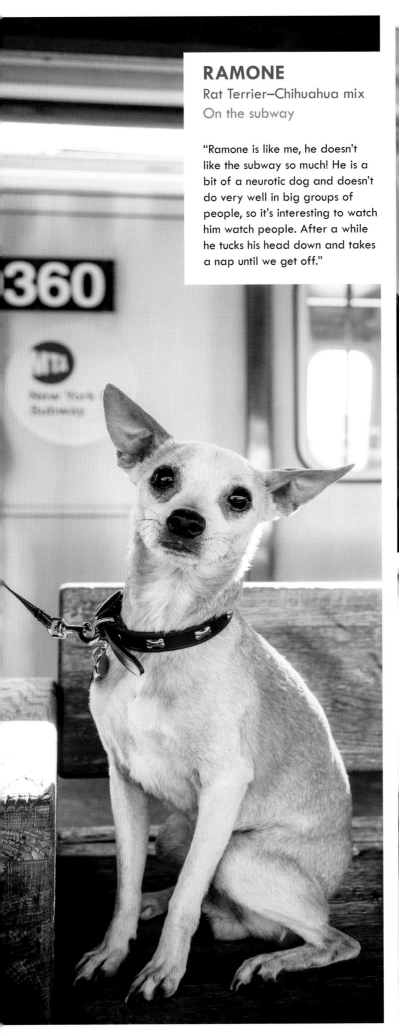

123

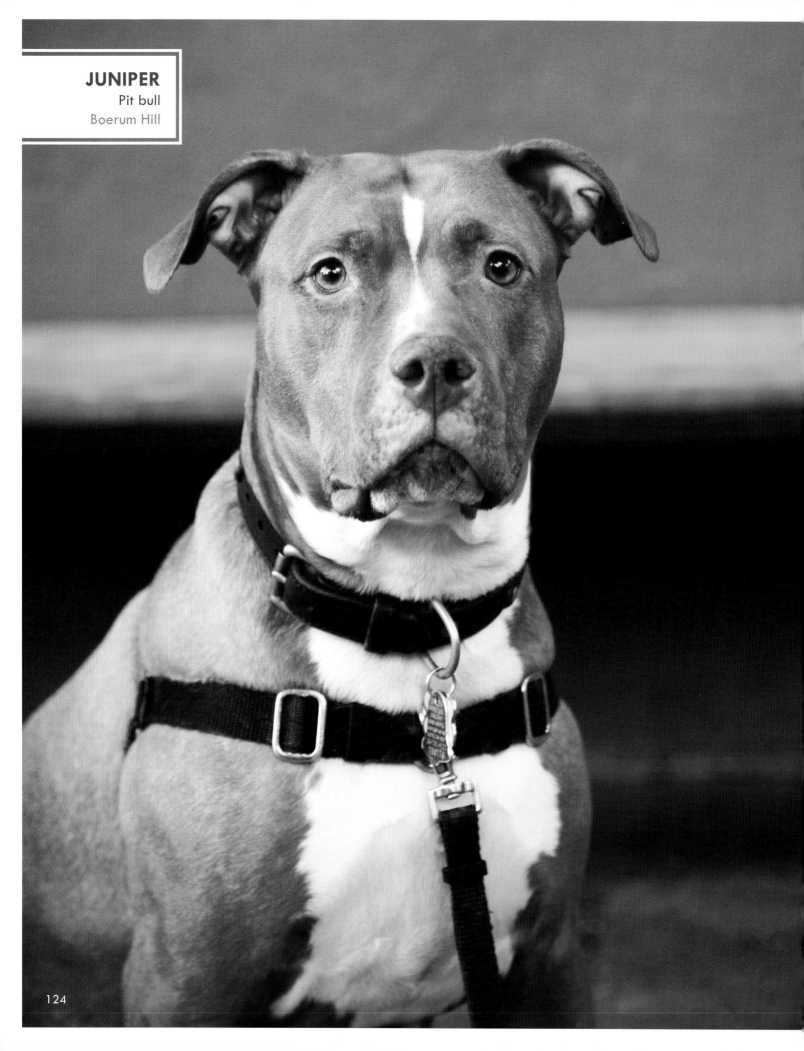

JUNIPER
Pit bull
Boerum Hill

124

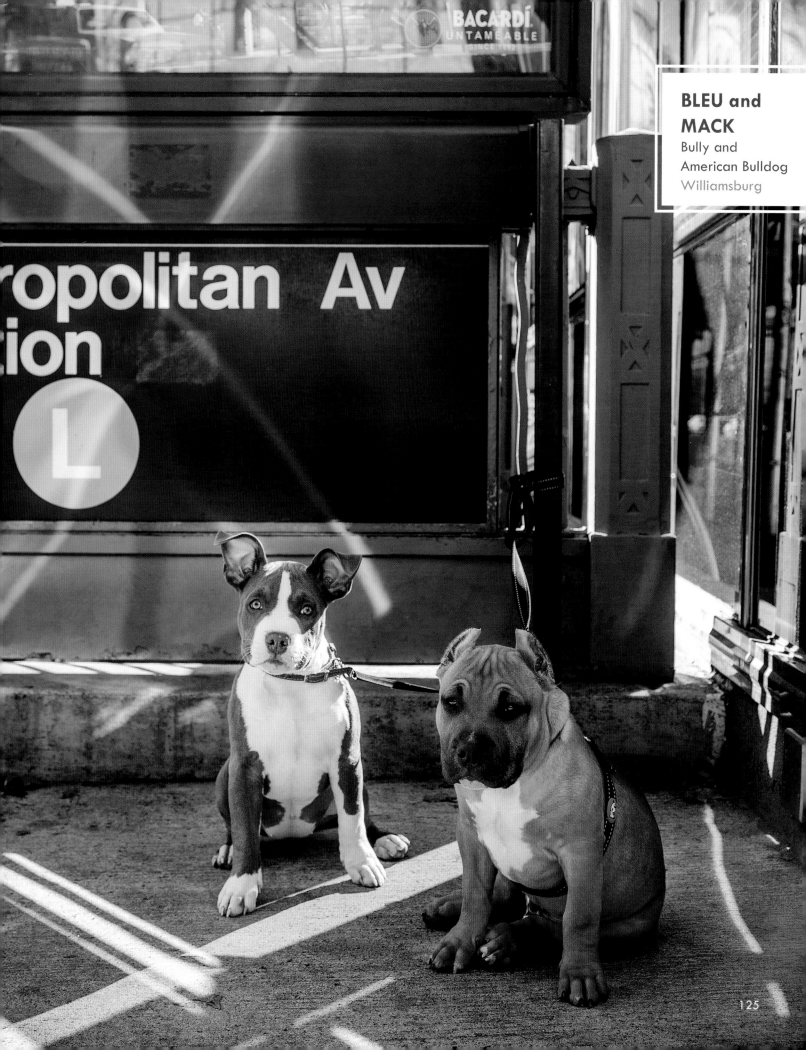

**BLEU and
MACK**
Bully and
American Bulldog
Williamsburg

ropolitan Av
tion

Ⓛ

QUEENS

"Queens, New York. The most ethnically diverse region not just in the United States, but on the entire planet . . . Not a melting pot, not even a tossed salad, but an all-you-can-eat, mix-and-match buffet."

—Victor LaValle, *The Devil in Silver* (2012)

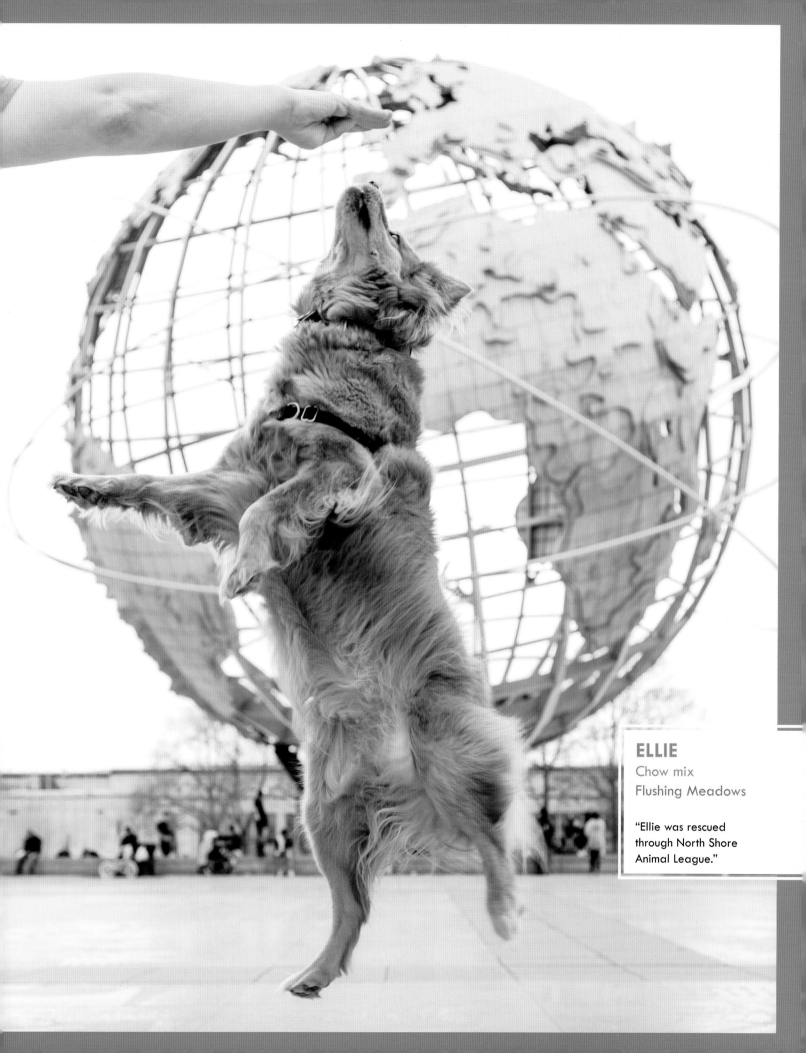

ELLIE
Chow mix
Flushing Meadows

"Ellie was rescued
through North Shore
Animal League."

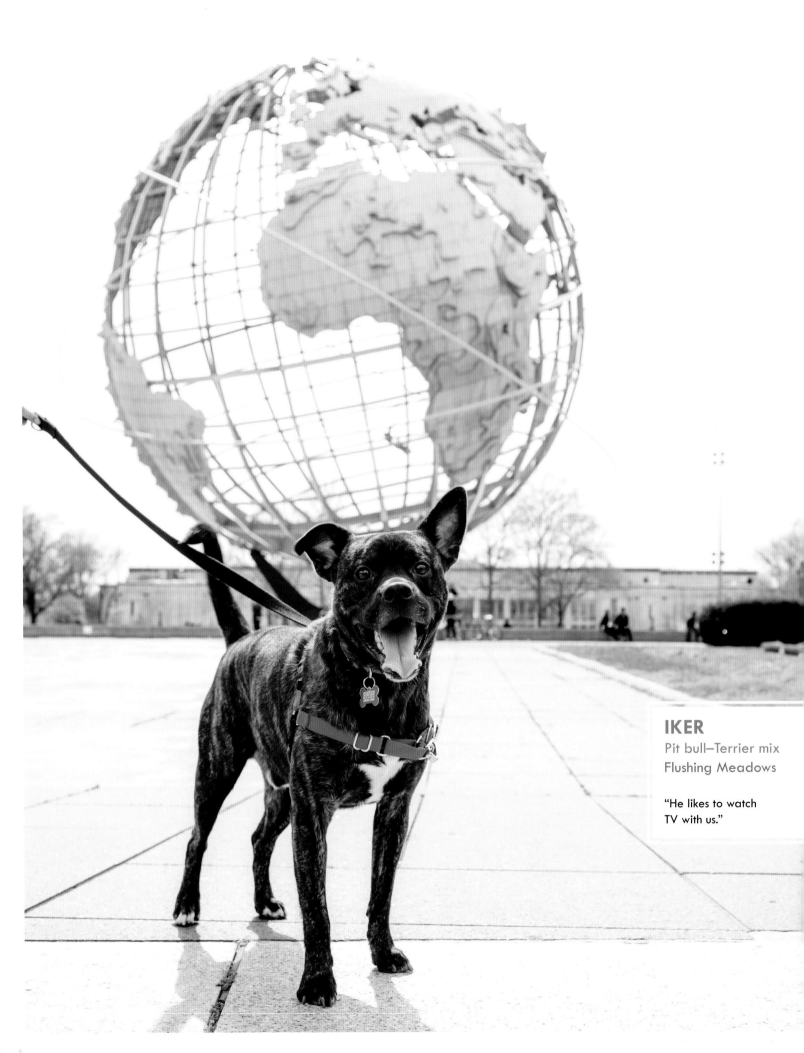

IKER
Pit bull–Terrier mix
Flushing Meadows

"He likes to watch
TV with us."

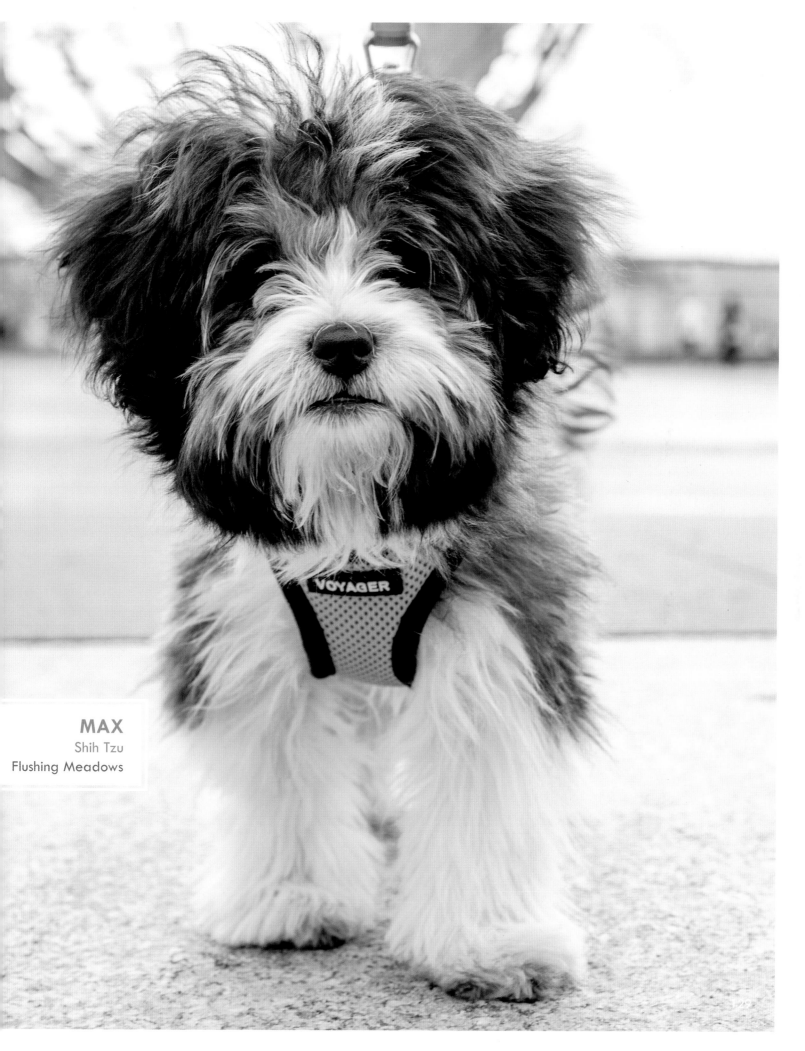

MAX
Shih Tzu
Flushing Meadows

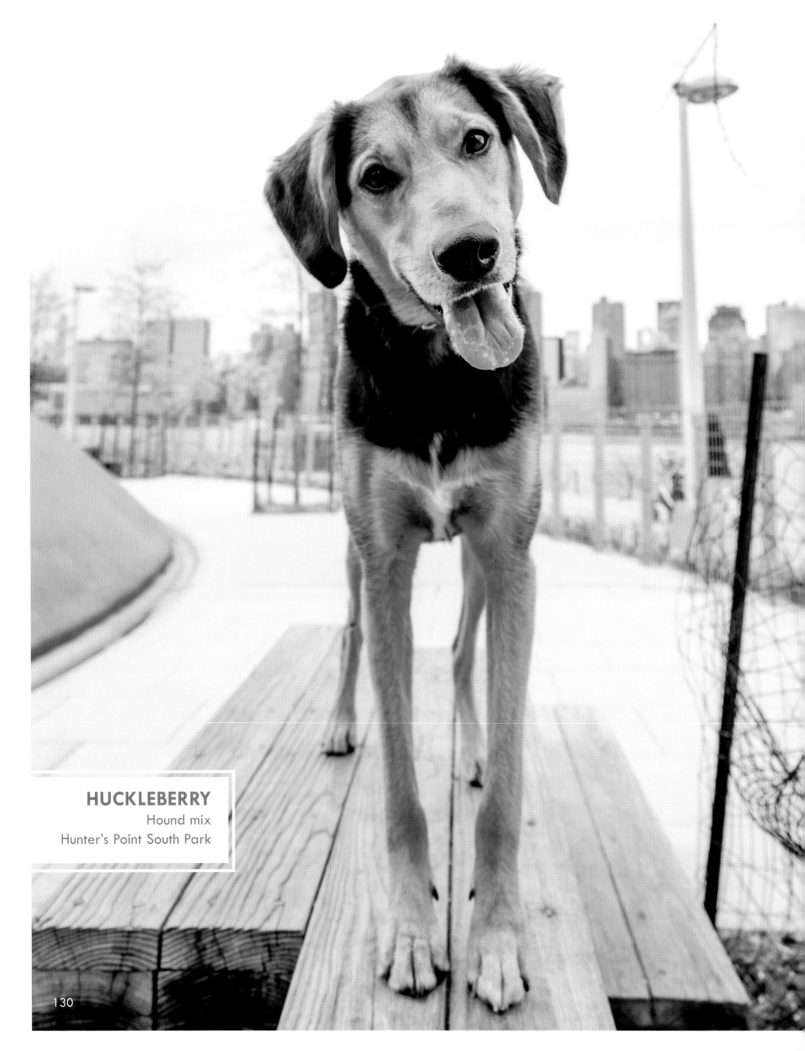

HUCKLEBERRY
Hound mix
Hunter's Point South Park

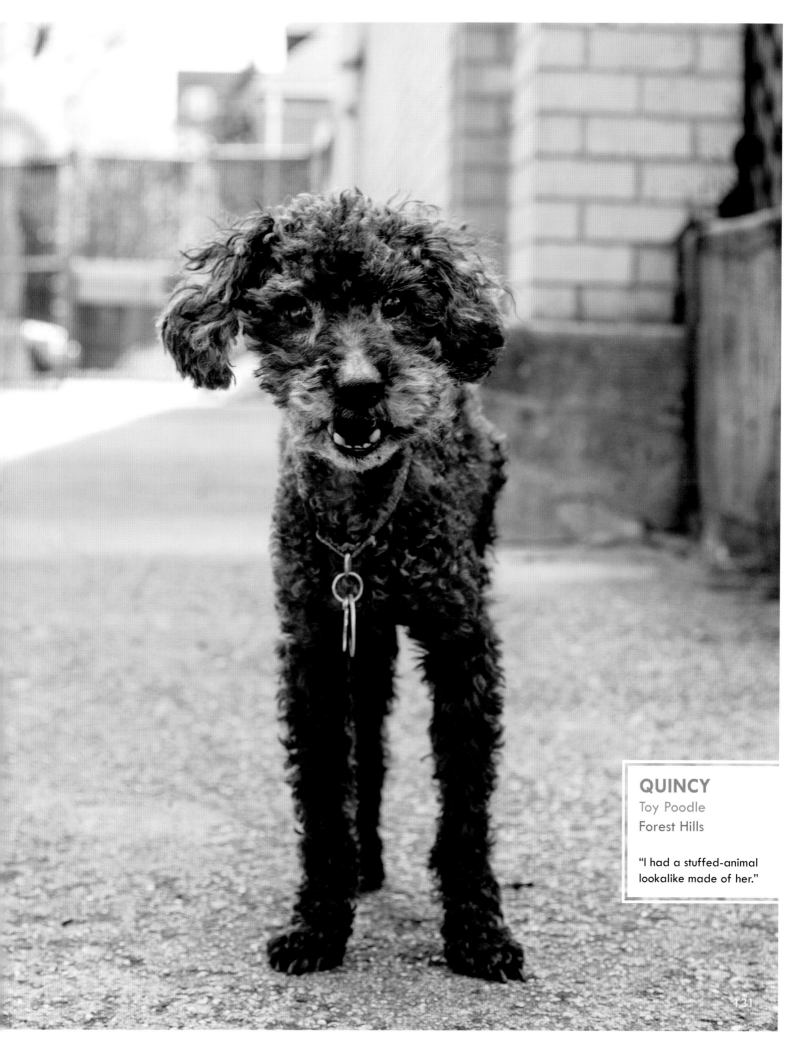

QUINCY
Toy Poodle
Forest Hills

"I had a stuffed-animal lookalike made of her."

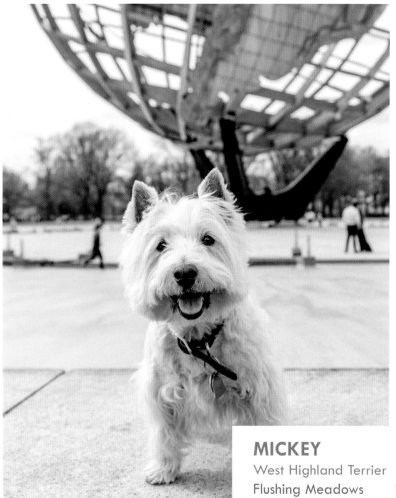

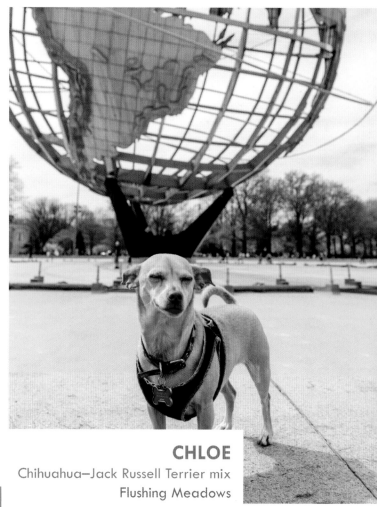

MICKEY
West Highland Terrier
Flushing Meadows

CHLOE
Chihuahua–Jack Russell Terrier mix
Flushing Meadows

DJ
Yorkshire Terrier
Flushing Meadows

TONY
Pit bull
Flushing Meadows

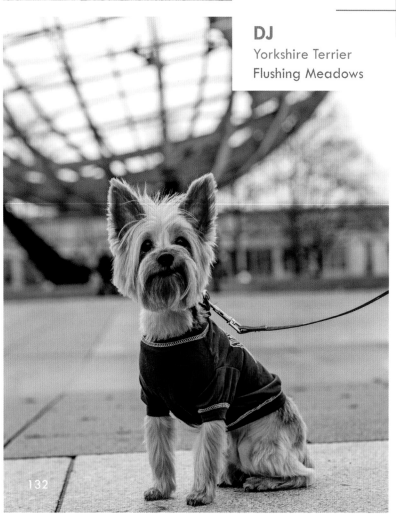

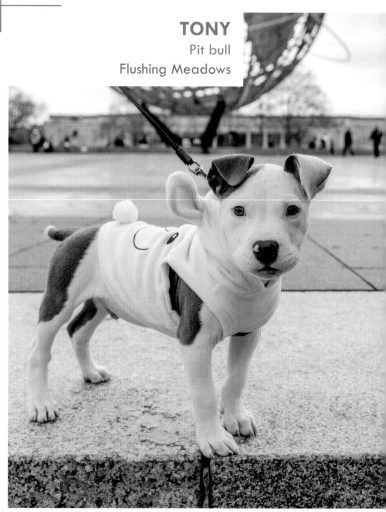

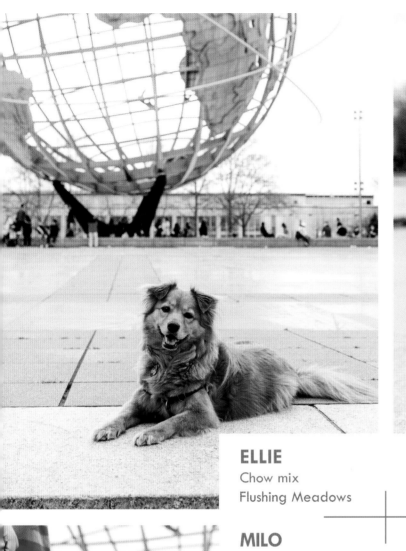

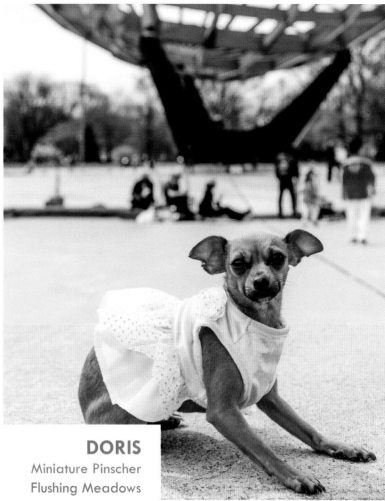

ELLIE
Chow mix
Flushing Meadows

DORIS
Miniature Pinscher
Flushing Meadows

MILO
French Poodle
Flushing Meadows

QUEVIN
Shih Tzu–Chihuahua mix
Flushing Meadows

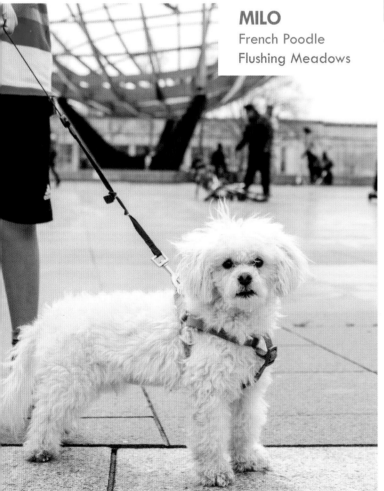

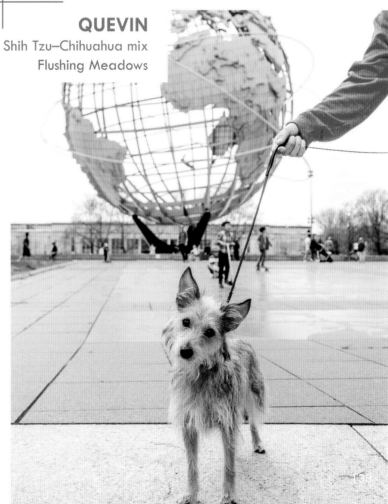

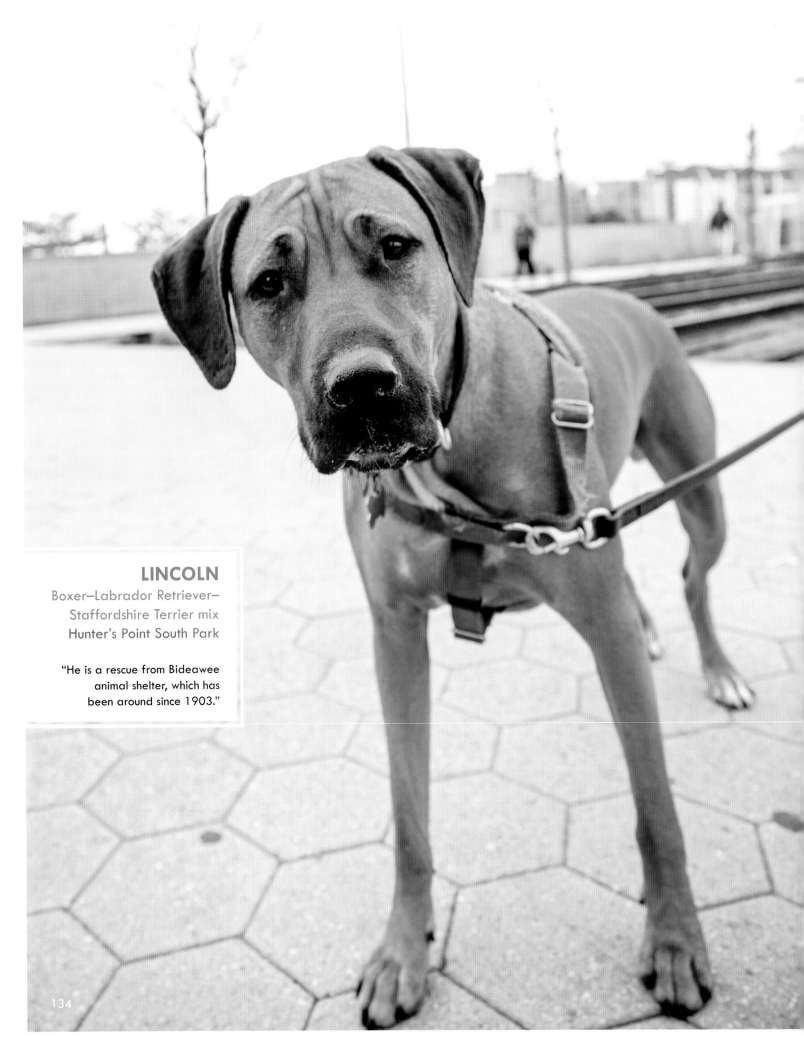

LINCOLN
Boxer–Labrador Retriever–
Staffordshire Terrier mix
Hunter's Point South Park

"He is a rescue from Bideawee
animal shelter, which has
been around since 1903."

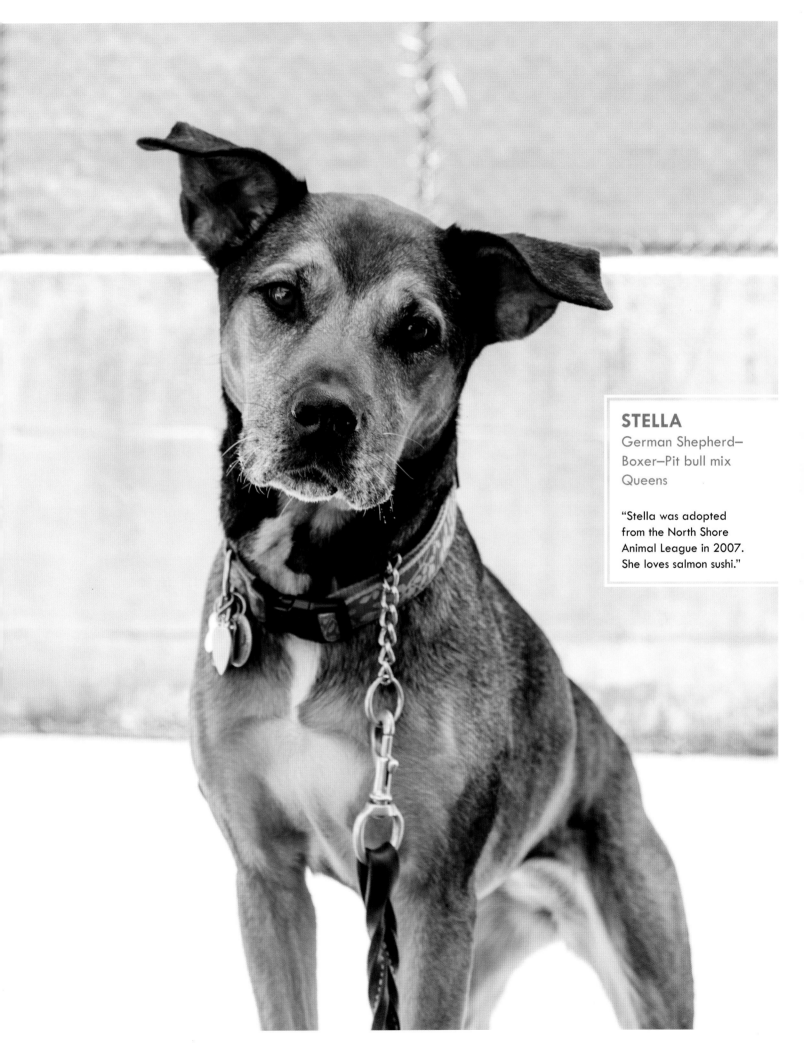

STELLA
German Shepherd–
Boxer–Pit bull mix
Queens

"Stella was adopted
from the North Shore
Animal League in 2007.
She loves salmon sushi."

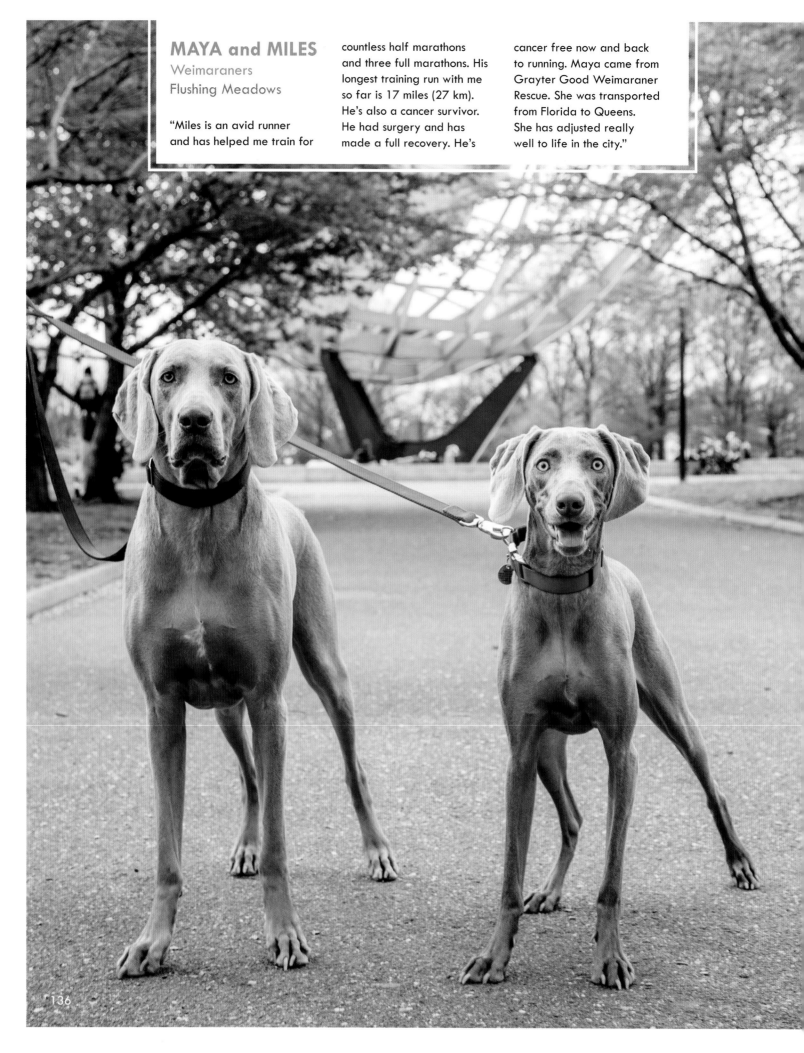

MAYA and MILES
Weimaraners
Flushing Meadows

"Miles is an avid runner and has helped me train for countless half marathons and three full marathons. His longest training run with me so far is 17 miles (27 km). He's also a cancer survivor. He had surgery and has made a full recovery. He's cancer free now and back to running. Maya came from Grayter Good Weimaraner Rescue. She was transported from Florida to Queens. She has adjusted really well to life in the city."

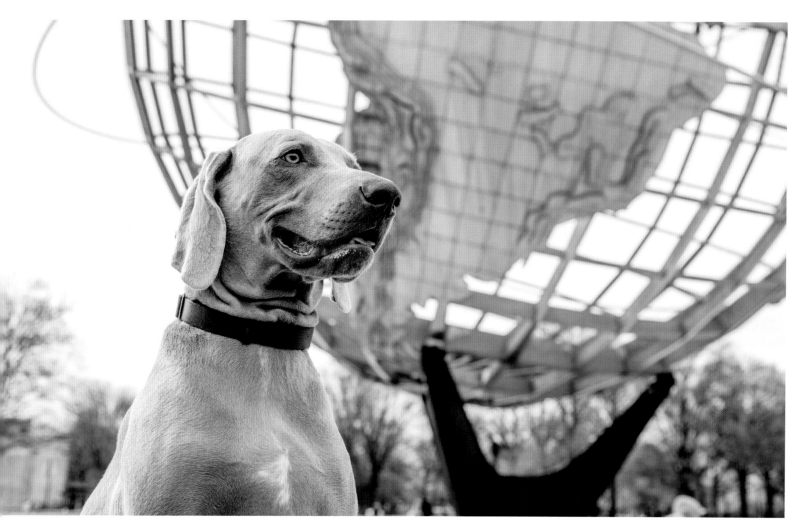

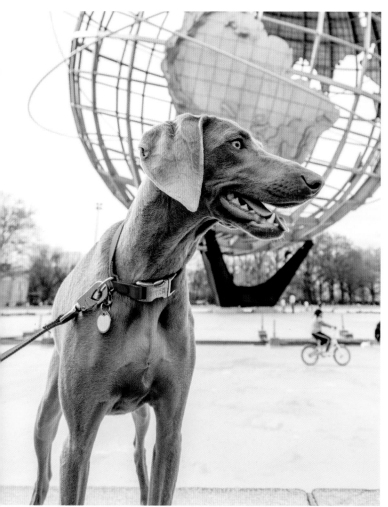

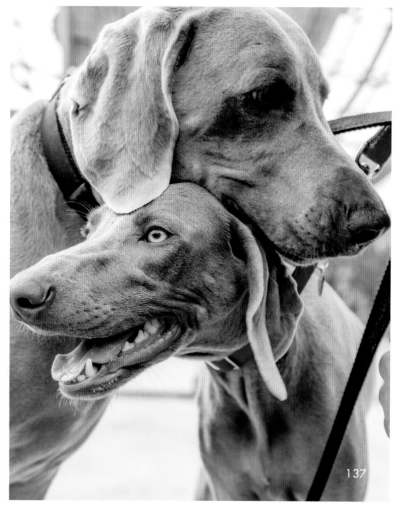

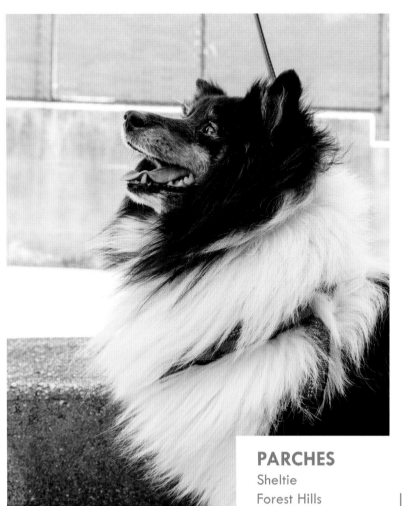

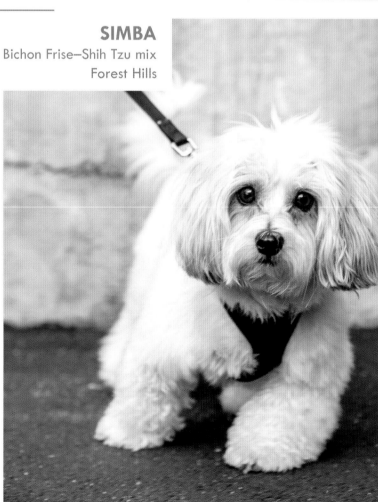

PARCHES
Sheltie
Forest Hills

ELLIE
Black Mouth Cur
Forest Hills

LILY
Cavachon
Forest Hills

SIMBA
Bichon Frise–Shih Tzu mix
Forest Hills

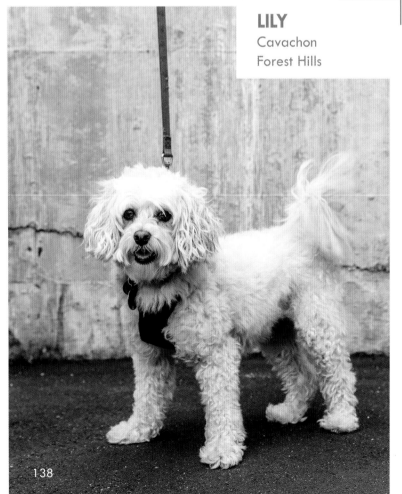

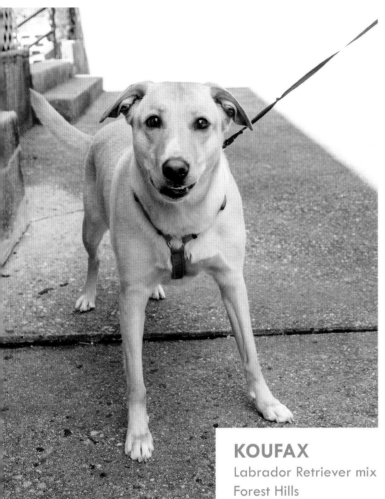

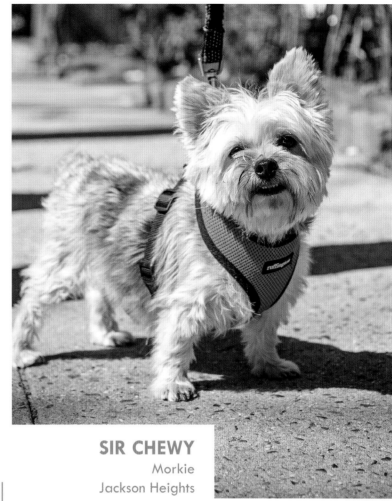

KOUFAX
Labrador Retriever mix
Forest Hills

SIR CHEWY
Morkie
Jackson Heights

CANDY
Poodle mix
Forest Hills

STELLA
Shepherd–Pit bull–Boxer mix
Forest Hills

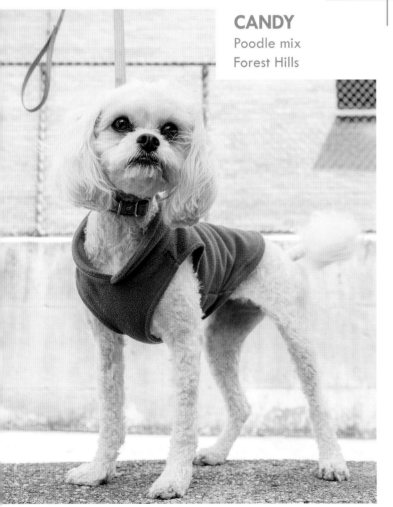

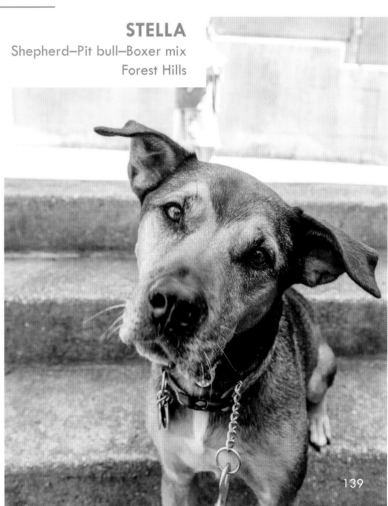

139

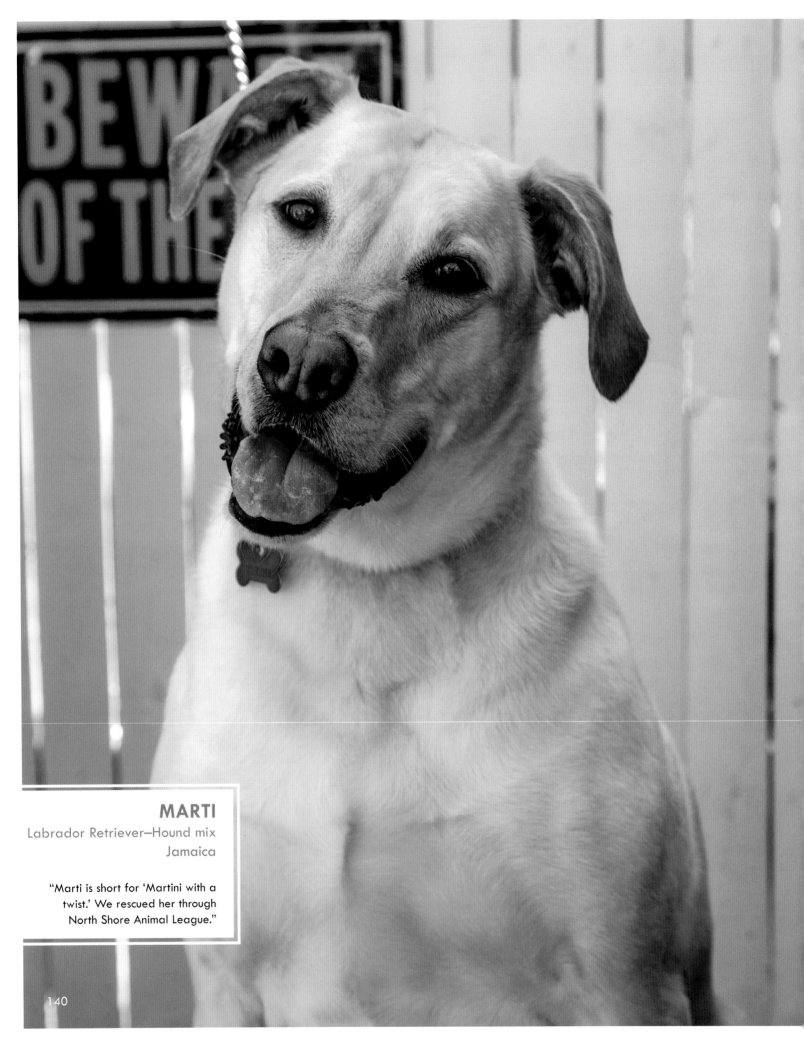

MARTI
Labrador Retriever–Hound mix
Jamaica

"Marti is short for 'Martini with a twist.' We rescued her through North Shore Animal League."

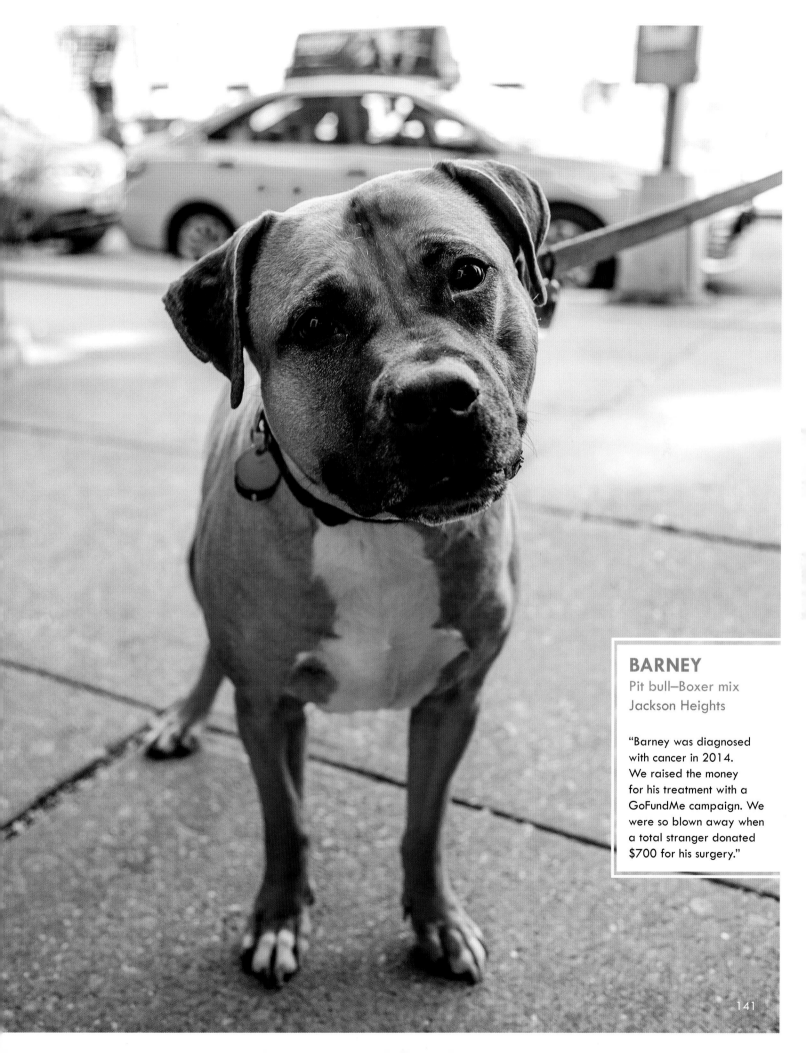

BARNEY
Pit bull–Boxer mix
Jackson Heights

"Barney was diagnosed with cancer in 2014. We raised the money for his treatment with a GoFundMe campaign. We were so blown away when a total stranger donated $700 for his surgery."

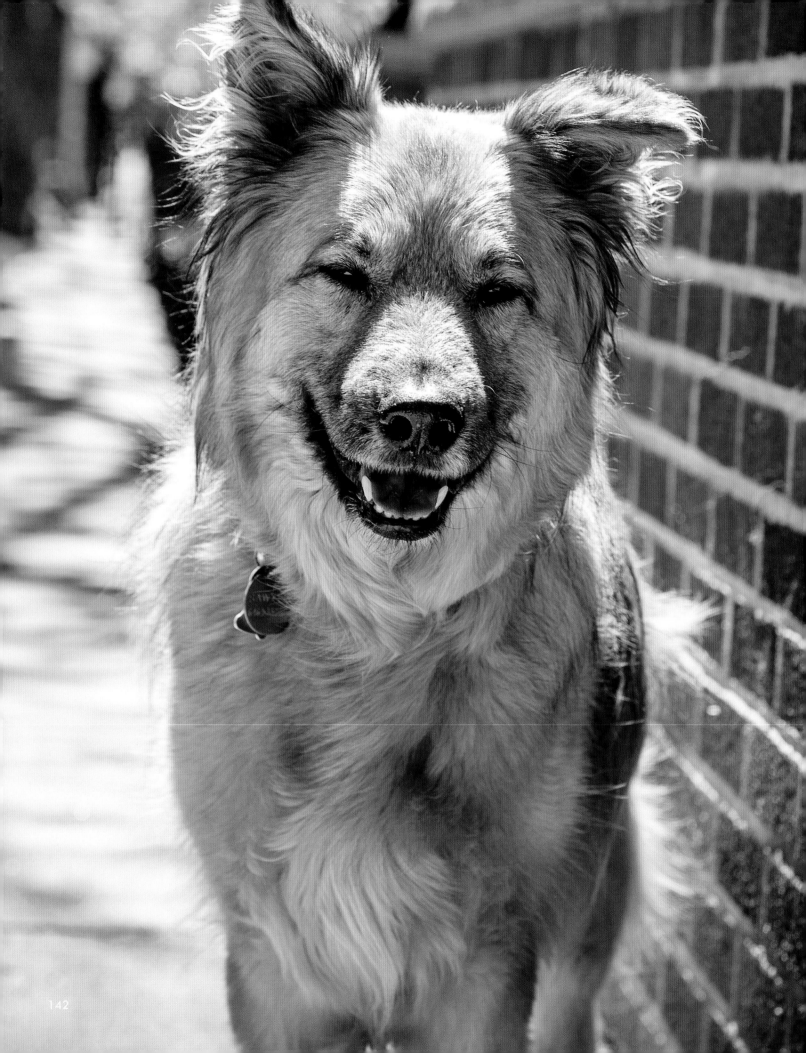

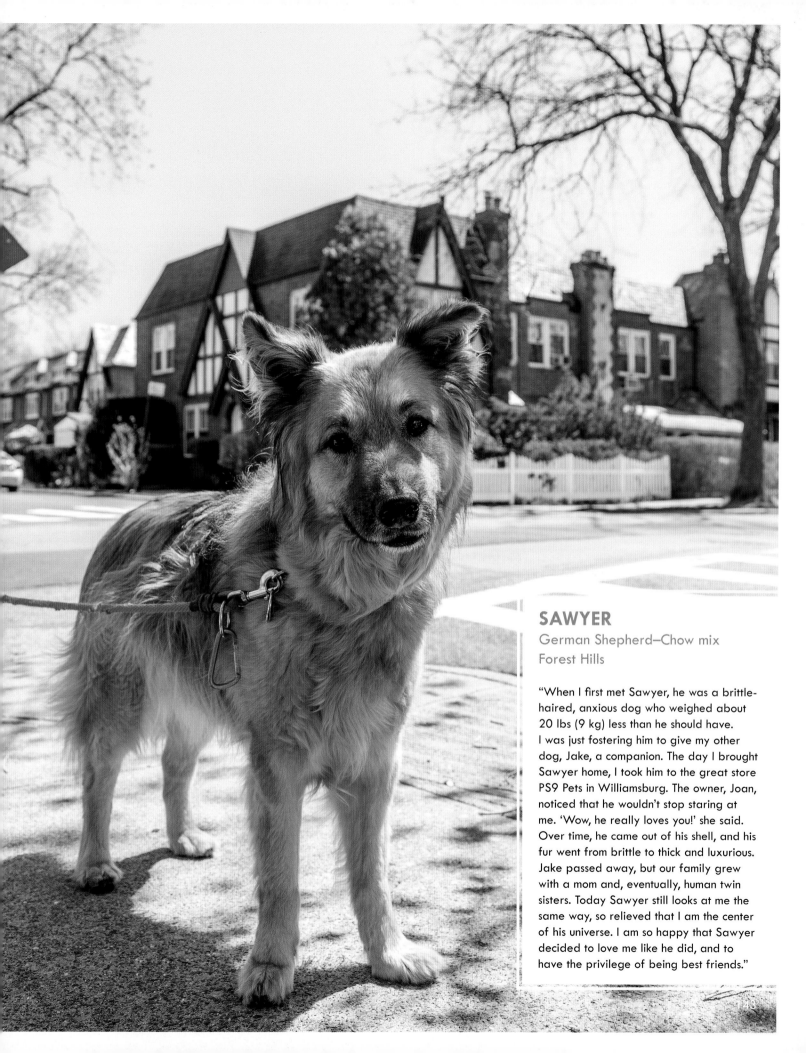

SAWYER
German Shepherd–Chow mix
Forest Hills

"When I first met Sawyer, he was a brittle-haired, anxious dog who weighed about 20 lbs (9 kg) less than he should have. I was just fostering him to give my other dog, Jake, a companion. The day I brought Sawyer home, I took him to the great store PS9 Pets in Williamsburg. The owner, Joan, noticed that he wouldn't stop staring at me. 'Wow, he really loves you!' she said. Over time, he came out of his shell, and his fur went from brittle to thick and luxurious. Jake passed away, but our family grew with a mom and, eventually, human twin sisters. Today Sawyer still looks at me the same way, so relieved that I am the center of his universe. I am so happy that Sawyer decided to love me like he did, and to have the privilege of being best friends."

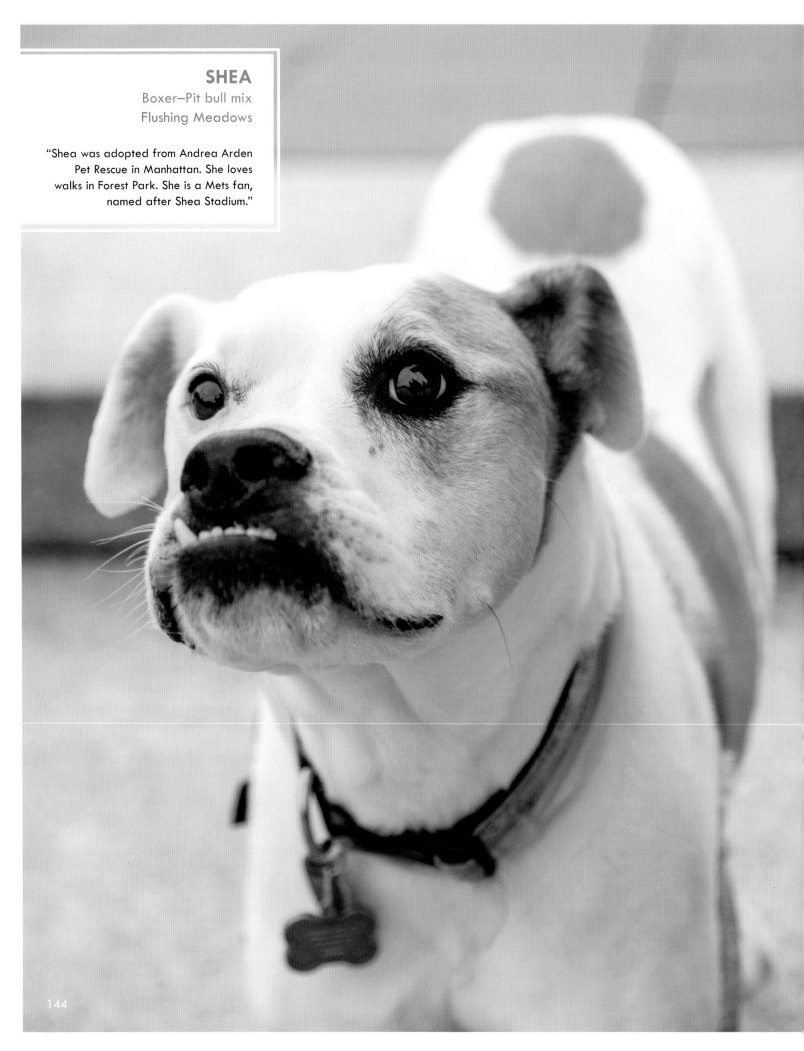

SHEA

Boxer–Pit bull mix
Flushing Meadows

"Shea was adopted from Andrea Arden
Pet Rescue in Manhattan. She loves
walks in Forest Park. She is a Mets fan,
named after Shea Stadium."

144

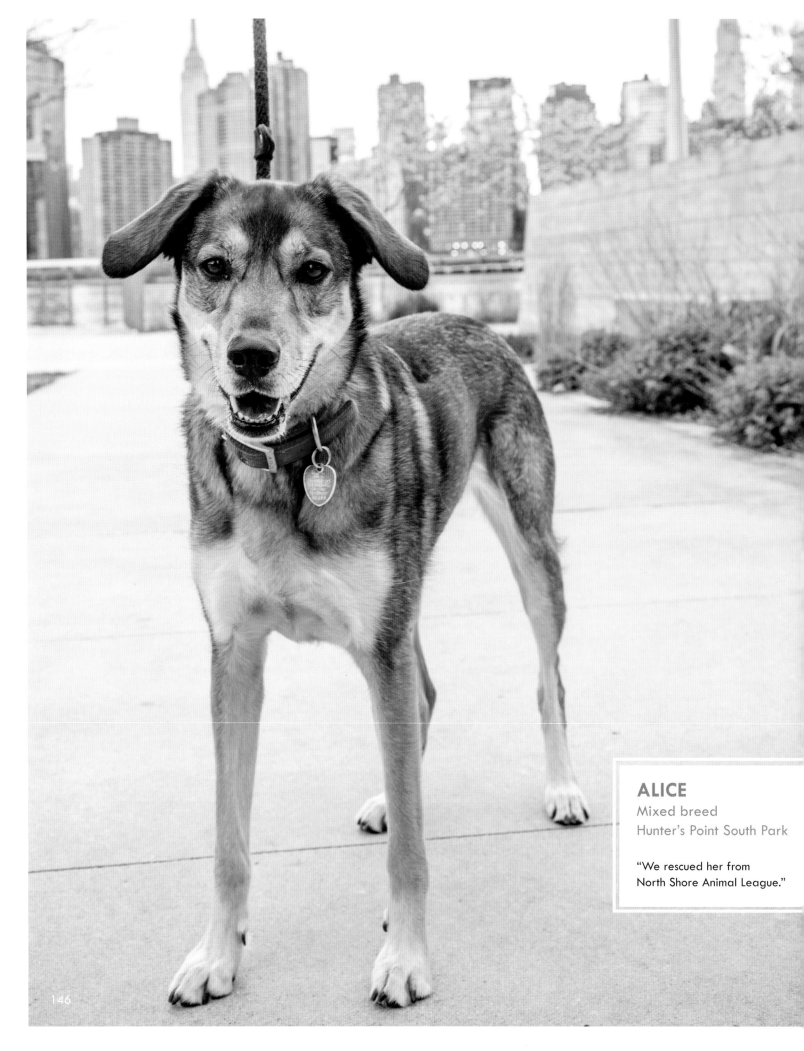

ALICE
Mixed breed
Hunter's Point South Park

"We rescued her from
North Shore Animal League."

146

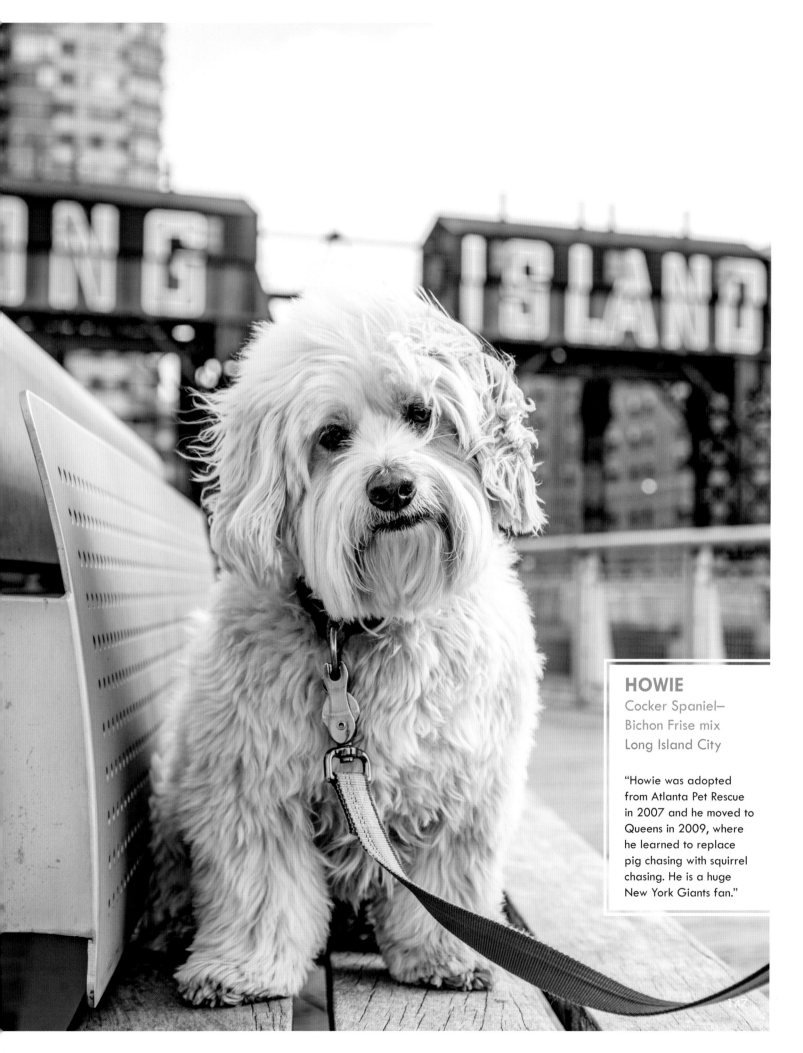

HOWIE
Cocker Spaniel–
Bichon Frise mix
Long Island City

"Howie was adopted
from Atlanta Pet Rescue
in 2007 and he moved to
Queens in 2009, where
he learned to replace
pig chasing with squirrel
chasing. He is a huge
New York Giants fan."

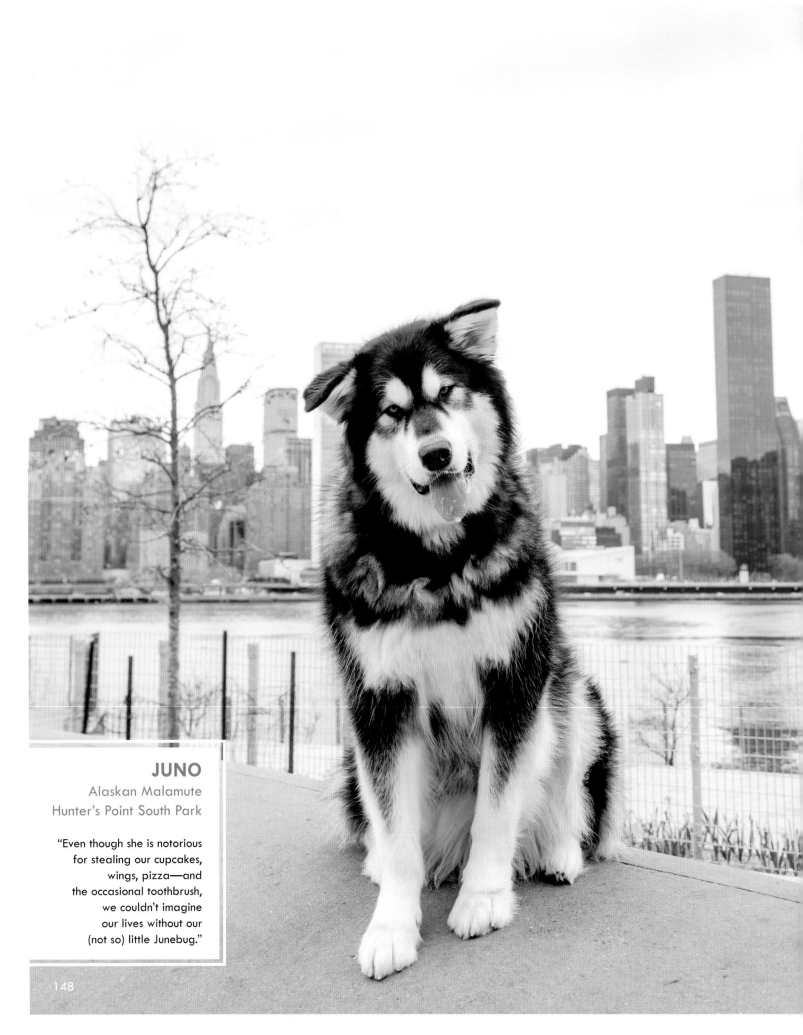

JUNO
Alaskan Malamute
Hunter's Point South Park

"Even though she is notorious
for stealing our cupcakes,
wings, pizza—and
the occasional toothbrush,
we couldn't imagine
our lives without our
(not so) little Junebug."

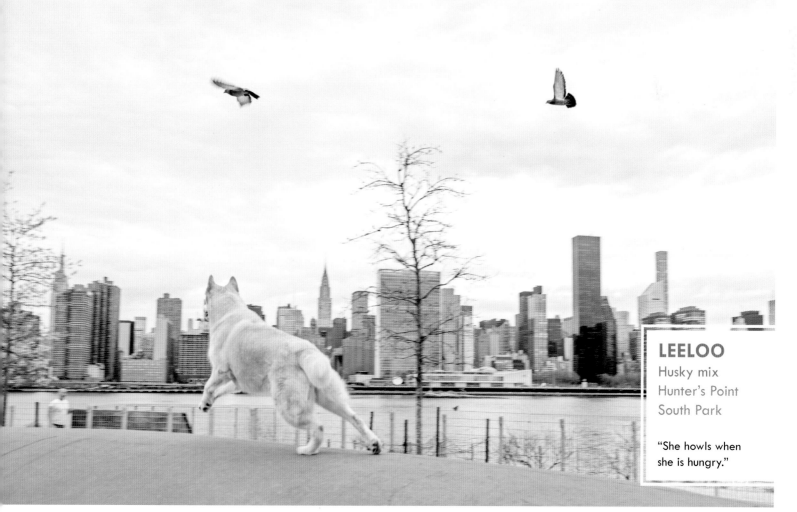

LEELOO
Husky mix
Hunter's Point
South Park

"She howls when
she is hungry."

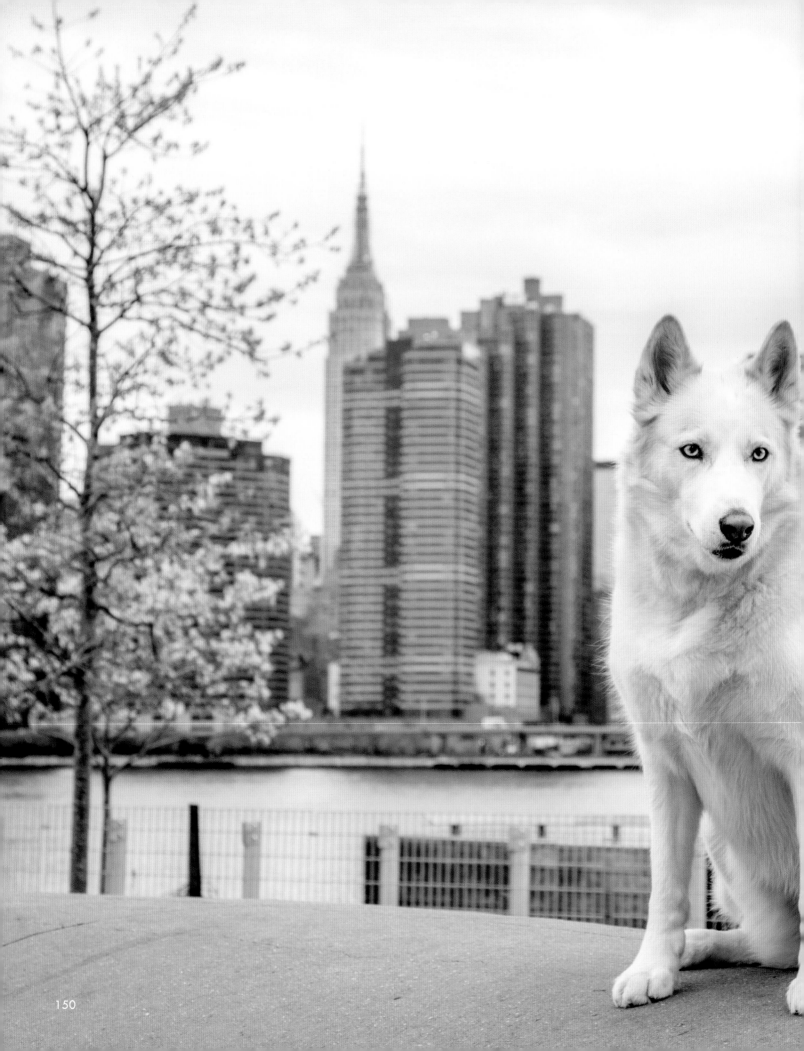

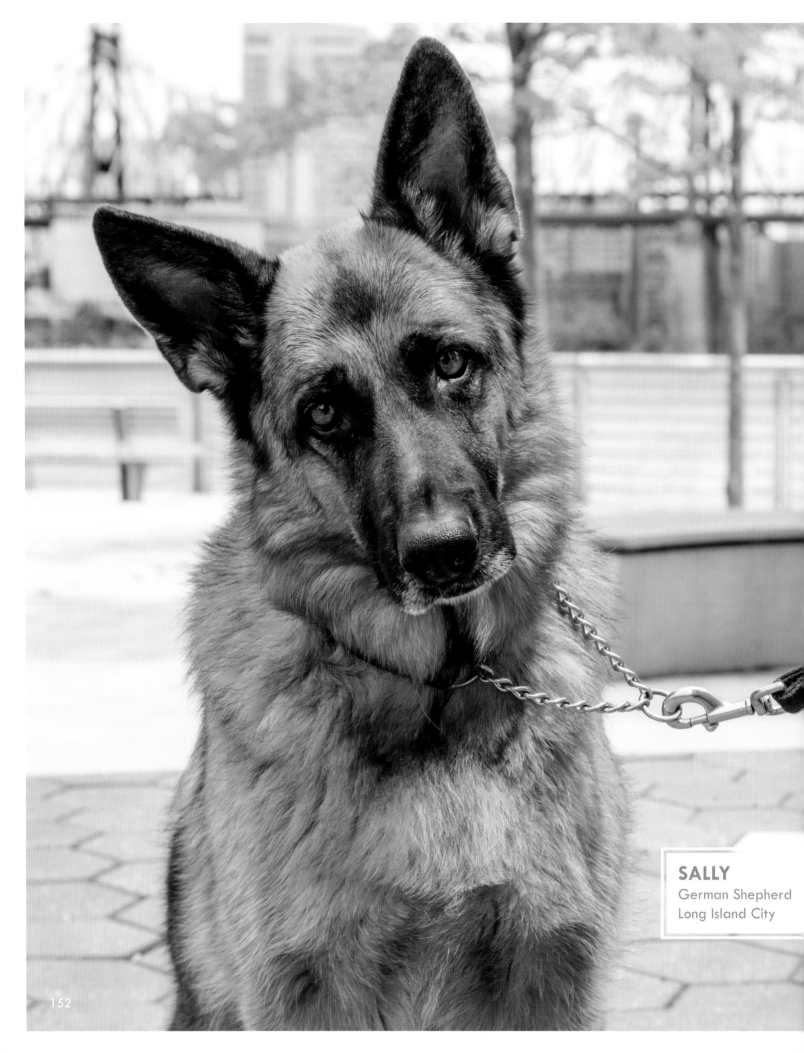

SALLY
German Shepherd
Long Island City

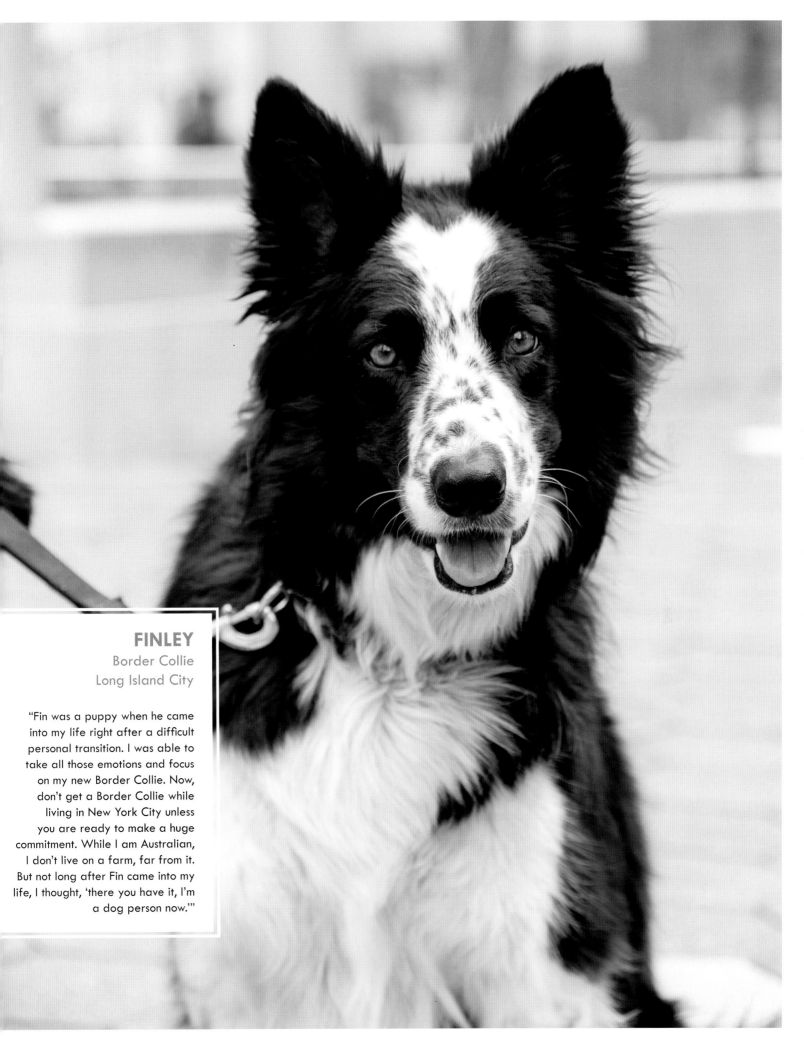

FINLEY
Border Collie
Long Island City

"Fin was a puppy when he came into my life right after a difficult personal transition. I was able to take all those emotions and focus on my new Border Collie. Now, don't get a Border Collie while living in New York City unless you are ready to make a huge commitment. While I am Australian, I don't live on a farm, far from it. But not long after Fin came into my life, I thought, 'there you have it, I'm a dog person now.'"

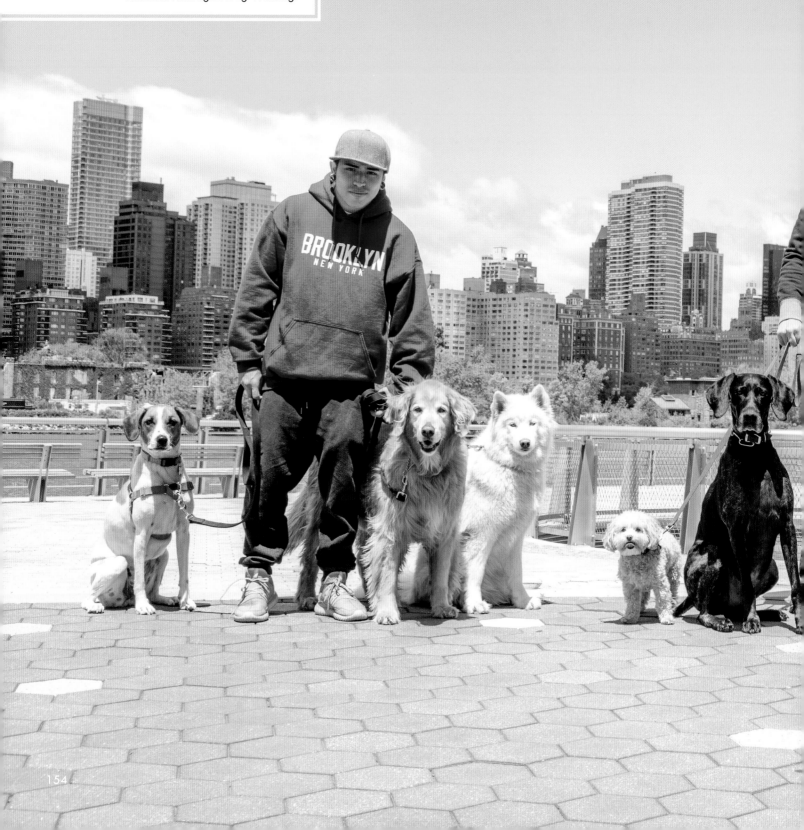

GEORGIE, BOO, BUTTER, LUCY, BO, DOTTIE, MILO, SALLY, EDDIE, BETTY, ABBY, FINLEY
Long Island City

Walkers: Luis, Sam, and Mike from Mischief Managed Dog Walking.

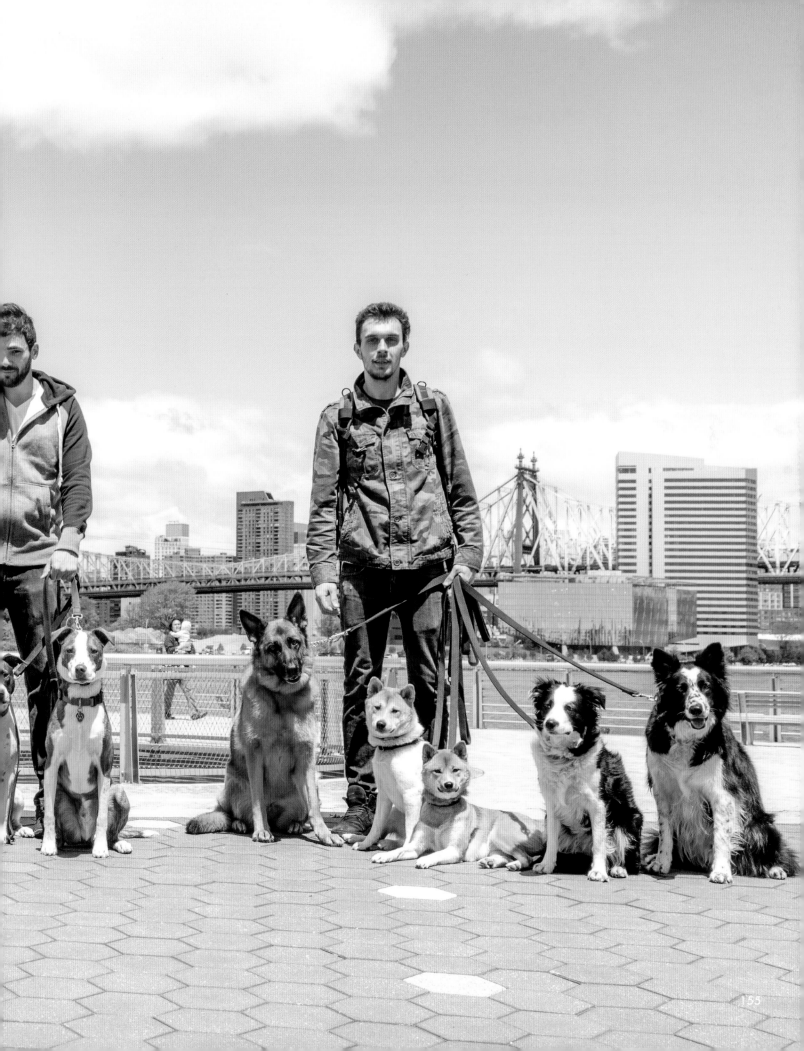

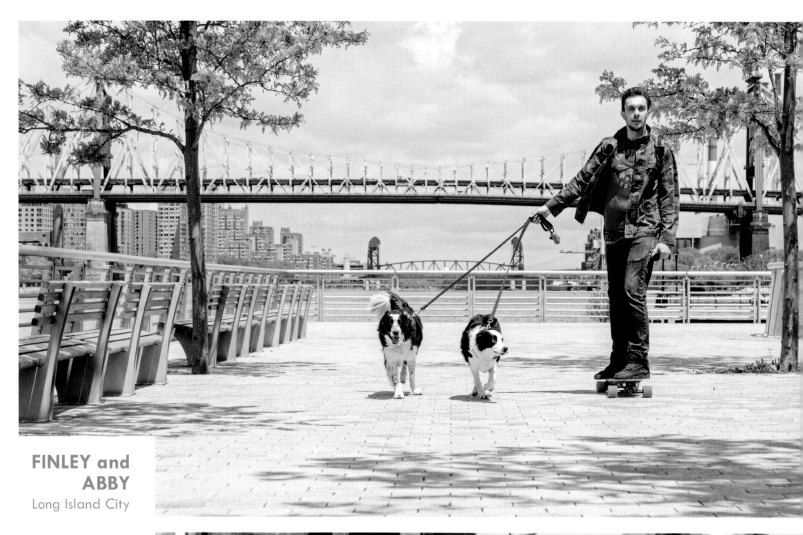

FINLEY and ABBY
Long Island City

DOTTIE
Pit bull–German
Shorthaired
Pointer mix
Long Island City

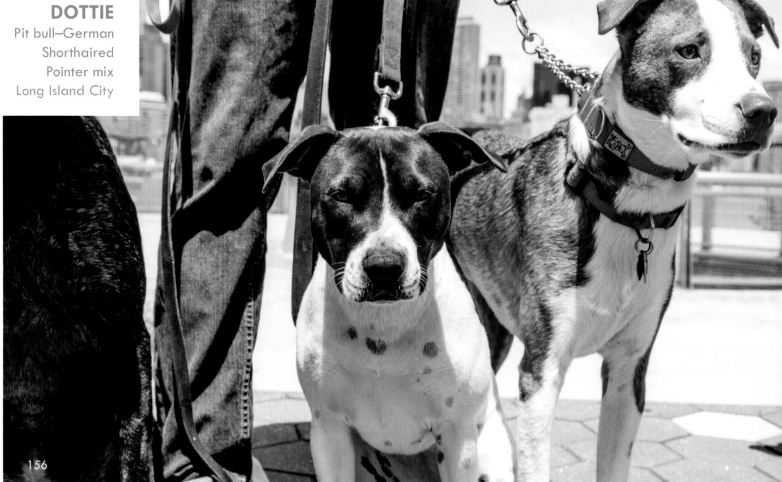

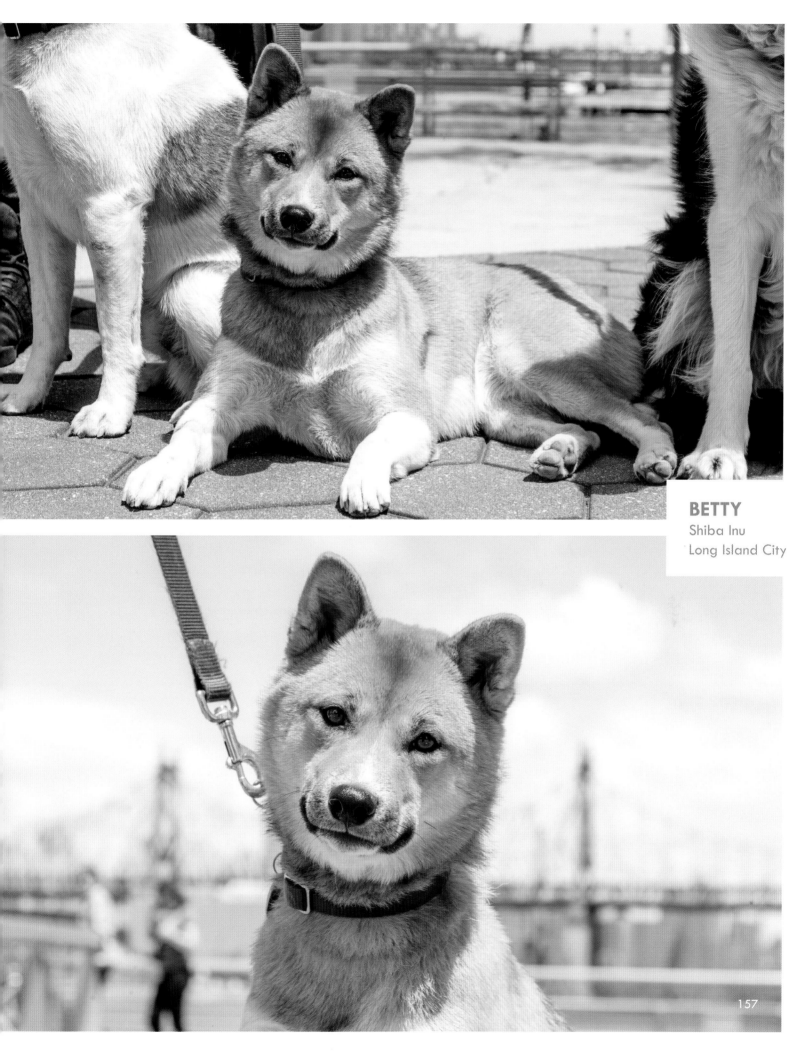

BETTY
Shiba Inu
Long Island City

157

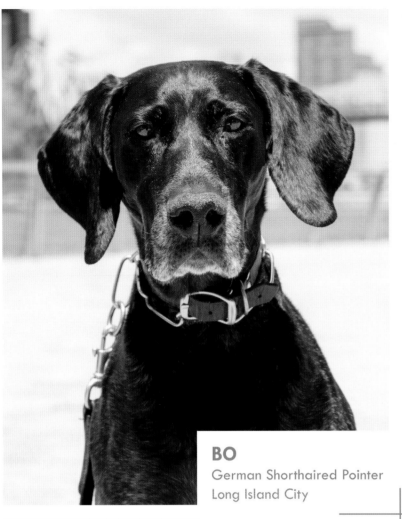

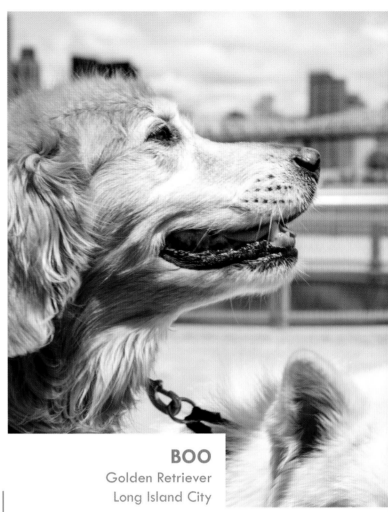

BO
German Shorthaired Pointer
Long Island City

BOO
Golden Retriever
Long Island City

ABBY
Border Collie
Long Island City

MILO
Australian Shepherd–Pit bull mix
Flushing Meadows

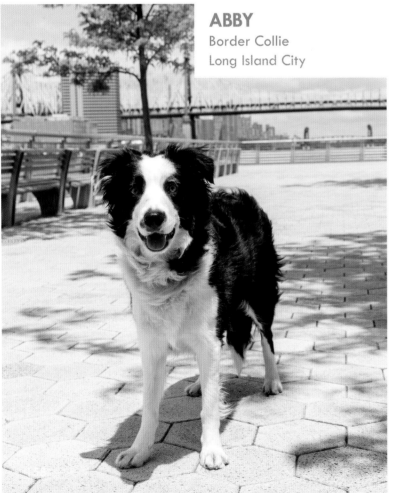

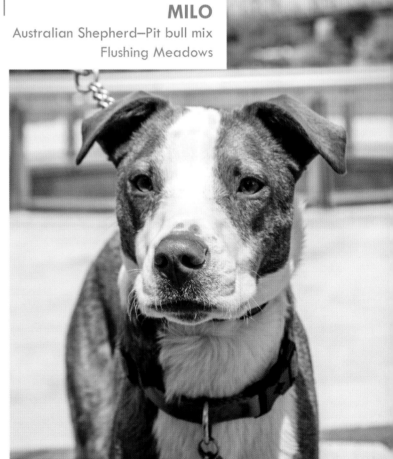

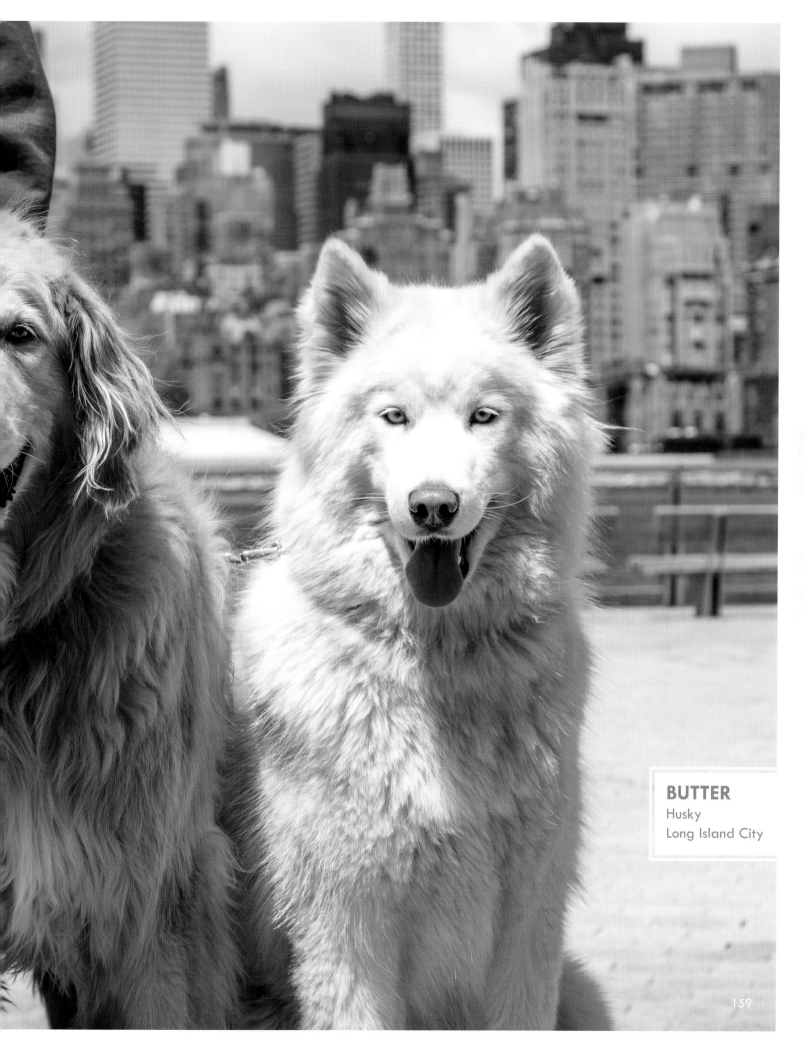

BUTTER
Husky
Long Island City

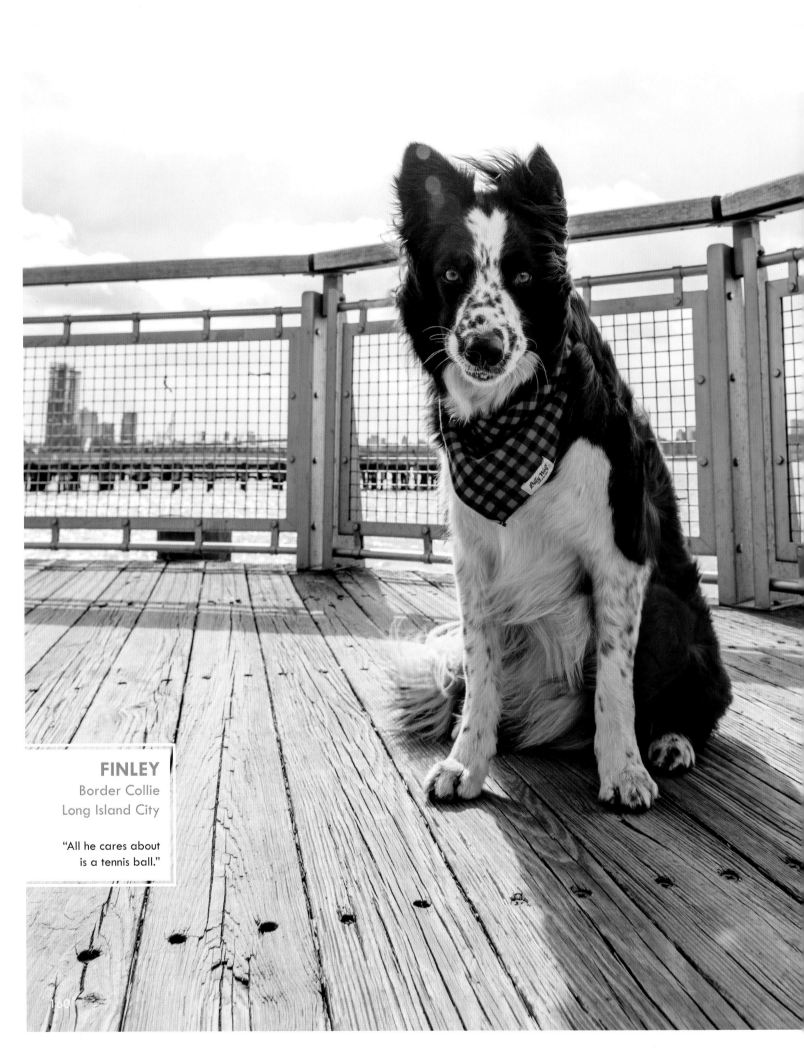

FINLEY
Border Collie
Long Island City

"All he cares about
is a tennis ball."

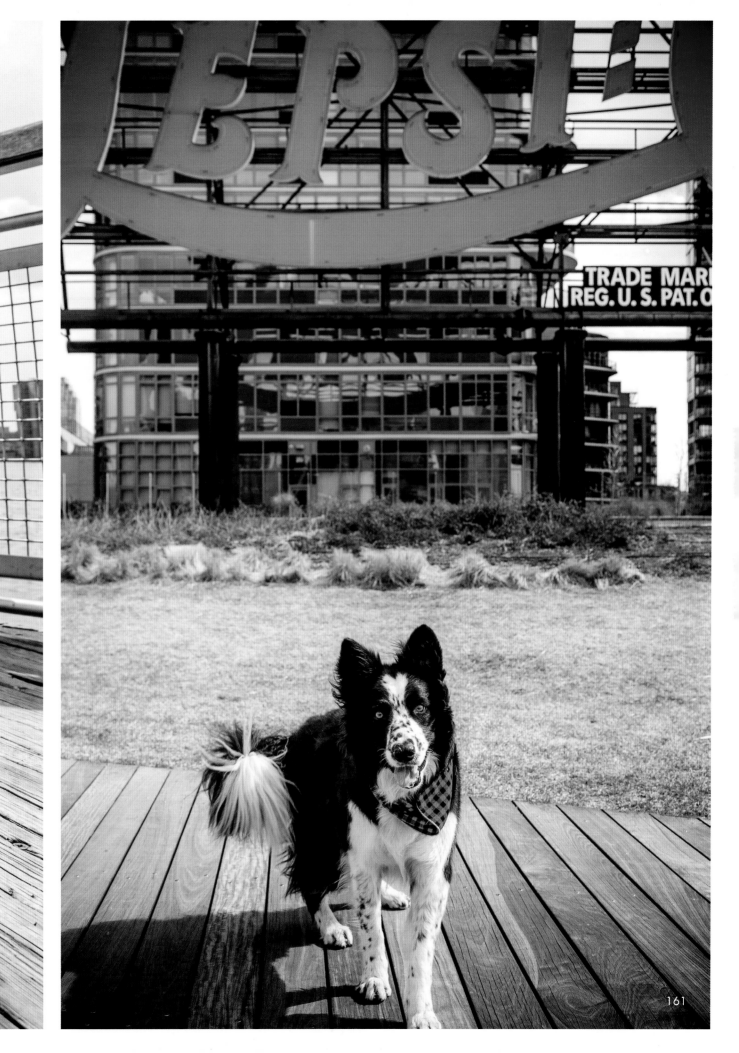

THE
BRONX

"Yet I will look upon thy face again,
My own romantic Bronx, and it will be
A face more pleasant than the face of men."

—Joseph Rodman Drake, from "Bronx" (1835)

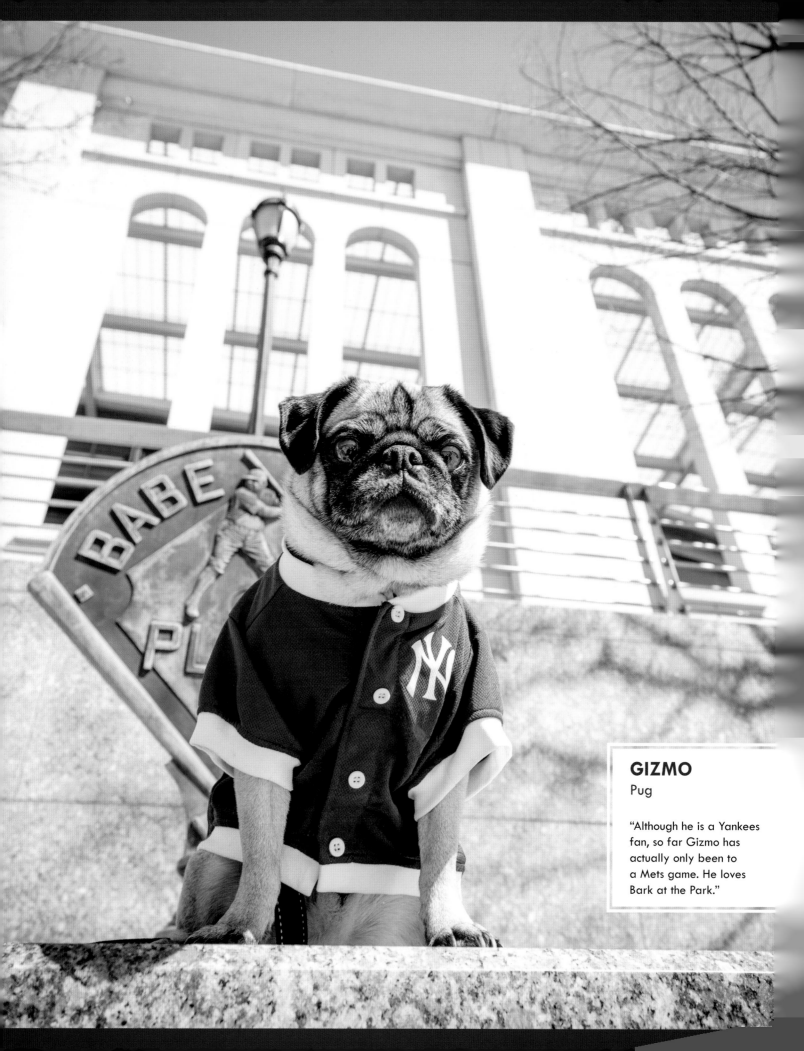

GIZMO
Pug

"Although he is a Yankees fan, so far Gizmo has actually only been to a Mets game. He loves Bark at the Park."

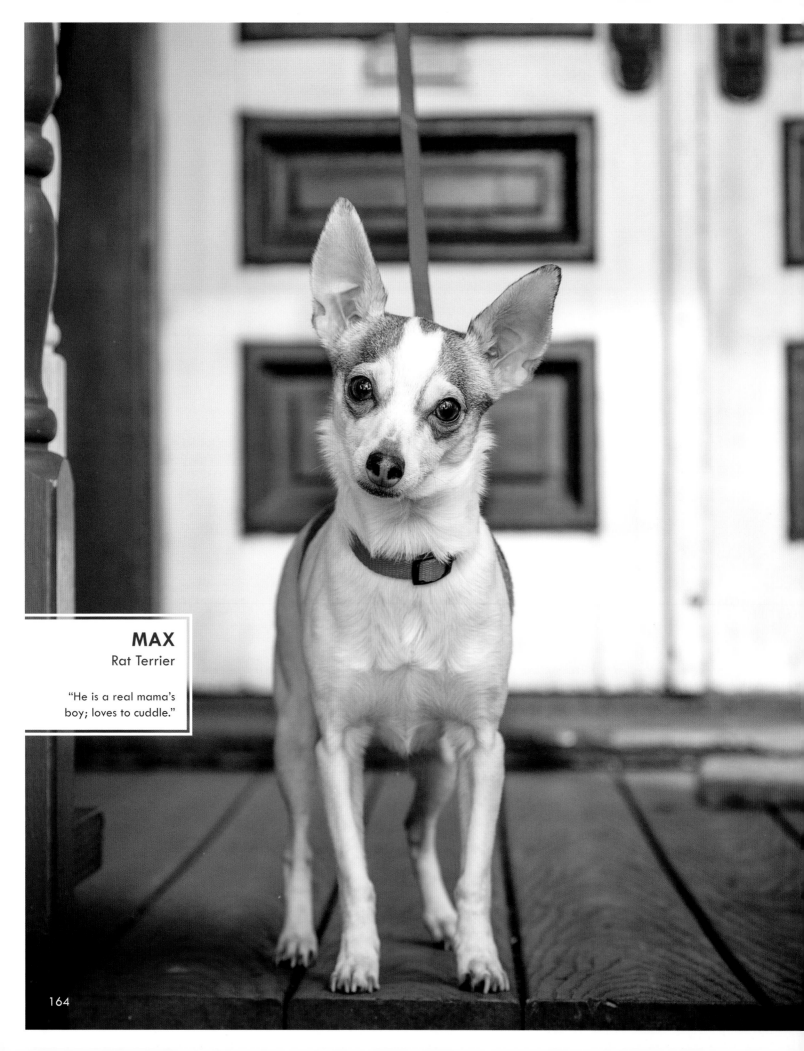

MAX
Rat Terrier

"He is a real mama's boy; loves to cuddle."

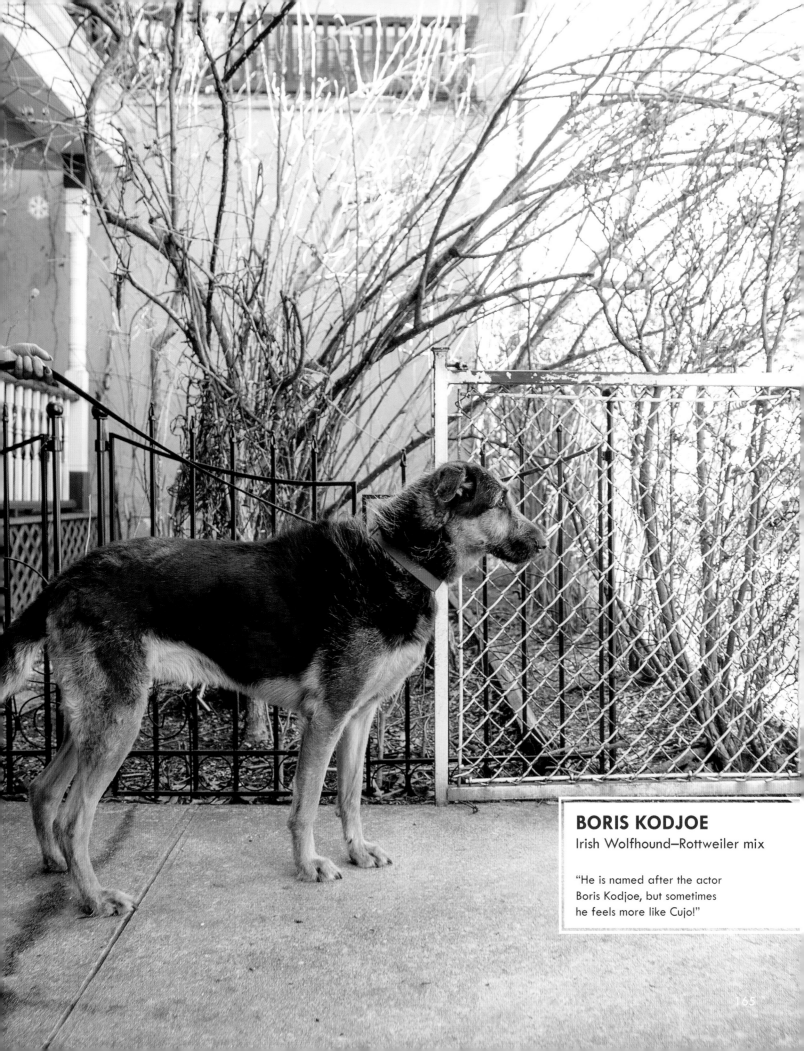

BORIS KODJOE
Irish Wolfhound–Rottweiler mix

"He is named after the actor
Boris Kodjoe, but sometimes
he feels more like Cujo!"

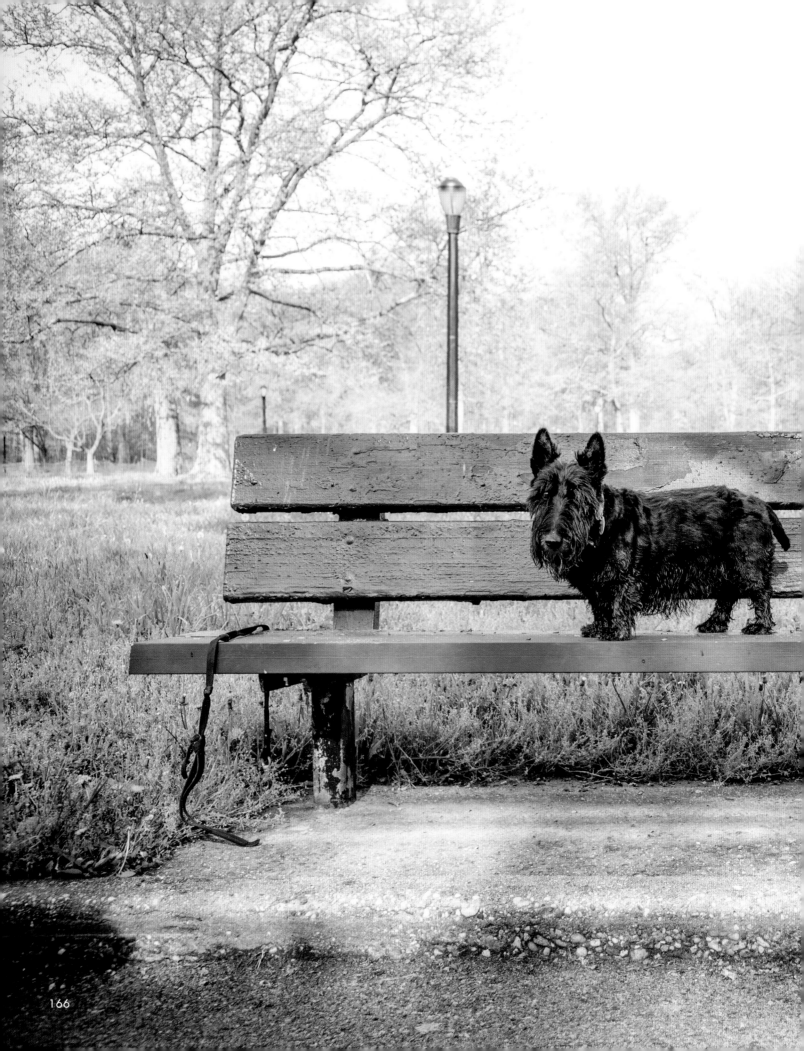

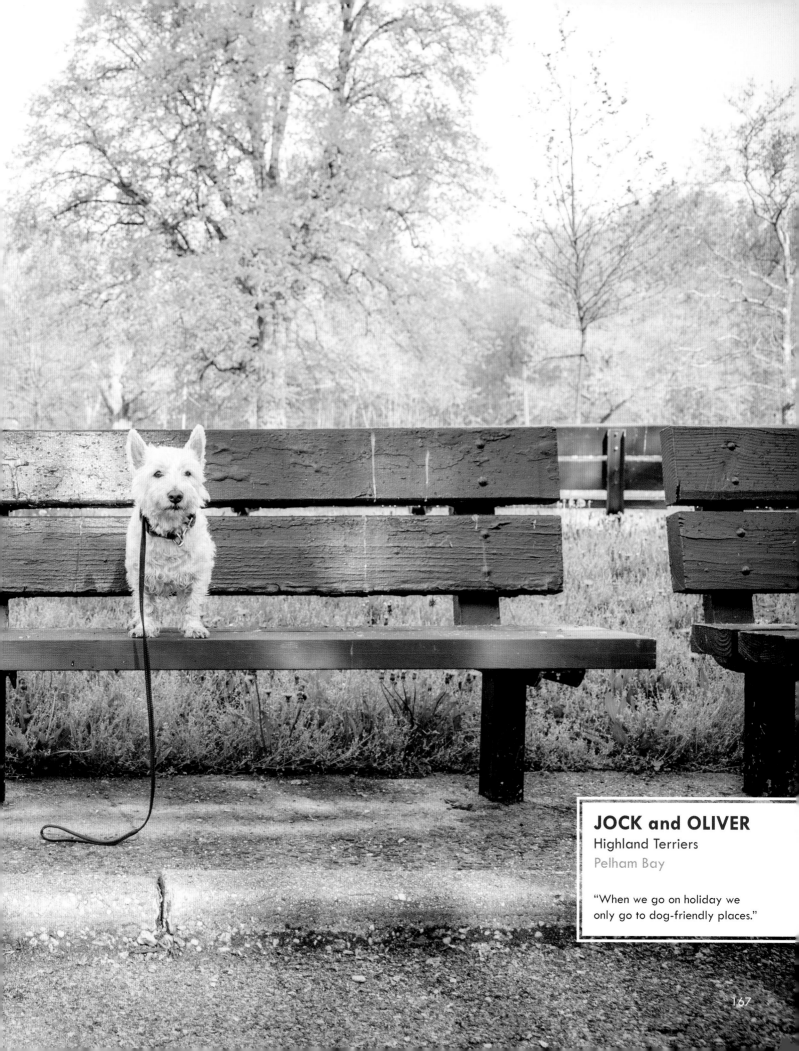

JOCK and OLIVER
Highland Terriers
Pelham Bay

"When we go on holiday we only go to dog-friendly places."

167

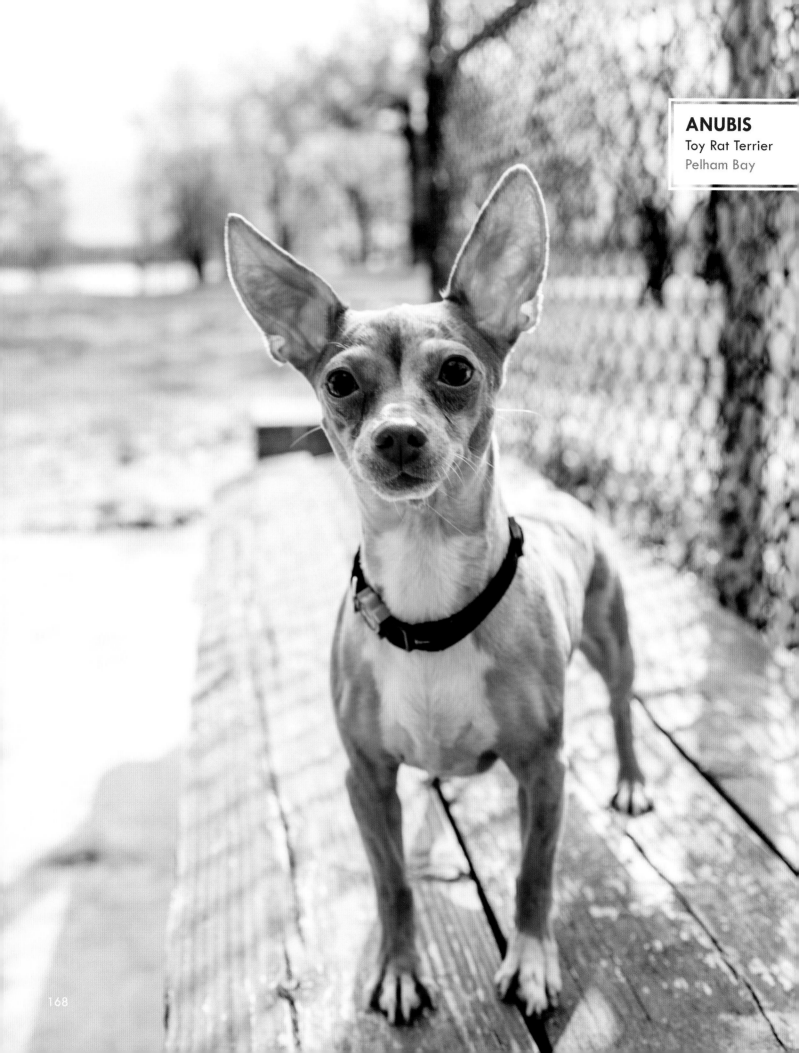

ANUBIS
Toy Rat Terrier
Pelham Bay

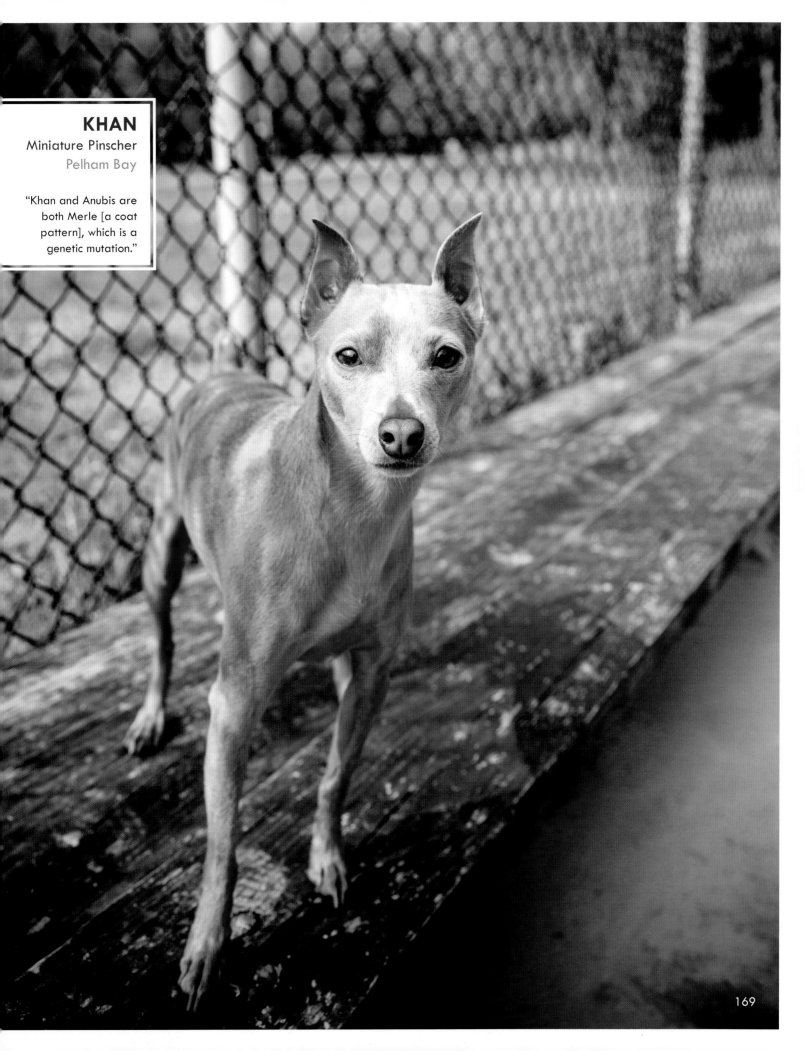

KHAN
Miniature Pinscher
Pelham Bay

"Khan and Anubis are both Merle [a coat pattern], which is a genetic mutation."

169

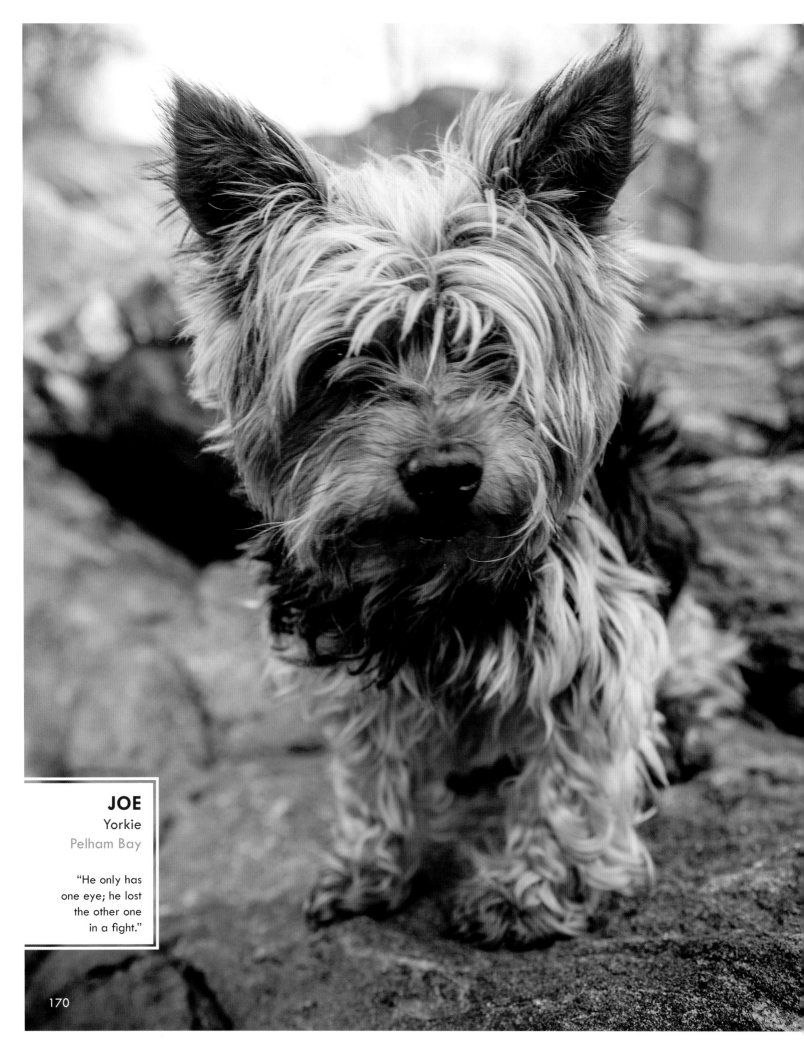

JOE
Yorkie
Pelham Bay

"He only has one eye; he lost the other one in a fight."

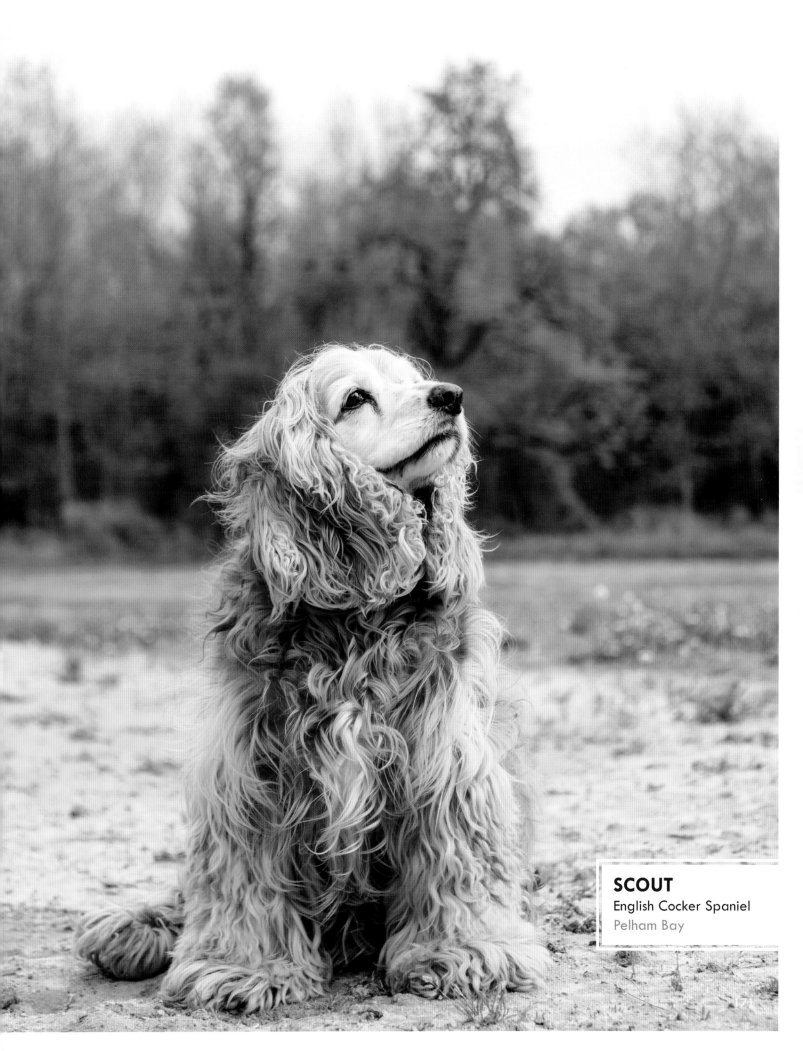

SCOUT
English Cocker Spaniel
Pelham Bay

171

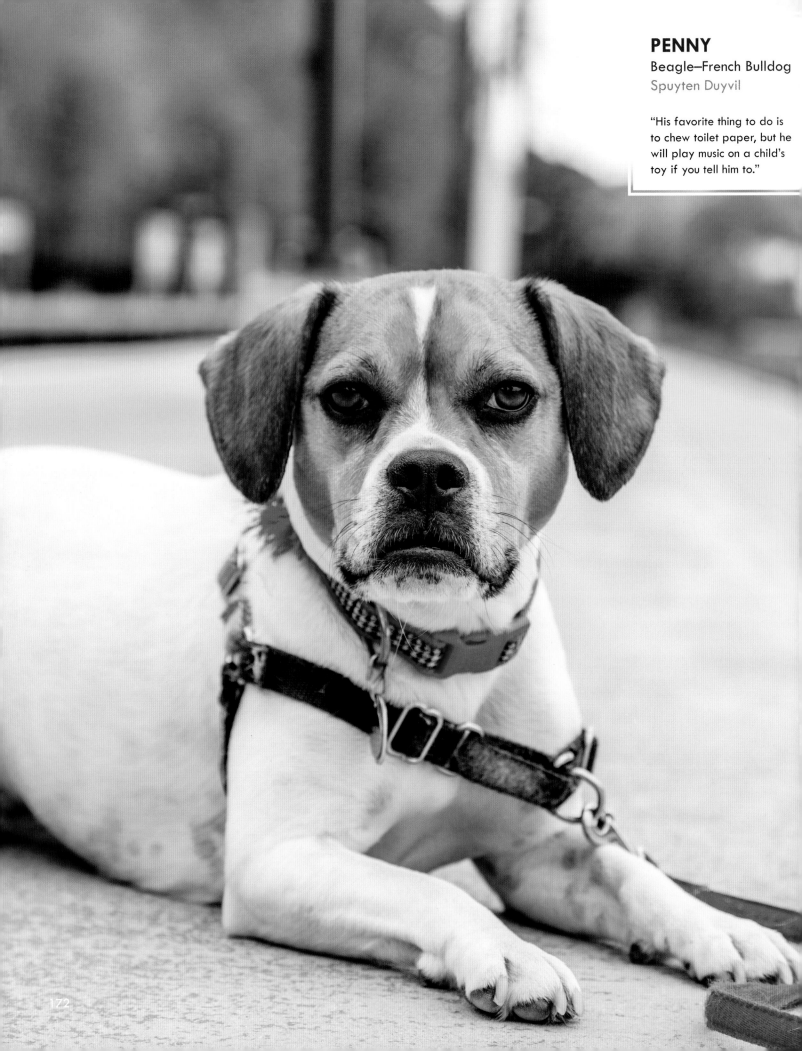

PENNY
Beagle–French Bulldog
Spuyten Duyvil

"His favorite thing to do is to chew toilet paper, but he will play music on a child's toy if you tell him to."

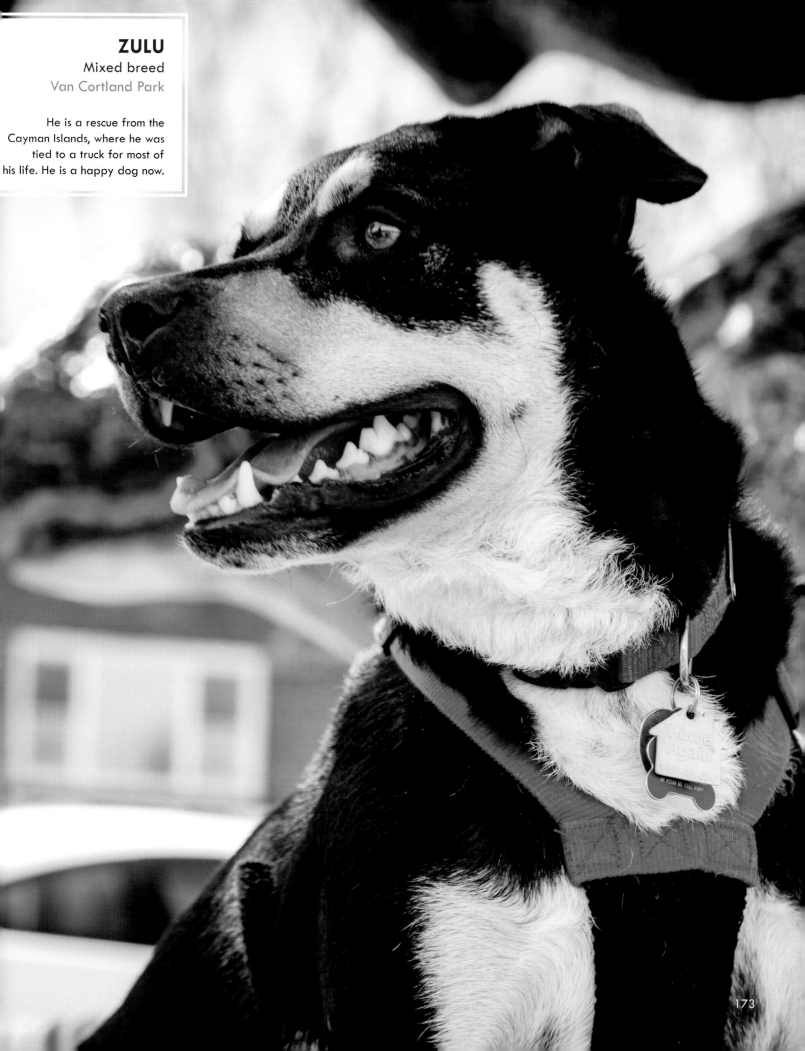

ZULU
Mixed breed
Van Cortland Park

He is a rescue from the Cayman Islands, where he was tied to a truck for most of his life. He is a happy dog now.

173

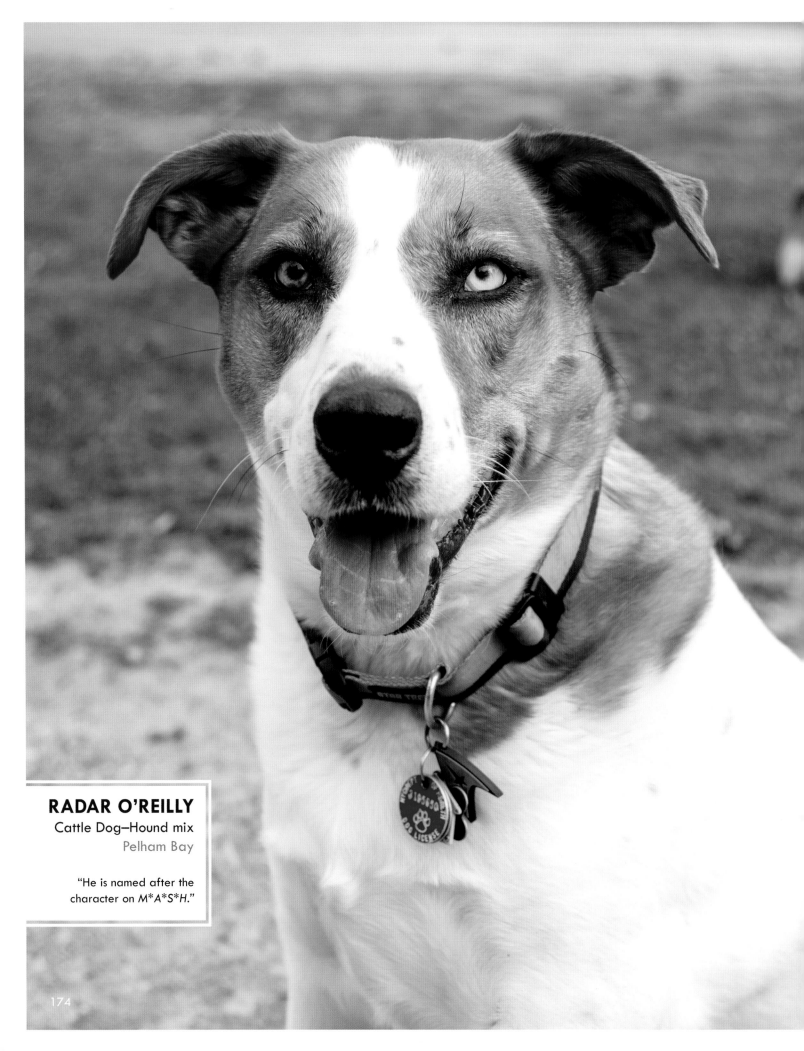

RADAR O'REILLY
Cattle Dog–Hound mix
Pelham Bay

"He is named after the
character on *M*A*S*H*."

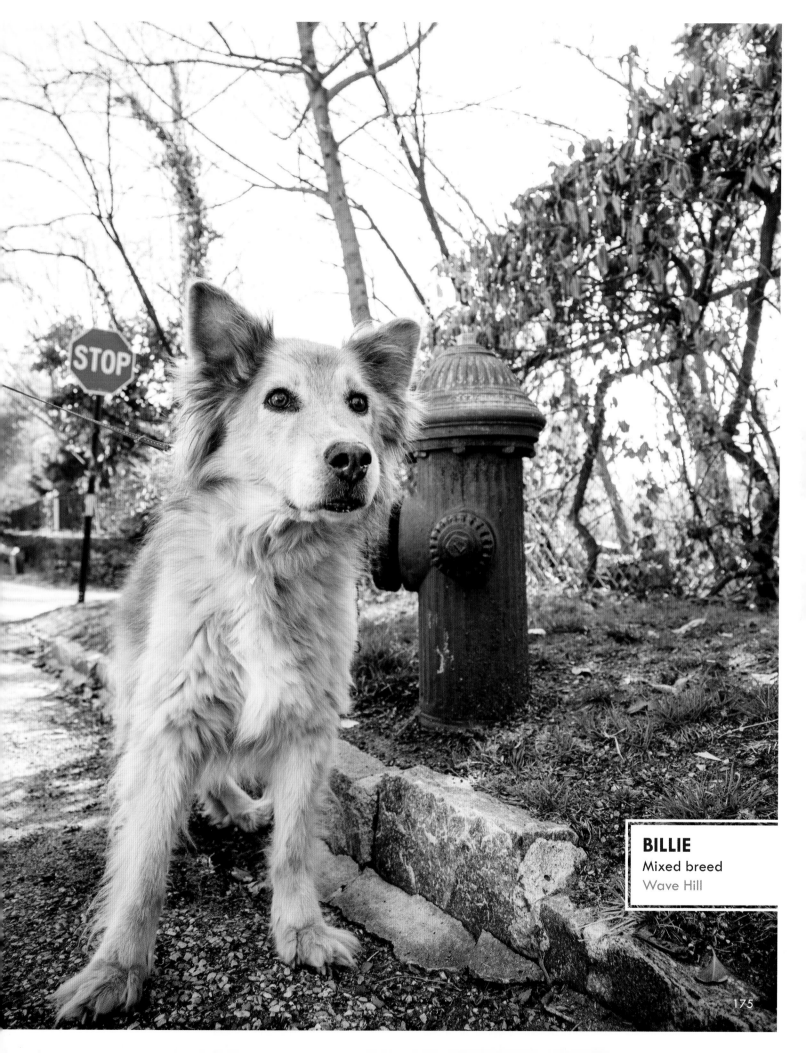

BILLIE
Mixed breed
Wave Hill

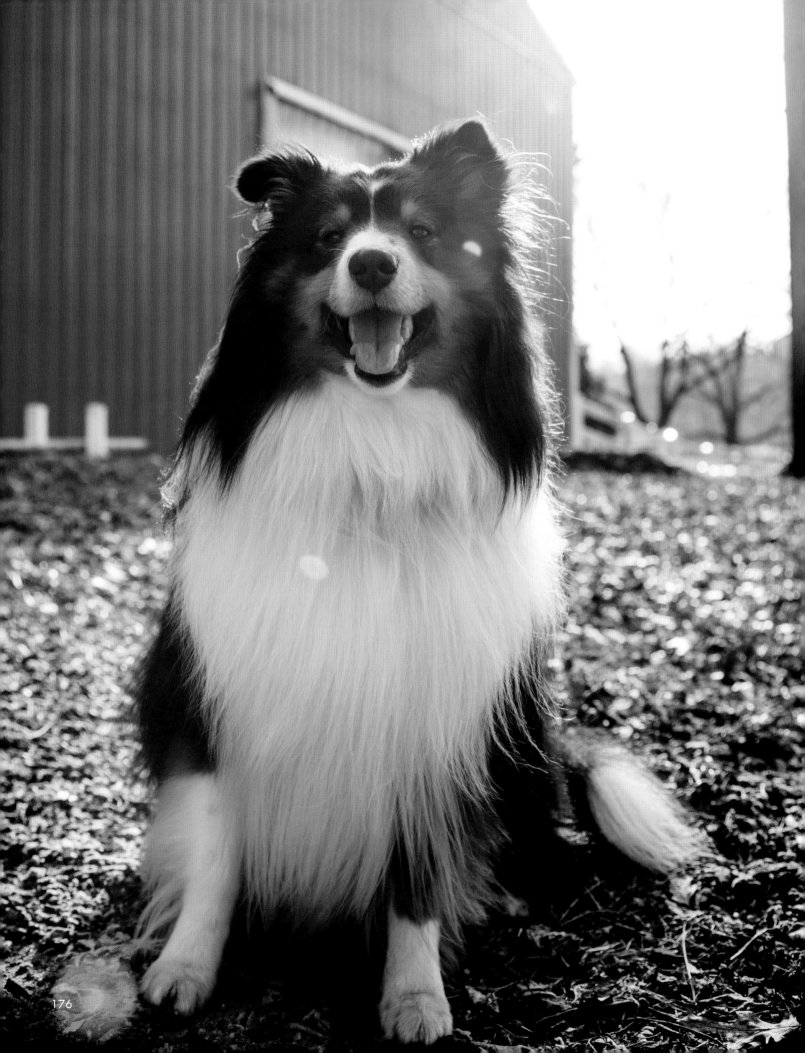

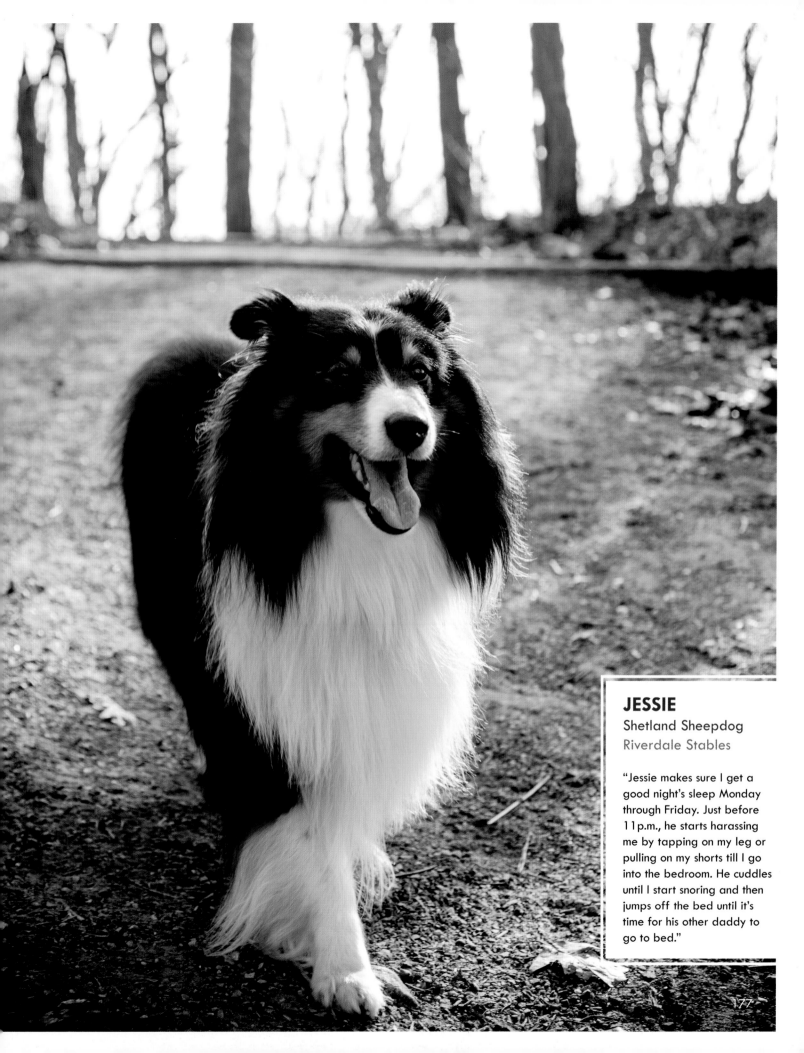

JESSIE
Shetland Sheepdog
Riverdale Stables

"Jessie makes sure I get a good night's sleep Monday through Friday. Just before 11p.m., he starts harassing me by tapping on my leg or pulling on my shorts till I go into the bedroom. He cuddles until I start snoring and then jumps off the bed until it's time for his other daddy to go to bed."

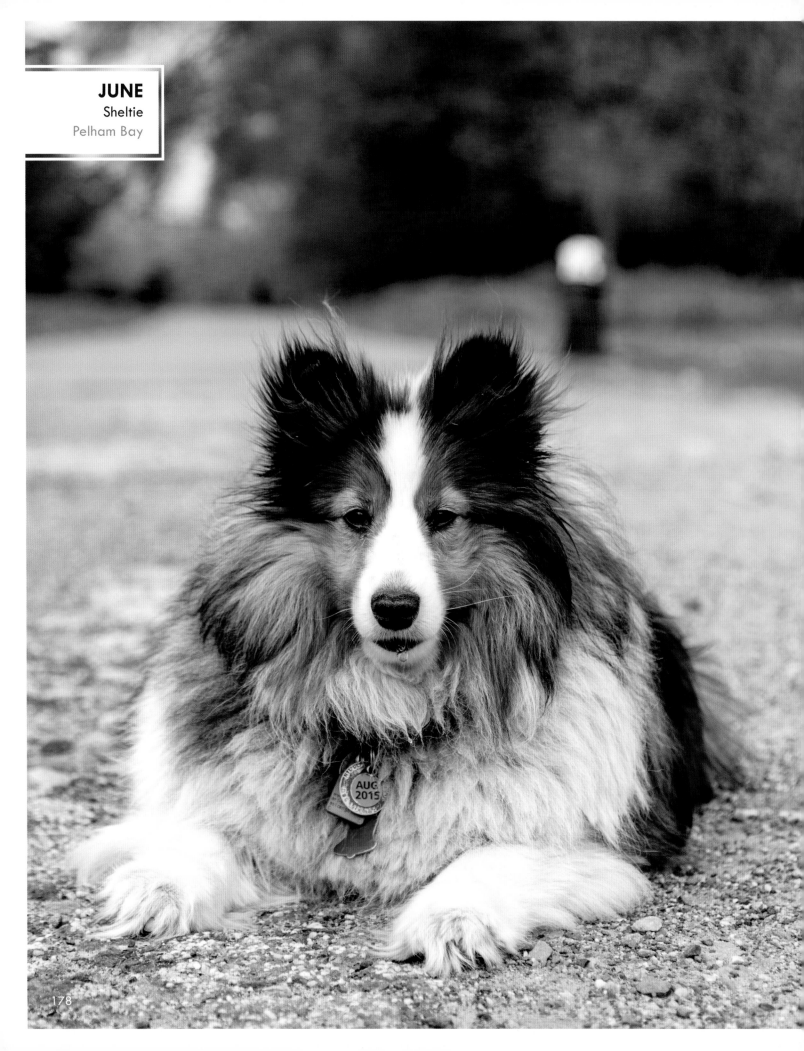

JUNE
Sheltie
Pelham Bay

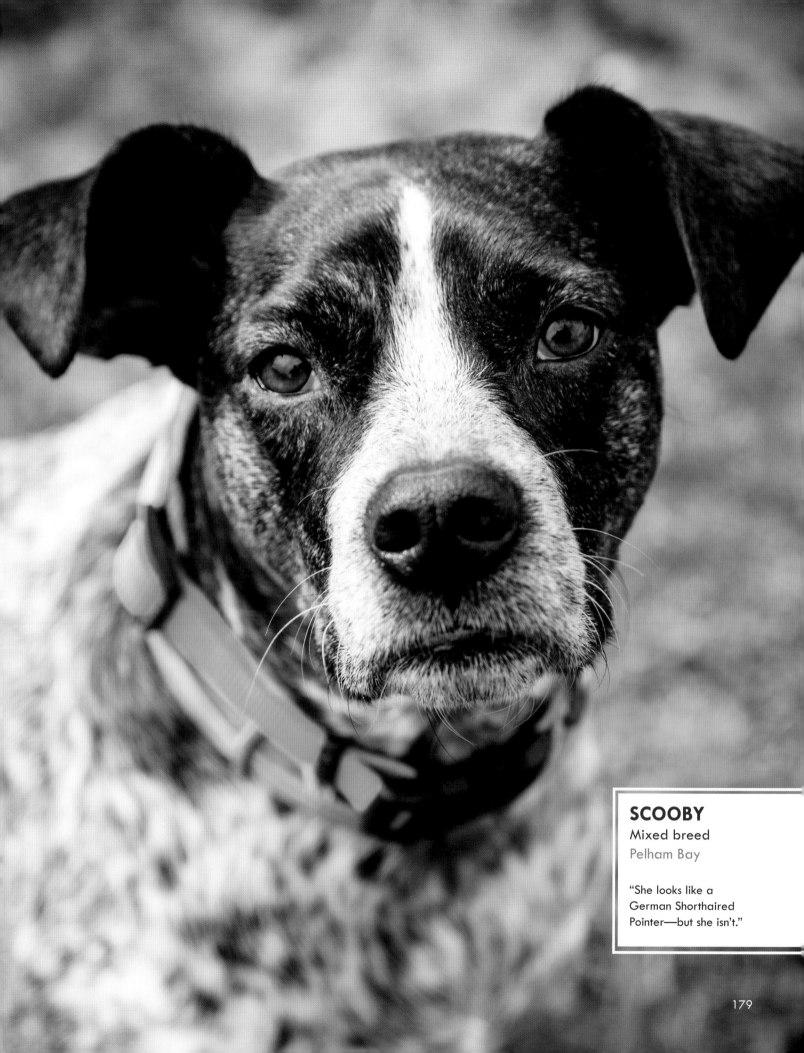

SCOOBY
Mixed breed
Pelham Bay

"She looks like a
German Shorthaired
Pointer—but she isn't."

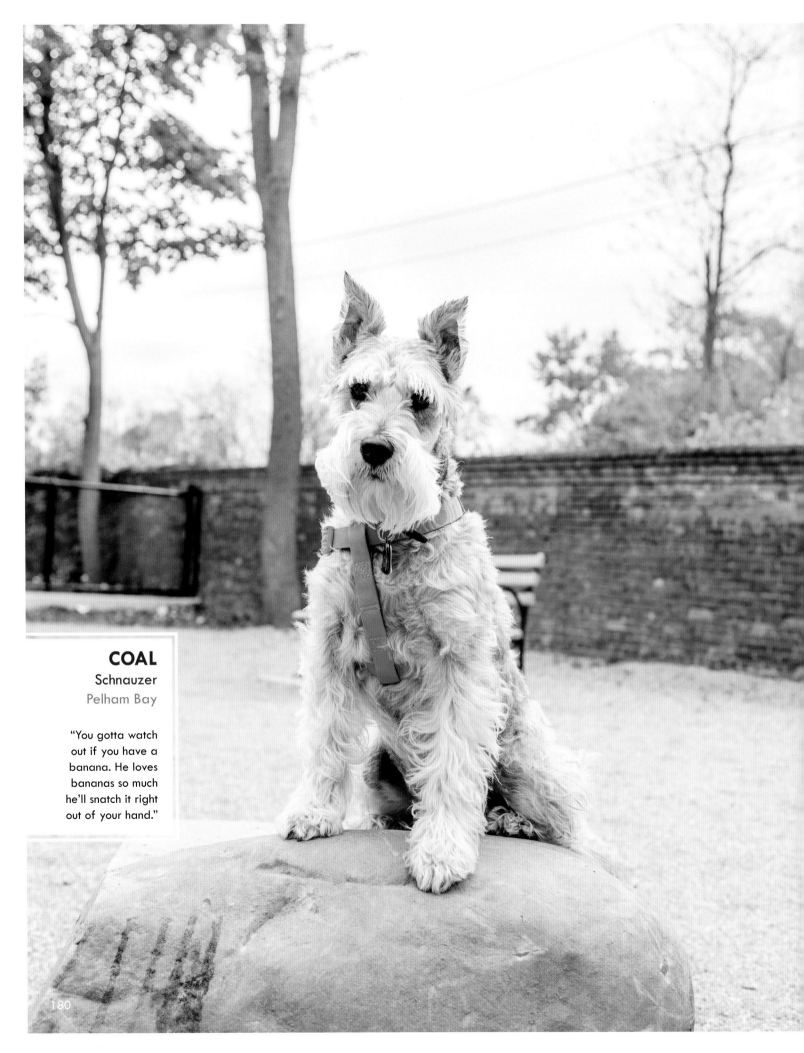

COAL
Schnauzer
Pelham Bay

"You gotta watch out if you have a banana. He loves bananas so much he'll snatch it right out of your hand."

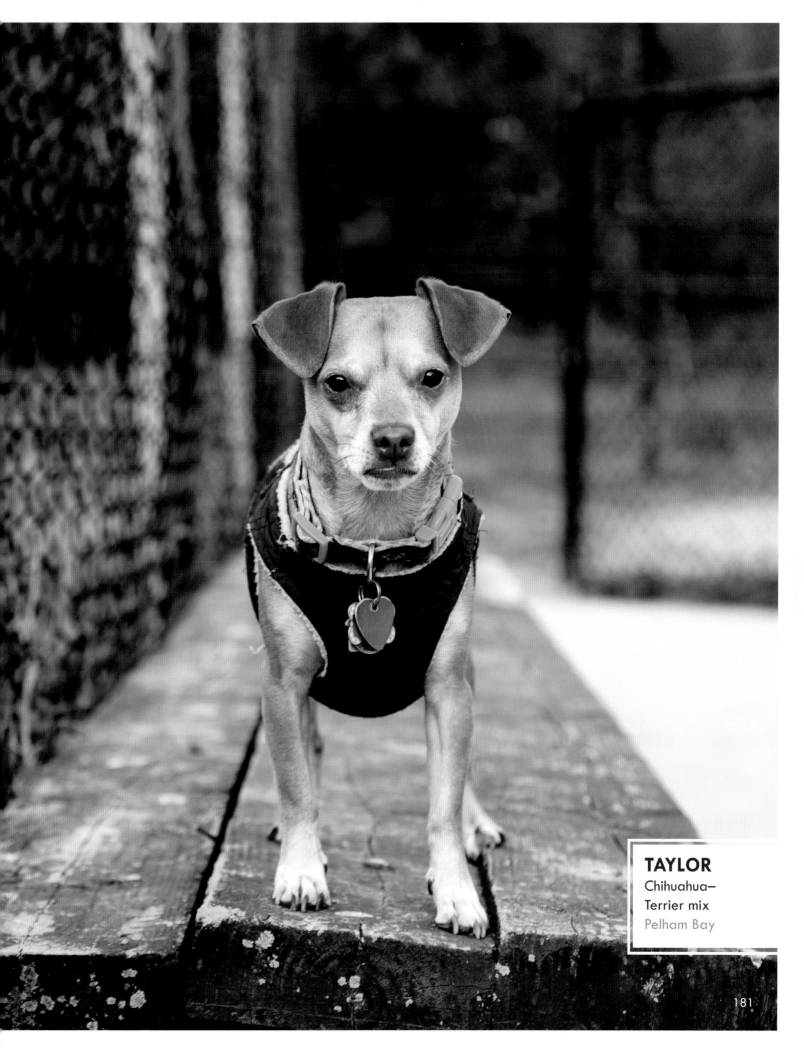

TAYLOR
Chihuahua–
Terrier mix
Pelham Bay

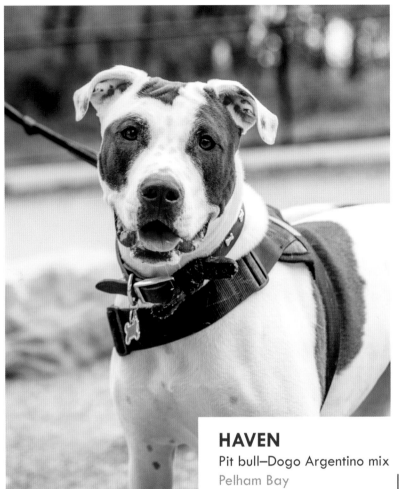

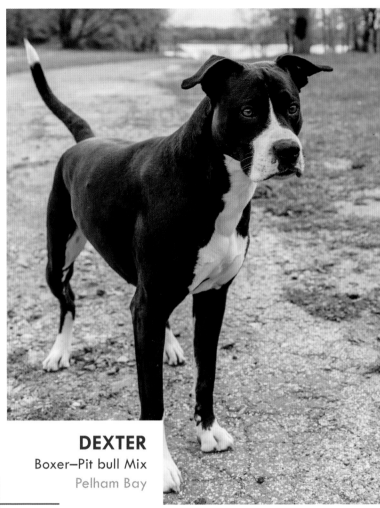

HAVEN
Pit bull–Dogo Argentino mix
Pelham Bay

DEXTER
Boxer–Pit bull Mix
Pelham Bay

LINCOLN
Great Dane
Pelham Bay

MISSY
Black Mouth Cur mix
Pelham Bay

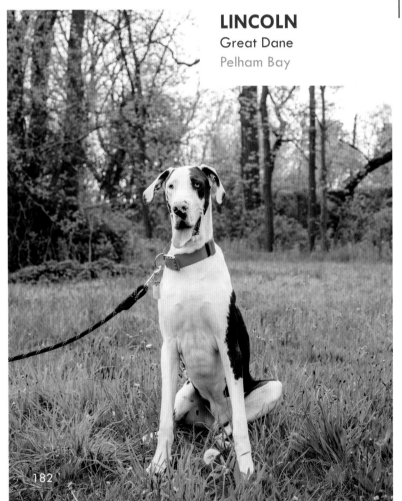

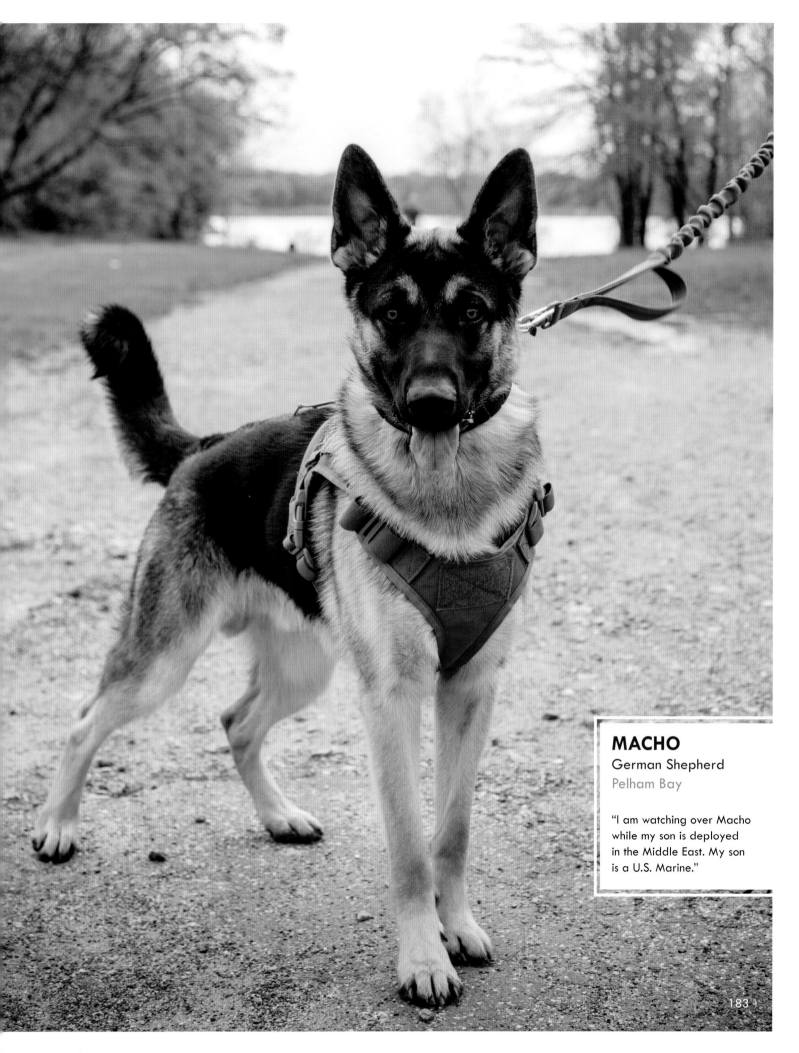

MACHO
German Shepherd
Pelham Bay

"I am watching over Macho while my son is deployed in the Middle East. My son is a U.S. Marine."

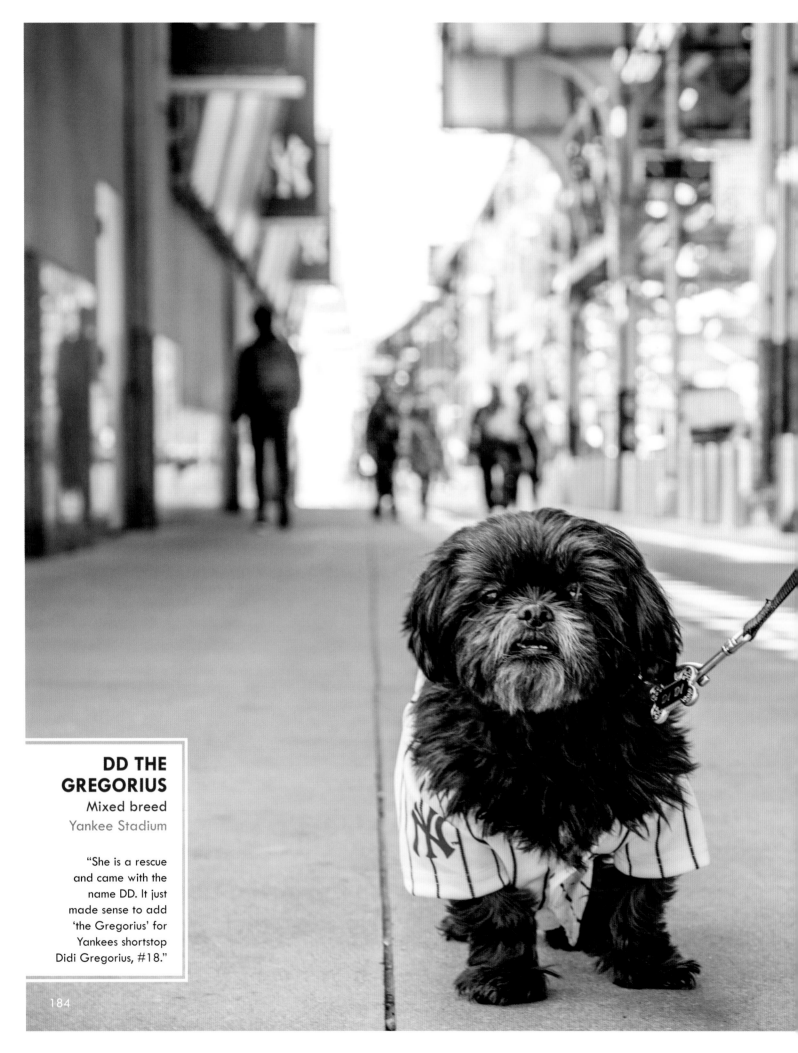

DD THE GREGORIUS

Mixed breed

Yankee Stadium

"She is a rescue and came with the name DD. It just made sense to add 'the Gregorius' for Yankees shortstop Didi Gregorius, #18."

184

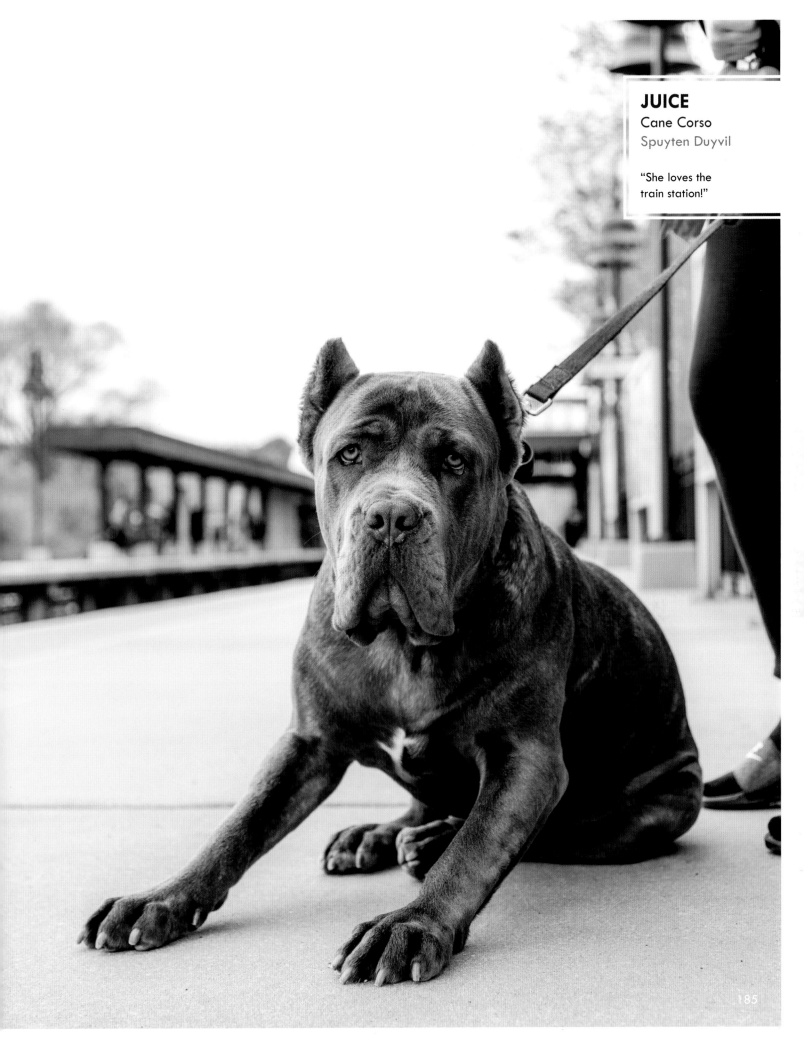

JUICE
Cane Corso
Spuyten Duyvil

"She loves the
train station!"

185

STATEN ISLAND

"An idyllic patch in the ravaged city. Right over a bridge. Staten Island."

—Eddie Joyce, *Small Mercies* (2015)

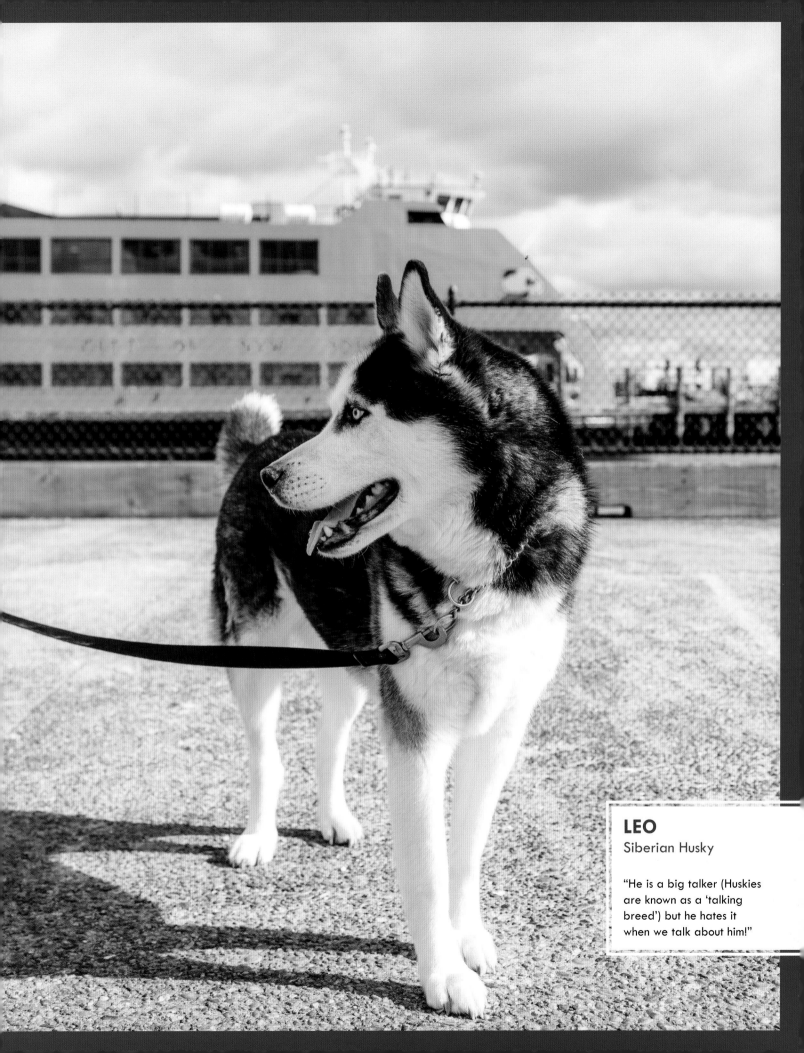

LEO
Siberian Husky

"He is a big talker (Huskies are known as a 'talking breed') but he hates it when we talk about him!"

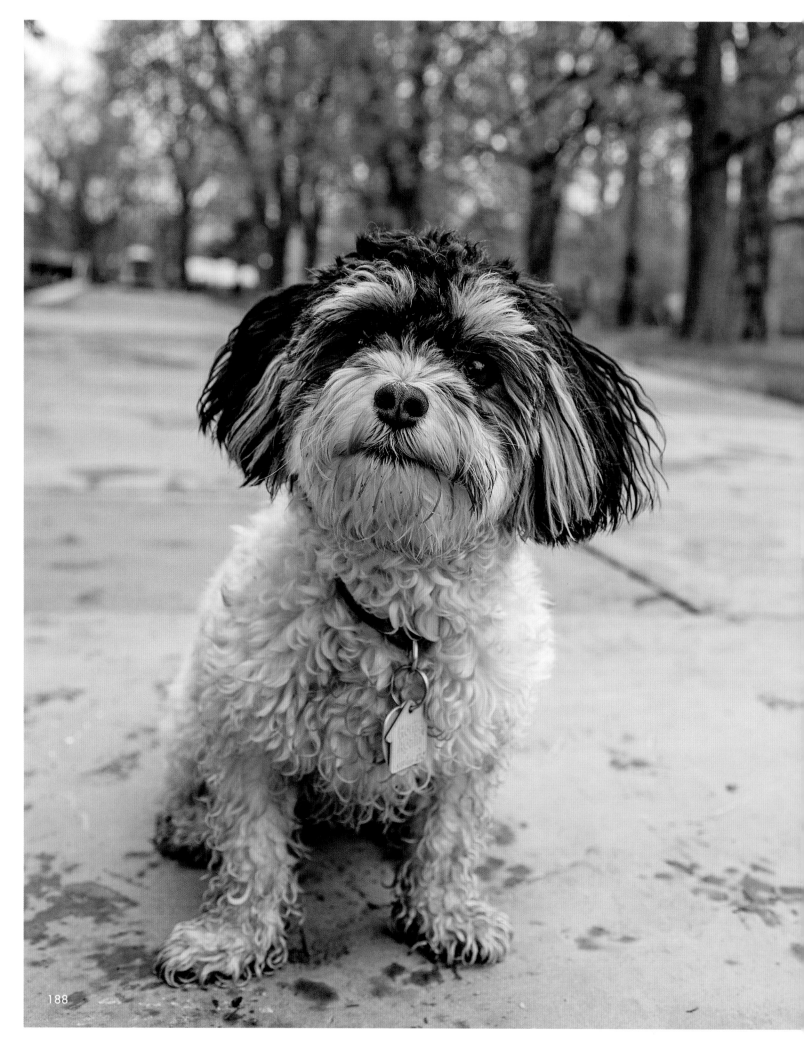

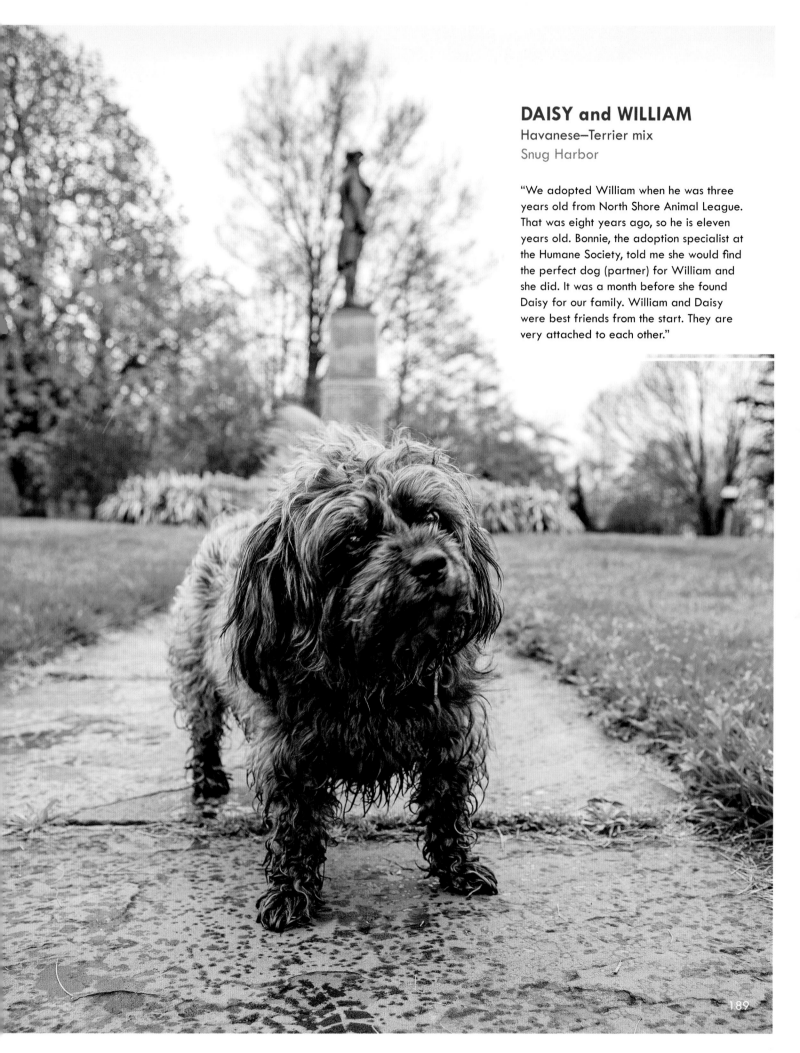

DAISY and WILLIAM
Havanese–Terrier mix
Snug Harbor

"We adopted William when he was three years old from North Shore Animal League. That was eight years ago, so he is eleven years old. Bonnie, the adoption specialist at the Humane Society, told me she would find the perfect dog (partner) for William and she did. It was a month before she found Daisy for our family. William and Daisy were best friends from the start. They are very attached to each other."

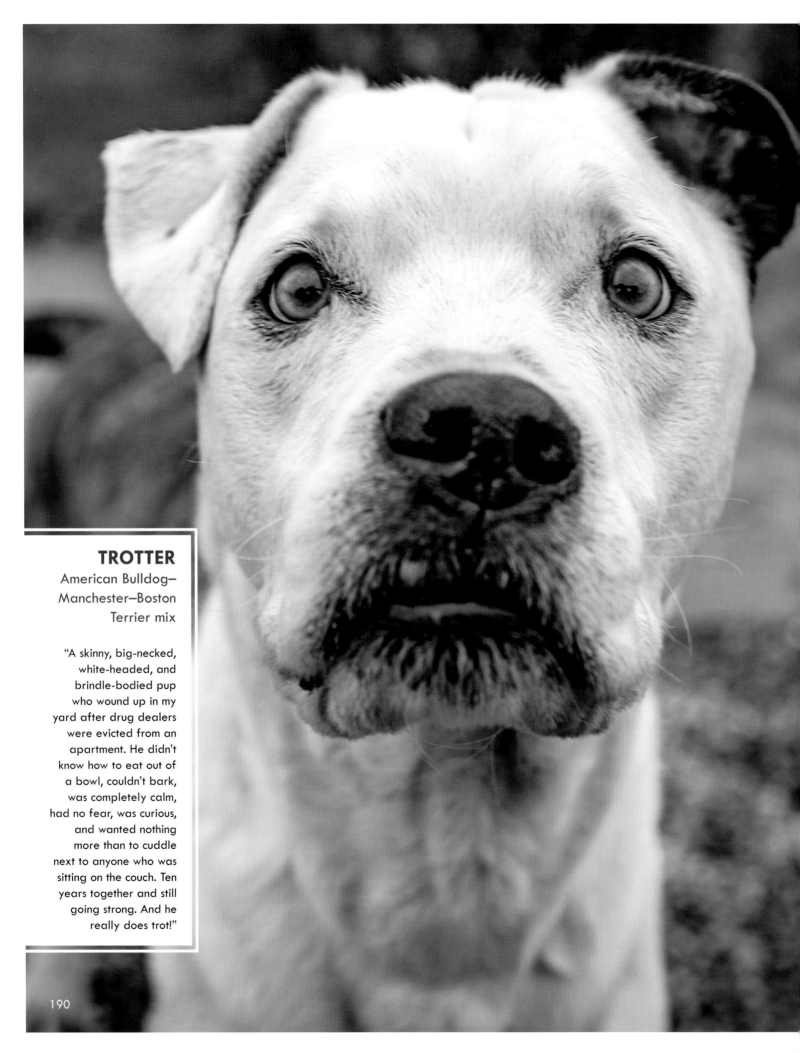

TROTTER
American Bulldog–
Manchester–Boston
Terrier mix

"A skinny, big-necked,
white-headed, and
brindle-bodied pup
who wound up in my
yard after drug dealers
were evicted from an
apartment. He didn't
know how to eat out of
a bowl, couldn't bark,
was completely calm,
had no fear, was curious,
and wanted nothing
more than to cuddle
next to anyone who was
sitting on the couch. Ten
years together and still
going strong. And he
really does trot!"

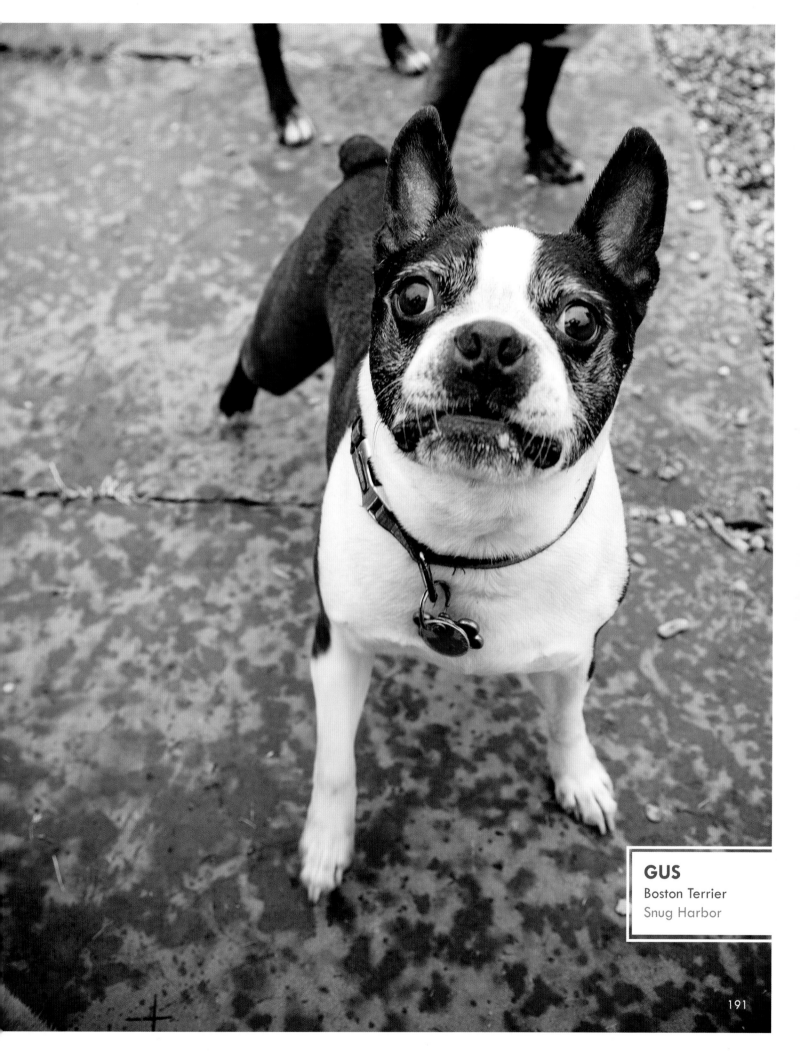

GUS
Boston Terrier
Snug Harbor

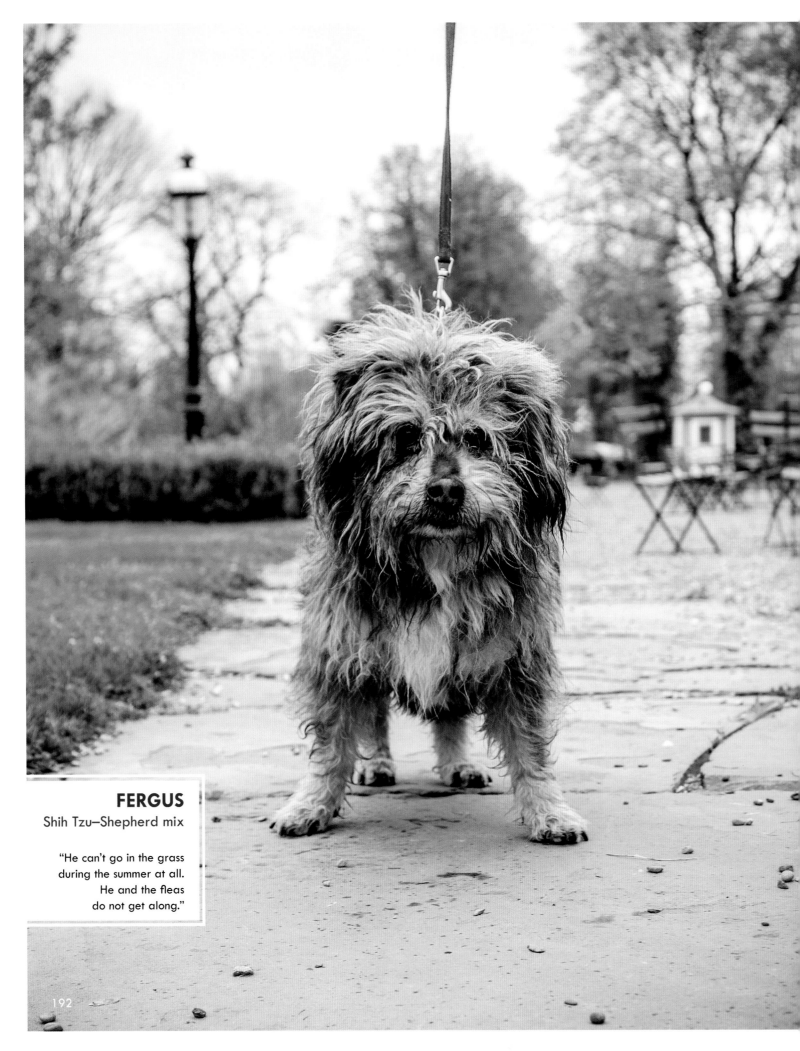

FERGUS

Shih Tzu–Shepherd mix

"He can't go in the grass
during the summer at all.
He and the fleas
do not get along."

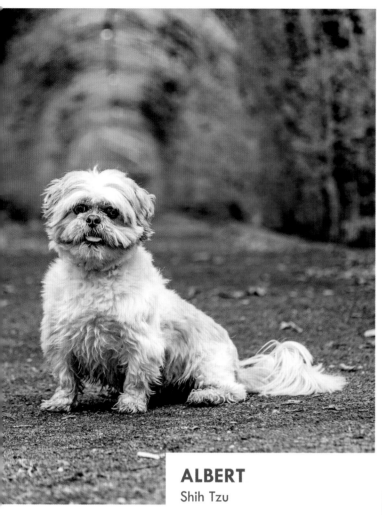

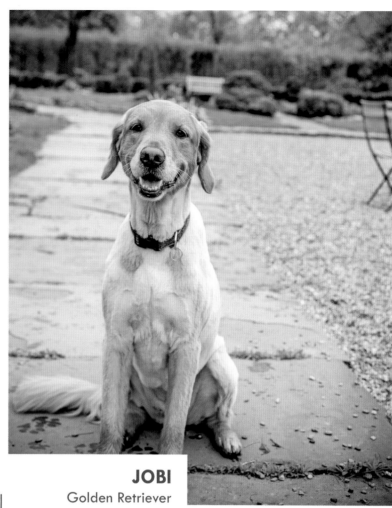

ALBERT
Shih Tzu

JOBI
Golden Retriever

ROKI RAE
Cavalier King Charles Spaniel

MEMPHIS
Ridgeback Coon Hound

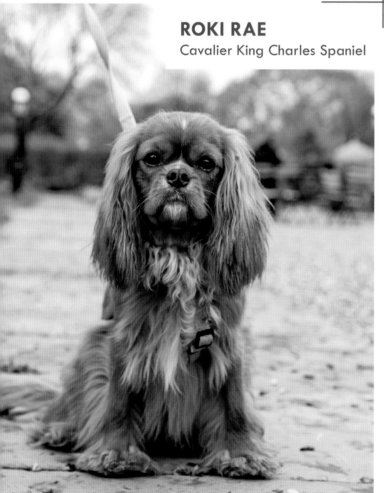

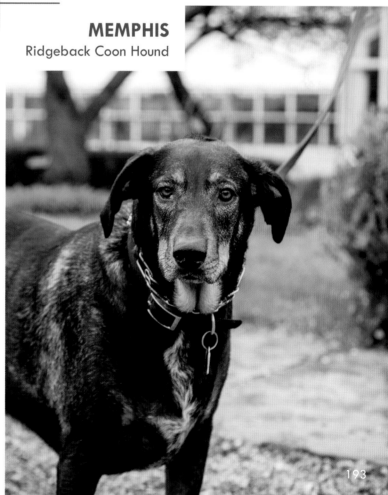

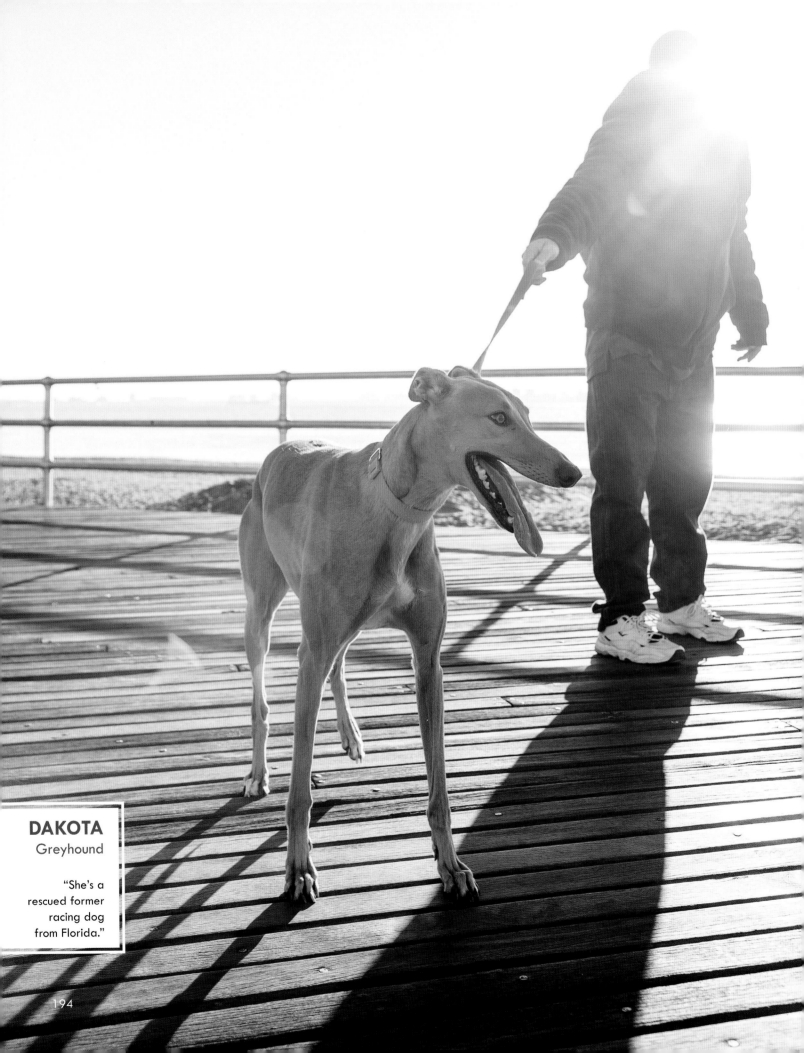

DAKOTA
Greyhound

"She's a
rescued former
racing dog
from Florida."

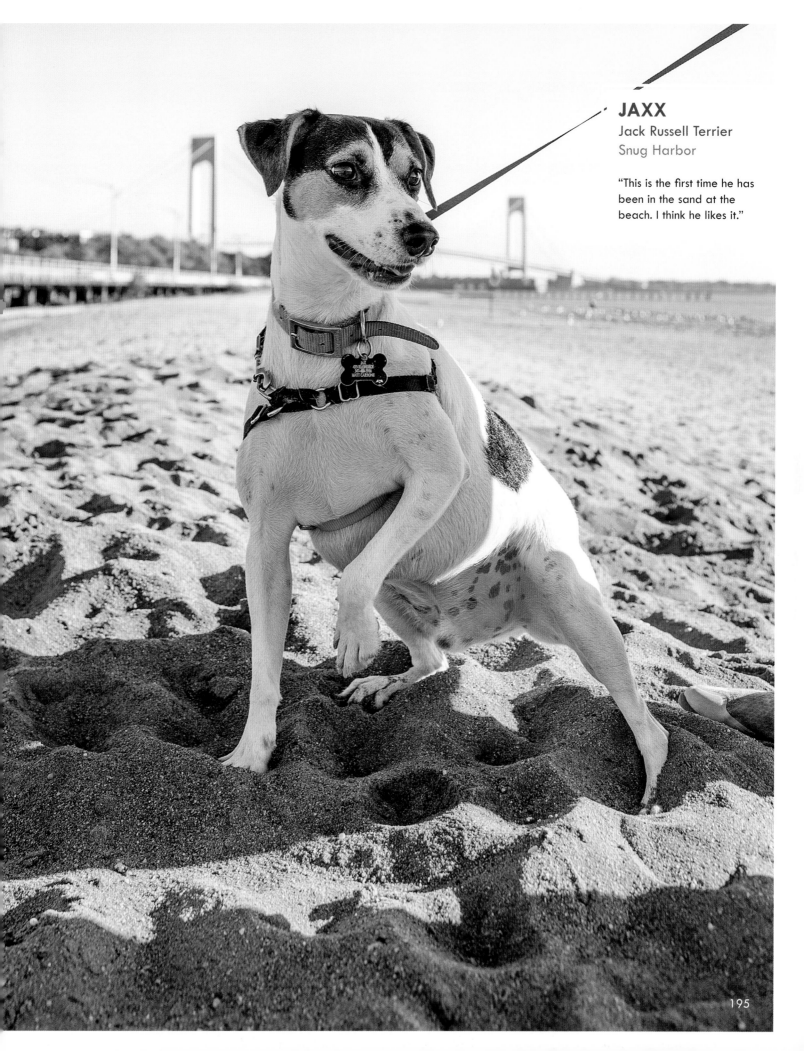

JAXX
Jack Russell Terrier
Snug Harbor

"This is the first time he has been in the sand at the beach. I think he likes it."

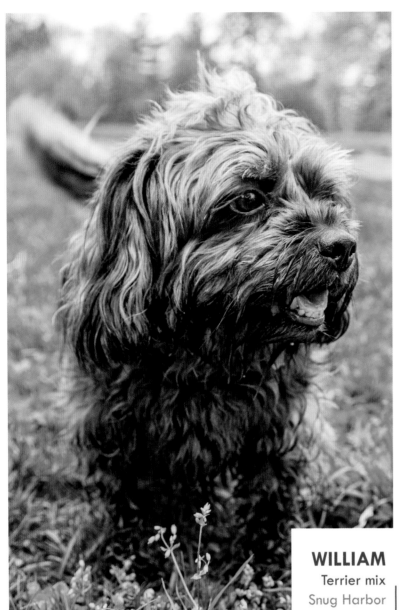

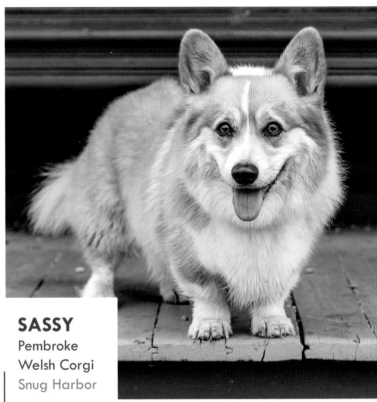

SASSY
Pembroke
Welsh Corgi
Snug Harbor

SHADOW
Collie
Snug Harbor

WILLIAM
Terrier mix
Snug Harbor

BELLA
Neapolitan
Mastiff
Snug Harbor

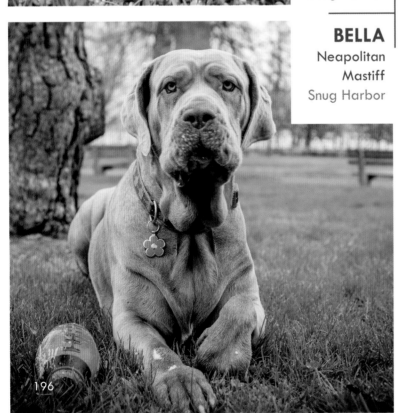

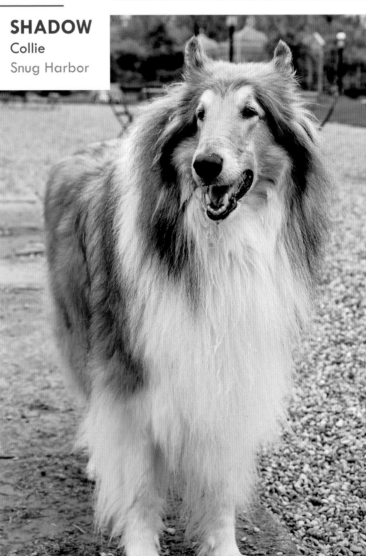

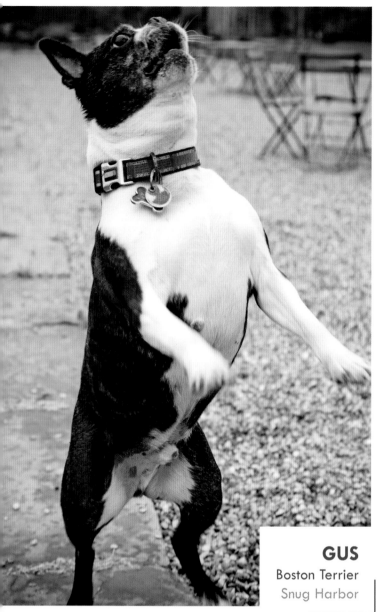

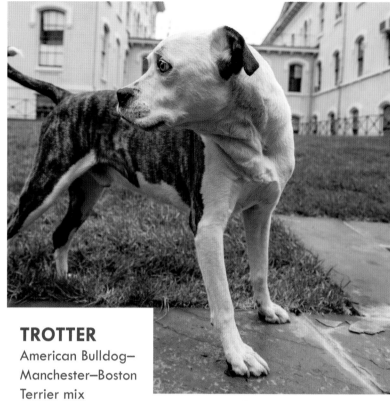

TROTTER
American Bulldog–
Manchester–Boston
Terrier mix
Snug Harbor

GUS
Boston Terrier
Snug Harbor

CODY
Mixed breed
Snug Harbor

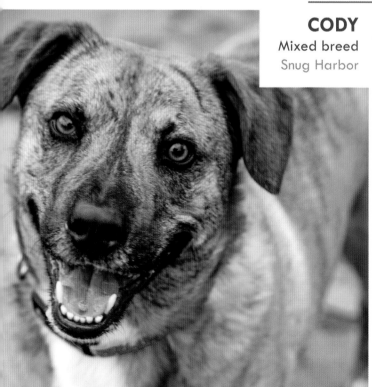

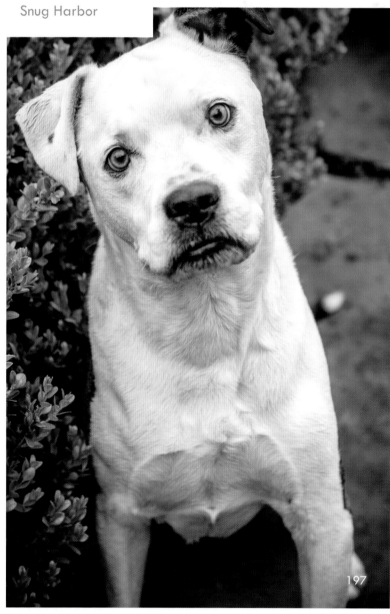

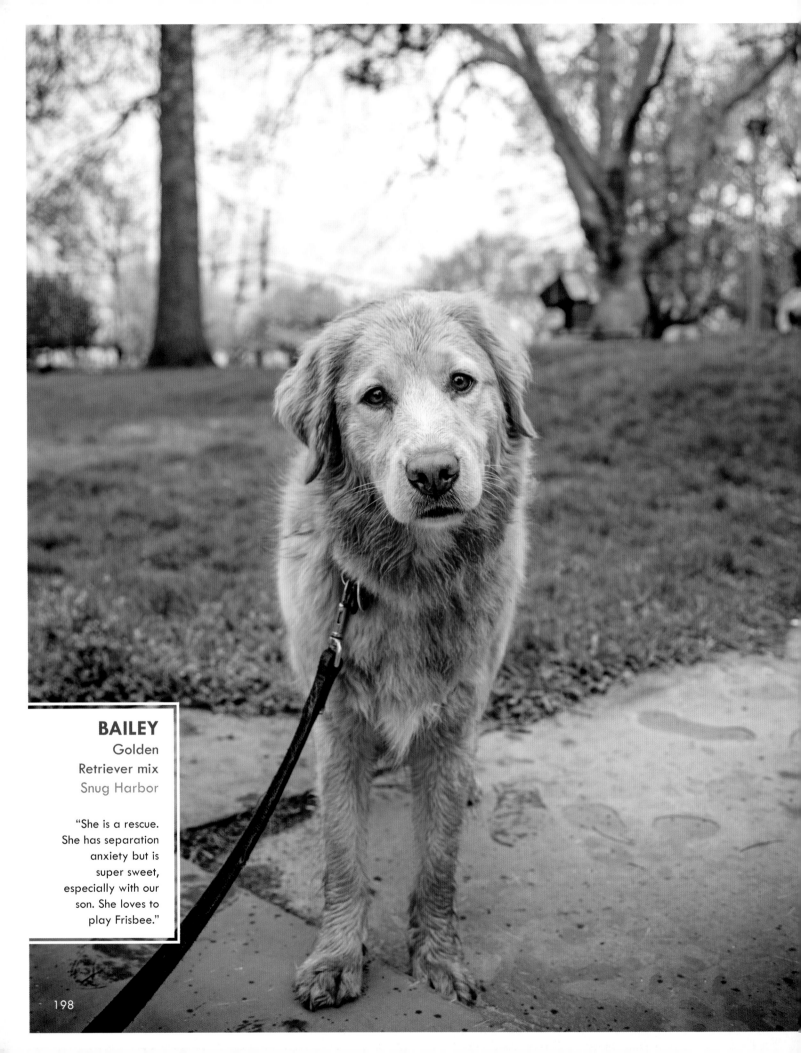

BAILEY
Golden
Retriever mix
Snug Harbor

"She is a rescue.
She has separation
anxiety but is
super sweet,
especially with our
son. She loves to
play Frisbee."

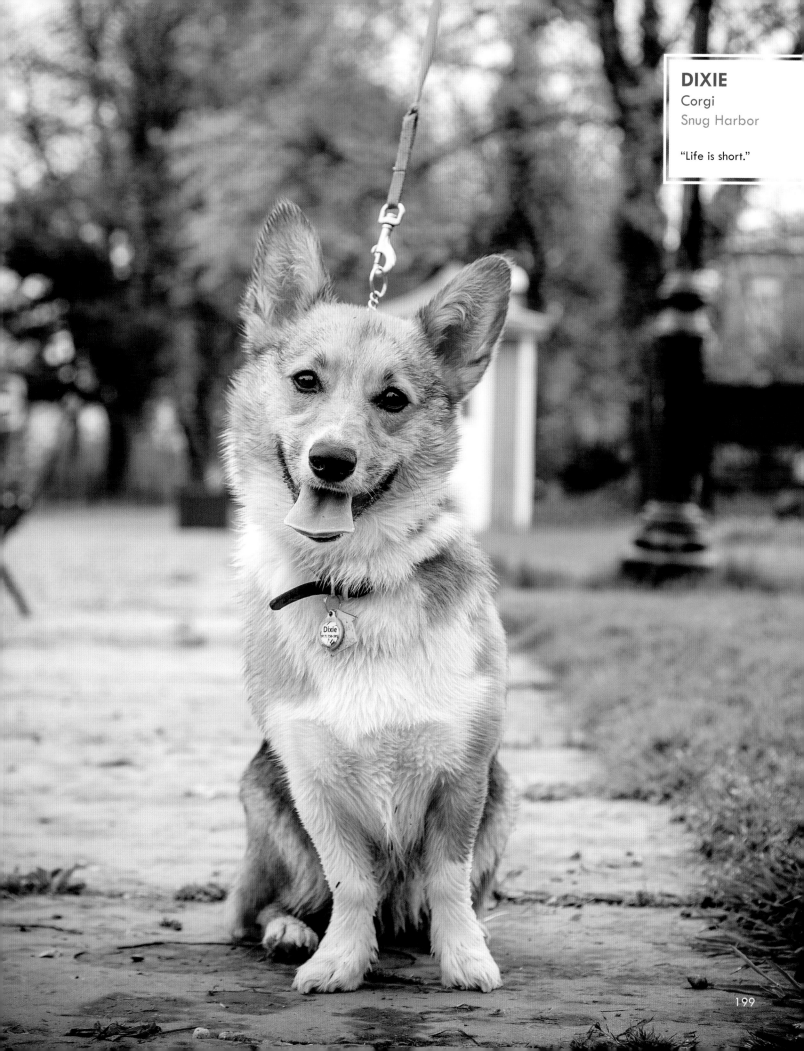

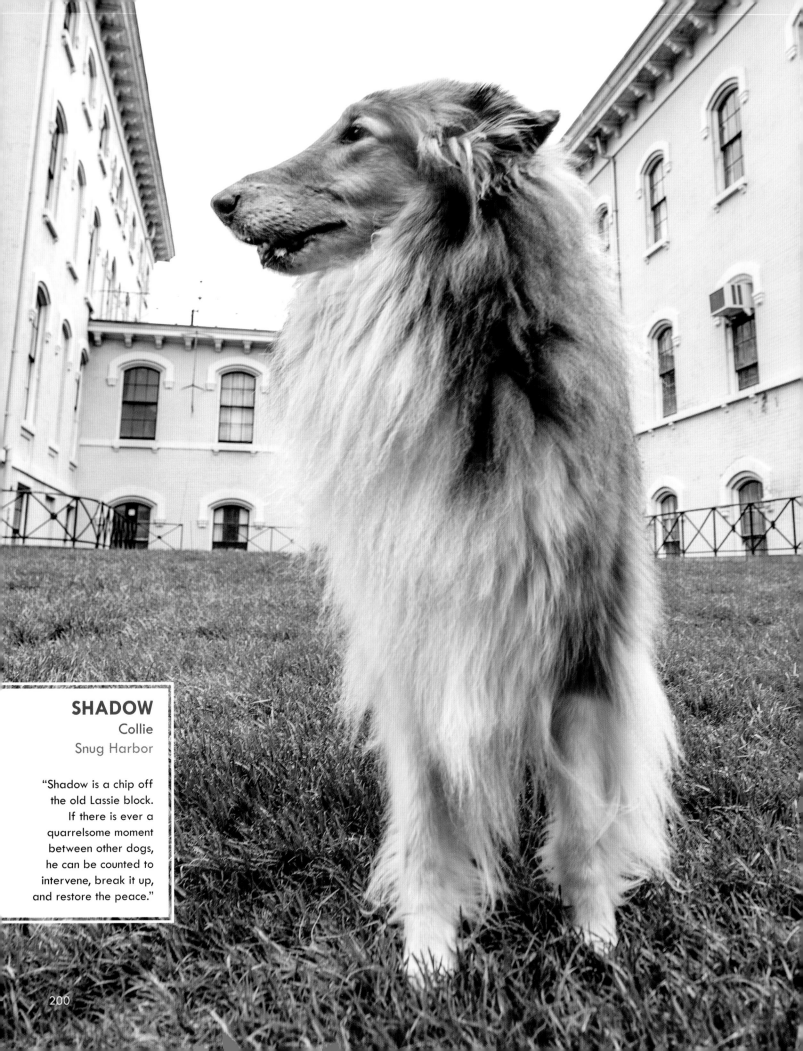

SHADOW
Collie
Snug Harbor

"Shadow is a chip off the old Lassie block. If there is ever a quarrelsome moment between other dogs, he can be counted to intervene, break it up, and restore the peace."

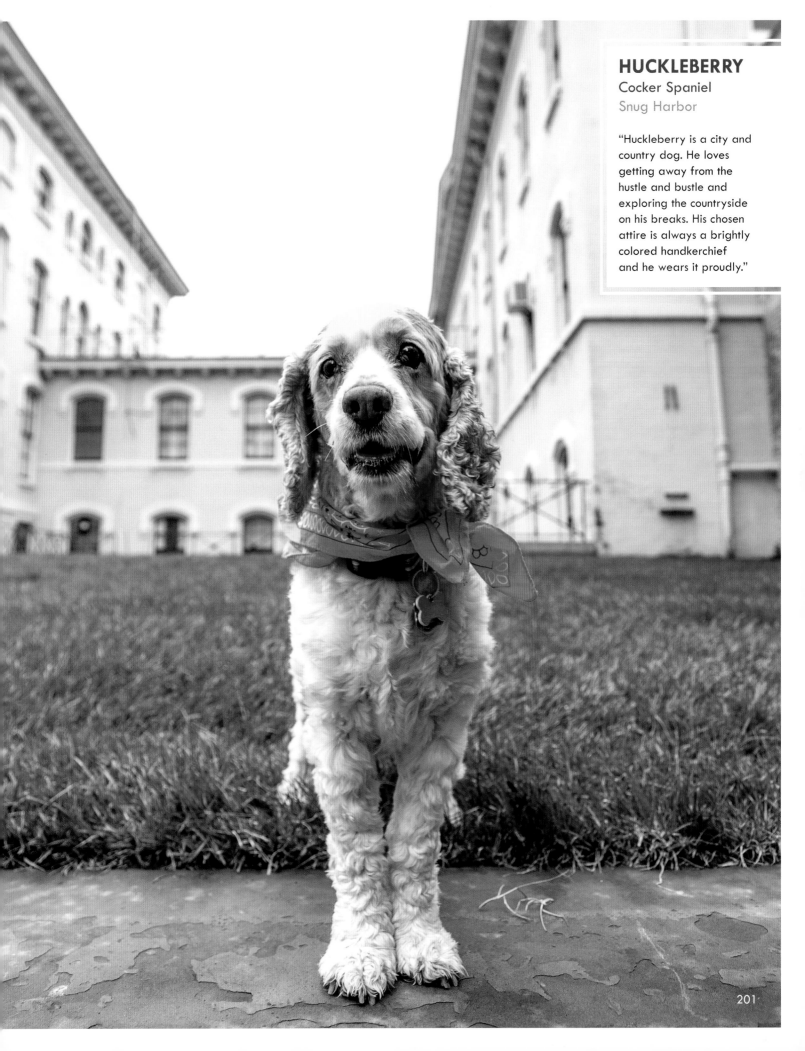

HUCKLEBERRY
Cocker Spaniel
Snug Harbor

"Huckleberry is a city and country dog. He loves getting away from the hustle and bustle and exploring the countryside on his breaks. His chosen attire is always a brightly colored handkerchief and he wears it proudly."

201

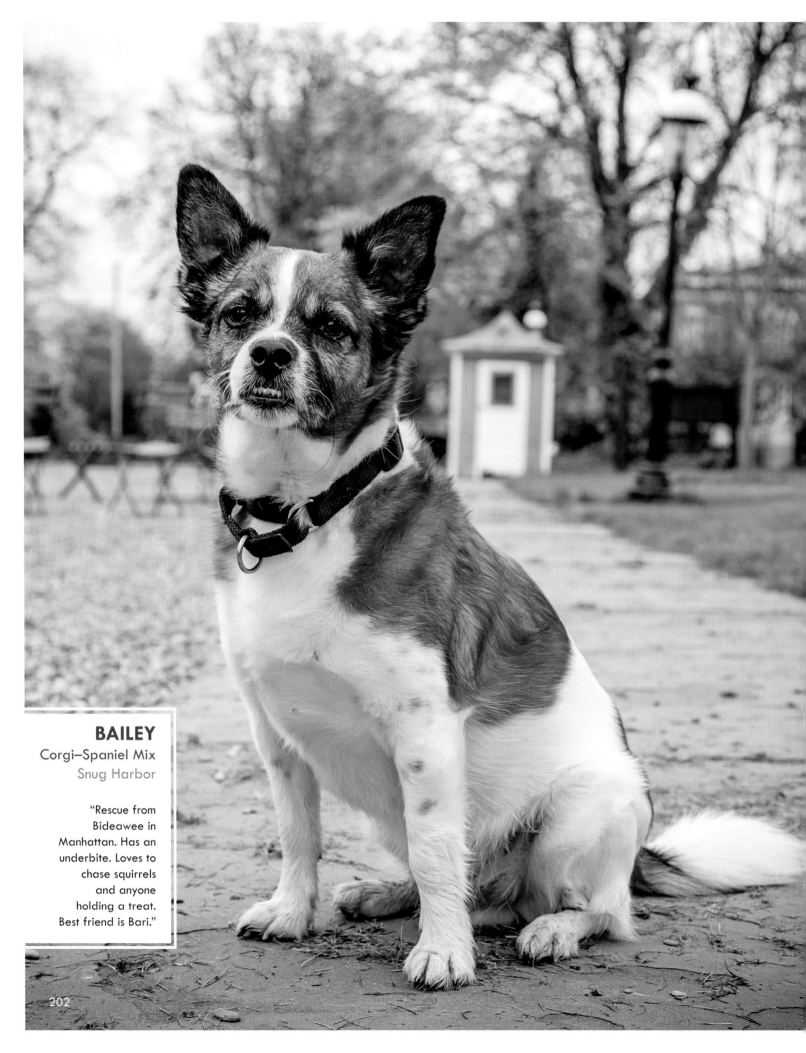

BAILEY
Corgi–Spaniel Mix
Snug Harbor

"Rescue from Bideawee in Manhattan. Has an underbite. Loves to chase squirrels and anyone holding a treat. Best friend is Bari."

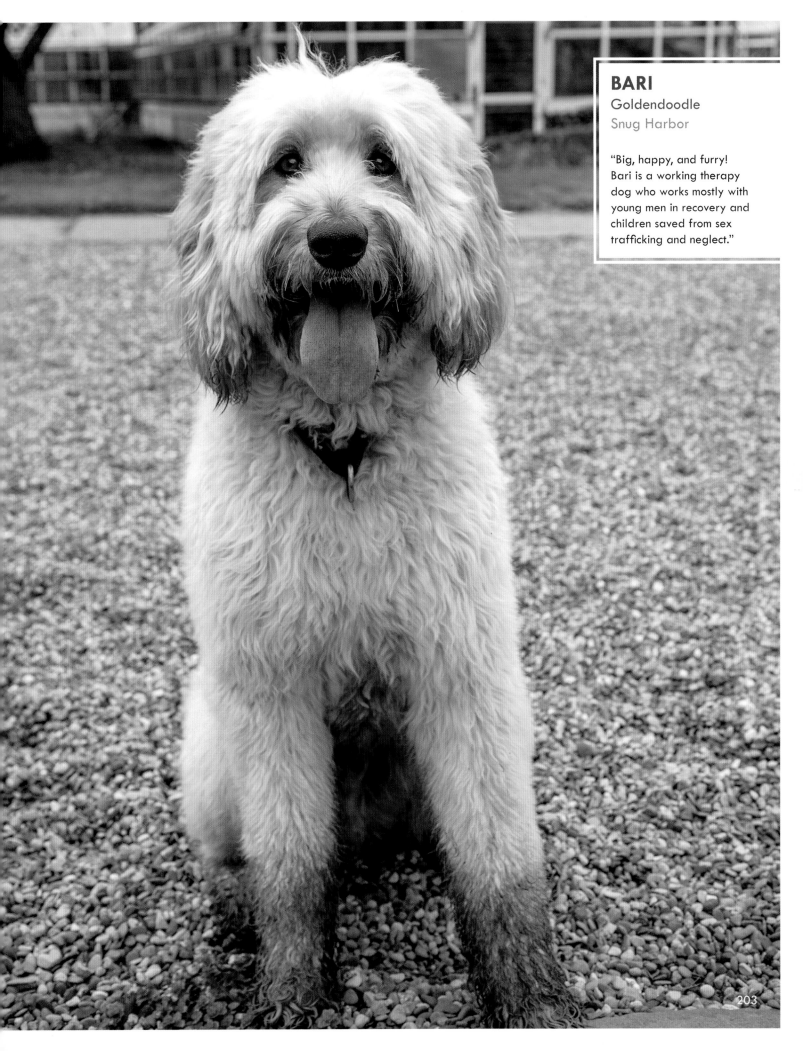

BARI
Goldendoodle
Snug Harbor

"Big, happy, and furry! Bari is a working therapy dog who works mostly with young men in recovery and children saved from sex trafficking and neglect."

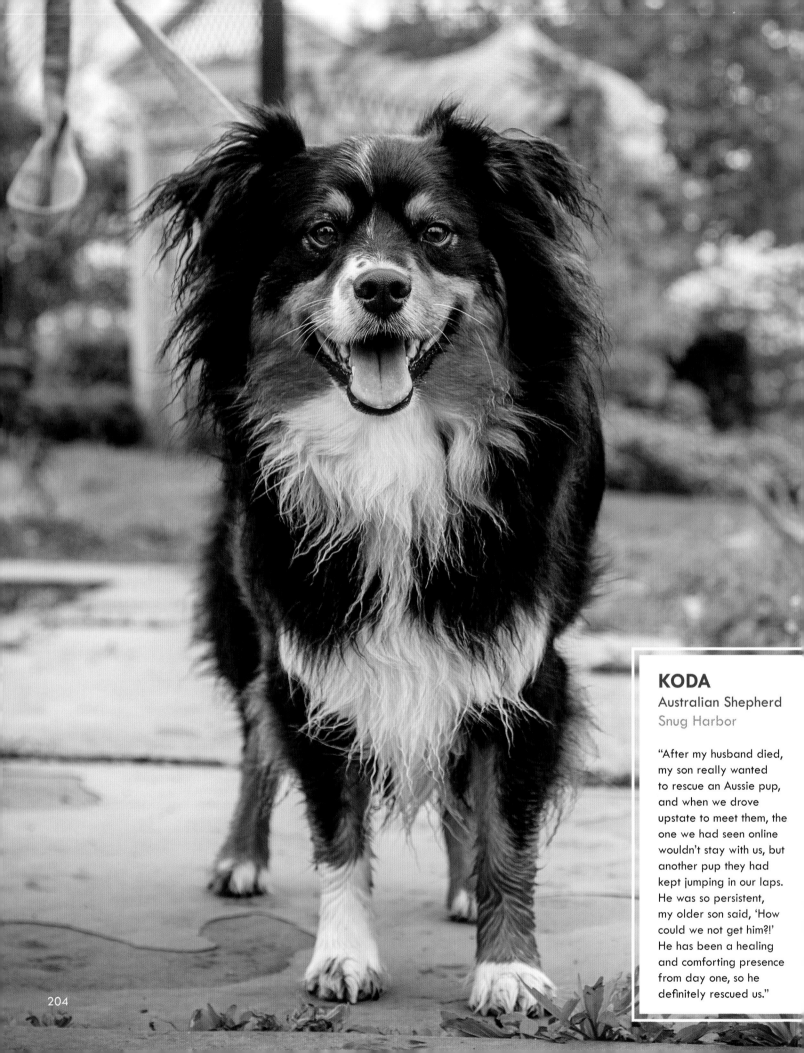

KODA
Australian Shepherd
Snug Harbor

"After my husband died, my son really wanted to rescue an Aussie pup, and when we drove upstate to meet them, the one we had seen online wouldn't stay with us, but another pup they had kept jumping in our laps. He was so persistent, my older son said, 'How could we not get him?!' He has been a healing and comforting presence from day one, so he definitely rescued us."

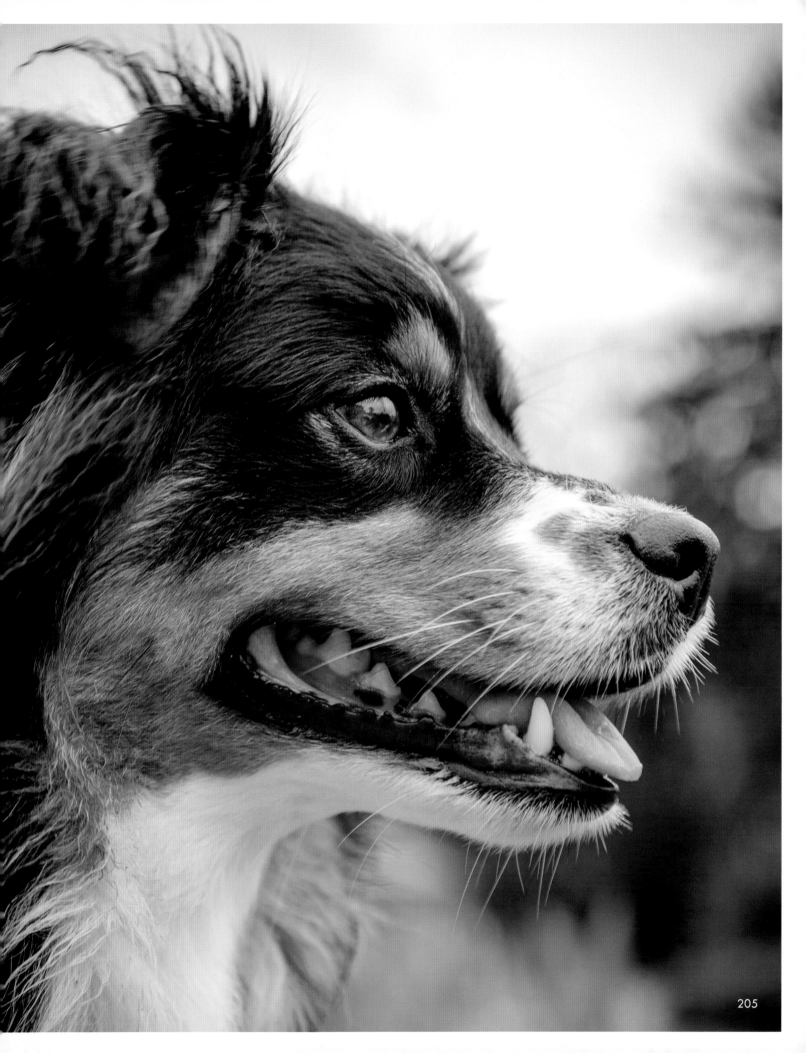

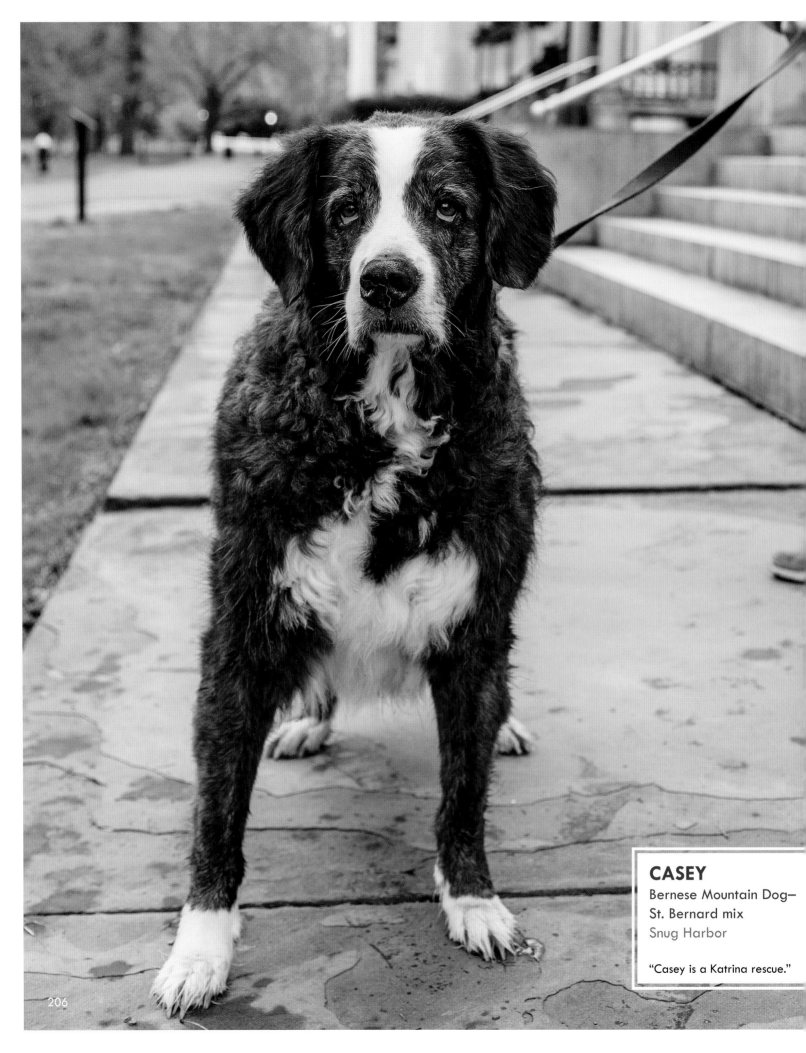

CASEY
Bernese Mountain Dog–
St. Bernard mix
Snug Harbor

"Casey is a Katrina rescue."

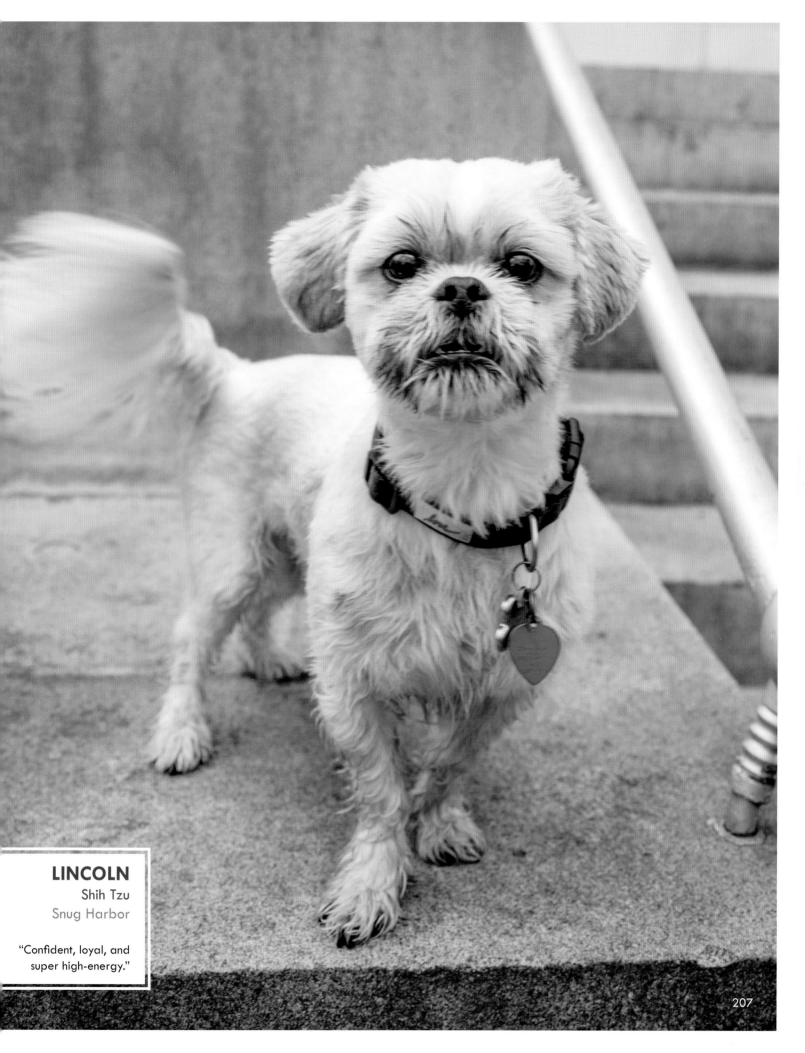

LINCOLN
Shih Tzu
Snug Harbor

"Confident, loyal, and
super high-energy."

K9 BLUE
German Shepherd
Snug Harbor

Blue is a New York state–certified police K9. His functions include explosive detection, tracking, evidence search/scent, and criminal apprehension.

K9 TORI
Black Labrador Retriever
Snug Harbor

Tori is a USPCA EDC–certified police K9. Tori was born in Alabama through Auburn University's Vapor Wake detection program. Tori is able to track the scent trails left behind by explosives. Tori is always behind the scenes at major events making sure everyone is safe in New York City.

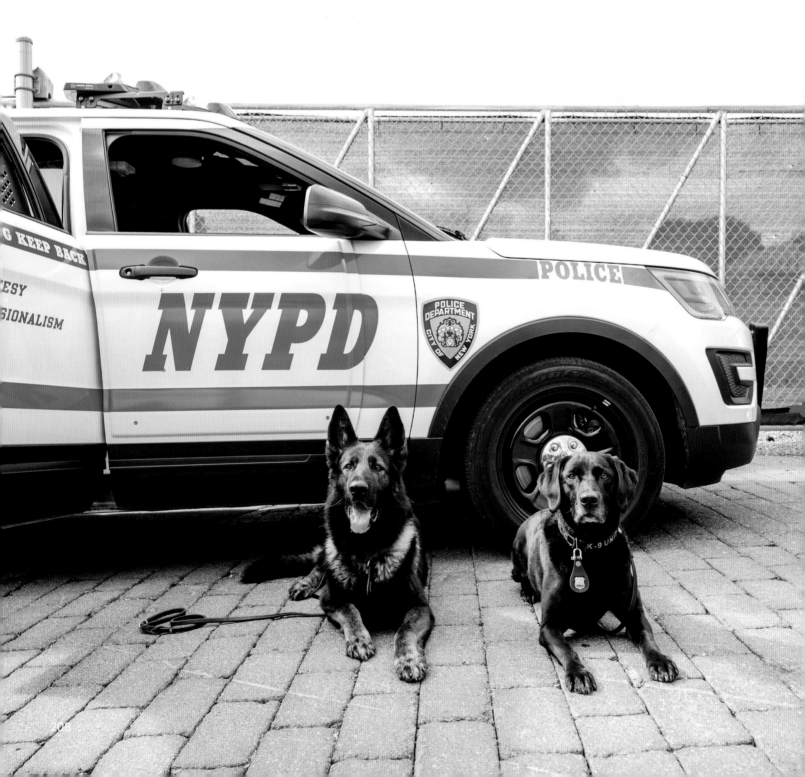

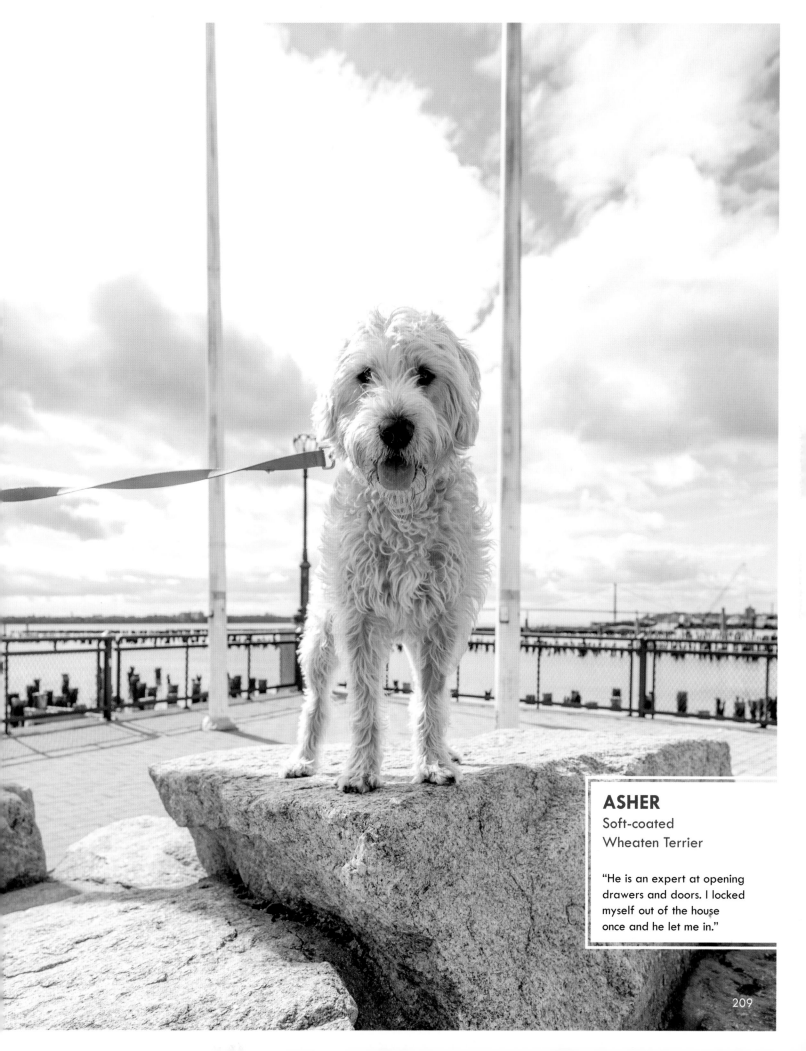

ASHER
Soft-coated
Wheaten Terrier

"He is an expert at opening drawers and doors. I locked myself out of the house once and he let me in."

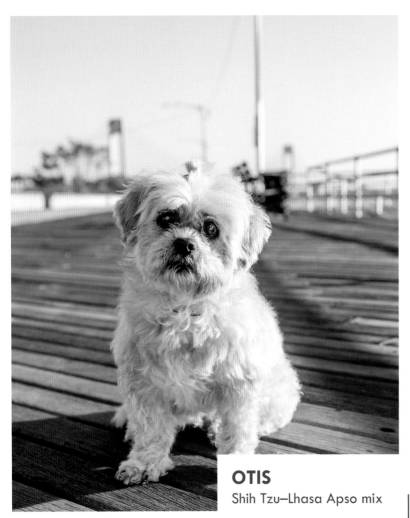

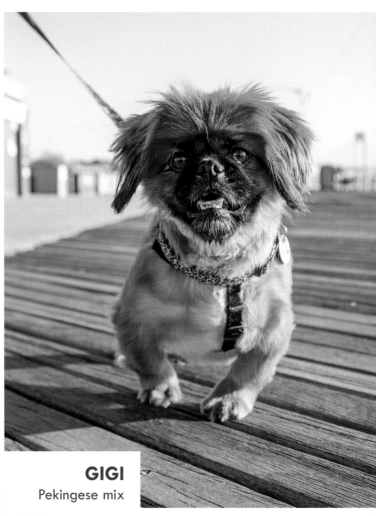

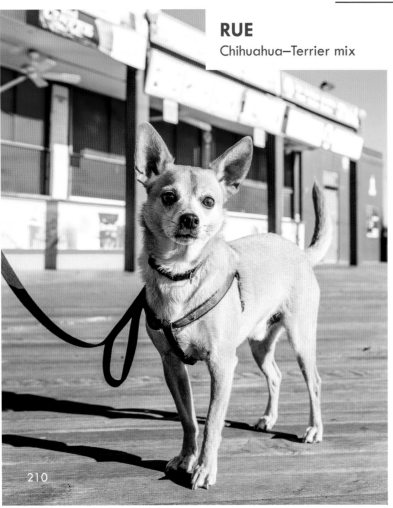

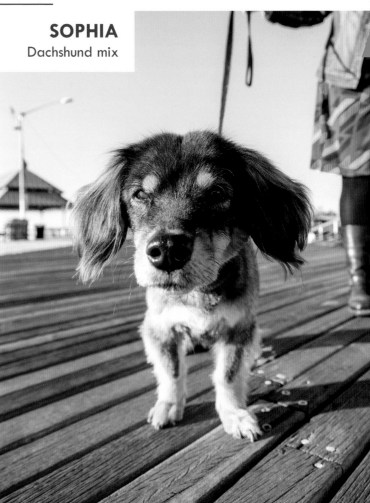

OTIS
Shih Tzu–Lhasa Apso mix

GIGI
Pekingese mix

RUE
Chihuahua–Terrier mix

SOPHIA
Dachshund mix

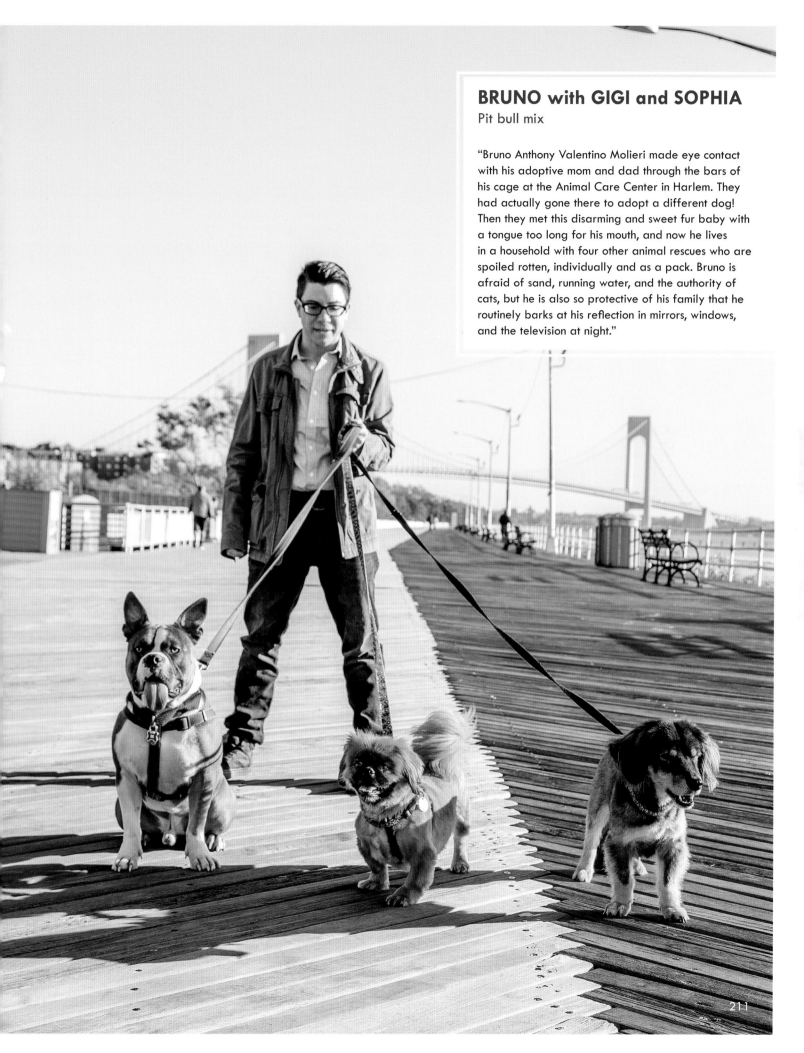

BRUNO with GIGI and SOPHIA
Pit bull mix

"Bruno Anthony Valentino Molieri made eye contact with his adoptive mom and dad through the bars of his cage at the Animal Care Center in Harlem. They had actually gone there to adopt a different dog! Then they met this disarming and sweet fur baby with a tongue too long for his mouth, and now he lives in a household with four other animal rescues who are spoiled rotten, individually and as a pack. Bruno is afraid of sand, running water, and the authority of cats, but he is also so protective of his family that he routinely barks at his reflection in mirrors, windows, and the television at night."

BEYOND THE BOROUGHS

"I believe in New Yorkers.
Whether they've ever questioned the dream
in which they live, I wouldn't know,
because I won't ever dare ask that question."

—Dylan Thomas

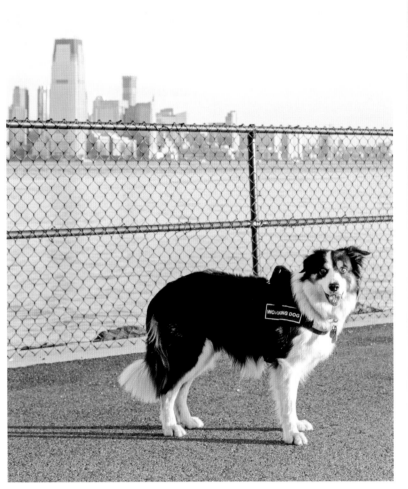

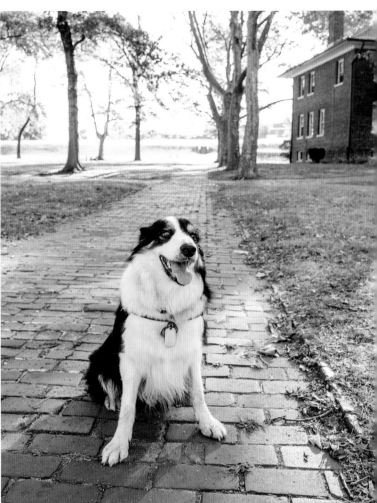

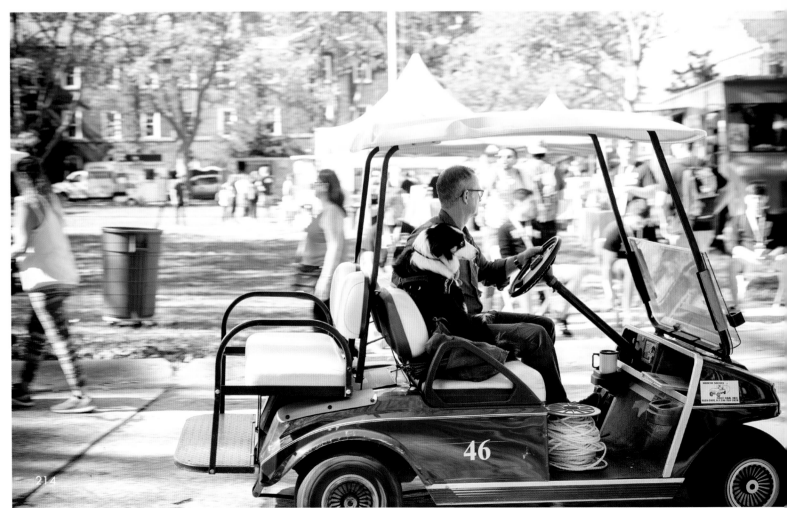

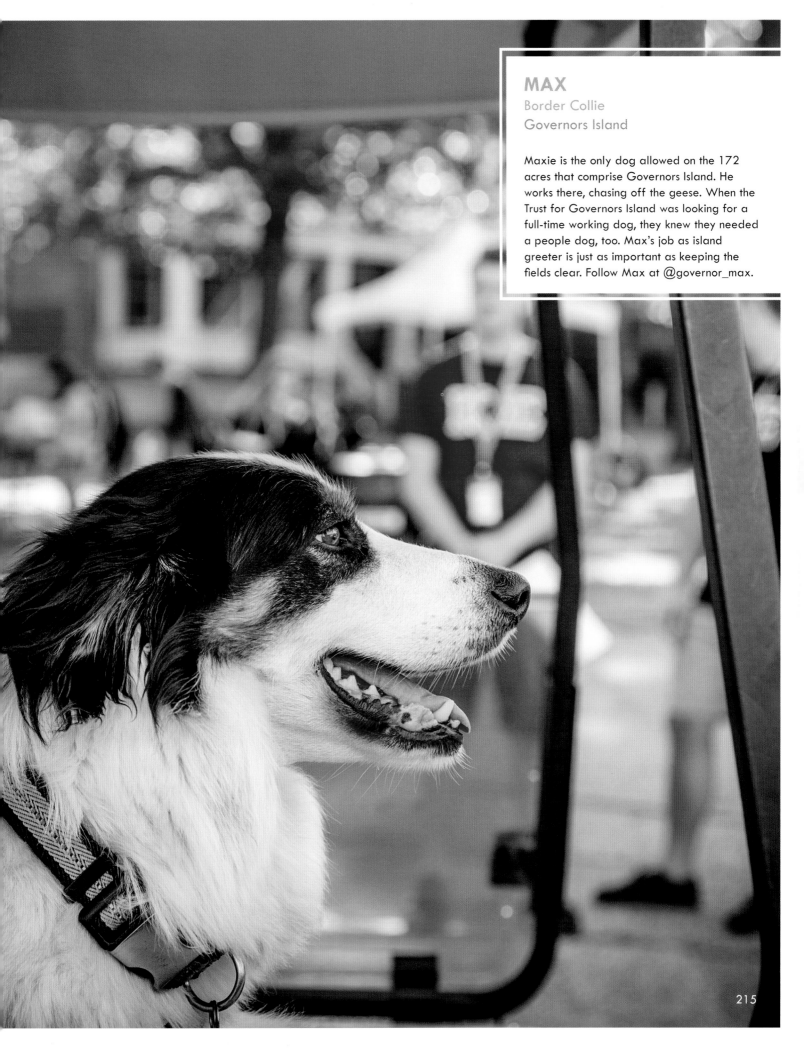

MAX
Border Collie
Governors Island

Maxie is the only dog allowed on the 172 acres that comprise Governors Island. He works there, chasing off the geese. When the Trust for Governors Island was looking for a full-time working dog, they knew they needed a people dog, too. Max's job as island greeter is just as important as keeping the fields clear. Follow Max at @governor_max.

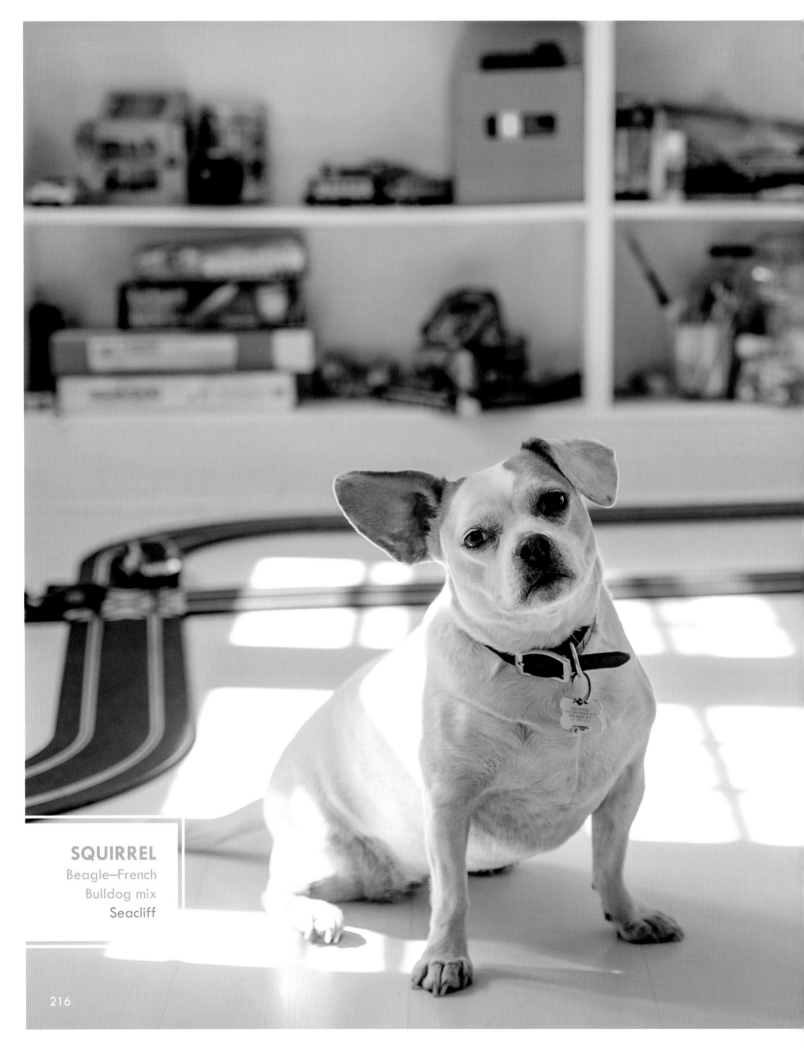

SQUIRREL
Beagle–French
Bulldog mix
Seacliff

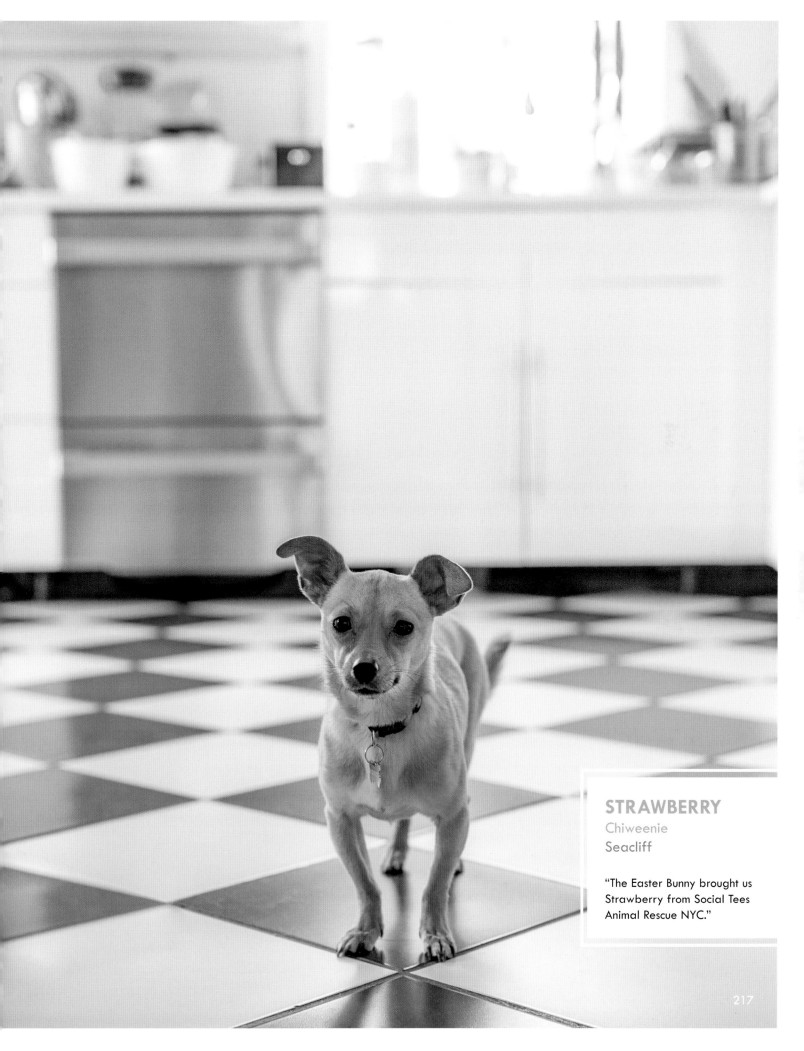

STRAWBERRY
Chiweenie
Seacliff

"The Easter Bunny brought us Strawberry from Social Tees Animal Rescue NYC."

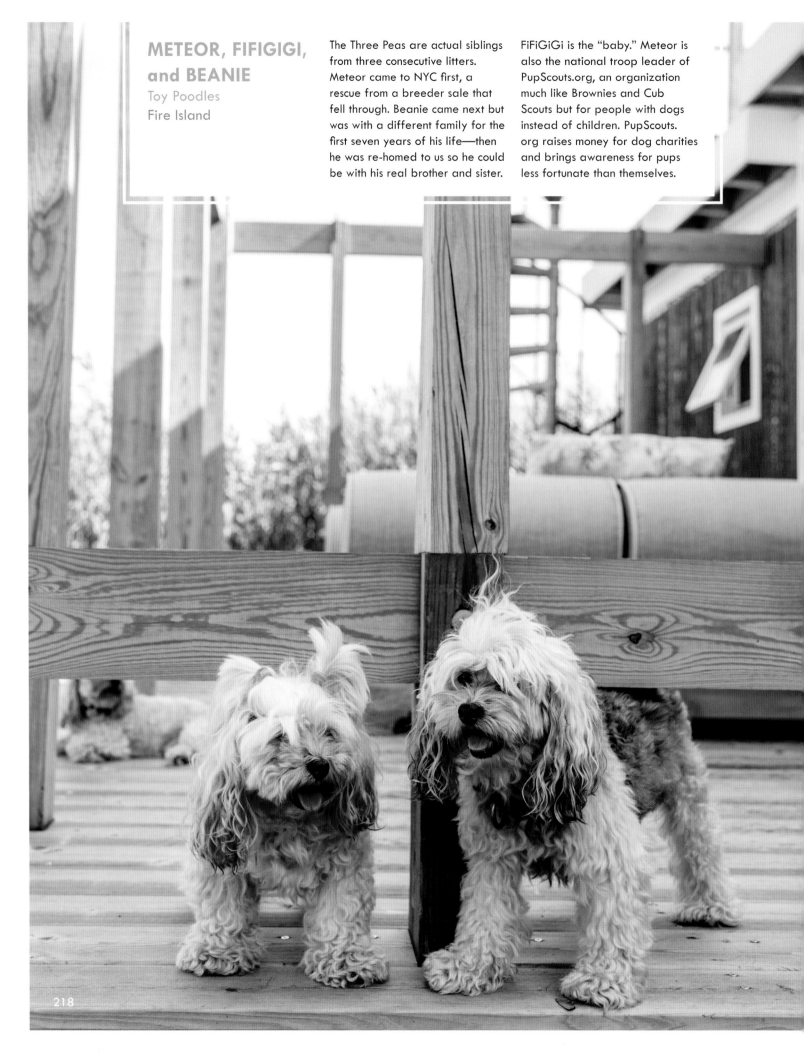

METEOR, FIFIGIGI, and BEANIE
Toy Poodles
Fire Island

The Three Peas are actual siblings from three consecutive litters. Meteor came to NYC first, a rescue from a breeder sale that fell through. Beanie came next but was with a different family for the first seven years of his life—then he was re-homed to us so he could be with his real brother and sister.

FiFiGiGi is the "baby." Meteor is also the national troop leader of PupScouts.org, an organization much like Brownies and Cub Scouts but for people with dogs instead of children. PupScouts.org raises money for dog charities and brings awareness for pups less fortunate than themselves.

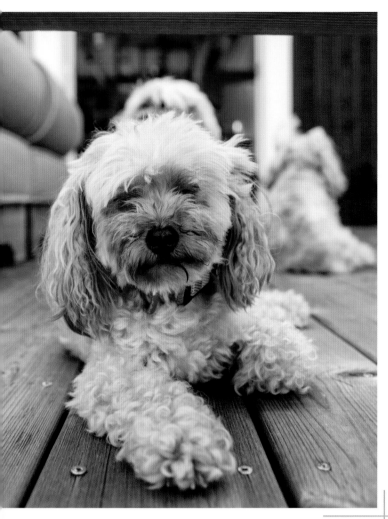

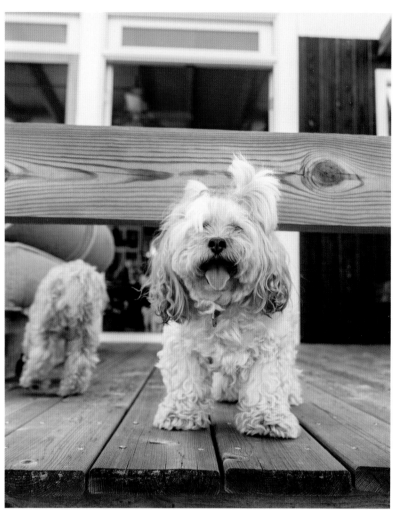

STELLA
Long-haired German
Shepherd
Fire Island

ROCKET
Soft-coated
Wheaten Terrier
Fire Island

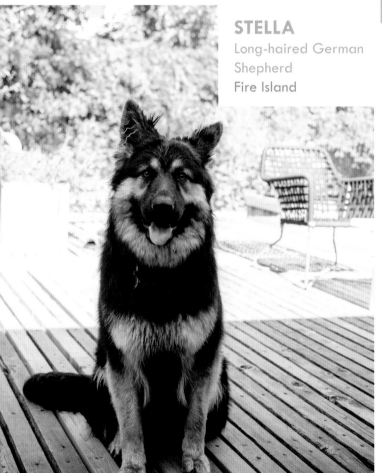

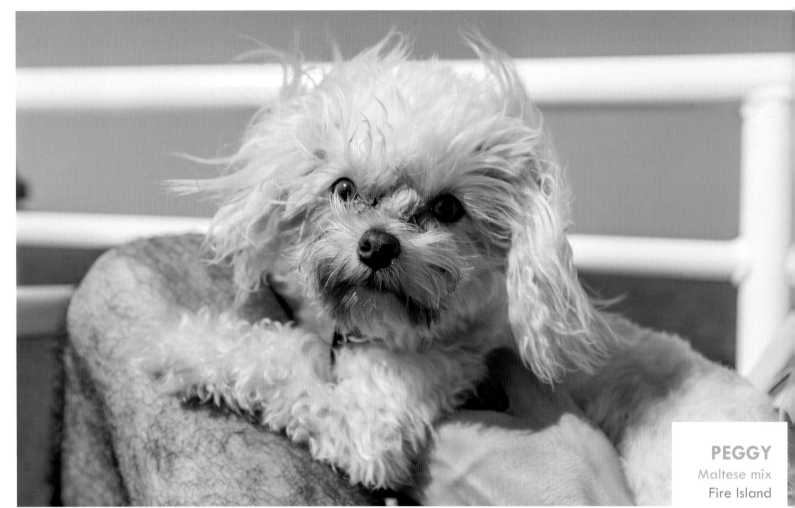

PEGGY
Maltese mix
Fire Island

MAC
Boston Terrier
Fire Island

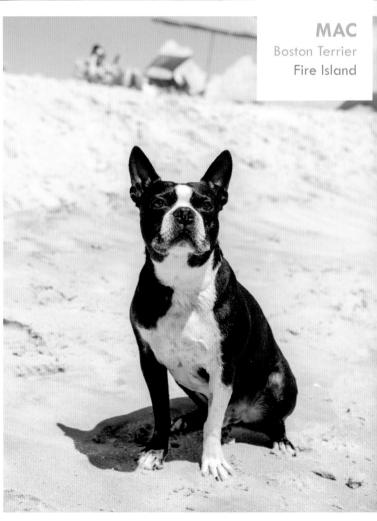

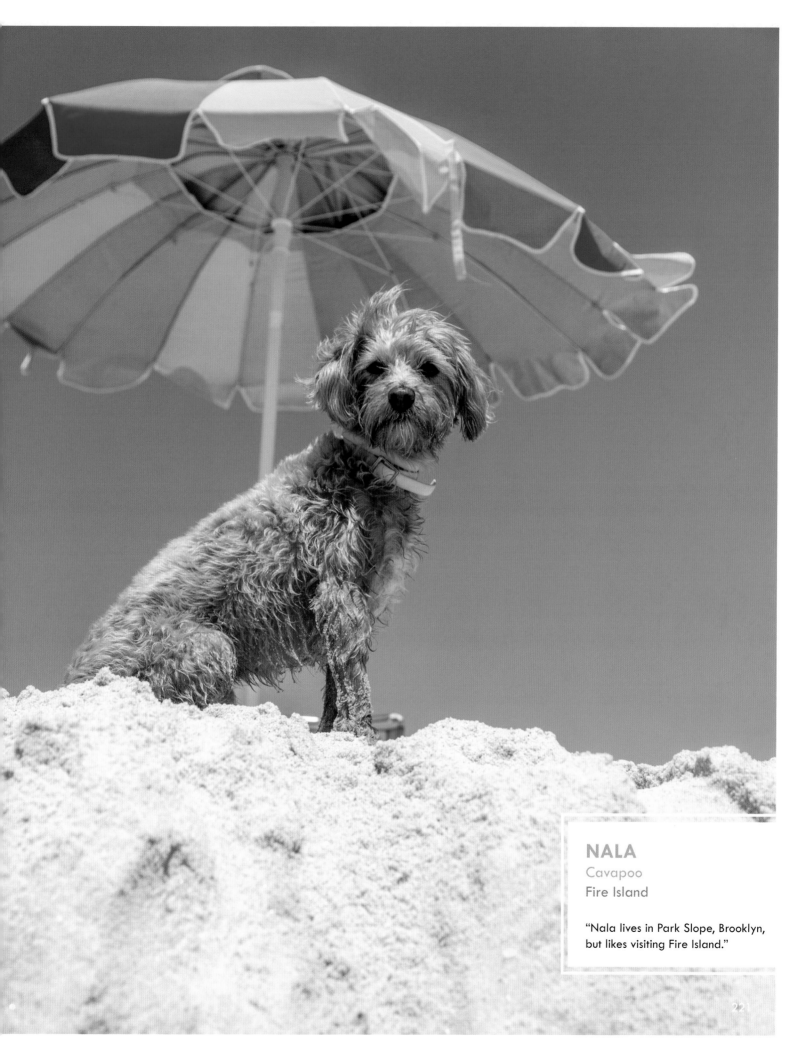

NALA
Cavapoo
Fire Island

"Nala lives in Park Slope, Brooklyn, but likes visiting Fire Island."

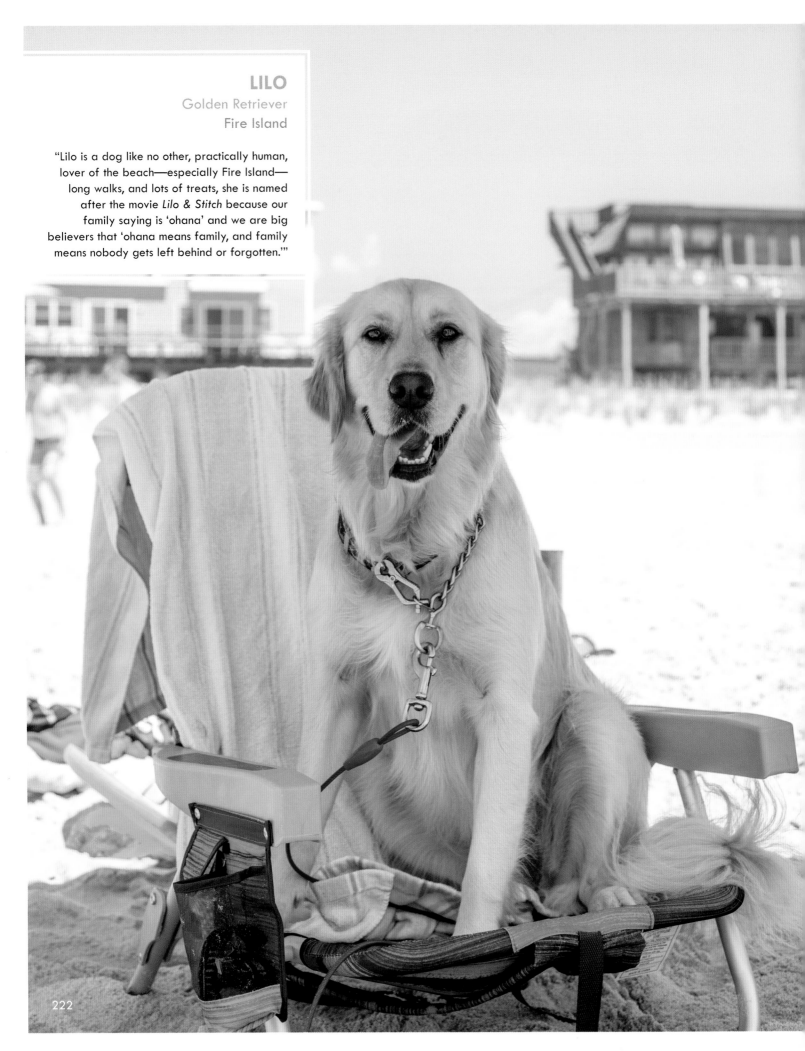

LILO
Golden Retriever
Fire Island

"Lilo is a dog like no other, practically human, lover of the beach—especially Fire Island—long walks, and lots of treats, she is named after the movie *Lilo & Stitch* because our family saying is 'ohana' and we are big believers that 'ohana means family, and family means nobody gets left behind or forgotten.'"

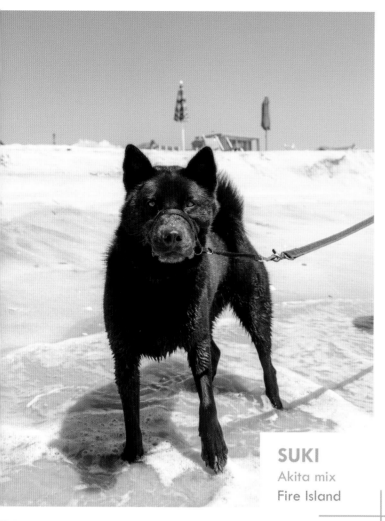

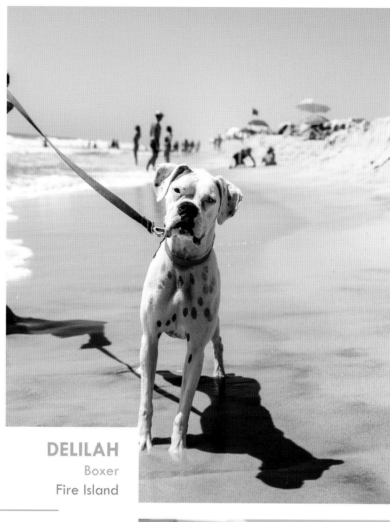

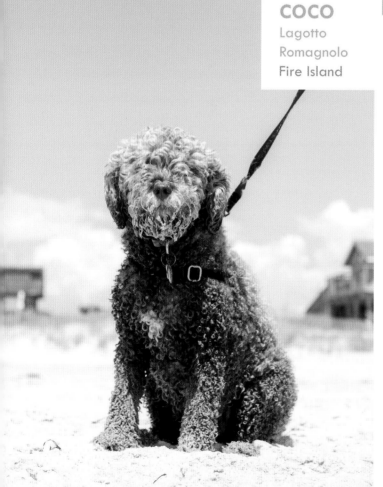

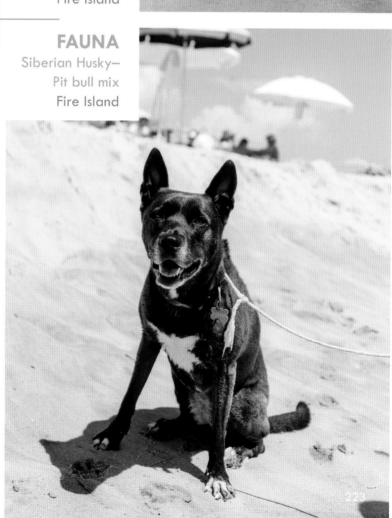

SUKI
Akita mix
Fire Island

DELILAH
Boxer
Fire Island

COCO
Lagotto
Romagnolo
Fire Island

FAUNA
Siberian Husky–
Pit bull mix
Fire Island

Acknowledgments

Thank you to all my friends who acted as assistants in helping me capture these beautiful dogs. Emily, my cat-loving friend, you are wrangler number one. You woke up early and accompanied me on many adventures. Driving, collecting stories, making connections, brainstorming, editing—and all just for fun. You are a gem I cherish. Hazel, my youngest wrangler, you brought your entourage and kept the pups entertained. And now you are making doggy treats! I am very impressed. Thank you to Daniel Aukin for always saying yes when I asked to borrow the car. Thank you, Kate and Maisie. Thank you, Nicole Kim, for trying to make me fill out those papers and not scolding me when I just never did! UN dogs for the next project. Thank you, Michael Sherman and Buddy, for multiple Manhattan and Brooklyn outings—always fun and fruitful. Michael, you are an A-plus connector. Thank you, Rachel Godsil, for trekking out to Fire Island in the summer heat and your tireless reference searches! Jim Freeman, you and Rachel are quote champions. Thank you to Lee Wade and Tad Hills for welcoming us at the beach and for hunting down all those beach pups. Thank you to Judy Coreless for jumping right in with connects and for allowing me to insist I couldn't possibly go to the Bronx without you. Thank you, Jason MacDonald, for listening and editing and inspiring me to continue. Thank you to my husband, Peter Daley, for not refusing to get up early on the weekends. Thank you to Sharyn Rosart for bringing me this project, and thank you to Krzysztof Poluchowicz for making it look so pretty. Thank you, Chris Navratil and all the folks at Blue Streak. Thank you, Lisa Cuff Bergofin, for always being ready with suggestions. Thank you to my Facebook friends who posted and kept the pups coming. I wish I had time to photograph every single one. Melissa Luckman Keller and Cindy Lobel: If not for you, I might have never gotten started in the outer boroughs. Thank you to my teen helpers Errolyn and Ivy. Thank you, Lisa Shapiro, for introducing me to your people in Long Island City and for joining me on that crazy cold and windy February morning. Thank you, Diane Matyas, for setting me up with the Canine Friends of Snug Harbor; and thank you, Jean-Marie, for making sure I found them! Thank you, Debra Manger—you are my number one Staten Island casting agent and location manager! Thank you to Melanie Acevedo, Rumaan Alam, Heather Damon, and Melissa Schreiber, my email connectors. Thank you to Samantha at Social Tees Animal Rescue for doing the good work you do. Thank you, The Dogist, an inspiration for his insightful work. Thank you, Amelia Ayrelan Iuvino, for applying your editor's eye to these pages. Thank you to all you dog people who didn't run away from me when I explained to you what I was doing, assuring you it would only take a few minutes. Thank you for letting me get to know your canine companions.

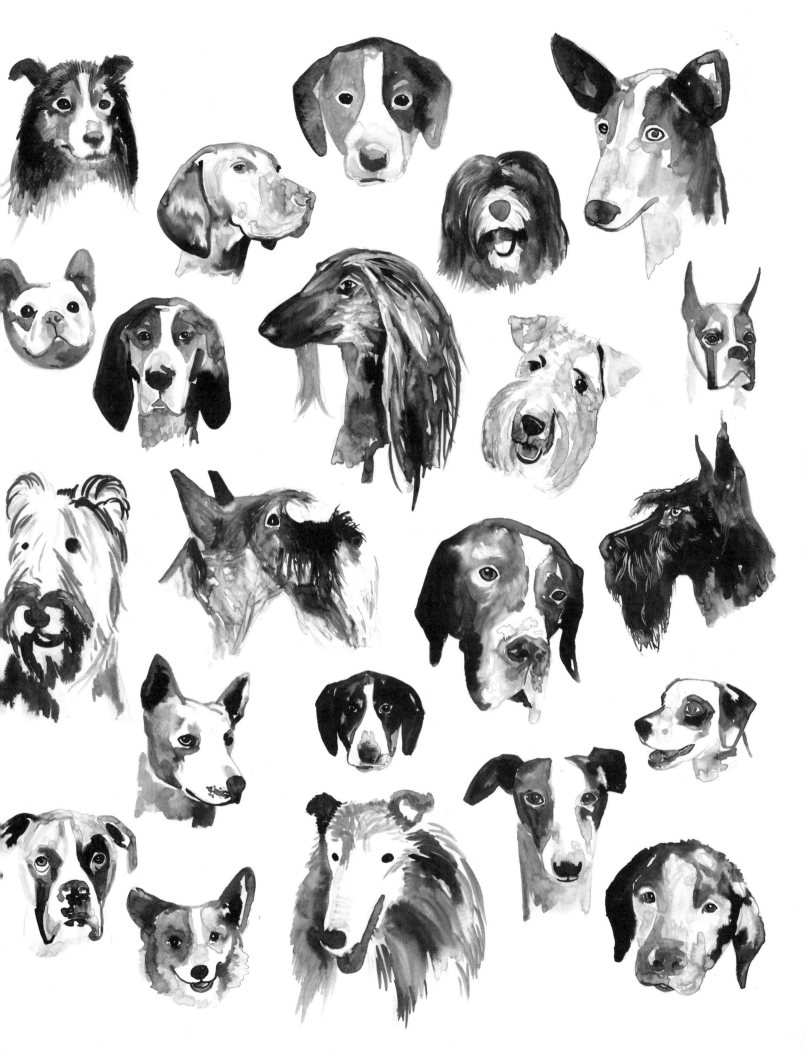